ART OF THE NORTHWEST COAST

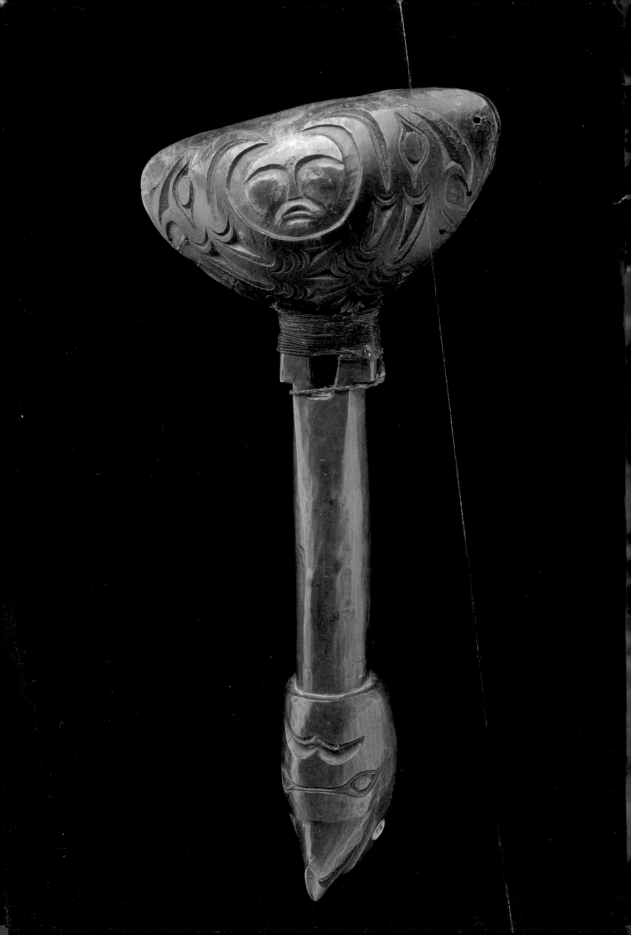

# ART of the
# NORTHWEST
# COAST

ALDONA JONAITIS

UNIVERSITY OF WASHINGTON PRESS

*Seattle and London*

DOUGLAS & MCINTYRE

*Vancouver and Toronto*

06 07 08 09 10  5 4 3 2 1

Originated by:
University of Washington Press
PO Box 50096, Seattle, WA  98145
www.washington.edu/uwpress

Published simultaneously in Canada by:
Douglas & McIntyre
2323 Quebec Street, Suite 201
Vancouver, British Columbia  V5T 4S7
www.douglas-mcintyre.com

LIBRARY OF CONGRESS
CATALOGING-IN-PUBLICATION DATA

Jonaitis, Aldona, 1948–
Art of the Northwest Coast / Aldona Jonaitis.
    p. cm.
Includes bibliographical references and index.
ISBN 0–295–98636–0 (pbk. : alk. paper)

    1. Indian art—Northwest Coast of North
America—History. 2. Indians of North
America—Northwest Coast of North America—
History. 3. Indians of North America—
Northwest Coast of North America—Social Life
and customs. I. Title.

E78.N78.J57 2006    704.03'970795—dc22
2006013866

LIBRARY AND ARCHIVES CANADA
CATALOGUING IN PUBLICATION

Jonaitis, Aldona, 1948–
    Art of the Northwest Coast / Aldona Jonaitis.

Includes bibliographical references and index.
ISBN–13: 978–1–55365–210–6
ISBN–10: 1–55365–210–X

    1. Indian art—Northwest coast of North
America—History. I. Title.

E78.N78J598 2006    704'.0899707111
C2006–901736–0

Design by Alan Brownoff
Maps by Eric Leinberger
Printed and bound in Canada by Friesens

Title page: *Rattle*, c. 1860
Seattle Art Museum, Gift of John H. Hauberg,
83.236
Photo: Paul Macapia

Douglas & McIntyre gratefully acknowledges
the financial support of the Canada Council for
the Arts, the British Columbia Arts Council, and
the Government of Canada through the Book
Publishing Industry Development Program
(BPIDP) for our publishing activities.

# ACKNOWLEDGMENTS

THERE ARE THREE very important individuals I wish to thank for their help: Bill Holm, Robin Wright, and Steve Brown. These three scholars have defined the study of Northwest Coast art history, and without their brilliant contributions to this field I could never have begun, much less finished this work. Bill of course is the senior scholar of this field. He, along with Robin and Steve, devised the vocabulary with which we describe this art, understand its complex history, and celebrate its named and unnamed yet clearly identifiable masters. Robin, Bill, and Steve read all or parts of the manuscript and made invaluable comments. I so appreciate their willingness to do this. Of course I take full responsibility for any errors in the book.

Numerous individuals offered help and advice on the illustrations. I would like to single out Bill McLennan of the Museum of Anthropology at the University of British Columbia for his patience with my numerous inquiries about objects at his museum and elsewhere, and Dan Savard

of the Royal British Columbia Museum, who helped enormously with our endless requests for information and assistance. Others who assisted us with the illustrations were Donna Baron, Bruce Kato, and Steve Henrikson, Alaska State Museum; Peter Whiteley, Barry Landau, and Kathleen Moore, American Museum of Natural History; Peter Bolz, Berlin Ethnographic Museum; Paul Gardner, Harry Persaud, Sovati Smith, Danielle Duff, and Jonathan King, British Museum; Ruth Janson, Brooklyn Museum; Rebecca Andrews, Burke Museum; Andrea Laforet, Leslie Tepper, Kelly Cameron, Frederic Paradis, and Nathalie Guenette, Canadian Museum of Civilization; Mindy McNaugher, Carnegie Museum; Carol Lee, Denver Art Museum; Jonathan Haas, Steve Nash, and Jerrice Barrios, Field Museum; Doreen Vaillancourt, Indian and Northern Affairs, Canada; Keely Parker, Makah Cultural and Research Center; Susan Otto, Milwaukee Public Museum; Susan Rowley, Museum of Anthropology, University of British Columbia; Paz Cabello, Museo de América; Linda Clouse, Museum of Art and Design; Ilse Jung and Elisabeth Reicher, Museum of Ethnology, Vienna; Dave Burgevin, Joanna Scherer, and Felicia Pickering, National Museum of Natural History; Mary Jane Lenz, Patricia Nietfeld, and Lou Stancari, National Museum of the American Indian; Paul D'Ambrosio and Shelly Stocking, New York State Historical Association; Karen Kramer and Christine Michelini, Peabody Essex Museum; Julie Brown and Shari Clark, Peabody Museum, Harvard; Martha Black and Julie Warren, Royal British Columbia Museum; Ken Lister, Royal Ontario Museum; Cathy Miller, Sealaska Heritage Foundation; Barbara Brotherton and Jill Walek, Seattle Art Museum; Sue Harris, Stark Museum; Angela Linn, University of Alaska Museum of the North.

Throughout the research and writing of this book, I have depended upon the assistance, advice, and goodwill of several individuals whom I wish to thank: Jack and Maryon Adelaar, Margaret Blackman, Charlotte Cote, Louis Dubin, Brigette Ellis, Aaron Glass, Louise Hager, Sandra Hunt, Dorica Jackson, Vickie Jensen, Molly Lee, Barry McWayne, Phil Nyutten, Dan Odess, Andrew Robinson, Allan Ryan, Charlotte Townsend-Gault, and Kesler Woodward. Of special note are my two wonderful intellectual sisters who both offered wisdom and sympathy during the process of writing this book: Janet Berlo and Ruth Phillips.

I also wish to express my deepest appreciation for the artists who have given their permission to reproduce their artworks: Daniel Brown, Doug Cranmer, Joe David, Robert Davidson, Dorothy Grant, Richard Hunt, Nathan Jackson, Larry McNeil, Marianne Nicholson, Marvin Oliver, Yuxwelupton/Lawrence Paul, Susan Point, Eric Robertson, Preston Singletary, Debra and Robyn Sparrow, Charlene Thompson, and Teri Rofkar. I also thank Chief Peter and Mabel Knox for permission to publish a photograph of their family's potlatch.

The professional staff at the University of Washington Press were, as always, helpful beyond expectations and hopes. I thank Pat Soden for his enthusiasm and support for this book; Jacquie Ettinger for her editorial expertise; Denise Clark for struggling through the painful process of eliminating too many illustrations, ordering them, then handling copyrights and permissions to reproduce the images; Mary Ribesky and Anna Eberhard Friedlander for editing the manuscript.

Finally, I would like to acknowledge the influence of the person to whom I dedicate this book: Wayne Suttles. Wayne and I had been friends for fifteen years before his sad death this past year. He was extraordinary, from his brilliant contributions to the field of Northwest Coast studies to his kind support of students and scholars and his genuine love of his consultants. I only hope I put enough Salish material into the book.

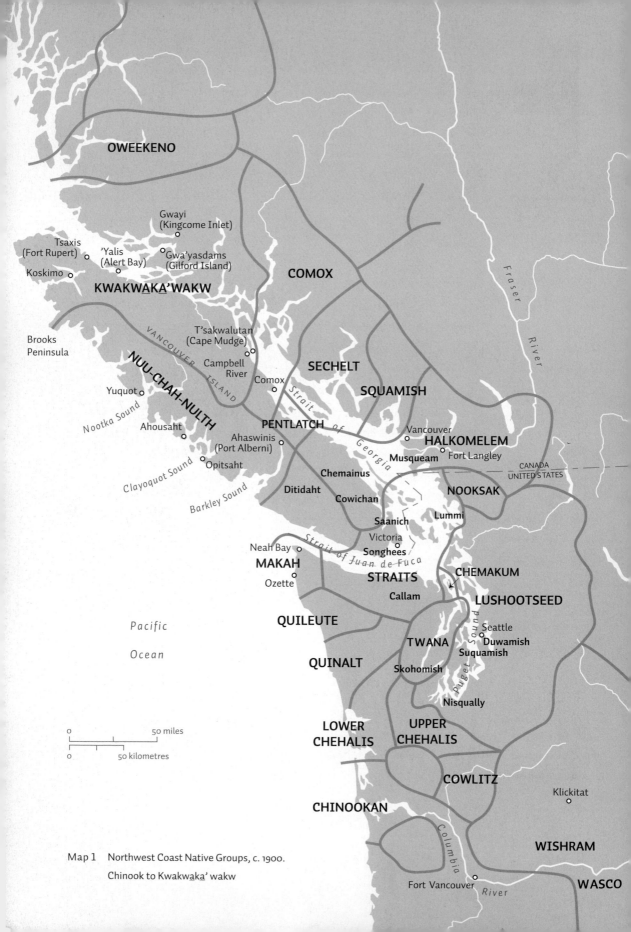

OWEEKENO

Gwayi
(Kingcome Inlet)

Tsaxis
(Fort Rupert)

'Yalis
(Alert Bay)

Gwa'yasdams
(Gilford Island)

Koskimo

COMOX

KWAKWA̲KA'WAKW

Brooks
Peninsula

T'sakwalutan
(Cape Mudge)

SECHELT

Yuquot

Campbell
River

NUU-CHAH-NULTH

Comox

SQUAMISH

VANCOUVER ISLAND

Ahousaht

Strait

PENTLATCH

Vancouver

Nootka Sound

Ahaswinis
(Port Alberni)

of

HALKOMELEM

Fort Langley

Musqueam

Opitsaht

Georgia

CANADA
UNITED STATES

Clayoquot Sound

Chemainus

Barkley Sound

Ditidaht

Cowichan

NOOKSAK

Lummi

Saanich

Victoria

Neah Bay

Songhees

CHEMAKUM

MAKAH

Strait of Juan de Fuca

Ozette

STRAITS

LUSHOOTSEED

Callam

Pacific

Seattle

Ocean

QUILEUTE

TWANA

Duwamish
Suquamish

Puget Sound

QUINALT

Skohomish

Nisqually

50 miles

LOWER
CHEHALIS

UPPER
CHEHALIS

50 kilometres

COWLITZ

Klickitat

CHINOOKAN

WISHRAM

Map 1   Northwest Coast Native Groups, c. 1900.

Chinook to Kwakwa̲ka' wakw

Fort Vancouver

Columbia

River

WASCO

Fraser

River

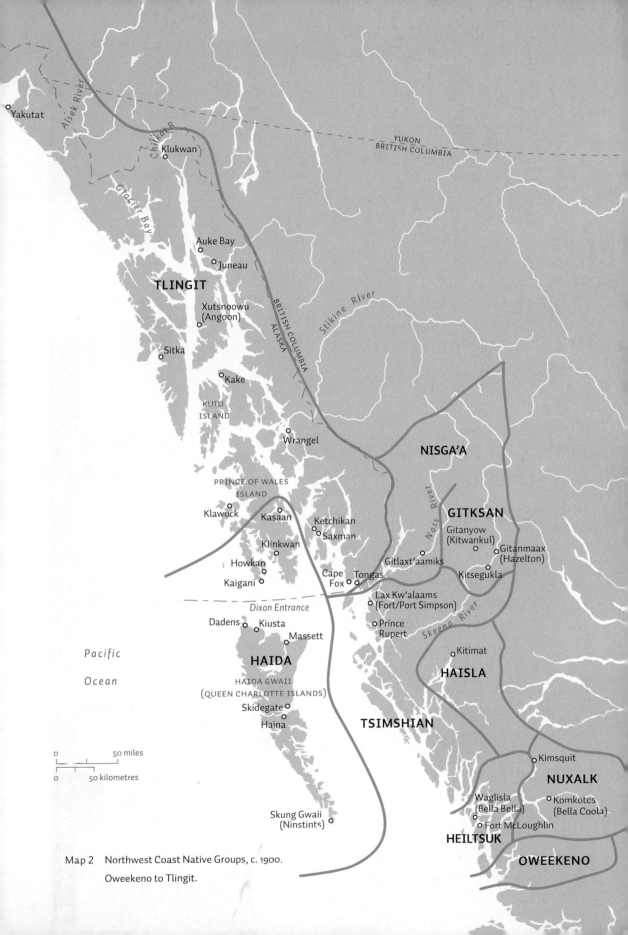

Yakutat

Alsek River

Chilkat R

Klukwan

YUKON
BRITISH COLUMBIA

Glacier Bay

Auke Bay

Juneau

TLINGIT

Xutsnoowu
(Angoon)

BRITISH COLUMBIA
ALASKA

Stikine River

Sitka

Kake

NISGA'A

KUIU
ISLAND

Wrangel

GITKSAN

PRINCE OF WALES
ISLAND

Nass River

Gitanyow
(Kitwankul)

Gitanmaax
(Hazelton)

Klawock

Kasaan

Ketchikan

Saxman

Gitlaxt'aamiks

Kitsegukla

Klinkwan

Howkan

Cape
Fox

Tongas

Kaigani

Lax Kw'alaams
(Fort/Port Simpson)

Skeena River

Dixon Entrance

Dadens

Kiusta

Prince
Rupert

Pacific

Massett

Kitimat

Ocean

HAIDA

HAISLA

HAIDA GWAII
(QUEEN CHARLOTTE ISLANDS)

Skidegate

TSIMSHIAN

Haina

Kimsquit

NUXALK

50 miles

Waglisla
(Bella Bella)

Komkotes
(Bella Coola)

50 kilometres

Skung Gwaii
(Ninstints)

Fort McLoughlin

HEILTSUK

OWEEKENO

Map 2   Northwest Coast Native Groups, c. 1900.

Oweekeno to Tlingit.

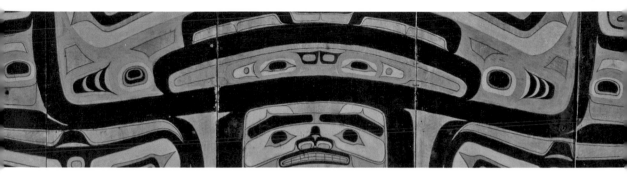

## INTRODUCTION

THE NORTHWEST COAST is a glorious land of precipitous mountains,
deeply etched fjords, gray mists, multitudinous islands, and lush, virtually
impenetrable forest. This spectacular land's original residents created one
of the most extraordinary art traditions in Native America. Their wealth of
artistry is impressive: totem poles, large communal houses made of cedar
planks, vivid dramatic masks, expertly made baskets, animal-shaped hats,
clothing decorated with abstract designs, feast dishes, carved spoons,
and so much more. How did it happen that so much art, so finely made,
developed here, in this strip of land from Puget Sound to Yakutat in
Alaska? This overview of the outstanding Native art of the Northwest Coast
attempts to answer this question by presenting the development of the
art's style and meaning in the context of the region's social history. The
narrative begins in prehistoric times, with the earliest unearthed stone
and bone carvings that did not decay in the wet climate of the region, and
concludes with works made by artists living today.

The distinctive style of Northwest Coast art, especially that of the northern region, has impressed many visitors. Étienne Marchand, a Frenchman who visited Haida Gwaii (Queen Charlotte Islands) during the last decade of the eighteenth century wrote:

> I remark... that the voyagers who have frequented the different parts of the Northwest Coast often saw there works of painting and sculpture in which the proportions were tolerably well observed, and the execution of which bespoke taste and perfection which we do not expect to find in countries where the men seem still to have the appearance of savages. But what must astonish most ... is to see painting everywhere, everywhere sculpture, among a nation of hunters.[1]

About one and a half centuries later, this art was still admired, now by surrealist and abstract expressionist artists who found significant connections between their own works and Northwest Coast abstract form and mythological meaning. In 1946, abstract expressionist Barnett Newman presented at the fashionable Betty Parsons Gallery *Northwest Coast Indian Painting*, an exhibit of four objects from Max Ernst's collection and sixteen from the American Museum of Natural History. Writing in the show's catalogue, Newman asserts that these two-dimensional works constitute "one of the most extensive, certainly the most impressive, treasuries of primitive painting that has come down to us from any part of the globe."[2]

Despite such accolades, most Northwest Coast art has, until recently, been exhibited not in art museums but rather in natural history museums, alongside plants, birds, mammals, minerals, and the like. And until recently, anthropologists rather than art historians have studied these works. In fact, Franz Boas—arguably the most important and influential American anthropologist of the twentieth century and the person who established the discipline of anthropology in the United States and Canada—devoted his life to Northwest Coast studies, oversaw the collection of vast amounts of Northwest Coast art at the American Museum of Natural History, and wrote extensively on Northwest Coast art.

Franz Boas, who worked as the curator of ethnography at the American Museum of Natural History from 1895 to 1905, had ideological and political motivations for collecting Northwest Coast art. For decades, Westerners had attempted to understand why the people they encountered around the world had such radically different cultures. At the end of the nineteenth century, the favored theory, based upon a social interpretation of Darwinian evolutionary theory, was that races had evolved differentially, with whites having advanced considerably beyond the darker races. Each rung on this evolutionary ladder had associated with it certain types of social organization, religion, art, myth. Boas challenged this social evolutionism by explaining cultural differences in terms of history: differences between peoples were the result of movements of cultural elements from one group to another, not of their location on an evolutionary ladder. As cultural elements moved from one group to another, sometimes the recipients accepted the elements unchanged, sometimes they altered them to better fit their own culture, and sometimes they rejected them. Over millennia of human interactions, the threads of these historic occurrences had become exceedingly complex.

Boas was particularly interested in Northwest Coast art, which over many centuries had developed unique and highly distinctive styles that differed according to region: the minimalist Salish art of the south, the vivid and dramatic art of the central area, and the elegant creations of the Northern groups. It is generally agreed upon today that Salish art represents the most archaic style, which in previous centuries was more widespread than today. Gradually, an increasingly refined two-dimensional style developed in the north, while a powerful sculptural style became typical of the central region. At the end of the eighteenth century, Northwest Coast Native people and Euroamericans came into direct contact for the first time, and commenced a lively trade in sea otter furs. The influx of new wealth from trade with foreigners, as well as other consequences that will be discussed more thoroughly in this book, stimulated an already significant artistic productivity, especially in the northern and central regions. Indeed, these encounters led to the creation of what has been called by some the classic art of the "golden

Fig. A   Klukwan Tlingit, possibly by Naakustaa.

Frog House painted Raven screen, c. 1810 (repainted in the 1890s).

*Spruce. 105 x 129 in.*

Seattle Art Museum, Gift of John H. Hauberg, 79.98. Photo: Paul Macapia.

Screens such as this were placed within clan houses to separate the quarters of
the "house master," or chief, from the main living area. The chief could enter
and exit his space through the belly of this crest, as if being reborn from his
ancestors. The black formline defines the raven's broad face, body (which contains
the passageway), tail feathers, and outstretched wings. Its legs are painted with
red formlines. Identification of the artist can be determined through unique
"signatures" of placement and proportion of design elements, presence or
absence of negative space, and use of details such as the small faces that populate
this carving.

age" of Northwest Coast culture. An example of this would be figure A, a painted Frog House screen from the Tlingit, probably carved around 1810 by the artist Naakustaa, a fine piece that adheres to the canons of the northern style (see pp. 31–34). Central to this style is the use of the formline—a swelling and narrowing calligraphy-like band—to define major and minor elements of the composition.

Part of Boas's efforts to reconstruct history involved establishing the nature of Native culture as it had existed prior to encounters with Europeans and Euroamericans. Accordingly, any evidence of contact diminished the pure "Indianness" of a culture, requiring the elimination of non-Native influences from anthropological descriptions of ethnic groups. An art history written under the Boasian paradigm would end at the end of the nineteenth century, when "traditional" Northwest Coast culture was tranformed by the ever-larger presence of non-Natives in the region. The perfection of art, particularly in the north, gave way to cruder visual expressions. Compare, for example, the Tlingit Thunderbird screen (fig. B), carved in the early twentieth century, with the Frog House work. Instead of a tight, integrated composition held together by formlines, in which all parts contribute to the whole, in this later piece disparate, unconnected elements appear on the screen, none rendered with the precision and elegance of the earlier work. For some, the striking difference between these two Tlingit artworks exemplifies the "death" of Northwest Coast art that occurred at the end of the nineteenth century. The rules of classic Northwest Coast art were to be rediscovered only during a renaissance that began in the 1960s. Figure C, for example, is a contemporary copy of a nineteenth-century Tsimshian house facade painted by a team of artists well versed in the canons of the northern two-dimensional style.

In truth, Northwest Coast art history is far more nuanced than this birth-death-rebirth scenario suggests. For several decades, anthropologists and art historians not only have addressed the "traditional" material that appears untouched by outside influence, but also have analyzed the continuities and changes experienced by Native culture as a result of the colonial encounter and subsequent white settlement. No longer is it believed that Native people lived in a golden age of aboriginality that abruptly ended once a more

Fig. B  Shangukeidi clan, Tlingit, Yakutat.

Thunderbird screen, early 20th century. *Wood. 10 ft. sq.*

*Alaska State Museum, Juneau, ASM II-B-845.*

This screen was displayed in the first communal house built at the present town of Yakutat. Around 1918, residents began moving from their traditional Old Town to be closer to the cannery and the commercial dock where the steamer regularly called. This painting does not have the elegant, integrated composition of the Frog House screen, but is nonetheless a great treasure of the family that originally owned it. What is important to them is how this object ties together their history, from past generations that once had it to the future generations that will own it.

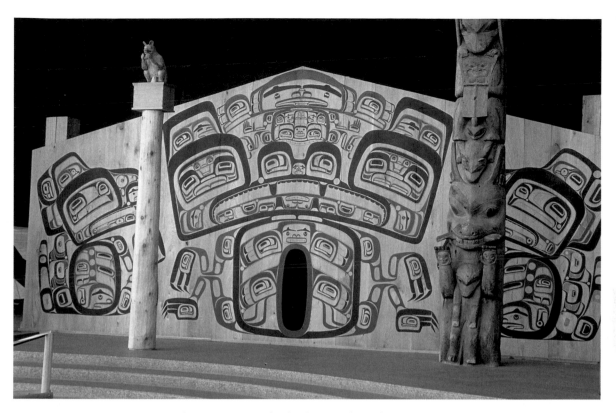

Fig. C   Reconstruction of mid-19th-century house from Lax Kw'alaams
(Fort Simpson), Grand Hall of the Canadian Museum of Civilization.

*© Canadian Museum of Civilization, LH994.277.1. Photo: Harry Foster, S92-4421.*

When George MacDonald, then director of the Canadian Museum of Civilization,
was planning the new building for his institution, he knew that the most
significant works in its collection were the Northwest Coast totem poles. He
featured these in the Grand Hall, designed as the museum's centerpiece. In
this vast, impressive space, historic totem poles stand in close proximity to
reconstructed house fronts from the Salish, Nuu-chah-nulth, Kwakwaka'wakw,
Nuxalk, Haida, and Tsimshian. This Tsimshian house front was made by
contemporary artists Glen Wood, Lyle Wilson, Terry Starr, Harry Martin, and
Chester Williams, who used portions of a house front in the collection of the
Museum of Anthropology at the University of British Columbia as their model. The
imagery on the original panels is barely visible to the eye, but was revealed through
the use of infrared photography.

powerful culture became politically and economically dominant. Despite the devastating consequences of disease, death, and discrimination, Native people adapted creatively to colonization and the influx of settlers. And this is revealed in their art.

For decades, "salvage anthropology" disregarded any indications of acculturation and sought the oldest, most "traditional" data, be they artifacts from or information on culture. Not only was this shortsighted, it could not really be accomplished, for culture inevitably responds to new stimuli—such as newcomers like fur traders and settlers. After its nineteenth-century efflorescence, some Northwest Coast art, such as the Thunderbird screen, became less refined and elegant. It has been suggested that this disruption of formal units reflected the cultural disruption caused by intruders into Native lands. Despite abandoning the classic canon, post-classic artworks held significant meaning within their communities and, in the light of the general contempt in which settlers held Native culture, represented forms of resistance to the majority society. While few post-classic artworks appear in standard Northwest Coast art books, these very same objects hold special interest for the contemporary scholar unconvinced by the Boasian bias that older is better and newer (especially non-Native-influenced) is worse. I hope that readers of this book will come to appreciate the value of the less refined late works of Northwest Coast art.

Nonetheless, this book's foundation is the nineteenth-century art so universally—and justifiably—admired. After its chapters on precontact, late-eighteenth-century, and nineteenth-century southern, central, and northern art, the book addresses how Euroamerican settlement of Alaska, British Columbia, and Washington State influenced art production, the development of knowledge about Northwest Coast art through tourism, museums, and world's fairs, the persistence of creativity during the difficult years between 1920 and 1960, and the flourishing of new art after 1960. Were we to exclude the information on twentieth-century art, we would eliminate some of the most interesting expressions of cultural endurance. As a consequence of including the entire history of Northwest Coast art, this book demonstrates the impressive ongoing presence of an artistic culture that developed in prehistoric times, continues into the present day, and will certainly persist in the future.

# CREATING A GREAT ART TRADITION

CLIMATE CHANGE can have dramatic consequences. Some 18,000 years ago, much of the thin strip of land between the Pacific Ocean and the coastal mountain range from Yakutat Bay in Alaska south to Puget Sound was covered with thick glaciers. Today's dramatically indented coastline, with thousands of islands large and small, could not be seen, for only the tops of the highest mountains stood out above the ice. Sea level was considerably lower than it is today, much of the ocean's water having gone into the immense ice fields that covered the British Columbia and Alaska coastal ranges as well as the land east of the Rocky Mountains, as far south as the north-central and northeastern United States. According to current theory, only Haida Gwaii (the Queen Charlotte Islands) and Prince of Wales Island remained ice free.

The inhabitants of the western hemisphere arrived in three waves. Human beings probably first wandered into the western hemisphere from eastern Siberia over the 1,000-mile-wide body of unglaciated land called Beringia, where the Bering Strait now lies. The most generally

1

accepted date at present for this event is 13,500 BCE, although new archeological evidence may push that date back. These Asians migrated south, maybe over the ice-free corridor between the Rockies and the coast ranges, or perhaps along the western edges of the glaciers on land that is now under water. After that initial migration of Amerindian language group speakers who populated North and South America to Tierra del Fuego, two more major west–east movements occurred. The second of these, of Na-Dene language group speakers, were the ancestors of the Tlingit (as well as of the Athapaskans, who live on the eastern side of the coastal range and the southwest of the United States). As the glaciers receded and sea levels rose, people settled on the coast of what is now British Columbia and southeast Alaska. The third migration, of the Eskimo-Aleuts, did not much affect the Northwest Coast.

People from different language families ended up living on the coast, making this region one of the most linguistically diverse in North America. Speakers of Salishan languages populated the region around Puget Sound, southern British Columbia, and southeastern Vancouver Island. North of them, as far as the central British Columbia coast, the east coast of Vancouver Island, and the northwest tip of the Olympic Peninsula, settled Wakashan speakers: Heiltsuk (Bella Bella), Haisla, Oweekeno, Kwakwaka'wakw (Kwakiutl), Nuu-chah-nulth (Nootka), and Makah. A group of Salish speakers, the Nuxalk (Bella Coola), moved, perhaps overland, into Wakashan territory, somewhat inland between the Heiltsuk and the Oweekeno. The three northern languages appear to be unrelated: the Haida of Haida Gwaii, the Tsimshian of northern British Columbia, and the Tlingit of what is now the panhandle of Alaska. Over the centuries, some boundaries changed through warfare or migration, but the general distribution of the Northwest Coast populations remained relatively constant.

These newcomers brought with them from Eurasia certain spiritual beliefs that persisted in various forms over the millennia—in some places, even to this day. Like other people around the world, residents of the Northwest Coast conceptualized a world beyond that of everyday life. Most did not recognize a formal system of deities, but instead believed in beings who resided in the forests, sky, and sea. According

to their traditions, human beings were created at some point in the distant past by actions of one or another of these supernaturals. Among the Haida, for example, Raven, the trickster-organizer of the world, discovered men in a clamshell at a particular spot, and later created women by casting a chiton at some of the men. Today some Northwest Coast people maintain that such stories indicate that Native Americans did *not* cross Beringia to the Americas, but instead were created in situ.

Many zoomorphic supernaturals lived in villages just like those of humans, assumed human form when home, and only donned their animal skins when encountering people. For example, land otters, the most feared supernaturals among the Tlingit, lived in undersea land-otter villages. A witness to their transformation from human to animal form would see a face becoming increasingly hairy until all features were those of a land otter. Tlingit shamans had direct access to land otters and other beings who lived in the supernatural world. With the assistance of spirit helpers, shamans could interact with them in order to cure disease, rescue lost souls, ensure adequate runs of fish, assist warriors in battles, challenge witches, and in general ensure that the world beyond the village did not intrude and harm its residents.

The social system of the Northwest Coast people began to change around 3,000 BCE, when the glaciers retreated and the sea level stabilized. Where the glaciers had gone, the land turned green. Small plants, then trees, slowly turned the tundra landscape into forests made especially lush by a high level of annual rainfall and by the mild climate warmed by the Japan Current. Salmon began migrating up streams by the millions. This anadromous fish is born in freshwater, travels out to the ocean, then returns to its place of birth to reproduce, and dies. During their migratory runs, these fish swim upstream in such density that rivers appear to contain not water but copper-colored ripples. It was relatively easy to harvest the salmon, which, fresh, smoked, or dried, became the staple for area residents. Halibut, shellfish, seal, deer, seaweed, and berries supplemented these rich runs, providing abundant food which could be preserved for the winter. The inhabitants of the region had for centuries been nomads, foraging and hunting for subsistence, but this abundance allowed them the luxury of settling into permanent villages.

During the winter, most Northwest Coast people lived in villages consisting of rows of cedar-plank houses facing the shoreline. During the summer months, families traveled to nearby areas to fish, gather shellfish, and harvest berries and green plants, often carrying with them their winter-house planks for use on their summer camps. Extended families claimed streams, beaches, and plots of land as their own. Gradually, a social ranking consisting of chiefs, nobles, commoners, and slaves evolved. Archeological opinion divides on why hierarchy developed in what were essentially hunting/gathering societies. Some suggest that status was originally based on a family's wealth in salmon and other natural resources, while others argue that hierarchies emerged as warfare began to develop on the coast. Regardless of cause, the hierarchy that became characteristic of the region between 500 BCE and 500 CE never developed into social units larger than the village. Chiefs governed their own communities, more through influence than by outright control.

The hierarchies came to be supported by two forms of wealth, material and intangible. Material wealth was manifested in ways not unlike the conspicuous displays of status in contemporary society—beautiful clothing, abundant food, luxurious dwellings, fine means of transportation in the form of canoes, well-crafted household goods. Intangible wealth included the rights to tell histories of ancient events, to dance, to sing songs, and to represent crests. A crest was an anthropomorphic or zoomorphic being, an inanimate object such as a rock, or even a meteorological event such as a rainbow, with which an ancestor had interacted in the mythic past, and who had bestowed upon that ancestor the right to tell the story of that encounter, to use regalia such as masks, to perform dances, and to portray the crest's image in art.

Material and intangible wealth merged within the plank houses (fig. 1.1). Kept within boxes were the treasured crest regalia, such as coppers, woven robes, and carved headdresses, brought out during potlatches. Architectural features such as interior house posts, exterior painted facades, and memorial poles also presented crests. Inside and out, houses displayed the privileges the family had acquired since early times, narrated their history of great events, and presented with pride the eminence of the living. Thus, the Haida village of Skidegate, photographed in 1878 (fig. 1.2), with its large, well-built houses and towering

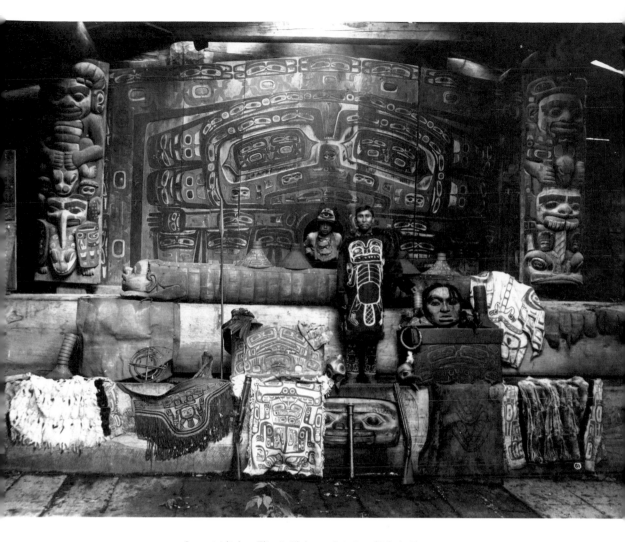

1.1   Ganaxteidi clan, Tlingit, Klukwan. Interior of Whale House, 1895.

*Alaska State Library, PCA 87–13. Photo: Winter and Pond.*

Yeilgooxu was the chief of the clan as well as the caretaker of this house
and all the historical clan emblems it contained. It was an especially large
and impressive house with two tiers of platforms and a painted screen that
measures nine feet high and eighteen feet long. Normally, the regalia worn
and shown would be seen only at potlatches, so the family might have
taken their treasures out from their usual storage boxes for this spectacular
photograph. According to Steve Brown, the posts were carved around 1800
by Kadyisdu.axch', and the screen was made by Shkilahka between 1800 and
1850. Although the house pictured here was taken down in 1899, the monu-
mental artworks remain in Klukwan to this day as cherished heirlooms.

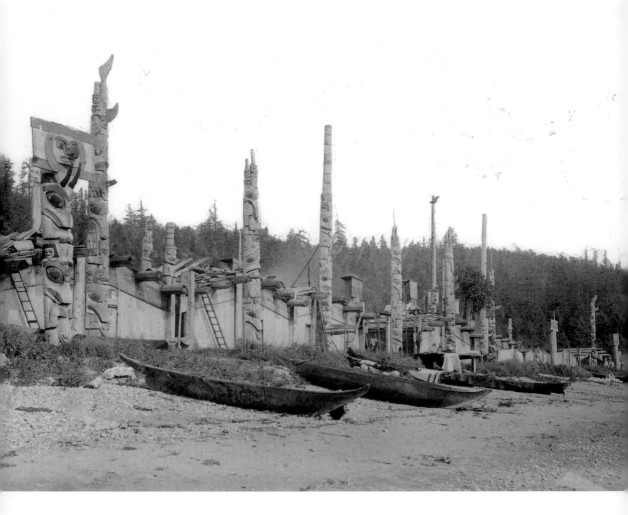

1.2 Haida. Skidegate village, 1878.

*Library and Archives Canada, PA–377756. Photo: George M. Dawson.*

This classic shot of Skidegate shows the houses with their totem poles facing the water. When visitors approached, their first sights were the tops of poles, some with "watchman" figures, diminutive men with conical hats facing forward and to each side. On the beach are a number of northern-style canoes that were particularly seaworthy (see fig. 1.8). This photograph was taken by George Dawson, who, while working as a geologist in British Columbia, studied the Haida and Kwakwaka'wakw, and wrote about Northwest Coast Native culture, language, and archeology.

totem poles, was not just a place to live, but an artistic embodiment of the past, the present, and the future of the community's different kin groups.

It was never sufficient simply to inherit a chiefly position and possess wealth. A chief, on behalf of his family (which could be quite extended), had to validate his position by hosting the ceremony called the potlatch, usually in the context of a major life event such as marriage, assumption of chieftainship, or death. At this event, hosts displayed to guests privileges such as songs, dances, and artworks, and often proudly presented their coppers, shield-shaped plaques that symbolized great wealth among many Northwest Coast peoples (fig. 1.3). Although the coppers in museums that have been analyzed chemically are made from sheet copper traded from Euroamericans, it is likely that precontact coppers were made of beaten placer metal from the Copper River northwest of Yakutat. On the copper, the T-shaped ridge might depict the shoulders and vertebrae of a being. At the conclusion of the potlatch, hosts distributed gifts to guests, who by accepting these gifts affirmed and validated their hosts' claims. Potlatches were, and continue to be, among the most dramatic settings for displaying and using art, with the presentation of masked performances, the wearing of elaborate garments and headdresses, and the consumption of abundant food with carved spoons from finely sculptured bowls.

## NORTHWEST COAST ART AND ARCHITECTURE

HISTORICALLY, Northwest Coast people have been divided into three groups—northern, central, and southern—which have in common many aspects of social organization and art. The Tlingit, Haida, and Tsimshian of the northern region share a rigid kinship structure, and produce an elegant, complex, and refined art (fig. 1.4). The Haisla, although speakers of Wakashan languages that characterize the central group, artistically fall closer to the northern region. Their Heiltsuk neighbors share some social and cultural features with their northern neighbors, others with those to the south. In the central region live the other members of the Wakashan language family—Oweekeno, Kwakwaka'wakw, and Nuu-chah-nulth—as well as the Nuxalk, who speak a Salishan language. These groups have a looser social organization than those farther north, and a more dramatic

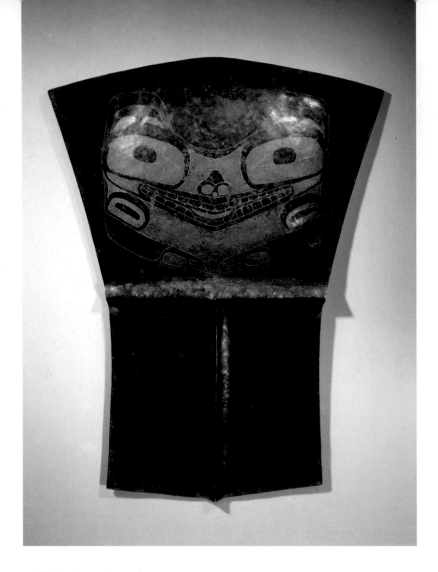

1.3   Haida. Copper, late 19th century.

*Copper, pigment. 29.75 x 22 x 1.75 in.*

*Brooklyn Museum, 16.749.1.*

Coppers symbolized great wealth, and were equivalent to measures of blankets
or other commodities. Later they had dollar value. Although it is assumed that
coppers predate contact, the metal with which this and other historic coppers
were made came from Euroamericans through trade. Early sailing ships had
thin copper sheathing on their wooden hulls, as well as pieces of copper aboard
for repair work. Once traders realized the appeal this metal had for the Native
people, they began bringing heavier sheets of copper, which Native artists beat
into this distinctive shape with its T-ridge and flaring top. This copper depicts
a clan crest, which is rendered by painting the surface black, then scraping
away the pigment to let the copper of the represented being show through.
This is an example of a kind of rendering, called the "simultaneous image,"
that appears not infrequently on northern two-dimensional art. What appears
at first to be a broad frontal depiction can be seen as two face-to-face profiles
that appear if one draws an imaginary line down the center of the field.

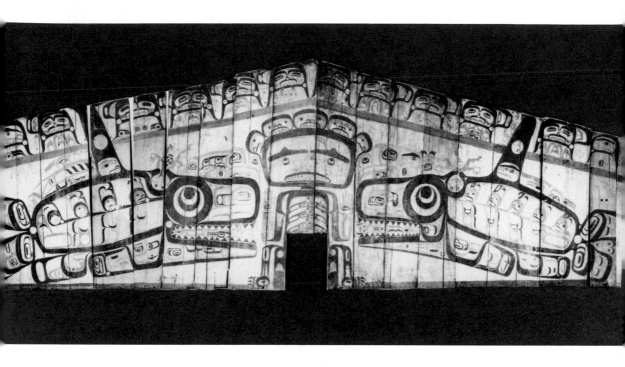

1.4 Lax Kw'alaams (Fort Simpson). Tsimshian house front,
   mid-19th century. *Wood, pigment. L. 38 ft.*
   *National Museum of Natural History, Smithsonian Institution, 2241.*

This exceptionally fine and visually complex painting perhaps depicts the mythical
sea creature Nagunak, a crest of the Gisbutwaada clan. Nagunak, chief of the sea,
is depicted in his human form in the center, flanked by two killer whales, which
might be depictions of him in his sea-mammal form. The meaning of all the other
little beings that populate this screen is ambiguous. James Swan, a schoolteacher
from Neah Bay, was commissioned by the Smithsonian Institution in 1875 to
collect Northwest Coast artifacts that would be exhibited at the 1876 Centennial
Exposition in Philadelphia. This is one of the pieces Swan acquired.

and highly sculptural art (fig. 1.5). The Salish, whose social organization is also relatively loose, create a comparatively minimalist art (fig 1.6).

Most Northwest Coast peoples depended upon red and yellow cedar, woods that are easily split into large, wide boards for house walls and roofs. Cedar is also a highly rot-resistant material, and becomes flexible when heated with steam or hot water. Once the residents of the region had developed technology for working this accommodating material, they used it in many important areas of their lives. They made clothing of shredded cedar bark. They paddled canoes made from cedar. And, between approximately 500 BCE and 500 CE, they started building large houses made of split cedar planks. Three styles of architecture developed over the centuries. In historic times, Tlingit, Haida, Tsimshian, and Haisla houses were around forty to sixty feet square or larger, with gabled roofs constructed with vertical planks. Nuxalk, Heiltsuk, Kwakwaka'wakw, Oweekeno, and Nuu-chah-nulth houses were aboriginally shed-roofed with horizontal wall planks, and after Euroamerican contact sometimes gable-roofed. These were usually longer than their typical width of forty to sixty-five feet, and Nuu-chah-nulth houses were sometimes as long as ninety feet. The Coast Salish usually built shed-roofed, but sometimes gable-roofed, structures. Some of these were conservatively estimated at five hundred feet long. Extended families lived in these large buildings, which could accommodate many residents, with interior partitions to separate family groups. See figure 1.7 for additional examples of house types.

The Northwest Coast people also made art forms of their transportation. In this temperate rainforest with its immense evergreens and dense undergrowth, overland travel is difficult. Instead, villages were located along sheltered beaches, accessible by canoe. In Skidegate, canoes line up on the beach, ready to transport the inhabitants to other communities (see fig. 1.2). To make a canoe, a carver fells a large cedar log and shapes the outside into a pre-form. The canoe pre-form is partially filled with water to which red-hot rocks are added repeatedly. The rocks bring the water to a boil, which limbers the wood and makes it sufficiently pliable for the canoe maker to use cross-pieces of wood to gently open the sides outward. After the water is removed and the wood dries and stiffens again, the canoe can be decorated on the bow and stern with paintings. These vessels are made in a variety of forms, which are presented in figure 1.8,

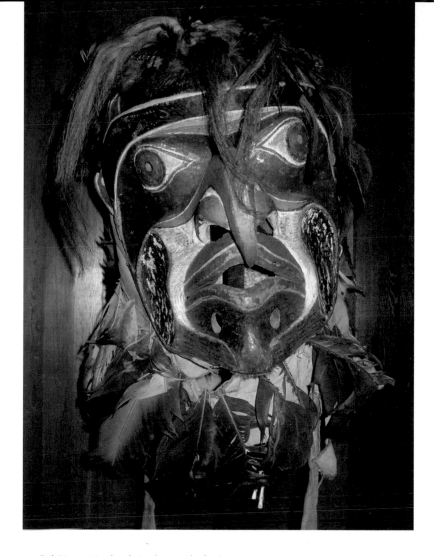

1.5 Bob Harris, Kwakwaka'wakw. Mask of Bakwas, c. 1890.

*Red cedar, horsehair, brass, feathers, cloth. H. 12 in.*

U'Mista Cultural Society, Alert Bay, British Columbia, Canada, 80.01.013.

Bakwas, also know as Wild Man of the Woods, is a being who entices humans to eat his ghost food, thus transforming them into nonhuman beings. Depictions of Bakwas typically have a skeletal face, hooked beaklike nose, and twigs, branches, and feathers in his hair. The bright paint, sharply defined facial planes, and dramatic energy inherent in this mask are characteristic of Kwakwaka'wakw carvings. During a potlatch, the mask's feathers and horsehair swayed with the dancer's movements, while the brass pupils reflected the firelight from the central hearth, adding to the mask's dynamic quality.

1.6 Quinault. Shaman's rattle, 19th century.

*Cedar, deer hooves, beads. H. 10 in.*

American Museum of Natural History Library, 16/4953.

This carving serves as a shaman's protector and represents tangible evidence of his power to cure illnesses caused by soul loss or intrusion of objects into the body. During a healing séance, the shaman either retrieved the lost soul or sucked out the foreign object. Like so many shamans around the world, the Quinault shaman used percussive instruments such as rattles to summon his spirit assistants. This rattle presents the typical southern coast three-dimensional face composed of three horizontal planes, each one receding from the one above.

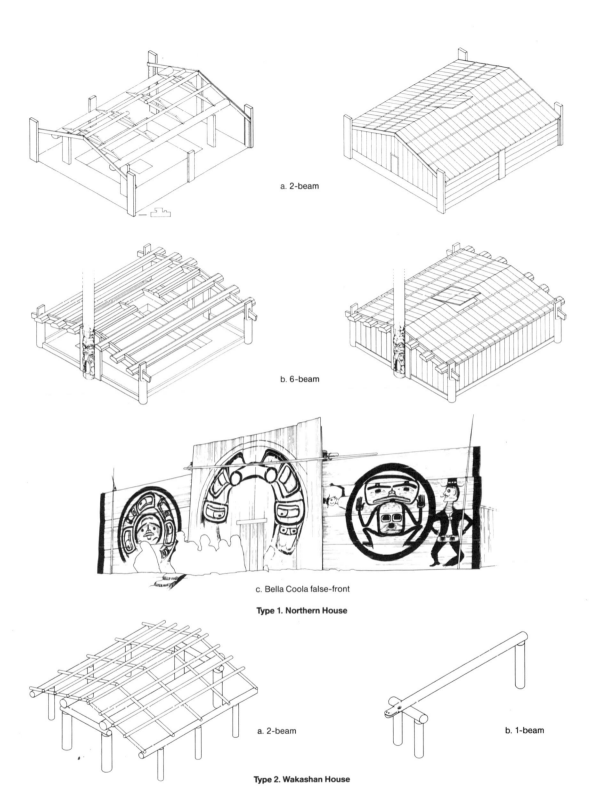

a. 2-beam

b. 6-beam

c. Bella Coola false-front

**Type 1. Northern House**

a. 2-beam

b. 1-beam

**Type 2. Wakashan House**

1.7  House types. *Illustration by Karen B. Achoff.*

*Used with permission from Wayne Suttles, "Introduction," in* Handbook of North American Indians Vol. 7: Northwest Coast, *ed. Wayne Suttles (Washington, D.C.: Smithsonian Institution Press, 1990), fig. 2, pp. 6–7.*

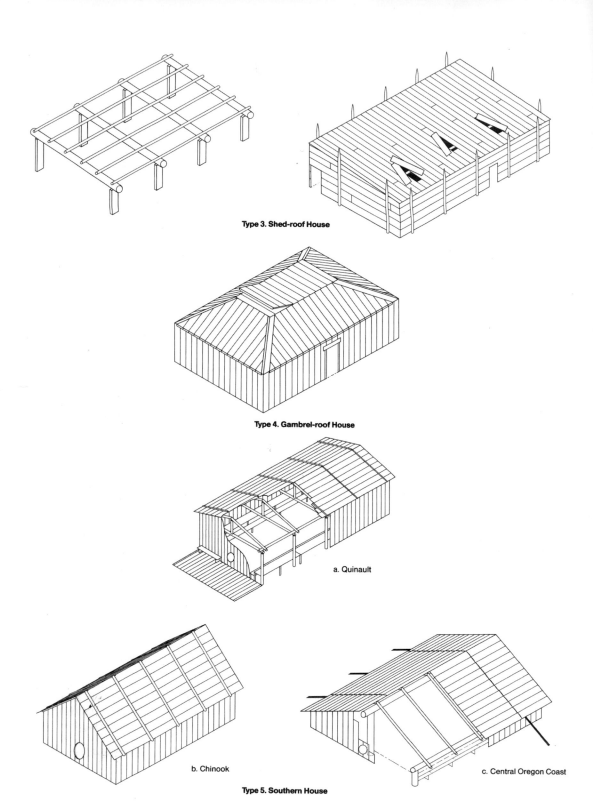

**Type 3. Shed-roof House**

**Type 4. Gambrel-roof House**

a. Quinault

b. Chinook

c. Central Oregon Coast

**Type 5. Southern House**

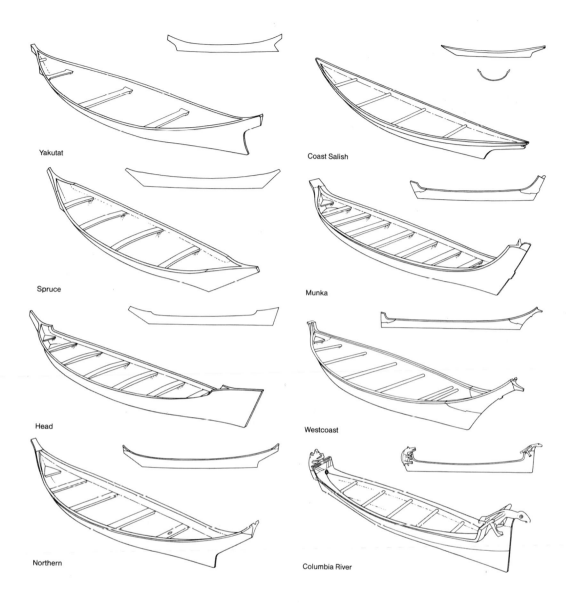

Yakutat

Coast Salish

Spruce

Munka

Head

Westcoast

Northern

Columbia River

1.8  Canoe types. *Illustration by Karen B. Achoff.*

Used with permission from Wayne Suttles, "Introduction," in Handbook of North American Indians
Vol. 7: Northwest Coast, ed. Wayne Suttles (Washington, D.C.: Smithsonian Institution Press, 1990),
fig. 3, p. 8.

but all are crafted using the same techniques. Canoes can become treasured family possessions, and are sometimes symbolic representations of wealth and distributed as high-status potlatch gifts.

## PREHISTORIC CULTURES

A FUNDAMENTAL QUESTION that students of Northwest Coast art ask is how this art developed. Because examples of prehistoric art come from diverse and sometimes incomplete sources, it is challenging to reconstruct a history of Northwest Coast stylistic evolution. Archeological excavations are limited in scope and range. The earliest European travelers to the region collected and described late precontact pieces, but only from the relatively few places they visited. Museums began to collect artworks systematically in the nineteenth century, but even their professional anthropologists acquired only pieces that they determined were important, ignoring some works we now would find of great interest. As a result, we cannot be certain we have a complete record upon which to base a solid history of Northwest Coast art, especially concerning those items that date to before European contact.

The vast majority of nineteenth-century Northwest Coast artworks are wood carvings. Unfortunately, in this rainy region, fiber and wood usually deteriorate rapidly. Thus, with a few important exceptions, the archeological record offers mainly stone and bone items impervious to the elements, remaining comparatively silent on the ancient wood carvings that have decayed. Specimens of zoomorphic and anthropomorphic images in stone, bone, and ivory begin to appear on the coast during the first millennium BCE; how much earlier they might have occurred in wood is unknown. The one certainty is that with these nascent creations, the great tradition of Northwest Coast art had begun.

In the Strait of Georgia and the Fraser River area, one of the earliest peoples whose art has been found belonged to the Marpole cultural phase, so called because the first objects of this style and type were found at a site in the area of that name in southern Vancouver, B.C. This cultural phase existed between 400 BCE and 400 CE and seems to have had all the elements of later southern Northwest Coast culture: a large village of heavy-timbered

rectangular houses that lined the shores, superior tools for subsistence activities and woodworking, and indications of social stratification.

It is often difficult to identify with any certainty the subject matter and function of archeological works. We can only speculate on whether an unearthed item was a powerful supernatural manipulated by a shaman, or a mythic crest displayed by a chief. Happily, certain ancient pieces seem to resemble objects used during the historical period and described by written documents. For example, one common form of Marpole art, a stone bowl held by an anthropomorphic being, sometimes in association with animals, appears very similar to certain bowls used by shamans in historic times (fig. 1.9). In 1890, Franz Boas published the following description of a Shuswap (Interior Salish) ritual:

> At the end of the puberty ceremonies the shaman led the girl back from seclusion to the village in grand procession. He carried a dish called *tsuqta'n*, which is carved out of steatite, in one hand. The dish represents a woman giving birth to a child, along whose back a snake crawls. The child's back is hollowed out and served as a receptacle for water. In the other hand the shaman carries certain herbs. When they returned to the village the herbs were put into the dish, and the girl was sprinkled with the water contained in the dish, the shaman praying at the same time for her to have many children. [1]

Perhaps the Marpole bowls appeared in similar puberty ceremonies 1500 years ago.

Farther north, in the Prince Rupert Harbour region of northern British Columbia, archeologists have discovered more evidence, dating from 500 BCE to 500 CE, of large houses, stratification, woodworking technology, and the beginnings of what could be crest art. There is also evidence of increased warfare in the form of whalebone clubs as well as in skeletal remains of individuals with forearm fractures and skulls with the kinds of depression fractures that could be caused by clubs. In addition, decapitated skeletons suggest the taking of trophy heads. Whalebone clubs similar to one excavated in Prince Rupert Harbour have been found to the south in Vancouver Island and in the Puget Sound region (fig. 1.10),

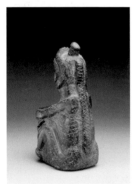

1.9  Gulf of Georgia region. Marpole bowl, 100–1000 CE.

*Steatite (?). 15 x 5.5 x 8 in.*

*Thaw Collection, Fenimore Art Museum, Cooperstown, NY, T766. Photo: John Bigelow Taylor, NYC.*

Thus far, several dozen stone sculptures similar to this one have been found between the lower parts of the Fraser River and the southern Gulf of Georgia; some are found as far inland along the Fraser River as Lillooet. All exhibit similar imagery of a sitting human with head tilted back, holding a bowl in its arms and between its legs. This example also has several features not found on all the other examples of human-figure bowls, such as a rattlesnake that hangs down the figure's back, emaciated and prominent shoulders, some sort of striated headgear, a topknot to which cedar-bark "hair" may have been attached, and a thick band that forms a V over the nose and extends around the cheeks to the mouth, which is open in what could be a gesture of singing. Several of these elements suggest that this depicts a shaman, for skeletal imagery is often found in shamanic art. Shamans are often accompanied by powerful animal helpers, and they often wear headdresses and sing during their rituals.

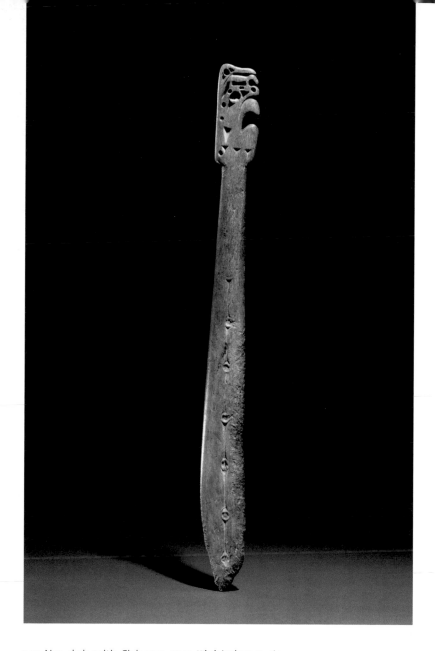

1.10  Nuu-chah-nulth. Club, 1600–1800. *Whale jawbone. 23.5 in.*

*Thaw Collection, Fenimore Art Museum, Cooperstown, NY, T157. Photo: John Bigelow Taylor, NYC.*

Clubs made of whalebone have been found in archeological contexts and date back as far as 500 years. Numerous examples come from outer coastal communities, ranging from Kuyoquot on Vancouver Island to Ozette on the Washington coast. On their pommels, these clubs often depict avian beings with other smaller beings on their heads. In this example, the artist has used delicate piercings to represent an open-mouthed raptor upon whose brow stands a canine that could be a wolf, above which hovers the upper beak of a bird. This club, with its line of circles and trigons down the blade, trigon and circle piercings of the face, and a simple canine that resembles Columbia River carvings (see figure 3.3), exemplifies the archaic style that was widespread before different groups began to create their distinctive styles.

1.11   Ozette. Box front, 16th century.

*Red cedar, sea-otter teeth, fish teeth. 19.25 x 31.5 in.*

*Makah Cultural and Research Center, Neah Bay, WA, 27/IV/6. Photo and copyright: Ruth Kirk.*

When a mudslide covered the Makah village of Ozette, it preserved numerous wooden articles that would otherwise have decayed in the moist climate. The site was excavated in collaboration with the Makah people, and the resulting collections reside today in the Native-owned and -operated Makah Culture and Research Center in Neah Bay, Washington. The gentleman in the photograph is the late Makah elder Harold Ides.

suggesting perhaps a widespread and relatively unified style during part of the prehistoric era.

Sometime in the sixteenth century, the hillside behind Ozette, a Makah village of cedar-plank houses facing the Pacific Ocean in Washington State, became waterlogged by torrential rains. Perhaps jarred by an earthquake, the mud slid down the hill, covering at least four houses. In the anaerobic environment under mud, wood does not decay, so much material that was in those houses was preserved. This most important prehistoric site in the region—the Pompeii of the Northwest—offers unparalleled insights into the development of Northwest Coast art in wood. Between 1970 and 1981, Richard Daugherty of Washington State University oversaw excavation work on this site in collaboration with the Makah of Neah Bay, unearthing objects that provide insights into a culture that flourished about a century before contact. Among the items found in Ozette is a box made of a thin cedar board bent into a rectangular form (fig. 1.11). The panel that forms the box's front is thought to depict a thunderbird's face with incised eyes, brows, nose, mouth, and power horns. Inlaid sea-otter and fish teeth decorate the surface.

The residents of Ozette were whaling people, and created many artworks presumably connected to rituals associated with whaling. As is the case with the Marpole carvings, historic practices provide clues about the symbolism and use of Ozette art. The Nuu-chah-nulth of western Vancouver Island, who, like the Makah, are Wakashan whalers, had many practices that might have been been shared with the people of Ozette. It was believed that whales were not overtaken by the brute force of humans, but instead allowed themselves to be taken as long as the hunters performed the proper rituals. According to legend, the thunderbird taught humans how to whale. After the whale allowed the harpooner to take it, the community still had to treat the whale with respect and perform proper rituals so that it would encourage its kin to let themselves be harpooned by these hunters in the future. Only after it was thanked publicly for its sacrifice could it be butchered and distributed to the community. The highest-ranking residents received the most prestigious section, the so-called "saddle" directly under and around the dorsal fin along with the fin itself. This section seems to have been important in Ozette as well, for archeologists discovered a dorsal fin effigy made from cedar and inlaid with sea-otter teeth arranged to depict a thunderbird with outstretched wings above a double-headed serpent.

## BASKETRY AND TEXTILES

THE OLDEST Northwest Coast artworks as yet found are 5,000-year-old basketry fragments recovered from the wet shoreline edging a stream in southeast Alaska, woven with techniques identical to those used in the nineteenth century. Their preservation is remarkable, given that woven works often deteriorate even before wood carvings, and few baskets and textiles appear in the archeological records. These are the first examples we have of an important Northwest Coast artistic tradition.

As is the case in many parts of the world, a gender division existed in art production. Men made figurative pieces, such as the sculptures and paintings that depict crests, shamanic beings, and spirits, whereas women produced baskets and textiles, most often decorated with abstract designs. Compared to men's art, with its birds, humans, mammals, and other beings, women's often nonrepresentational weavings, devoid

of identifiable subjects, might appear to be less meaningful. In truth, women's art has considerable meaning, but of a conceptual rather than a concrete nature; women's creations embody gender identity and express the female world that balances that of the male. Many geometric designs have specific names—such as head of the salmonberry, waves, lightning—which, while not representational in the literal sense, are perhaps metaphorical or allegorical. Considerable knowledge of the rhythm of the seasons and the quality of materials goes into the creation of women's art. For example, Haida women made their baskets of skillfully split spruce root and decorated them with dyed grasses and maidenhair fern (fig. 1.12). The women could collect the spruce roots only at certain times of the year, the grasses and ferns at another. Women also had to be sensitive to the spiritual dimensions of growing things. When gathering materials, women asked the plants, which were thought to have a spiritual essence, to *allow* themselves to be collected and transformed into baskets, not unlike the hunter who asked his prey to allow him to take it, or the carver who spoke to the tree. By transforming natural materials into carefully crafted, precisely decorated works of considerable elegance, women's art can also be seen as balancing the human and nonhuman worlds.

Basketry techniques had their origins in prehistoric time. Although a detailed explanation of the nuances of weaving is beyond the scope of this book, some definitions are in order (fig. 1.13a–e). Basketry is based on a vertical framework called the warp, around which are woven horizontal elements called the weft. Some baskets from the coast are plaited, that is, the wefts and warps are equally thick and pliable, sometimes producing a checkerboard-like surface. A variant of this technique is twilled weaving, in which the weaver passes the weft over or under two warps, producing a diagonal pattern. Twining, the most common type of Northwest Coast basketry, uses a straight, vertical warp. Two (or sometimes three) wefts are intertwined around these warp pieces, alternatingly over the front and over the back. On each stitch, the first weft moves from behind the warp, the second goes from the front to the back side of the next warp. Variations on this basic technique result in interesting patterns and textures. Another basketmaking technique used in the southern region is coiling, in which coils of plant fibers are sewn together, forming first the basket bottom and then spiraling up to form the sides (fig. 1.14).

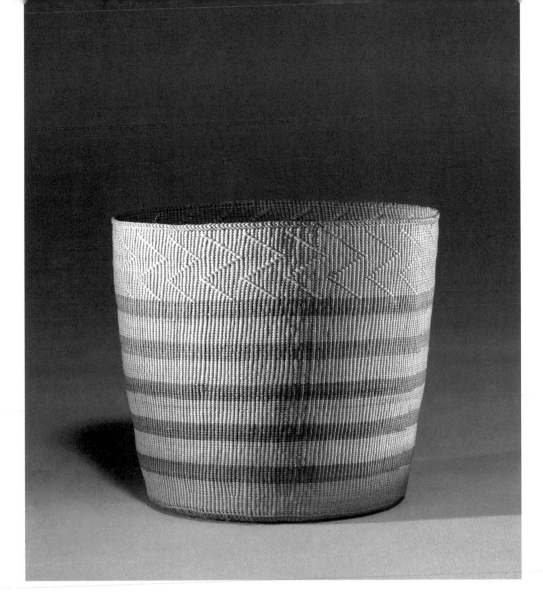

1.12 Haida. Twined basket, late 19th century.

*Spruce root. 5 x 5.5 in.*

*Brooklyn Museum, 05.588.7326.*

Haida weavers twined their baskets upside down—that is, they started with the
bottom and worked downward to create the sides. This example shows how
a skilled basket weaver could manipulate spruce roots into perfectly formed
and precisely rendered horizontal and vertical lines, with all exposed wefts of
equal size. The colored bands are made by using dyed spruce roots for the wefts,
and the zigzags by covering two warp pieces with a weft. This basket would
have been used for berry picking or, when new and clean, storing valuables.

a                                                b

c

d                                                e

1.13a–e  Basketry techniques: *a*, plaited; *b*, twilled; *c*, twined (two and
three-strands); *d*, coiled; *e*, imbricated.

*From Oliver Mason, "Aboriginal Indian Basketry,"* Report of the U.S. National
Museum, 1902. Washington, D.C.: Smithsonian Institution. Fig. 80, pl. 154.

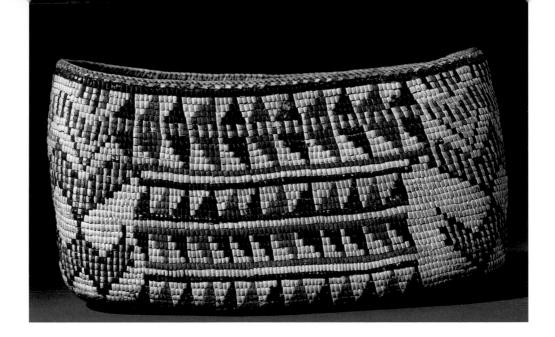

1.14  Cowlitz, Southwestern Coast Salish. Coiled basket.

*Fiber, pigment. L. 8 in.*

National Museum of Natural History, Smithsonian Institution, 2614.

This coiled basket, collected in 1841, once had a lid. Its four-field design is characteristic of precontact Cowlitz baskets. These baskets were made of peeled and split cedar root. The coils themselves are made from the rough inner root, and are sewn together with the shiny outer part of the root. The basket is decorated with imbrication, in which dyed pieces of materials such as beargrass, cherry, cedar, or horsetail root are folded accordion-style and sewn into the coils themselves (**see** fig. 1.13e).

Textiles are another major type of art created by Northwest Coast women. These textiles share similar weaving techniques with twilled and twined baskets (fig. 1.15). Although the apparatus upon which the artist creates her textile is commonly called a loom, it is a simple support for the warp strands and does not operate mechanically to produce the in-and-out of the weaving process. The Northwest Coast weaver works on a loom made of two uprights connected by one or two horizontal poles and weaves her textile completely with her fingers, as is done in basketry. This is labor-intensive and complex creative work, and especially-skilled weavers, of both textiles and baskets, became highly regarded in their communities.

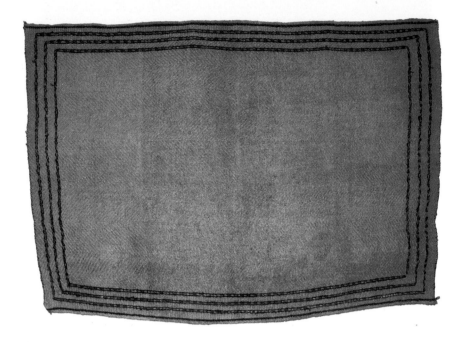

1.15   Salish (?). Blanket, 18th century.

*Mountain-goat hair, pigment. 58 x 42.5 in.*

© *The Trustees of the British Museum, NWC 52.*

When Captain George Vancouver, who had been on Captain Cook's voyage to the Northwest Coast, returned to the area with his own vessel in 1792, he encountered Salish-speaking people near Puget Sound. He commented that some wore animal skins, but most clothed themselves in "a woolen garment of their own manufacture, extremely well-wrought." This blanket is an example of twilled weaving, evident in the subtle zigzags in the woven wool. Four thin lines of dyed wool with small dashes of white around the edges add visual interest to the white field.

## BODY ART

ANOTHER TYPE of Northwest Coast art not often included in surveys is the decoration of the body that served as markers of position within the social system. Northwest Coast men and women often painted their faces with figurative or abstract designs, such as those seen on some masks. They also pierced their ears and noses to insert various kinds of adornments such as copper, shell, or bone rings. In addition to the temporary face paintings and these small face piercings was more permanent body art. In the central and southern regions, head flattening or deformation

indicated membership in the group. From the Nuxalk to the Chinook regions, the forehead was flattened in the cradle by pressure from a board, while among the Kwakwaka'wakw, Nuu-chah-nulth, and northern Coast Salish, infants' heads were also lengthened by binding.

In the northern groups, women pierced their lips and inserted labrets to denote their marriageability and status. At the age of puberty, girls had their lip pierced and wore a small plug that signaled availability for marriage. As they matured, they received larger and larger labrets that reflected their social position, with the highest-ranking women wearing the largest labrets. Early travelers universally scorned the labret as a perfectly hideous custom. Jean François de la Perouse described Tlingit women he saw in 1786 with the following words: "Their faces would be agreeable [without labrets]. This whimsical ornament not only disfigures the look, but causes an involuntary flow of saliva, as inconvenient as it is disgusting."[2] Even though labret wear became less and less common during the nineteenth century, when a northern artist wished to depict a woman, he usually showed her wearing a labret (see fig. 7.2).

Some Northwest Coast groups also practiced tattooing. In the north, men and women had crest images tattooed onto their chests, arms, and legs, and in the central region some women had geometric tattoos on their arms, legs, and sometimes faces. The Haida had the most elaborate tattoos, and used them as indicators of social position (fig. 1.16). In prehistoric times, they used the sewing method to create permanent images on the skin, soaking mountain-sheep wool in black pigment and then drawing it through the skin with a copper needle. Another technique was pricking the skin and rubbing the holes with soot. A youth's first tattoo was a general clan crest image; as he or she grew, more crests could be applied; the number and nature of them dependent upon the individual's rank. Great chiefs could be resplendent with tattoos.

## TWO-DIMENSIONAL ART

THE DISTINCTIVE surface designs on Northwest Coast artworks are composed of formal elements with distinguishing features and their own vocabulary (fig. 1.17). Bill Holm and Steve Brown, both scholars and non-Native artists with considerable expertise in Northwest Coast art, have

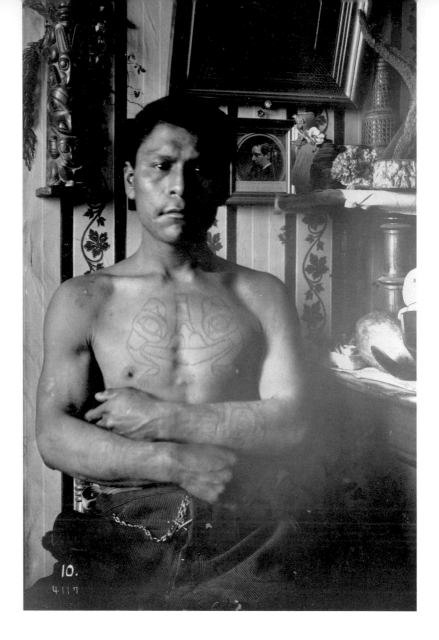

1.16  Johnny Kit Elswa, Haida, with tattoos, c. 1886.

*National Anthropological Archives, Smithsonian Institution, SI 4117. Photo: Ensign A. P. Niblack, USN.*

This photograph was taken in the Port Townsend, Washington, home of ethnographer and museum collector James Swan, who acquired two items pictured in this volume (figs. 1.4, 4.3). Elswa served as Swan's assistant and Haida interpreter and was also a competent artist. This photograph shows Elswa's tattooed crests on his chest and arms. On the wall to Elswa's right is a model totem pole that he carved on the basis of a sketch Swan made of a pole in Kiusta, Haida Gwaii.

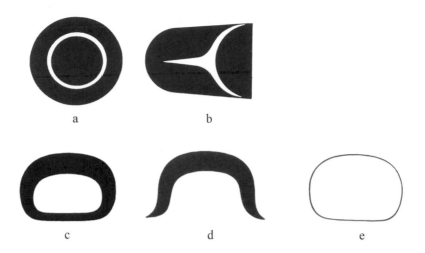

a           b

c           d           e

1.17 Northwest Coast two-dimensional design components: *a*, circle;
*b*, trigon; *c*, ovoid; *d*, u-form; *e*, fineline. *Illustration by Steve Brown.*
*Used with permission from Steve Brown, "Observations on Northwest Coast Art," in*
The Spirit Within *(Seattle: Seattle Art Museum, 1995), figs. 6, 9, 13, pp. 273, 276, 279.*

published valuable works clarifying the elements and analyzing how they
are put together to create the region's unique two-dimensional works.

It is thought that the very earliest type of art in the region was recti-
linear and geometric, as seen in the carvings made during the historical
epoch in the Columbia River region (fig. 1.18), and in baskets up and down
the coast. This style is ancient and found in many regions throughout the
world. At some point in history, Northwest Coast artists began to use
visual motifs that would be assembled and reassembled over the centuries
in myriad ways. In the south, circles, crescents formed from half-circles,
and T-shaped incisions called trigons create a fundamental artistic vocab-
ulary (fig. 1.17). These elements are often incised, creating negative forms
that define the positive forms of the being represented. A late prehistoric
southern work that uses these elements is the Ozette box discussed above
(see fig. 1.11). In this example, the negative trigons define eyelid lines, horn,
mouth, and featherlike u-forms on the cheeks and chin. Trigons appear
on the corners of the mouth, along the bottom, on the cheeks, and in the
eyes, defining the pupils. The line of trigons along the bottom creates the
positive image of a row of U's. A line of trigons and circles decorates the body
of the Nuu-chah-nulth club (see fig. 1.10), and pierced trigons its handle.

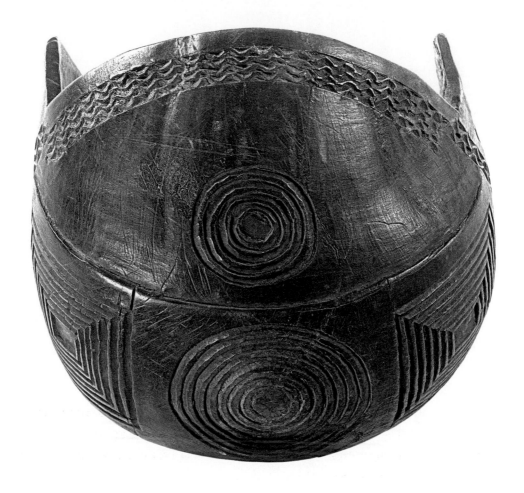

1.18  Wasco-Wishram. Bowl, 1800–1850. *Mountain-sheep horn. D. 6 in.*

*National Museum of Natural History, Smithsonian Institution, 10079.*

The underside of this bowl—a view not often shown in publications—shows the
artist's delight in playing with curves and straight lines. The concentric circles
seem to be having a dialogue with the ever-expanding squares. Notice that these
forms are made of eight lines that, along with the four rows of zigzags, indicate the
importance of the number four.

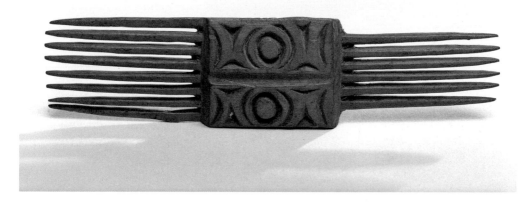

1.19 Central Coast Salish. Comb, late 18th century. *Wood. L. 7.5 in.*
   © *The Trustees of the British Museum, VAN219.*

Incised circles and trigons produce raised bands that decorate this comb's surface with graceful, curvilinear shapes.

The mature southern style is exemplified by figure 1.19, a comb collected in 1792 and thus representative of the late precontact style of Salish two-dimensional art and characteristic of Central Coast Salish style in the nineteenth century.

In the north, early artists began to employ other motifs that might have evolved from the circle and trigon. The resulting ovoid and u-form, rendered both in formline and fineline, would form the vocabulary for a highly complex system (see fig. 1.17). The ovoid can be seen as a squared-off oval or as a rounded-corner rectangle. What often gives it a distinctive look is the use of formline, a broad swelling and narrowing band that surrounds the negative ovoid shape.

An early example of northern two-dimensional art is an incised bone comb carved between 800 and 1200 CE and found in the Prince Rupert region (fig. 1.20). Its arrangement of visual motifs has some commonalities with southern Northwest Coast art, and probably represents a widespread type of two-dimensional art made throughout

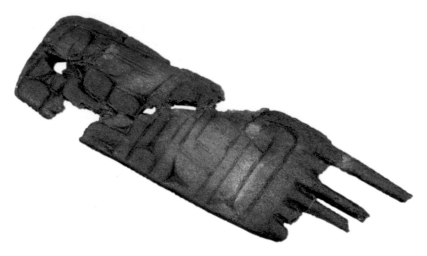

1.20  Tsimshian. Comb, c. 800–1200 CE. *Bone. L. 3.5 in.*

*© Canadian Museum of Civilization, GbTo 34-1805. Photo: Ross Taylor, S93-9015.*

In 1966, the National Museums of Canada began a major project that investigated
the archeology of Tsimshian and Haida territory. Between that date and 1978,
more than 18,000 artifacts were found in more than 200 sites. This is one of the
decorated objects recovered during that project. The difficult-to-decipher design
contains trigons and straight lines, suggesting a stylistic affinity with the
southern style.

the coast in prehistoric times. Nevertheless, the artist does line the
surface with the northern u-forms and u-forms "split" by trigons.
Some u-forms are thinner and longer, others squatter and wider,
some positioned vertically, others horizontally. The resulting depic-
tion, obscure as it may be, does exhibit the same kind of negative
incisions that create positive images as seen on the southern pieces
just discussed. The positive elements here, though, are a series
of vertical and horizontal bands that do not, as in historic works,
form a continuous flow around and within the composition.

An example of the use of negative carving to create the positive
design elements characteristic of the northern two-dimensional
style is shown in figure 1.21, another late precontact carving, this
one collected among the Haida. The designs above the extended arm
represent wing feathers. Closest to the figure's head is an ovoid that
probably depicts the joint of the wing, as marking joints occur else-

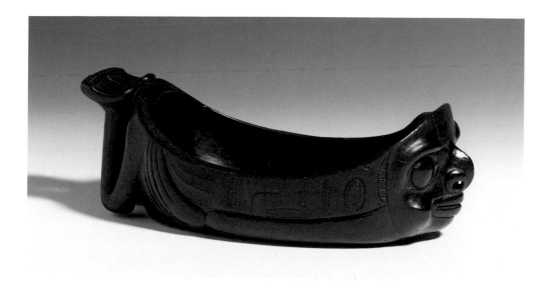

1.21  Haida. Grease bowl, c. 1700. *Wood. L. 10 in.*

The bulging sides and raised front and back of this bowl are characteristic of canoe-shaped vessels. Such a bowl held the pungent seal oil into which a diner dipped dried fish and other delicacies; this piece was already dark with oil saturation when it was collected in 1787 by Captain George Dixon. The bowl appears to depict a transformation between man—with deeply modeled face, arms extended along the sides, and legs with delicate upturned feet—and bird—represented by feathers (the two-dimensional incised lines above the arms) and the beaked nose.

where in Northwest Coast designs. A crescent form on the upper left, and a u-form on the right create the incised ovoid in their center.

During the nineteenth century, the Haida, Tlingit, and Tsimshian, as well as the Heiltsuk created a highly structured and well-integrated system of two-dimensional design already seen in painted screens and house fronts. After contact, artists creatively elaborated upon the conventions established earlier—relatively thick formlines and spare decorative motifs—and transformed those elements into the complex and refined components of an even more sophisticated visual system. Primary formlines became narrower and more differentiated in width, and artists began experimenting with secondary formlines and tertiary design elements. Differing characteristics of formlines in designs can be

diagnostic of individual artists' hands, and indicate that considerable license existed for creativity within the canons that developed over the years. In addition to using formlines to create these elements, the northern artist also employed the more delicate fineline, which often added lightness and detail to designs.

Nineteenth-century northern art has appealed to subsequent generations of art appreciators who have labeled these works "classic," a term connoting a period of perfection.

The application of these elements can be seen in the painted Tlingit screen placed inside a house and used to separate the house chief's living quarters from those of the other residents (see fig. A). The artist who created this screen, Naakustaa, uses several varieties of formlines to represent a raven. The large frontal face, torso, and tail of the bird are outlined in black primary formlines, as are some of the details within the being. Secondary formlines, here painted in red, delineate the bird's feet as well as some internal elements within the primary formlines. Blue-painted tertiary spaces balance and contrast the other design elements. Even more complex and detailed is the Tsimshian house front shown in figure 1.4, in which a primary formline delineates the shape of the two killer whales and the central human, as well as some internal details such as the whale's eyes. Secondary formlines in red as well as black finelines outline more details. In both examples, ovoids, u-forms, and negative elements work together within the main formline system to create a highly controlled, smoothly flowing, yet rhythmic and dynamic image.

**2**

## ART AT THE TIME OF CONTACT

THE ARCHEOLOGICAL RECORD offers valuable information about art made during the times before written history, but has its limitations when it comes to interpretation of the meaning and function of those objects. Scholars can draw parallels with later examples of art, and knowledgeable contemporary Native interpreters can offer their understandings of the pieces, but we can never be entirely certain of what any individual item signified and how it was used. Moreover, only those items that actually were preserved can be analyzed, leaving out what were likely vast quantities of organic creations. Once foreigners arrived to the Northwest Coast in the late eighteenth century, objects, often of wood and fiber, began to be collected, sometimes along with information from their owners. These earliest collections provide invaluable documents on Northwest Coast art that was made and used before interactions with Europeans and Americans led to the nineteenth-century classic style.

UNTIL THE LATE EIGHTEENTH CENTURY, Northwest Coast people lived
without any direct contact with those foreigners who had, for almost
three centuries, irrevocably changed the lives of millions of Native North
and South Americans. It is estimated that before contact, approxi-
mately 150,000 people lived between southeast Alaska to the Columbia
River, making this one of the most densely populated regions north
of Mesoamerica. This was to change when a convergence of national
political ambitions and promises of tremendous wealth from furs that
could be found in the region brought Europeans and Euroamericans to
the Northwest Coast.

Imperialist conflicts between Spain, with its vast lands in the western
hemisphere, and Russia, which controlled Siberia and the Russian Far
East, inspired the initial exploration of the Northwest Coast. In 1741 the
Russian czar sent Vitus Bering on a voyage to claim American lands. Bering
sailed the sea now bearing his name and became the first European to
see Alaska. Soon Russia declared sovereignty over this newfound land,
encouraged traders and hunters to take advantage of whatever oppor-
tunities presented themselves for commercial enterprises, and in 1792
established its first permanent settlement, on Kodiak Island. Men began
sailing from Kamchatka to the Aleutians, where they discovered abundant
numbers of sea otters. Called "soft gold," the plush, luxurious fur of these
aquatic mammals sold for extremely high prices in China. The Russians
enslaved the highly skilled Aleut hunters and forced them to harvest
the otters, leading to the virtual elimination of these animals from the
Aleutian archipelago.

Spain, threatened by the expansion of the Russians into the New
World, feared that their imperialist rivals might continue southward and
threaten their Mexican lands. In 1773, on information provided by the
Conde de Lacy, Spanish minister to Russia, who had learned of the czar's
secret plans for more expeditions to North America, Spain sent its own
ships north to claim lands and halt Russian expansion. In 1774, under the
leadership of Juan Pérez, a Spanish ship sailed from San Blas, Mexico.
Pérez and his crew, the first non-Native people to sail the Northwest Coast
waters, encountered Haida on Haida Gwaii and Nuu-chah-nulth in Nootka

Sound. Because the Spanish remained secretive about their expeditions, rarely announcing or publishing books on their discoveries, Pérez has until recently received relatively little credit for his historic voyage.

Like so many other voyagers during the age of exploration, Pérez acquired natural and cultural objects commonly called "curiosities." The artifacts collected by him and by the other earliest Europeans to the Northwest Coast constitute a historically significant body of material, as they represent the art made shortly before contact and thus serve as a baseline for later artistic developments. Pérez has the distinction of being the first European to have acquired a Northwest Coast artwork, a small ivory bird (fig. 2.1). On its wing a formline created by incisions encircles an eye and a thin mouth that together create an upside-down profile face. This figurine, which might have been a pendant or charm, was already of some age when Pérez acquired it, so it can definitively be classified as an example of late precontact art.

## EARLY ENCOUNTERS AMONG THE NUU-CHAH-NULTH

THE HONOR of being the first European to interact extensively with Northwest Coast people and get credit for it has gone to Captain James Cook. Cook had already made two voyages around the world and was on his third when he traveled to the region in 1778, seeking the Northwest Passage. In 1745 the British Parliament had offered a reward of 20,000 pounds to whoever found a sea route between Hudson Strait and the Pacific Ocean. This passage would enable the British to sail from England to the Far East more quickly and avoid the Spanish lands of South and Middle America. In pursuit of this prize, Cook sailed his ship, the *Resolution*, east from England, stopping in New Zealand and Tahiti before sailing into Nootka Sound on western Vancouver Island in March 1778. Needing to repair his ship, he remained until April in the place he named Friendly Cove. This extended stay gave Cook and his crew the opportunity to visit Yuquot, a town of 1,500 people of the Mowachaht band of Nuu-chah-nulth, where he recorded extensive information and collected considerable amounts of art. He then sailed farther north and explored parts of coastal Alaska. In the body of water now called Cook Inlet, where Anchorage is located today, is an inlet with a plaintive name suggesting

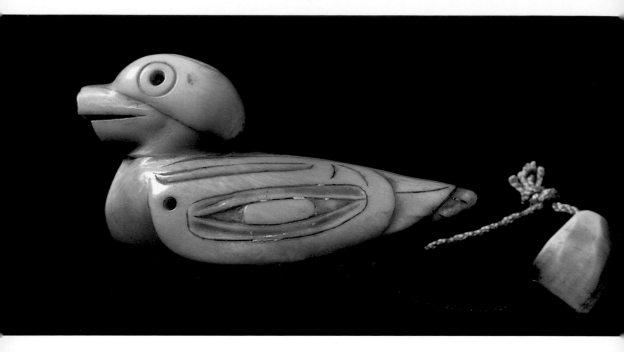

2.1  Haida. Bird, c. 1750. *Whale ivory. 1.75 x 2.5 in.*

*Museo de América en Madrid, 13.042.*

On the first non-Native exploration of the Northwest Coast, Spaniard Juan Pérez
Hernández sailed as far north as the Dixon Entrance, which separates Haida Gwaii
from the Alaskan panhandle. It was here that he acquired this small ivory seabird
from "a woman who wore it around her neck with a string of little teeth" that were
presumably from sea otters. On the bird's wing is an upside-down profile. The
refined ovoids and formlines that define the elements of the face, demonstrate
that northern two-dimensional style had reached a level of sophistication prior
to contact.

continued unhappiness with his fruitless pursuit of the nonexistent
Northwest Passage—Turnagain Arm.

Accompanying Captain Cook in 1778 was John Webber, an artist of
considerable ability charged with making "Drawings and Paintings of such
places in the Countries you may touch at in the course of the said Voyage
as may be proper to give a more perfect Idea thereof than can be formed
by written descriptions only."[1] Webber's illustrations are the earliest
images of Northwest Coast house exteriors and interiors (figs. 2.2, 2.3).

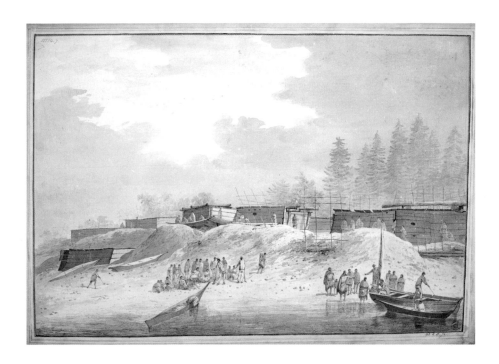

2.2 Nuu-chah-nulth. Houses, Yuquot, 1778. *Drawing by John Webber.*

*By permission of the British Library, 15514, no. 7.*

This scene shows the meeting of Captain Cook with the Mowachaht at the village of Yuquot, called Friendly Cove by Cook. The shed-roofed houses sit on a large midden, which indicates the centuries-long habitation of this site on the west coast of Vancouver Island. The poles on the midden were used for drying fish. The canoe in the middle foreground is a typical West Coast style of canoe (see fig. 1.8).

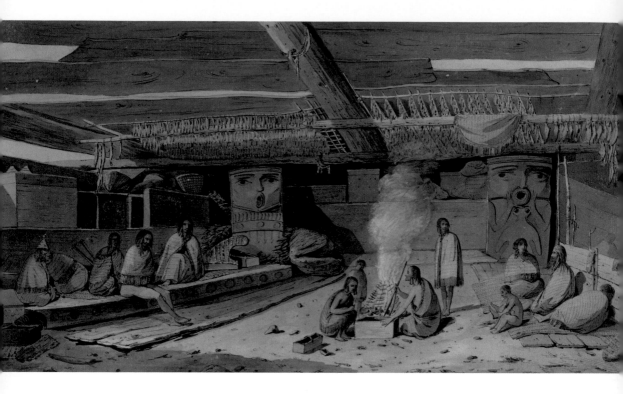

2.3   Nuu-chah-nulth. Interior of Maquinna house, Yuquot, 1778.

*Drawing by John Webber.*

*Peabody Museum, Harvard University, N26744.*

This drawing depicts with ethnographic detail the inside of a chief's house at the
time of first contact between Northwest Coast people and Euroamericans. The
wide posts at the rear are carvings that could represent ancestors. The importance
of whaling is reflected in the carved image of a whale's saddle—the dorsal fin and
its base—that sits on the platform next to the left-hand post. On the left end of the
bench sits a man wearing cedar-bark garments and a woven hat like the one shown
in figure 2.5; this is probably the chief. Inhabitants used platforms along the walls
for sitting, as shown here, as well as for sleeping, and for storing the bentwood
boxes that hold ceremonial regalia and baskets used for storage. Small fish hang
from the rafters to dry, while others are being cooked over the central fire.

His drawing of a Yuquot village depicts flat-roofed plank houses perched atop rather steep mounds called middens. Yuquot had been inhabited for thousands of years, and shell debris discarded from generations of residents had raised the village higher and higher from the beach.

Although many people associate the Northwest Coast with totem poles, Webber's illustration of this village includes none, for at that time the Nuu-chah-nulth did not erect exterior cedar columns. Instead, they depicted anthropomorphic beings on posts that stood within their houses such as that of the Yuquot chief, Maquinna. Cook was unable to ascertain what the images represented, but later travelers learned that they were ancestral figures.

Captain Cook appreciated many of the artworks he saw in Yuquot, and described them in his journal.

> An endless variety of carved wooden mask[s] and vizors, applied on the face, or to the upper part of the forehead. Some of these resemble human faces, furnished with hair, beards, and eyebrows.... In general they ... are painted, and often strewed with pieces of the Foliaceous Mica, which makes them glitter.... They not only preserve, with great exactness, the general character of their own faces, but finish the more minute parts, with a degree of accuracy in proportion and neatness in execution.[2]

Like so many explorers during the age of enlightenment, Cook and other visitors to the Northwest Coast collected considerable amounts of artifacts (see, for example, fig. 2.4). At this time, these were called "artificial curiosities" to distinguish them from the "natural curiosities" of organic and inorganic materials also collected upon such voyages. The collections of items from Yuquot today constitute an invaluable artistic record of late prehistoric and early historic Wakashan art.

As for their Makah cousins at Ozette, an important privilege of the Nuu-chah-nulth chiefs was hunting whales. In the Webber drawing of the house interior, a carved whale "saddle," like that from Ozette, sits on the platform in front of the left-hand house post. The importance of whaling also becomes evident on the onion-topped conical hats called Maquinna

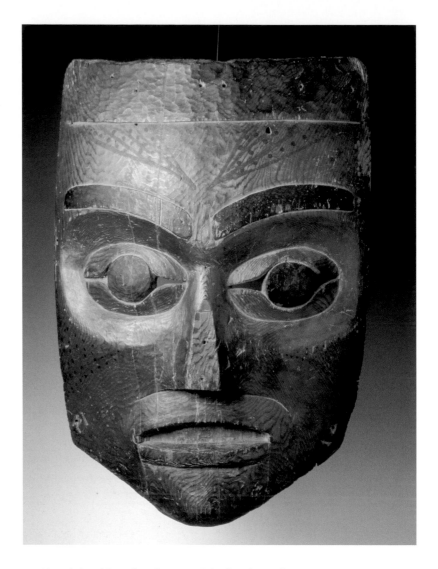

2.4   Nuu-chah-nulth mask. 18th century. *Painted wood. 27 x 20 in.*

*Museo de América en Madrid, 13.919.*

Such a large carved face mask would probably have been displayed within
the house, and alluded to the family's ancestral lineage. This particular
piece was collected in 1792 by José Mocino, a naturalist who traveled with
the Spanish expedition led by Juan Francisco de la Bodega y Quadra. The
piece of wood for the tip of the nose is missing. Nuu-chah-nulth carving
of this early period was more sculptural, with its articulated cheek-
bones and eye sockets, than many later carvings of the 19th century.

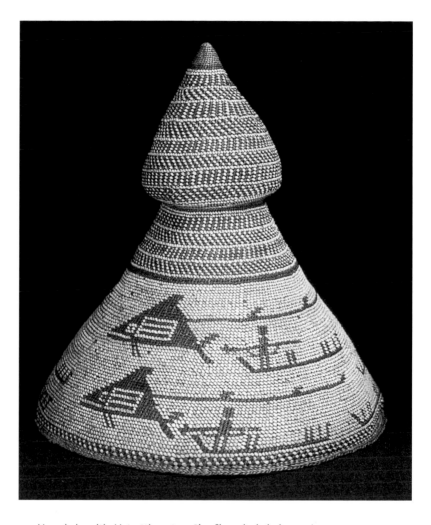

2.5  Nuu-chah-nulth. Hat, 18th century. *Plant fiber and cedar bark. 12 x 12 in.*
 *Museo de América en Madrid, 13.570.*

Twined hats of this type, with onion-shaped finials, are sometimes called
"Maquinna hats" because they were first seen on Chief Maquinna in Yuquot during
the late 18th century. The hats themselves were worn only by the highest-ranking
people, and thus can be considered emblems of status and position. They are
quite rare, with only about twenty known in collections. This one, like the others,
depicts scenes of hunters in canoes harpooning whales, a privilege reserved for the
chief, and undertaken only after considerable ritual purification and prayer. The
weaver used the overlay twining technique to create the images. A dark and light
pair of weft elements twine around the warp; when the artist wishes to outline an
image, she twists the pair to show the dark strip. Like the mask in figure 2.4, this
hat was likely collected in 1792 by José Mocino.

hats (fig. 2.5). The man at the far left of the drawing wears one of these, into which are woven scenes of canoes with men wielding harpoons directed toward whales. Only a chief could harpoon a whale, and only a chief could wear one of these hats.

## EARLY NORTHERN ART

IN ADDITION to basketry, Cook also acquired the earliest examples of twined robes made of shredded cedar bark and mountain-goat wool. Cook commented that "these kinds of dresses were the property of strangers," which has led scholars to conclude they were crafted by northern people such as the Tlingit, Haida, or Tsimshian, whose early formline art these images resemble. One, for example (fig. 2.6), integrates the geometric motifs, commonly found on baskets and other textiles, with simplified rectilinear depictions of four frontal faces. The free-floating features—eyes, nose, brows, and mouth—of the central top face contrast with the three upside-down faces positioned along the bottom, in which the nose and mouth are defined by rectilinear formlines. This robe and others with anthropomorphic or zoomorphic imagery probably depicted clan crests and were worn by the elite.

During his voyages along the coast, Cook saw none of the tall, elaborately carved and painted crest monuments erected out-of-doors that represent the most famous and well-known type of Northwest Coast art. Indeed, totem poles were rare during the early years of contact. At that time, treasured family crests were more commonly depicted on other types of monumental art, such as the house posts inside Maquinna's house that Webber illustrated, and painted house facades. It was only in 1791 that John Bartlett, a seaman on the ship *Gustavus III,* drew the earliest known depiction of a totem pole, a forty-foot-high frontal pole in the Haida village of Dadens on Haida Gwaii (fig. 2.7). This is the first recorded image of a totem pole, although two years earlier John Meares had sighted and briefly mentioned an exterior pole on North Island. Before that time, no traveler had described or illustrated exterior poles, and it would only be during the nineteenth century that villages from the Tlingit to the Kwakwaka'wakw erected large numbers of totem poles.

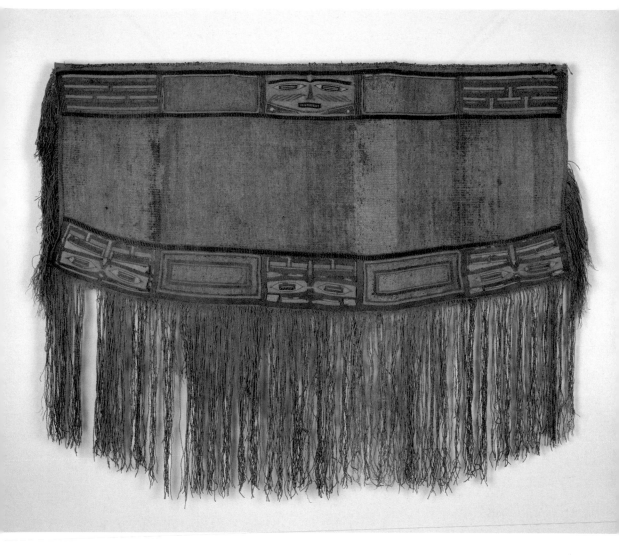

2.6 Twined robe, probably from northern region, 18th century.

*Cedar bark and mountain-goat wool. 43 x 52 in.*

Museum für Völkerkunde, Wien, 218.

This robe was collected on Captain Cook's 1778 voyage, and like many other items acquired during his final voyage, ended up in the private Leverian Museum, which had to sell the pieces in 1806 due to financial exigencies. Some of its pieces, including this example, were purchased for the Imperial Cabinet of Natural History in Vienna, the kind of "cabinet of curiosities" that preceded the great European natural history museums. On this unusual textile, the weaver has interspersed geometric patterns with a face and stylized formline designs. Note the subtle variations within the elements of this piece, such as the single line inside the bottom central eyes that contrasts with the double lines inside the eyes of the flanking formline designs.

2.7   Haida Gwaii. Haida house, Dadens, 1791. *Drawing by John Bartlett.*
*Photograph courtesy Peabody Essex Museum, A4956.*

In 1791, John Bartlett sailed on the *Gustavus III* to the north island of Haida
Gwaii and visited Dadens, where a house with an attached forty-foot-high
totem pole stood. In his journals, he described the pole as having been
made before the Haida had iron. He also noted that the entrance to the
house was between the teeth of the lowermost face, which are clearly
depicted on his drawing. This is the first known depiction of the kind of
Northwest Coast artwork that has never ceased to fascinate non-Natives.

## EARLY TLINGIT ART

DURING THE LATE eighteenth and early nineteenth centuries, foreigners
collected a good number of Tlingit artworks which offer insights into
early northern-style art. This group, like other inhabitants of the
Northwest Coast, traveled in dugout cedar canoes. Many Tlingit paddled
vessels of the variety called "head canoes," characterized by tall,
broad bows and slanted sterns. On the exterior, crests were painted in
the more minimalist style of archaic Tlingit works. The canoe fashion
changed in the nineteenth century, and head canoes were replaced
by other types. Although no full-size head canoes were ever collected,
models provide acceptable representations of what they probably looked
like (fig. 2.8).

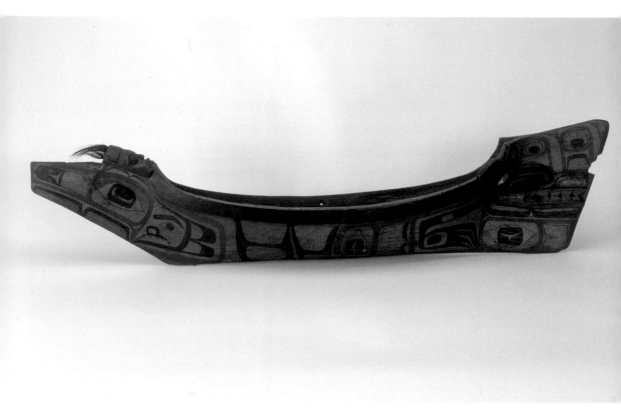

2.8  Tlingit. Head canoe model, early 19th century. *Wood, pigment. L. 34 in.*

*Courtesy National Museum of the American Indian, Smithsonian Institution, 03/5496.*
*Photo: Gina Fuentes-Walker.*

This kind of canoe was used in precontact and early contact times. No head
canoe exists in museum collections, and the vessel is known only by models
such as this and drawings made by early Euroamerican travelers. The unique
head canoe form is characterized by thin fins—a slanting, longer one that
serves as the stern and a vertical one that makes up the bow—both of which
provide large, relatively flat surfaces for painted crest images. Although impres-
sive, the head canoe was not easy to paddle and was ultimately replaced by the
northern-style canoe (see fig. 1.8). As in most canoe models, the center section
of this one is proportionately half the length that it would be if full-sized.

The Tlingit placed crest images on numerous items including protective wear for use in warfare. Enjoying a reputation for being difficult, belligerent, and especially warlike, the Tlingit devoted considerable artistic energy to enhancing their military attire. The well-dressed warrior covered his torso with armor formed from wooden slats that often contained illustrations of his crest. Over that, a thick hide tunic, also depicting a crest being, provided additional protection to the body. On his head, the warrior wore a heavy wooden helmet (fig. 2.9) and a thick visor—only his eyes could be seen between these two massive carvings. Thus armored, Tlingit warriors would imitate the cries of their crest animals as they charged their enemies in battle.

The Russians had the opportunity to see these men in action in 1802. The interactions between the Northwest Coast people and most Europeans and Euroamericans during the early years of contact were usually peaceful, as it was in everyone's interest to maintain cordial relations. But this was not to last for the Tlingit, who resented the Russian presence in their land. Since 1792, the Russian-American Company had maintained a capital in Kodiak to the northwest, but needed trading centers farther south; in 1796 the company founded a post in Yakutat Bay. In 1799 Alexandr Baranov, then director of the Russian-American Company, founded Redoubt St. Michael near present-day Sitka. He remained until fall 1800, then returned to Kodiak, leaving Vassili Medvednikov in charge to manage the small settlement and acquire furs. Relations between these newcomers and the Tlingit were tense, but for two years Medvednikov ignored rumors of an uprising, which finally happened in June 1802. Six hundred Tlingit, emboldened by guns and ammunition purchased from Americans and British traders, paddled into Redoubt St. Michael in a flotilla of more than sixty canoes. The warriors destroyed the fort, killed 20 Russians and 130 of their Aleut slaves, and took as prisoners women and children whom they later ransomed for considerable amounts of money. In retaliation, Baranov sent four ships in 1804 with 120 Russians and 900 Aleuts in 300 skin boats to Sitka. He attacked the town, forced the Tlingit out, and established a new community he called New Archangel, the present-day Sitka. In order to further ensure Russian control of this region and its warlike natives, Baranov moved the capital of Russian America from Kodiak to Sitka.

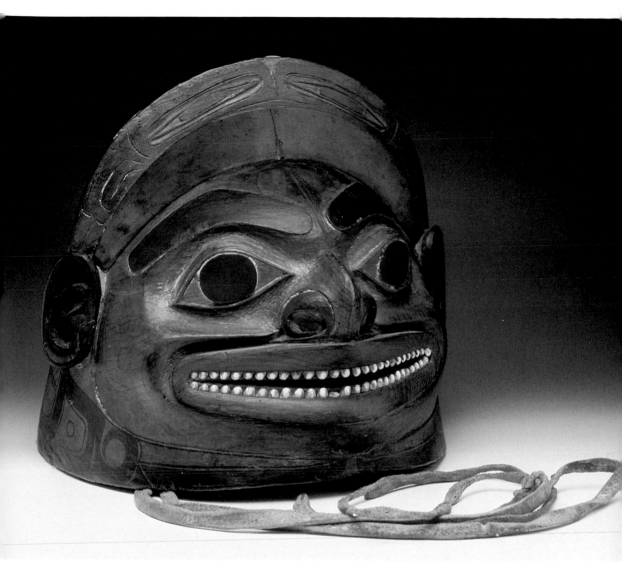

2.9   Tlingit. Helmet, c. 1750.

*Collection attributed to Alejandro Malaspina, 1791–92.*

*Wood, paint, opercula, copper. H. 11 in.*

*Museo de América en Madrid, 13.909.*

Despite their decorative artistry, such helmets were meant to protect their wearers; the portion that surrounded the head was up to 1 ½ inches thick. Until warriors obtained firearms in the early 19th century, these helmets, worn along with visors, functioned well during hand-to-hand combat between two knife-wielding opponents, the typical form of Tlingit fighting. This example depicts an energetic face crowned by a curved piece of copper, a material that signaled wealth and was often applied to artworks owned by the elite. Above that crown, the wood is carved with the long, thin eyes characteristic of late precontact art. Surrounding the eyes are broad formlines created by incisings.

The Russians had good opportunities to observe clothing worn during peacetime. Like the elite in many other places, Tlingit nobility had special garb that indicated their status. The most finely dressed individual would often wear a basketry hat, woven robe, shirt, leggings, and apron. Hats made of spruce-root baskets painted with a crest being or of wood carved to represent that being were the most highly prized portable crest objects. A stack of basketry rings, sometimes called "nobility rings," that topped these headdresses conveyed the tremendous esteem with which they were was held. Several such hats can be seen on individuals posed in the interior of the Klukwan Whale House shown in figure 1.1.

Reserved for the nobility as well were robes made from mountain-goat wool and decorated in the pattern known as the raven's tail weave, named after a geometric motif said to resemble that of a bird's feathers (fig. 2.10). Within the constraints of the geometric style, raven's tail weavers created varied and original designs. In the illustrated example, each half contains a different pattern that "quotes" the motifs diagonally opposite. The vivid lozenges on the right side are miniaturized and divided by the zigzags on the left, and the four strong horizontals and verticals of the "H" design repeat, somewhat less distinctly, on the right. Some raven's tail robes are lined on the inside with sea-otter fur, providing a luxuriously soft and plush feel.

## THE EFFECTS OF CONTACT

THE HISTORY of imperialism involves narratives not only of how European nations assumed control of territories, but also of their involvements with the first residents of those lands. The most devastating consequences for Northwest Coast people of these early encounters resulted from disease. From a precontact estimate of 150,000, the Northwest Coast population plunged to less than 35,000 by 1880. This precipitous decline in population, like similar devastations throughout the New World, resulted from epidemics introduced by Europeans to Native Americans, who had no resistance to diseases such as smallpox, malaria, and measles. Sometime between 1769 and 1780, a major smallpox epidemic on the Northwest Coast took the lives of approximately 60,000 people.

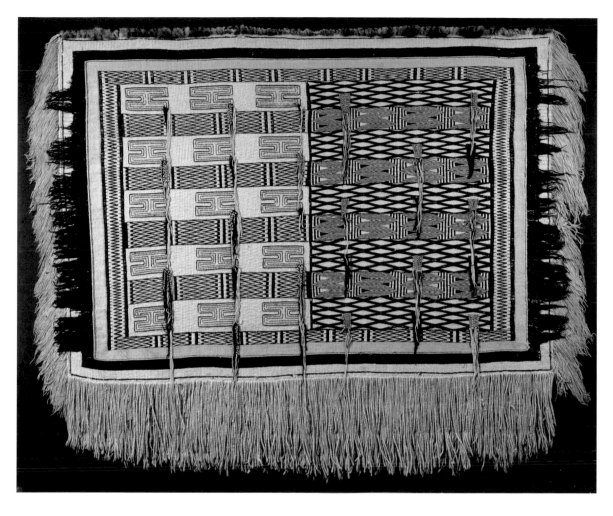

2.10  Tlingit. Raven's tail robe, "The Swift Blanket," 18th century.

*Mountain-goat wool. 65 x 55 in.*

*Peabody Museum, Harvard University, 09-8-10/76401.*

Geometric robes such as this one are rare—only eleven complete specimens
and four fragments exist. This robe, called the "Swift Blanket" after its collector,
and another at the Peter the Great Museum of Anthropology and Ethnology in
St. Petersburg, are the two best-preserved examples. The geometric designs and
twining technique of manufacture are derived from basketry. This textile's central
division into two separate patterns is unusual in comparison to the other known
raven's tail robes. When dancing in this robe, a chief could appear to be wearing
two different robes as he moved from side to side.

Opinion still divides as to the source of this epidemic: it could have been carried by the earliest ships to the northern Pacific and spread far from the place of those actual contacts; it could have arrived overland from the east; or it could have been introduced from Russia, spreading eastward from Kamchatka through the Aleutians and into Tlingit territory.

After that, epidemic after epidemic hit the coast. These epidemics did not strike all of the coast at the same time, but came and went in different places. The earliest smallpox epidemic, in the late 1770s, affected the Tlingit, Haida, Tsimshian, Kwakwaka'wakw, and all the coastal Salish; the ones around 1800–08, 1824–25, and 1853 mostly affected the Salish; and the 1836–37 epidemic hit the northern groups. In 1847 a measles epidemic affected the Tlingit, Tsimshian, Heiltsuk, and Salish. The most disastrous of all was the 1862 smallpox epidemic. From 1848 to 1880, the Haida population declined from 5,694 to 1,598, and the Kwakwaka'wakw dropped from 7,965 to 3,750.

Devastating as these losses were, the early interactions with Euroamericans also had positive consequences. The residents of this region of natural abundance had a resource greatly desired by these foreigners—furs—and during the late eighteenth century and early nineteenth century many Northwest Coast people benefitted economically from trade with Euroamericans. Importantly for our story, the wealth this fur trade brought to the coast inspired a great flowering of artistic activity. Although he could find no Northwest Passage, Cook did obtain from the coastal people he visited various furs, the most beautiful of which was from the sea otter, which the Russians had been harvesting farther north. After Cook was killed in the Sandwich Islands (now Hawaii), his crew sailed to Canton and discovered what the Russians already knew—that these pelts could be sold for enormous sums. News of this became widespread in 1781 when the account of Cook's voyage was published, inspiring numerous merchant ships to make the long voyage to the Northwest Coast. The first such British ship, the *Harmon*, arrived in Nootka Sound in 1785 and left for China with a good inventory of pelts. The next year, ten more ships joined it. And between 1790 and 1794, more than 100 ships sailed to the region, eager for the profits to be made from the sea otter. But, as the Russians had learned in the Aleutian Islands, overharvesting could make the sea otters scarce.

No one seemed to care about that, and ships began sailing from Europe and New England to purchase every available pelt. To their surprise, they encountered highly skilled and experienced Native traders. For centuries, Northwest Coast groups had traded amongst themselves and with more distant Native groups for obsidian, dentalium, dyes, copper, and other raw materials not found in the region. This had honed their considerable bargaining skills, to the chagrin of the Euroamericans, whose baubles offered in exchange for sea-otter furs were disdainfully dismissed. The locals had the advantage that they could simply reject inadequate offers, whereas ships could not afford to leave the coast without furs. Native traders were inconsistent in their preferences, sometimes wanting iron, sometimes copper, sometimes liquor; a ship might sail halfway around the world with some material that the previous season had been esteemed, only to find out the people had lost interest in it and desired something else they did not have. The Spaniards, for example, grumbled that the Nimpkish Kwakwaka'wakw rejected the iron they brought and demanded instead copper and blue cloth. During the peak of the fur-trade years, harbors would have in them ships flying flags from various countries, offering the coastal people opportunity to play different foreigners off against each other and thus realize even greater profits.

To simplify their transactions with Native villages, merchants often interacted with a single individual, usually the person of highest rank. By monopolizing all the fur trade in his village—and sometimes even beyond—that chief became immensely wealthy. Chief Maquinna, whom we met earlier when Captain Cook visited Yuquot, became such a "super-chief" during the years when Friendly Cove was a center of the sea-otter fur trade. Yuquot was significant for international politics as well as for trade. The Spanish feared both the Russians and the British, who had plans of their own for the coast. So, intent on solidifying their position in the northern Pacific region, the Spanish established a settlement in 1789 at Yuquot, which they called Nootka. This, understandably, did not please the Mowachaht, who under the leadership of Chief Maquinna abandoned their long-inhabited community and moved north along the coast to another village site. The British were also unhappy about the Spaniards' northernmost outpost, and in 1792 they sent George Vancouver there to

negotiate a withdrawal; the ultimate result was that the Spanish relinquished to the British any claim to that part of the world. Once the short-term settlers left, Maquinna led the Mowachaht back south to Yuquot, where they lived unmolested for decades.

The Native residents of the Northwest Coast cared little about international disputes, as long as these did not interfere with the trade that made them wealthy. Trade also brought new materials into the Northwest Coast, some of which Native people absorbed into their artistic repertoire. Euroamerican clothing and decorations suited some chiefs, such as Haida Canya, who in 1792 met Spanish traveler Jacinto Camano wearing two frock coats, one over the other. Coins and blue beads ornamented both coats and his breeches. The Spaniard found this garb astonishing, and later wrote that when the chief moved about he sounded like a mule in harness. In 1793 another traveler, Sigismund Bacstrom, sailing with Captain William Alder on the British ship *Three Brothers*, encountered Hangi, daughter of a Kaigani Haida chief on Dall Island, who was adorned with not only the usual labret but also an assortment of trade items, including copper rings on her wrists and ankles and a silver dining fork pendant around her neck.

## THE END OF MARITIME TRADE AND THE BEGINNING OF LAND-BASED FUR TRADE

THE MARITIME FUR TRADE flourished only for several decades, and by 1810, the sea otter had become rare, overhunted to near extinction. Conservation was a concept unimaginable at that time: traders simply depleted the stock of one kind of fur-bearing animal, then turned to others. Abundant terrestrial animals, particularly in interior British Columbia, soon became the focus of a land-based fur trade. For years, the Hudson's Bay Company had controlled all the fur trade in eastern Canada, so it was well situated to take advantage of new fur-trading opportunities in the west. Company representatives traveled overland from the east and established their first forts in interior British Columbia, at Fort Nelson in 1805 and Fort St. James in 1806. Two decades later, they arrived at the coast and founded Fort Langley on the lower Fraser River.

Fort Simpson, at the mouth of the Nass River in northern B.C., followed in 1831, and Fort McLaughlin, in Milbanke Sound, in 1833. Like the maritime fur traders, the Hudson's Bay Company brought prosperity to many Northwest Coast groups. In some cases, entire Native communities moved from their traditional village sites to live in the vicinity of the trading fort.

The coastal people, whose bargaining acumen with foreigners had been perfected during the maritime fur trade years, remained formidable trading partners. Unlike many other Native groups, the Northwest Coast people refused to deal with the Hudson's Bay Company on its terms. For example, the Company was unable to impose the kind of monopoly it enjoyed with other Canadian First Nations, discovering instead that in some communities the indigenous people themselves exerted monopolistic control over the furs. The Stikine Tlingit leaders of the Shakes dynasty had exclusive access to the Athapaskan trappers of the interior. By preventing anyone else from obtaining Athapaskan furs, they could control the prices, and consequently became fantastically wealthy and powerful.

The Hudson's Bay Company also could not force Northwest Coast merchants to trade only with the British. If, for example, a Native trader encountered Russians or Americans who offered better prices for his furs, he ignored the demands of the Company and sold his goods to Britain's competitors in the international fur market. Just as they had during the maritime fur trade years of the first half of the nineteenth century, Northwest Coast Native people transacted with foreigners from strong positions, establishing mutually beneficial relationships.

As the land-based fur trade replaced maritime commerce, the art of the Northwest Coast continued developing. Prior to contact with Europeans, family rankings and village hierarchies of the Northwest Coast had been fairly well established. But with the new wealth pouring into certain villages that were well situated to control the fur trade, some traditional chiefs (such as Maquinna) became especially wealthy. Increased wealth provided certain families with more materials to give away, enhancing the abundance of the potlatch ceremonies and necessitating the creation of new and more impressive artworks to embody family history and status.

Using metal tools and commercial paints, artists produced more lavish works. Their carving became even more refined, their painting more elegant. As a result, nineteenth-century Northwest Coast art flourished, and the era is identified by many critics as its golden age.

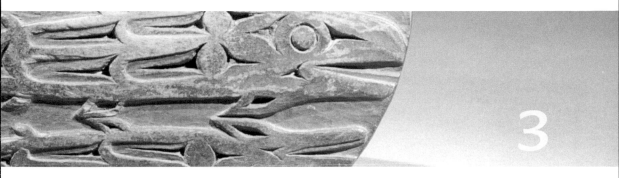

# NINETEENTH-CENTURY
# SOUTHERN COAST ART

THE SOUTHERNMOST AREA of the Northwest Coast ranges from the
Columbia River to southern British Columbia. This region of relatively
mild climate and abundant resources was the first to be settled by non-
Natives, and thus experienced early cultural disruptions. Groups speaking
Salishan languages inhabit the area from the coast of British Columbia
and Washington State, over the coast range, and into the interior. Those
on the coast belong to the Northwest Coast cultural area, whereas those
in the interior are Plateau people with a culture considerably different
from that of groups to the west. Another Salishan group, the Nuxalk, who
live on the central British Columbia coast, will be discussed in the next
chapter, as they are artistically closer to the Wakashan speakers than to
their Coast Salish cousins. Although most of the art to be discussed in
this chapter was made by speakers of Salishan languages, the Chinook
speakers who live along the lower Columbia River produced some fine

woodwork and basketry that probably represent a more widespread archaic style.

Southern coast architecture includes both gable- and shed-roof structures. Columbia River tribes lived in gable-roofed houses that were dug into the ground, so only the uppermost parts of the side walls could be seen from outside. The interior of such a house, painted in 1846 by artist Paul Kane (fig. 3.1), includes panels with geometric decoration and a central anthropomorphic house post in the minimalist style characteristic of southern Salish figurative work. This structure is relatively small compared to some of the larger Chinook buildings, which could be several hundred feet long. Some Salish winter houses, often of the shed-roof type, were also of enormous size.

Unlike the fixed floor plans characteristic of both the Chinook and more northern Northwest Coast houses, some southern houses could expand as needed. Wayne Suttles has suggested that the structure of these houses developed from the special social and ceremonial needs of the Salish, which differed from those of groups farther north. Potlatches and spirit dances were held for large numbers of people and thus required a great deal of space. For example, the Suquamish Old Man House on the Kitsap Peninsula, constructed in the early nineteenth century for a great potlatch, measured between 40 and 50 feet wide and as long as 500 feet. Moreover, in striking contrast to the strict rules of marriage found among some other Northwest Coast groups, Salish had considerable flexibility in choosing a spouse. Despite the hierarchical social structure of the Salish, their descent rules were comparatively pliant, with some upward mobility possible for particularly talented lower-ranking individuals. A family could move about to live with different relatives from both the father's and the mother's sides, causing households to expand in size.

The Coast Salish people are divided into four geographic groups: northern, central, southern, and southwestern. The Northern Coast Salish inhabit Vancouver Island, south of the Kwakwaka'wakw, and the opposite mainland. Central Coast Salish range from southern British Columbia and southern Vancouver Island to northern Washington State and the north shore of the Olympic Peninsula. The Southern Coast Salish populate the Puget Sound area, and the Southwestern Coast Salish dwell on the Pacific

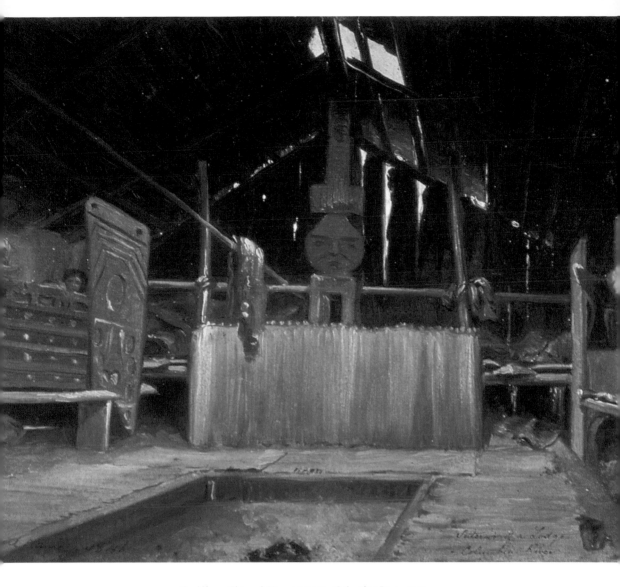

3.1 Paul Kane. Chinook House interior, Columbia River, 1846.

*Oil. 9.5 x 11.5 in.*

*Stark Museum of Art, Orange, Texas, 31.78/120, WOP13.*

At the time when artist Paul Kane traveled around the Northwest, Fort Vancouver
was a major center of Hudson's Bay Company activities and attracted numerous
Native groups. It is thought that the house depicted here was located below Fort
Vancouver along the Columbia River. The gable roof, central excavated hearth,
raised plank floor that in this painting is covered with mats, elevated platforms
for beds, and an anthropomorphic house post all reveal close affinities with the
architecture farther north. See figure 1.7, which illustrates the exterior of this type
of house.

coast of the Olympic Peninsula. Although linguistically unrelated, the Quilleute on the coast of Washington State and the Columbia River tribes who speak Chinookian languages such as Wasco, Wishram, and Chinook share certain cultural and artistic features with these Salish groups.

The Salish shaman enjoyed direct access to the supernatural world, but was not the only person in a community with that power, for supernaturals also served as guardian spirits for laypeople. Spirits could grant their guardees success in fishing, gathering, and gambling, skill at basketry and carving, and wealth. Sometimes the spirit came of its own volition, having selected the individual with whom it wished to interact. Other times, a person might seek out a spirit more actively by bathing, purging and fasting, or traveling to sites known to be especially connected with the supernatural. Once the individual encountered an animal spirit, he or she fell into a trance and had a vision. While in that altered state, the initiate was transported to the spirit's house and given power, as well as dance steps, music, songs, visual images, and costumes. On regaining consciousness, the individual, now strengthened by the new relationship with a personal guardian spirit, returned home.

After successfully securing a guardian spirit, an individual could, at times, commune with it through the powers received during the original encounter. He or she might sing the song, perform the dance, or don the costume bestowed by the spirit. Unlike the more public demonstrations farther north, encounters with supernaturals for the Salish were intensely private affairs, because spirits became angry at breaches of confidence. Recounting the details of a spiritual experience put one in peril of abandonment, illness, or even death. So, even though individualized dances, songs, and regalia were presented publicly, specific meanings were never revealed, details of the human–guardian spirit relationship never made explicit.

## COLUMBIA RIVER PEOPLES

COLUMBIA RIVER TRIBES lived in permanent villages of gable-roofed cedar-plank houses, had a ranked social structure with chiefs, commoners, and slaves, and counted wealth with strings of dentalium shells, slaves, and canoes. Like the Salish, individuals embarked on

vision quests that resulted in adoption by a personal guardian spirit who gave power that was manifested in songs, dances, and particular carvings. Both men and women of the Columbia River area made art of considerable aesthetic merit. Carvers worked bighorn-sheep horn into elegant bowls and ladles by removing the inner bony core of the horn and cutting away a section of its outer curve to make the receptacle's basic shape (fig. 3.2). This was then placed in boiling water, which renders the horn more plastic, allowing the artist to bend the bowl into the desired form. When cool, the horn can be carved, as seen in figure 3.3, a Wasco-Wishram ladle with characteristic zigzag lines on the outer rim and a handle upon which stands an animal, possibly a wolf, with chevron ribs that are also common in this art.

Four-legged animals also appear on twined Wasco-Wishram baskets such as the one in figure 3.4, an early example collected during the Lewis and Clark expedition. Vertical rows of diamond-shaped geometric anthropomorphic heads form a grid, broken only by a row of open diamonds populated by wolves, dogs, or coyotes. Complete human bodies make their appearance on some of these weavings, such as the root bag shown in figure 3.5, which is decorated with standing people and four-legged canines. The simple, straightforward, rigidly presented humans resemble the Chinook house post discussed above (see fig. 3.1), and presumably characterize the type of anthropomorphic depiction more widespread in earlier times. This small bag could have been used during ceremonies celebrating the first harvesting of roots, a major ritual of the region.

## SOUTHWESTERN COAST SALISH

THE SOUTHWESTERN COAST SALISH speak Quinault, Lower Chehalis, Upper Chehalis, and Cowlitz and lived in gable-roofed houses along the Pacific Coast of Washington and in the southern interior of the Olympic Peninsula. Household goods such as bowls, tools, and combs were decorated in simple yet often elegant fashion. The Quinault whalebone and iron adze for making canoes that is pictured in figure 3.6 is a masterwork of balanced functionality, with its perfect hand-hold. Oliver Mason, grandson of the man from whom this piece was collected and whose ancestors carved it, commented that the curved-back figure clutching the

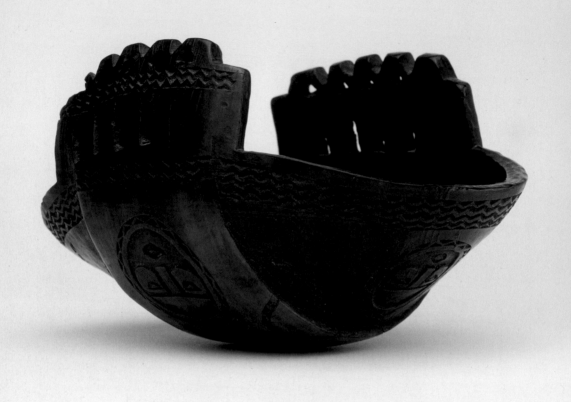

3.2 Wasco-Wishram. Bowl, 1800–1850. *Bighorn sheep horn. 5 x 6 x 8.5 in.*

*Thaw Collection, Fenimore Art Museum, Cooperstown, NY, T148. Photo: John Bigelow Taylor, NYC.*

The geometric carvings on this vessel—such as the prevalent use of zigzags around the bowl's rim, on its raised ends, snaking round the body, and encircling the upside-down faces—represent an archaic style that was probably once widespread. The simple faces composed of three planes, the forehead, nose-cheek area, and mouth area, belong to the same artistic tradition as the Salish faces they strongly resemble. This type of bowl might have been used during the springtime celebration of the first emerging food plants. The geometric faces on the bowl's side perhaps represent the guardian spirits who influence the productivity of the land.

3.3 Wasco-Wishram. Ladle, 1800–1850. *Bighorn sheep horn. 6 in.*
*National Museum of Natural History, Smithsonian Institution, 701.*

The geometric patterns on this work have a conceptual link to art from farther up
the coast, in that the characteristic zigzags that decorate its surface are created by
incising rows of negative-space triangles that create the positive angular lines. The
animal on the handle is perhaps a wolf, with exposed ribs that in many parts of the
world indicate that this is the soul of the creature. Ladles of this type, along with
bowls like the one illustrated in fig. 3.2, were used by members of the Root Society,
who esteemed the artworks as expressions of spirits from past generations. After
the proper rituals conducted over the first emerging plants of the season, families
could go and harvest root crops for their own uses.

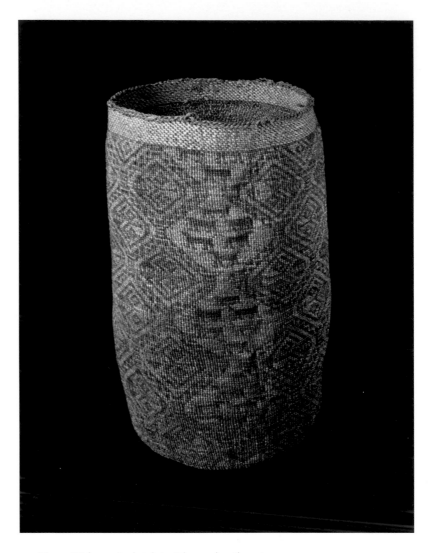

3.4  Wasco-Wishram. Basket, late 18th or early 19th century.

*Vegetable fiber. 6.75 x 12 in.*

Peabody Museum, Harvard University, 99-12-10/53160.

This basket was collected by Lewis and Clark in 1805–6, and thus is the oldest
Wasco-Wishram bag known. It was long assumed that Wasco-Wishram weavings
that depicted human and animal designs were postcontact artistic developments.
This very early basket proves the antiquity of figurative work on basketry; such
doglike animals appear on a variety of southern Northwest Coast objects. The
weaver used two types of twining on this basket, plain and wrapped. In wrapped
twining, the weaver uses two warps, one placed vertically, the other horizontally,
forming a latticework. The weft element, of more flexible material, wraps around
the place where horizontal and vertical warps meet. The plain-twined top and
bottom portions are undecorated. The artist used overlay technique to create the
geometric and animal images.

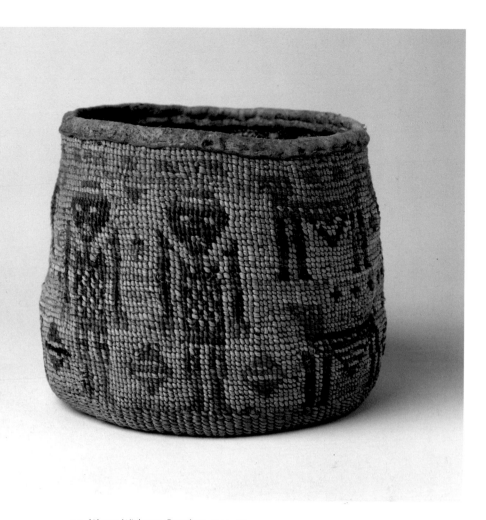

3.5  Wasco-Wishram. Root bag, 1840–60.

*Indian hemp, grass, buckskin, pigment. 5 x 5.75 in.*

Thaw Collection, Fenimore Art Museum, Cooperstown, NY, T150. Photo: John Bigelow Taylor, NYC.

The fiber called Indian hemp comes from the bark of the woody deciduous plant of
the same name. It is so strong and durable that Native people used it to make long-
lasting net bags as well as finer ones such as this. The stiff frontal figures have the
same form as Salish figures, such as the one on the comb shown in figure 3.7, with
truncated-diamond-shaped head and slightly raised shoulders. The canine figures
have upturned tails, which suggests that they could be dogs rather than wolves,
which are usually depicted with tails extended or hanging down, as in figure 3.3.
This piece would have been used in ceremonies that celebrated the first harvests of
the season and thanked the earth spirits.

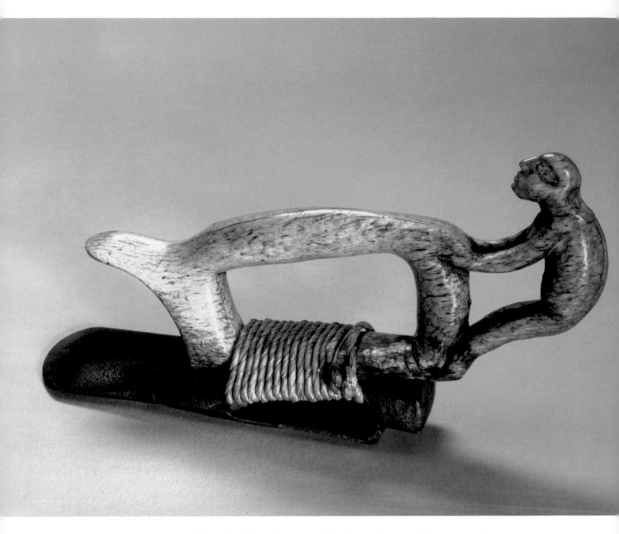

3.6  Quinault. Adze, 19th century. Whalebone, iron, rawhide. *10 x 3.5 x 2 in.*

*Peabody Museum, Harvard University, 5-7-10/65509.*

This is called a D-adze because of the shape of its handle. The little human figure
clinging to the side of the handle, with its rounded back, slightly bulging stomach,
and upward-gazing eyes, is a picture of energy as it seems ready to spring forward.
It is said to have given strength to the wielder of the adze in time of fatigue.

side "represents the spirit that helped carve the canoes. He was a helper and when they'd get tired, he'd help them keep going."[1] An early bone comb, dated between 1800 and 1850 (fig. 3.7), which could come from a southwestern or southern coast group, depicts a central being standing in an open space, surrounded by fields with nucleated circles. The subject, whose geometric face is typical of other Coast Salish anthropomorphic images, has nucleated circles identifying the power points of heart and navel. The two profile animals could depict an especially important power being, the wolf, its joints accentuated by similar circles.

Some Coast Salish women used coiling instead of the more common twining to create baskets decorated with geometric designs. The decorations were applied with a technique called imbrication (see fig. 1.13e), in which dyed strands on the outside of the basket are folded accordion-style into the coils and sewn down with cedar root.

Shamans, who had the ability to suck out intrusive objects as well as to travel with ease to other, nonhuman worlds, manipulated carvings depicting their supernatural helpers. For example, a Quinault shaman sought assistance from the power spirit on his wand (see fig. 1.6) for protection during supernatural journeys to retrieve stolen souls or to visit the land of the dead. The carving had power to help him overcome dangers on the route and to help him recapture the soul. As is the case among many Salish groups, the shaman was not unique in his connection with the supernatural, for laypeople could also enjoy the protection of guardian spirits, and sometimes portrayed them in art on carved and painted boards.

## SOUTHERN COAST SALISH

THE SOUTHERN COAST SALISH of the Puget Sound area have two language groups, the Lushootseed (Duwamish) and Twana. The Southern and Central Coast Salish, as well as the Nuu-chah-nulth south of Barkley Sound and the Makah of the Olympic Peninsula, lived in shed-roofed houses that often stood parallel to the shoreline. Inside the houses, platforms two or three feet high and four to six feet wide stood against all the walls and served as sleeping areas. House posts with simple carvings or paintings stood in some of these structures. Families lived in the houses

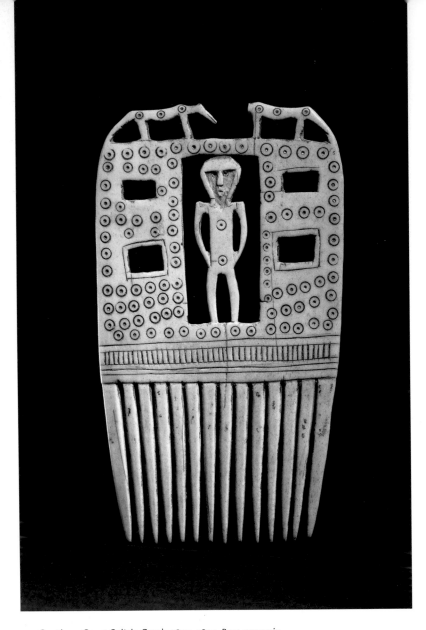

3.7  Southern Coast Salish. Comb, 1800–1850. *Bone. 5 x 2.75 in.*

*Thaw Collection, Fenimore Art Museum, Cooperstown, NY, T152. Photo: John Bigelow Taylor, NYC.*

This rare piece depicts an anthropomorphic being whose face and body resemble the figures that decorate the Quinault shaman rattle shown in figure 1.6 and the Wasco-Wishram bag in figure 3.5; all share a stark simplicity, strong horizontal brow, and open spaces between the arms and body and the legs. In the two sculptures, those spaces are pierced, as are four rectangles on the comb's body and the spaces between the legs and body of the two animals on top of it. These canine figures with long, straight tails could represent wolves such as those seen in figure 3.3. The circles probably indicate power. On this anthropomorphic figure they appear over the heart and navel, whereas on the wolves they are located at the shoulder and leg joints and the stomach, all areas in which, according to some cultures, spirit power can concentrate.

3.8  Twana, Basket, before 1832. *Plant fiber. H. 13.75 in.*

Peabody Essex Museum, E3624.

The simple, straightforward geometric design on this basket is characteristic
of one type of early Twana twined basket. Like many articles in museums, the
piece has a complex biography of how it arrived at the Peabody Essex Museum
in Salem, Massachusetts. The collector of record was a merchant in the China
trade who apparently never traveled to the Northwest Coast. Instead, he probably
acquired this fine basket in trade when he encountered other collectors in Fort
Ross, California, or in a port where he stopped during his Pacific voyages. He then
donated the basket to the museum.

during the winter months; when summer arrived, they removed the
cedar planks that composed the sides and roofs and transported them to
summer camps. The Twana also wove fine-twined baskets decorated with
rectilinear geometric designs (fig. 3.8).

For the Salish, sickness had several possible causes: the intrusion of
some object that required removal, the theft of the soul or a guardian
spirit which needed to be found and returned, and unwanted possession
by an individual's guardian spirit. To cure disease, the Salish consulted the
shamans whose supernatural spirit helpers assisted them in diagnosing
and curing sickness. Two spirits in particular—a two-headed serpentlike
being and a reptilian creature—had special powers for the shaman.

The most dramatic ritual of the South Coast Salish was the soul-recovery ceremony conducted by a group of shamans (sometimes joined by laymen) before a large crowd of observers. Shamans were charged with retrieving a soul that ghosts had stolen and brought to the land of the dead. They accomplished their task by pantomiming a canoe trip to the land of the dead to recapture the soul and return it to its owner. Although shamans tended to act alone, and sometimes maintained great rivalries with other shamans, in this ceremony they cooperated and functioned as a team, together acting out travels through dangerous terrain and interactions with malevolent supernaturals. Art played an important role in this performance, for the shamans stood within a "spirit canoe" composed of carved and painted images, and manipulated painted staffs both to "paddle" and to combat supernatural enemies. Because of the highly sacred and private nature of these carvings, the present-day Salish prefer that photographs of them not be published. A contemporary interpretation of a canoe board in glass by Marvin Oliver is shown in figure 9.23.

### CENTRAL COAST SALISH

THE CENTRAL COAST SALISH, which include speakers of Halkomelem (Musqueam, Stó:lō), Nooksak, and Straits (Klallam, Lummi, Songhees) languages, live on the northern part of the Olympic Peninsula, the southeastern portion of Vancouver Island, and the mainland from Bellingham to Howe Sound. Their social distinctions distinguished "worthy people" with wealth, manners, spirit guardians, and noble ancestors from "worthless people," who did not have those qualities, and slaves. They lived mainly in shed-roofed houses that had a permanent frameworks of beams and posts and removable planks for the roof and sides (fig. 3.9). Some shed-roofed houses in the central region grew to enormous sizes, such as the one Simon Fraser described from his visit to a Stó:lō village consisting of a single house 640 feet long and 60 feet wide, with a shed roof that rose to 18 feet at its highest point. The interiors of these structures were separated into individual quarters for nuclear families; sometimes house posts decorated with anthropomorphic or zoomorphic beings or four-foot-high partitions demarcated these more private areas (fig. 3.10). The

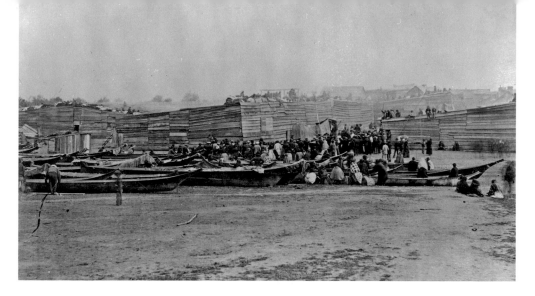

3.9  Shed-roofed Songhees houses during potlatch, 1874.

*Royal British Columbia Museum, PN6810. Photo: R. Maynard.*

The Salish distinguished between feasts and potlatches. Feasts were held indoors at any time of year, whereas potlatches typically occurred outside in good weather. During the gift distribution, men would throw the blankets from the rooftops to the guests. At the event shown in the photograph, Chief Sqwameyuqs was about to give canoes to visiting chiefs—note the Salish-style canoes (see fig. 1.8) lined up on the beach.

Central Coast Salish traveled in canoes that, because the waters of this region are quite gentle, tended to be elegant and low, and characterized by a split bow.

Central Coast Salish men carved house posts, grave monuments, masks, and ritual paraphernalia such as rattles, and women crafted woven robes, some plain, some elaborately colored. According to Wayne Suttles, such artworks are connected to the four important sources of power: the vision, the ritual word, the ancestors, and wealth. The vision signified an individual's special relationship with a guardian spirit, the nature of which he or she kept quite secret. The ritual word lay at the heart of various activities, such as cleansing rites, and could be inherited. The ancestors had always been present on earth, or had descended from the heavens at some distant times. Some of the ritual words and ritual paraphernalia were given by these ancestors to certain families who maintained the privilege to own them. Wealth resulted from and reflected the

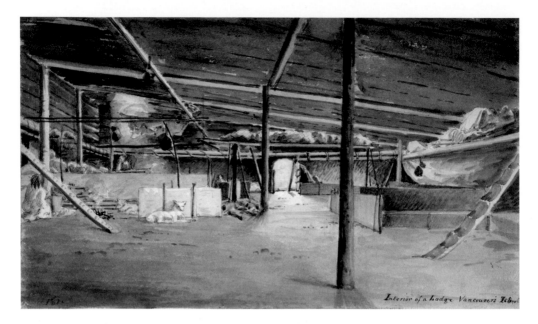

3.10  Paul Kane. Interior of a Klallam lodge, Strait of Juan de Fuca,
c. 1846–47. *Watercolor on paper.*
*Stark Museum of Art, Orange, Texas, 31.78/80 WWC 81.*

Artist Paul Kane traveled to the Northwest and recorded much that he saw during his
journey with watercolors such as this one. Later, he used some of the watercolors
as the basis for oil paintings, such as the one reproduced here as figure 3.1.
Because he sometimes creatively juxtaposed images from several sketches in the
same oil painting, these field-drawn originals are considered more accurate. This
house, which appears to be eighty to ninety feet wide, with house posts placed
at twenty- to thirty-foot intervals, was said by Kane to hold eight to ten families.
The walls of these houses were lined with cattail or tule mats that provided a
weather-tightness not possible with only the loose wall boards. See figure 1.7
for a drawing of the exterior and internal structure of the Coast Salish house.

other three sources of power. These sources of power were not flagrantly
displayed, and were most of the time kept covered, to be ceremonially
unveiled only during potlatches.

Laypeople and shamans both had visions and supernatural helpers,
with the shamans receiving special powers to heal. During the winter,
people with spirit songs performed spirit dances for hours, often before
large audiences. The dancers had different categories of songs, identified
by distinct regalia, actions, and clothing. Some, for example, danced with
knives that pierced their chests, some animated objects like spirit boards,

and others wore shirts similar to those of warriors. The words these dancers sang suggested the nature of their vision but were never explicit.

The Salish believed that at times of uncertainty or danger, particularly during life crises such as birth, puberty, marriage, and death, an individual became especially vulnerable to illness and malicious magic. Dietary restrictions, observation of taboos, and bathing helped protect that person. Sometimes specialists were engaged who had inherited the right to express the ritual words and manipulate various art objects that could "cleanse" people. A cleansing event usually included speeches, the actual cleansing ritual, and the remuneration (with gifts) of guests for having been witnesses. Facilitating such cleansing activities were rattles made from sheets of mountain-sheep horn bent and then sewn to form volumetric triangles originally adorned with strands of mountain-goat wool (fig. 3.11). In the rattle reproduced here, a central frontal face is framed by symmetrically positioned profile birds whose feathers intersect under the face's chin. We have no information on the meaning of these and other images incised onto rattles.

These rattles also effectively evoked guardian spirit–dancer interactions. A Musqueam shaman who owned four such instruments explained how she used them when trying to inspire new dancers to sing their songs and see their guardian spirits. She first painted images on the initiate's body while reciting the appropriate ritual words. If that did not prompt a song, she placed red ochre on her rattle that had a face carved on it, and "stamped" the visage on the initiate. This would inevitably provoke a song.

The performance of masked *sxwayxwey* dancers was an important component of the purification ritual (fig. 3.12). Masked dancers—who had to have the inherited right to the mask—performed to the accompaniment of a special song sung by a group of women, and stroked the individual to be cleansed with red cedar boughs. Their masks with protruding cylindrical eyeballs, "horns" of animal heads, and long, drooping tongues were made in a variety of types such as Raven, Sawbill, Ghost, and Snake. Each type had slightly different accouterments, such as the merganser head that formed the Sawbill's nose or the snake bodies undulating on each side of the Snake mask. Large feathers (and in later years Chinese feather dusters) were often used to form a dynamic crown on these masks,

3.11 Halkomelem. Rattle, c. 1860.

*Mountain-sheep horn, yew, sinew, buttons. 14 x 6.5 in.*

*Seattle Art Museum, Gift of John H. Hauberg, 83.236. Photo: Paul Macapia.*

This type of rattle has an ancient history among Coast Salish groups. Its is formed by sheep horn that has been boiled and folded into the characteristic bulbous, three-sided rattle. Its incisions and complex surface decoration are typical of the southern two-dimensional style. By incising the horn with trigons, crescents, and circles, and thus forming a pattern of negative spaces, the artist portrayed a central anthropomorphic spirit face flanked by two inward-facing profile birds.

3.12 Songhees *sxwayxwey* dancers, 1895.

*Royal British Columbia Museum, PN 6492-B. Photo: B. Edward James Eyres.*

This photograph was taken on May 27, 1895, during the potlatch held by Ches-lum George to honor his late wife and his two daughters. The *sxwayxwey* dance is a privilege possessed by certain families and is used in purifying rituals. It is noteworthy that this highly public event, with many non-Native spectators, occurred during the time when the potlatch was banned in British Columbia (see pp. 174–75). At that time, the ban was not as seriously enforced as it would be in later years. The openness of this ceremony contrasts with contemporary *sxwayxwey* dances, which today take place indoors and in private, with non-Native observers present only by invitation.

which always were worn along with a special costume that featured a biblike collar, feathers attached to clothing and leggings, and hoof rattles suspended from the ankles. The dancers, each of whom held in his hand a shell rattle, usually appeared in groups of four or six, and performed by taking high, short steps, raising the right arm with the right leg, and the left arm with the left leg. Box drums were sometimes beaten as accompaniments. Interestingly, the *sxwayxwey* mask does not appear to represent any particular being, and probably served not so much as the impersonation of a specific being as a vehicle for the appearance of

purificatory feathers and patterns that enhanced the efficacy of the ritual words spoken during the rituals.

It was believed that after death, a person's soul remained in the vicinity of the village and needed food and clothing, which its descendants provided by burning these articles. Carved ancestor figures, some depicting named individuals, some portraying distant relatives, embodied the power and importance of the deceased, and in some cases were believed to actually hold the soul of the ancestor. Cleansing was another theme of some funerary sculptures of the elite, as the cleansing privilege was possessed and used exclusively by high-ranking families. Mustelids, the group of animals that includes minks, otters, weasels, and fishers, were associated with cleansing, as when their stuffed skins were drawn over the bodies of pubescent girls, or up and down posts that represented deceased individuals. In figure 3.13, an 1859 painting of a Songhees grave, a chief kneels on the left while on the right an individual performs purification rites with minklike animals. A Songhees house post (fig. 3.14) presents the same concept indoors.

## Women's Art

Women's art played a significant role among the Central Coast Salish. Only the most prominent families could use the especially prized mountain-goat wool that was associated with purification. Mountain-goat wool was not the only material used for weaving—it has been said that smallish dogs that resembled Pomeranians and had thick white coats were specially bred for their wool. These dogs were apparently quite numerous; in 1828, the author of a journal written at the Hudson's Bay Company's Fort Langley commented that he saw 160 canoes, each holding a family and "generally about half a dozen dogs more resembling Cheviot Lambs shorn of their wool."[2] This line of dogs apparently became extinct by the mid-nineteenth century, when commercial sheep's wool became readily available.

When preparing to make a robe, the weaver first cleaned the wool and removed excess oil by beating it with diatomaceous earth, then shaking out the earth on a mat. She twisted loose strands of this wool between her palm and thigh to form a loose ball, which she then spun on a spindle made up of a four-foot-long rod and a large wooden whorl that could be

3.13 Central Coast Salish grave, Songhees, Victoria Harbour,
by Montague William Tyrwhitt-Drake, 1859. *Watercolor.*
© *The Trustees of the British Museum.*

The Songhees interred their elite at various sites in Victoria Harbour that included
both burial houses and carved figures such as the ones depicted here. Funerary
sculptures could be portraits of the deceased or depictions of the acquisition of
powers from animals. This grave seems to have both types, for the carving at the
left appears to be a portrait, and the right statue shows an individual with two
minklike animals on his chest. According to the *Victoria Gazette* of October 15, 1858,
one such grave held the remains of two great warriors and two renowned hunters.

up to 8 inches in diameter (fig. 3.15). The loom upon which she actually
wove the textile consisted of two upright bars to which were attached two
horizontal rollers (fig. 3.16). The weaver twilled or twined the wool on
this loom into blankets of various sizes up to 12 feet long. Although the
smaller textiles were often functional, many larger robes served as indica-
tors of wealth.

It appears that textiles have been treasured for centuries. A twill-woven
white blanket with dark blue plaid stripes was excavated in Ozette. An
early example of the plain blanket, possibly collected by Captain Cook
in 1778 in Nootka Sound and perhaps made by Salish weavers, is shown
in figure 1.15. White textiles, either plain or decorated with simple lines,
were made throughout the historical period, but twined textiles could

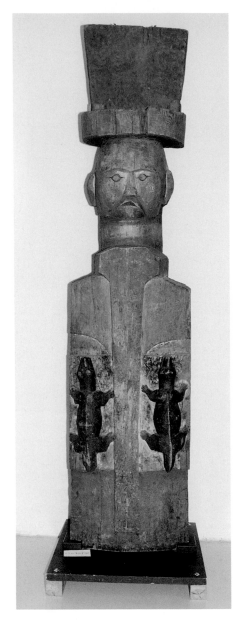

3.14  Songhees. House post, 19th century. *Cedar. 7 in.*

*Courtesy National Museum of the American Indian, Smithsonian Institution, 2/5904.*

*Photo: NMAI Photo Services staff.*

Central Coast Salish house posts sometimes stood as the central poles within the house, but could also line the walls. Anthropomorphic images such as this could depict ancestors, guardian spirits, or cleansing devices. Owners of such artworks were usually reluctant to explain in detail the meanings of their imagery, because sources and illustrations of power were meant to be private.

3.15  Paul Kane. Songhees woman spinning wool, 1847. *Watercolor.*
*Stark Museum of Art, Orange, Texas, 31.78/96, WWC97.*

To process raw wool, the weaver cleaned and loosely spun it by rolling fibers along her thigh, forming what is known as the roving, seen in this painting in the lower-left corner. Then she attached the end of the roving to the whorl on her spindle. As she spun the whorl, wool was pulled with tension to create finished yarn. Among the Salish, the process of transforming mountain-goat wool into a complete textile had a spiritual dimension related to the process of purification. As she spun, the weaver perhaps recited ritual words either to the wool itself or to the spindle whorl.

also be vividly colored, such as the robe shown in figure 3.17, made in the early nineteenth century. This example of fine weaving in wool and some vegetable fibers, perhaps of stinging nettle, has as its central focus a bold rectangle with broad horizontal bands of cream and tan containing thin dark lines. To the left and right are bold zigzags of the same colors, flanked by thin vertical bars. Above and below the zigzags are horizontal bands composed of zigzags, waves, and bright diagonals. Although quite different in spirit and form, this kind of formal geometric decoration on

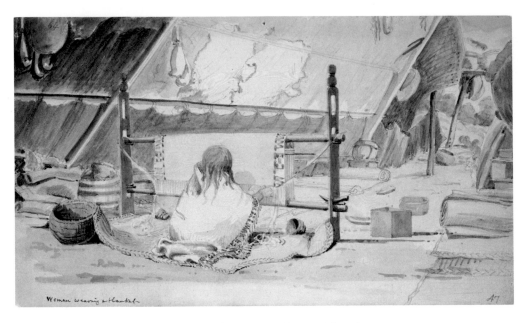

3.16   Paul Kane. Saanich woman weaving, 1847. *Watercolor.*

*Stark Museum of Art, Orange, Texas, 31.27/73, WWC73.*

This woman is twining a robe, possibly of dog hair mixed with mountain-goat
wool. The location of this activity is possibly a temporary summer house,
constructed of poles and mats, with boxes, baskets, and rolled mats on the floor.
After the weaver dyed the wool, she began to weave at her loom, which consisted
of two upright posts and two horizontal bars. She first tied the warp thread onto
the horizontal bars, then with her fingers either twilled or twined the weft around
the warp. On the right-hand side of the painting a small dog peers out from
behind rolled mats.

early Salish weavings bears some relationship to the Tlingit "raven's tail"
textiles also made during the early years of contact.

Salish weaving changed somewhat by the mid-nineteenth century. An
early example of the new style (fig. 3.18) also contains a central rectilinear
panel, but with a vivid pattern of radiating stepped lozenges. This panel
appears almost to "float" upon a background of zigzags composed them-
selves of small, bright triangles. Here the weaver has expertly balanced
all these brightly colored geometric forms into a vivid visual experi-
ence that nonetheless remains balanced. Although this type of weaving
superficially resembles Navajo "eyedazzler" blankets, these predate those

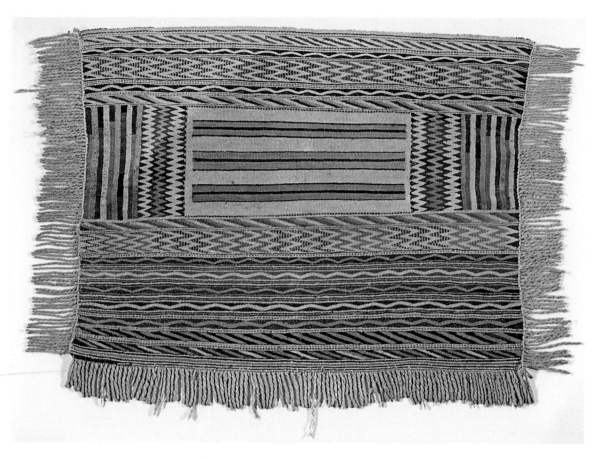

3.17  Central Coast Salish. Robe, early 19th century.

*Mountain-goat wool, vegetable fibers, pigment. 50 x 62 in.; fringe 7 in.*

*National Museum of Natural History, Smithsonian Institution, 2124.*

This is the classic type of Salish robe, characterized by a horizontal design, and wider than it is long. The wool of which this robe was woven is from mountain goats that live on high, rocky cliffs in places that sometimes appear impossible to get to. Sometimes these animals were hunted for meat and their wool given to the weavers, other times the wool was collected from the beds that females filled with their soft hair and used for birthing kids. Sometimes the tufts of their shed winter coats were collected from bushes above the timberline.

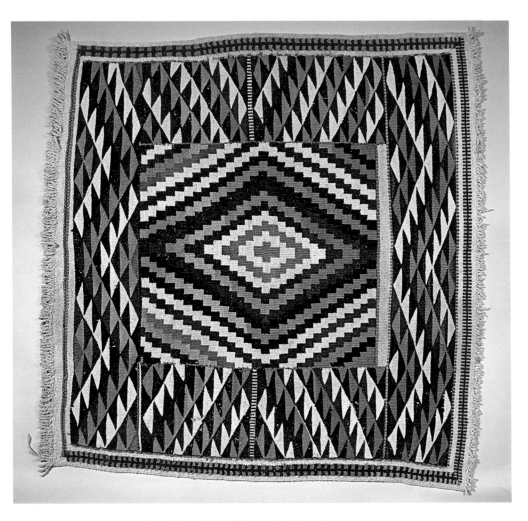

3.18   Central Coast Salish. Robe, early 19th century.

*Mountain-goat wool, pigment. 60.5 x 60.5 in.*

*National Museum of Natural History, Smithsonian Institution, 1891.*

This fine example of Colonial-style twined Salish weaving was collected in 1841 on the first United States Exploring Expedition that was led by Lt. Charles Wilkes, with the goal of surveying the coast and exploring the interior of what is now western Washington. Colonial-style textiles are characterized by a focus on the center, and a more square shape than the classic type. This robe's central panel consists of concentric stepped lozenges arranged along a horizontal central line. The outer portion, however, consists of vertically positioned zigzags, each composed of contrasting colors in a small zigzag design. In order to view the outer portion horizontally, one must turn the blanket ninety degrees. This adds even more vibrancy and movement to an already vivid textile.

southwestern textiles by twenty years, and no reasonable connection can be made between the two types.

Like so much else in Salish society, weaving had spiritual dimensions. Unlike the typically unadorned tools used by men, many objects used by women in the processing of wool—mat creasers, spindle whorls, implements for beating wool, and the poles of looms—were often decorated. For example, some loom-poles contained anthropomorphic or zoomorphic figures perched at their tops (fig. 3.19). Combs used during the process of preparing the wool or to push the wefts during the weaving process also bore images. Some of the most elaborately decorated objects used by the Central Coast Salish are spindle whorls, circular pieces on which enigmatic beings are depicted (fig. 3.20). As befits an item that whirled about, most whorls could be read from either top or bottom.

Although the actual meaning of the being shown in figure 3.20 and other spindle-whorl illustrations is unknown, Wayne Suttles suggests that such artistic embellishment of a functional object might have been connected to a practice during which the woman recited ritual words as purifying agents while spinning and weaving. Another possibility is that the very material the woman wove—mountain-goat wool—might have signified purification and, as such, required the presence of visual embellishments. The importance of weaving in the spiritual as well as economic lives of the Salish provides vivid evidence of the subtle power of women. Although the designs they wove onto their textiles did not have narrative "meaning," they did, like so many other examples of women's art, communicate in abstract form certain highly valued cultural concepts. This is perhaps one explanation for the esteem in which fine weavers were held, and the importance to a girl's education of learning how to weave well.

## NORTHERN COAST SALISH

THE NORTHERN COAST SALISH, who include the Sechelt, Pentlatch, and Comox, live on Vancouver Island and the mainland north of the Central Coast Salish, as far north as lower Johnstone Strait. Members of these groups constructed shed- and gable-roofed houses with planks that could be moved from winter to summer structures. The elite of the northernmost

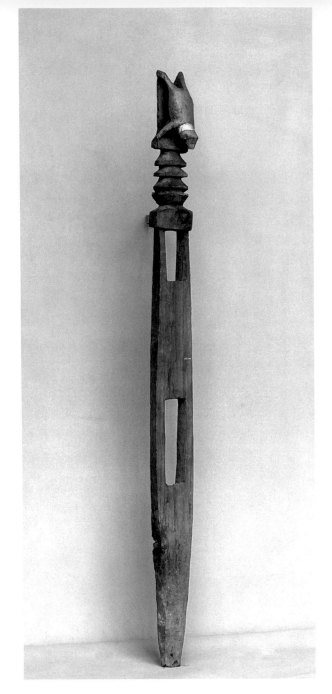

3.19  Central Coast Salish. Loom post, 19th century. *Cedar. 65 in.*

© *Field Museum, #A90949.*

This post, which would have stood vertically with another similar piece to hold the
horizontal bars of a loom (see fig. 3.16), has a simplicity and directness found in
the work of some of the Salish groups farther south. Although the downward-
facing animal is not identified, the sacred aspects of weaving and wool make it
possible that it is a mink or minklike creature.

3.20 Central Coast Salish, Halkomelem Chemainus. Spindle whorls,
19th century. *Wood.* Left, *D. 8.75 in.*; right, *D. 7.25 in.*
*Brooklyn Museum, 05.588.7382; 05.588.7383.*

These decorated whorls were mounted onto spindles, wooden shafts
approximately 2.5 feet long. Weavers spun their wool with these implements, as
is seen in figure 3.15. Although many Salish spindle whorls are plain, others, like
these, are completely covered with incised designs. The example on the left depicts
an open-mouthed anthropomorphic figure with bent arms squatting beneath two
animals whose face-to-face profiles create a frontal image of yet another animal.
On the right is a whorl covered with images of whales. The artist carved out
crescents, trigons, and u-forms to depict these beings. The imagery reflects the use
of these whorls—on both pieces, some component images are upside down, such
as the profile heads on the anthropomorphic piece, and two of the fish; when the
whorls spin, these images turn right-side up.

of these groups, the Comox and Pentlatch, were influenced by their Wakashan neighbors, and often preferred gable-roofed structures such as those found among the Kwakwaka'wakw. Poorer people lived in shed-roofed structures. With as many as eight posts to support the roof, and excavated central house pits, these structures were costly to build because of the labor needed to excavate the floor.

Unlike the groups to the south, the Comox and Pentlatch depicted family privileges in architecture and architectural decoration, and claimed more crests than other Salish peoples. Like similar carvings from farther north, those of the Comox were inherited treasures, sometimes brought into families through marriage, and unconnected to the guardian spirits so central to Salish culture farther south. Unlike the kind of personal spirit possession that occurred during Salish spirit dancing, performances among northern Salish groups presented inherited privileges that embodied social status. Some of these dramatized possession by spirits, but these were public proclamations of prestige rather than individual private experiences. House posts and house fronts sometimes depicted anthropomorphic beings that may have been inherited privileges, images from dreams, or even purchased. In front of a gable-roofed plank house in Comox, photographed in 1866 (fig. 3.21), stands a large carved figure, frowning and crouching tensely. Unlike the immediacy of spiritual power of the more southern Salish images, carvings such as this one integrate the supernatural power with social significance.

Potlatches were hosted for weddings, name-givings, and erecting memorial poles. Some pole raisings included presentations of dancing privileges, the most prestigious of which was the *sxwayxwey*, performed only by certain families. Owning and performing another type of mask, the *Tal*, which depicts a giant ogress who eats children, is a privilege inherited or purchased by certain families. These appeared at funerary rituals such as those of the mainland Comox, where the privilege was transferred from the deceased to his heir. These masks were placed on effigies of the deceased, while a master singer hired for the occasion sang mourning songs along with a chorus. After the bereaved family, who had sat apart during the singing, distributed goods to those present, the songs became livelier, as the guests began performing humorous dances intended to amuse the host family and encourage them to forget their loss.

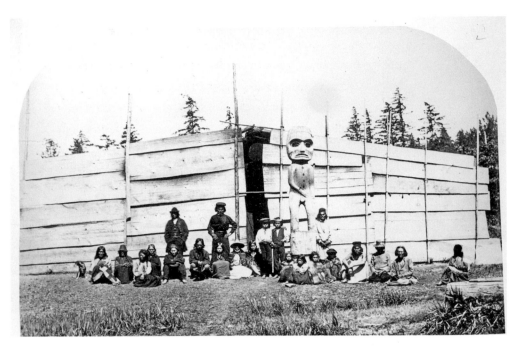

3.21  Comox house, 1866.

*British Columbia Archives, C-09265. Photo: F. Dalley.*

This gable-roofed house was constructed by tying large cedar planks between two pairs of upright poles. This facilitated their removal when the families traveled during the summer to subsistence camps and used the same planks to create temporary shelters. The carved figure is closer in style to the northern neighbors of the Comox, the Kwakwaka'wakw, than to their southern Salish relatives, and conveyed social standing more than supernatural powers.

## COAST SALISH ART

COAST SALISH ART differs considerably from that of the central and northern regions. It tends to be minimalist, and, with the exception of the distinct Central Coast Salish two-dimensional work, is more straight-forward and simple. The type of art made historically by the Coast Salish doubtless resembles the archaic style once more widespread across the entire Northwest Coast. In addition to its simplicity, Salish art differs in other significant ways from the art of more northern groups. Unlike the coastal groups farther north who felt that the more artworks the better, most Salish believed that overexposure of spirit images might dilute the

powers of the beings they represented, and thus produced fewer pieces of art. Moreover, because it was governed by rules of great secrecy, Salish art often remains enigmatic in meaning. The exceptions are the transitional Northern Coast Salish groups, who used art to demonstrate the privileges of an inherited elite, much as their neighbors, the Wakashan groups, did.

The simplicity, antiquity, limited quantity, and sometimes impenetrable iconography of Salish art have led some to dismiss it as uninteresting and deficient, or, at the very least, as an inferior ancestor of the more spectacular and highly decorated northern and Wakashan styles. This could not be more wrong. Salish art, like that of the other Northwest Coast groups, responds to social needs for which the archaic style was well suited. The Salish, whose leaders enjoyed more subtle power than chiefs of the north, did not indulge in the kind of aggressive clan promotion that inspired lavish displays of crest art. The special spirit knowledge possessed by individuals could not be publicly expressed, so any representation had to be somewhat obscure. And with such constraints against explicit expression, little demand for multiple artworks existed. Salish art cannot be judged according to alien values appropriate to other Northwest Coast groups, but, like most kinds of art, must be understood as visual statements meaningful and valuable to their creators.

NINETEENTH-CENTURY
CENTRAL REGION ART

THE CENTRAL REGION of the Northwest Coast encompasses western and northeastern Vancouver Island and the mainland from Discovery Passage to Douglas Channel. Most inhabitants speak Wakashan languages, although one group is Salish-speaking. The Wakashan language family can be divided into the northern group—Haisla, Heiltsuk, and Oweekeno—and the southern group—Kwakwaka'wakw, Nuu-chah-nulth, and Makah. The northern Wakashan, especially the Haisla and the Heiltsuk, represent transitional cultures between the three northern matrilineal tribes and the less formally structured southern Wakashan. The Nuxalk are a group of Salish speakers who have absorbed various elements of Wakashan culture from their surrounding neighbors.

Throughout the central region, a major inherited privilege was membership in one or more ranked dancing societies. Individuals were initiated into these societies during dramatic performances that

reenacted the encounter of an ancestor with a supernatural being, and theatrically recreated his original spirit possession, often using masks and providing music by means of singing, drums, and wooden batons beaten on log drums. Masks, costumes, regalia, musical instruments, and other visual enhancements contributed to the drama and dynamism of dancing society performances. The theme of direct interaction with a supernatural resonates with the Salish guardian-spirit experience. However, unlike the southern and more like the northern groups, the rituals and art of these dancing societies communicate the power and prestige of the elite, and are, in their flamboyance, decidedly public.

### CENTRAL REGION CARVING AND PAINTING STYLES

LATE-PRECONTACT Wakashan art was characterized by volumetric, relatively unadorned sculpture such as the Kwakwaka'wakw house post, dated to about 1800, shown in figure 4.1. By the early nineteenth century, this archaic style had become more painterly, and artists generated an impressive body of work that includes some of the most flamboyant, dramatic, intense sculptures in North America. Although some naturalistic Heiltsuk masks bear a resemblance to those of the Tsimshian, most carving from the central region effectively utilizes the sculptural possibilities of wood. The Kwakwaka'wakw make masks of bold three-dimensionality, with planes separated by crisp transitions, often amplified by energetic, bright painting (see fig. 1.5). Sculptural orbs of the eyes meet the brows and cheeks sharply, and lips tend to be clearly demarcated continuous bands. Nuxalk masks (fig. 4.2) share the strong three-dimensionality of their southern neighbors, but have a characteristic bulbous quality, with flaring nostrils and a conical mouth with lips that, unlike those of the Kwakwaka'wakw, are tapered at the corners; they also typically make extensive use of blue paint. A good number of central region masks have moving parts, such as beaks that snap or fins that wave. Some even depict more than one being. The Nuu-chah-nulth have several varieties of masks, most of which do not share the volumetric qualities of objects from farther north. One type, for example, is composed of two planes that meet in a sharp ridge down the center. Often the two sides are painted with different images (fig. 4.3). Another type is the headdress assembled

4.1 Kwakwaka'wakw. House post, Koskimo, c. 1800. *Red cedar. 72 x 26 x 12 in.*

*Seattle Art Museum, Gift of John H. Hauberg, 83.242. Photo: Paul Macapia.*

Early Kwakwaka'wakw sculpture such as this carving exhibits strong, bold
forms often decorated with thin repeated ridges. This is characteristic of the old
Wakashan style that was typical of Kwakwaka'wakw and Nuu-chah-nulth sculpture
in prehistoric and early-contact times. The deep-set spherical eyes of the principal
being contrast with the pinched-corner eyes of the small anthropomorphic figure
it holds, possibly indicating the difference between human and other worlds. The
original had more carvings above the principal figure that were sawed off, perhaps
because they had decayed.

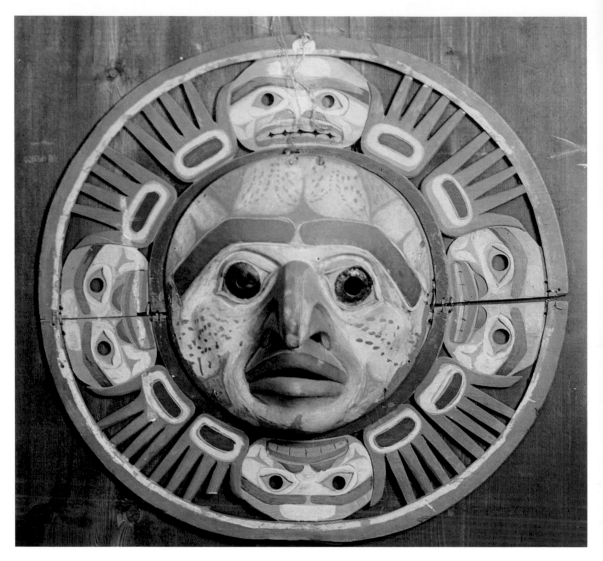

4.2  Nuxalk. Sun mask, c. 1870. *Wood, pigment. D. 24.75 in.*

*American Museum of Natural History Library, 16/1507.*

The "rays" of the sun are formed by the upraised hands of the four small beings who surround it. These are the four supernatural carpenters who arranged the world and gave humans culture. Masks such as this were presented during dramatizations of the major deity who guides the sun on its daily journey. Sometimes these were not worn but instead moved via mechanical means to "rise" and "set" within the house.

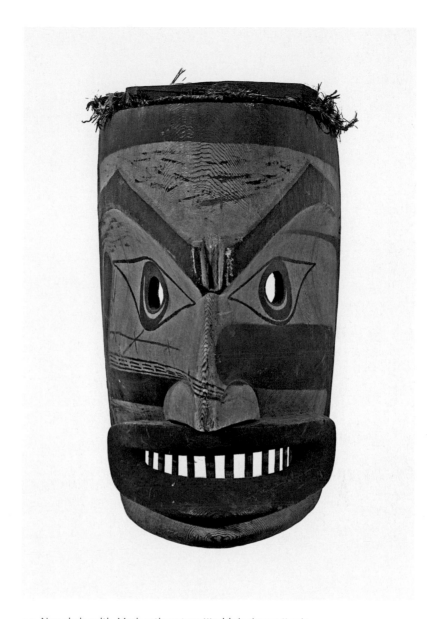

4.3  Nuu-chah-nulth. Mask, 19th century. *Wood, hair, pigment. H. 12 in.*

*National Museum of Natural History, Smithsonian Institution, 30210.*

Masks of this type are formed of two intersecting planes that meet along a sharp
middle line. Within the limitations of this prism shape, artists had freedom to
be creative in their rendering of facial features such as brows, eyes, and mouth,
and in painting the masks. The artist painted this piece with different designs on
either side, allowing the dancer to present different beings to his audience when
he moved his head from side to side. James Swan collected this mask when he was
acquiring objects for the 1876 Centennial Exposition.

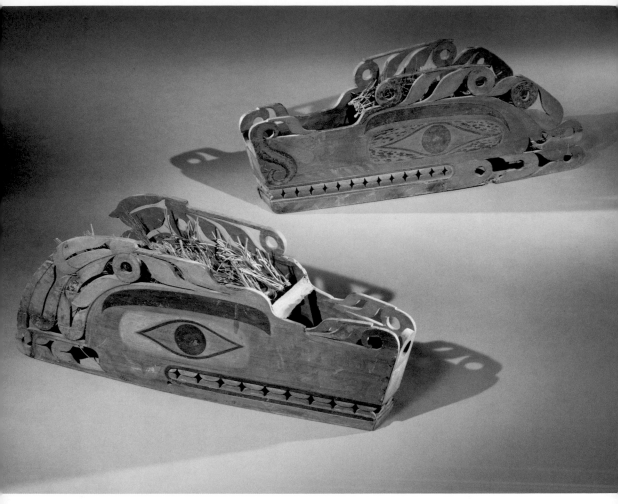

4.4 Nuu-chah-nulth. Pair of Lightning Serpent headdresses, 19th century.

*Cedar, cedar bark, cotton, cloth, iron nails.*

*Left, 16 x 8.5 x 10 in.; right, 25.75 x 9 x 9.75 in.*

*Brooklyn Museum, 08.491.8905a, b.*

During the multiday Wolf Ritual, dancers performed wearing headdresses such
as these, which always came as a pair. These were worn atop the head, facing
slightly upward. As is the case with the mask in figure 4.3, these also have different
paintings on their two sides, which the dancer reveals as he sweeps his head from
side to side. The right to any specific image or being is a family's privilege and
can only be used by them. These masks constitute a depiction of the Lightning
Serpent that often appears near the Thunderbird, and is sometimes called the
Thunderbird's harpoon. The two masks represent a male and female, the female
being the smaller of the two, with a shorter eyelid shape and a different eyebrow.

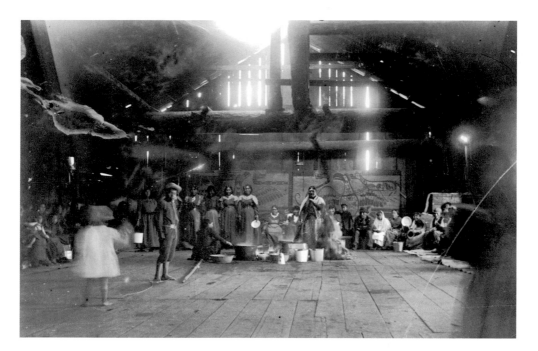

4.5   Nuu-chah-nulth. House interior, late 19th to early 20th century.
*Vancouver Public Library, 9287.*

Painted boards such as these were displayed inside houses as evidence of the
chief's history and privileges. An exceptionally important ceremony at which the
boards served as powerful presences was the coming-of-age ceremony of a young
woman, which indicated her readiness to enter into marriage.

from flat pieces of wood, which is also decorated with abstract geometric
designs (fig. 4.4).

Some Wakashan two-dimensional art of the nineteenth century
contains elements of the northern formline, whereas other pieces
show little evidence of such influence. More narrative paintings of the
Nuu-chah-nulth consist of elements arranged in a bold, unconstrained
manner; in effect the artists have translated the tight, controlled formline
style of the north into a unique and distinctive two-dimensional style, one
less subject to the precise rules that govern northern-style work. Examples
include a Nuu-chah-nulth house interior (fig. 4.5) and a screen that
depicts a thunderbird, with outstretched wings and decorative elements
on its neck and torso, grasping a whale and flanked by a lightning snake
and a supernatural wolf (fig. 4.6). The artist shows the chest and legs of

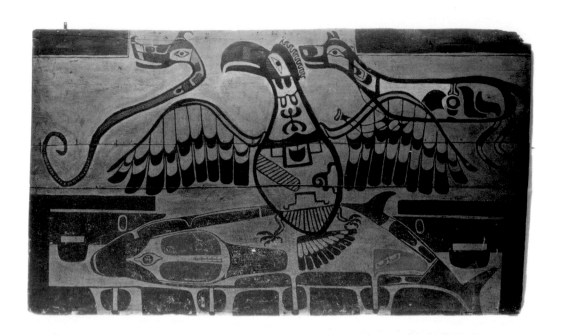

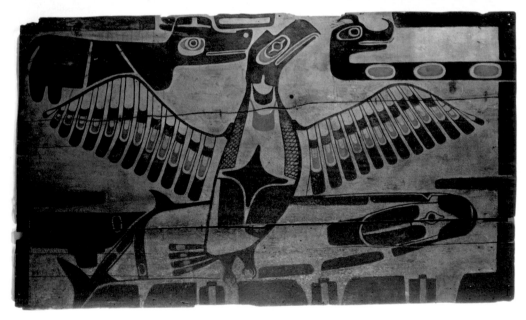

4.6  Nuu-chah-nulth. Screen, mid-19th century. *Red cedar, pigment. 114 x 68 in.*
*American Museum of Natural History Library, 16.1/1892.*

Although these paintings allude in some parts to northern formline style, the
artist, like his Nuu-chah-nulth colleagues, is comparatively less bound to tradition
and thus willing to experiment with line and form. This image demonstrates the
centrality of whales to the Nuu-chah-nulth, who, along with their relatives the
Makah, hunted whales. Some histories relate that the Thunderbird taught humans
how to make and use harpoons, thus the large and dramatic presence of that bird
and its physical connection to the whale. The Lightning Serpent appears in the
upper corners opposite the wolves.

the wolf, presumably "through" the thunderbird's wings. Present in this painting are the ovoids, u-forms, and formline-like outlines that allude to the northern style, but which do not together constitute its characteristic complete system. Kwakwa̱ka'wakw two-dimensional painting, such as in a housefront painting from Gilford Island (fig. 4.7), tends to be somewhat bolder and less restricted to the formality of an uninterrupted formline, but compared to Nuu-chah-nulth examples it is more symmetrical and organized.

Some Haisla and Heiltsuk art adheres more closely to the formline canons of the north than to the more colorful and less formal style of their linguistic siblings. In the early nineteenth century, the Heiltsuk lived in a number of independent villages, but after the 1862 smallpox epidemic, many survivors moved to Bella Bella, or Waglisla, near the Hudson's Bay Company's now-defunct Fort McLoughlin. Waglisla became known, especially between 1860 and 1880, for the quality of its distinctive painted bentwood boxes, which the Heiltsuk (who were also known as the Bella Bella after the town) traded up and down the coast. These developed out of earlier boxes with archaic, broader formlines and a relative simplicity that resulted from a large expanse of negative space. Characteristic of "Bella Bella boxes" are thin formlines, copious surface imagery, small ovoids positioned nonconcentrically within larger ones, both cross- and uni-directional hatching, and the use of an intense blue. An especially well-known Heiltsuk artist was Captain Carpenter (1848–1931; see fig. 4.8).

## HAISLA, HEILTSUK, AND OWEEKENO

THE HAISLA, who live east of the southern Tsimshian, may have originated from a mixing of Tsimshian with some northern Wakashan people. With an exogamous clan system that originated among the Tsimshian, the Haisla resemble their northern Northwest Coast neighbors more than the other Wakashan groups. But, like their other northern Wakashan neighbors, they have an elaborate dance-society system. On the central British Columbia coast, the Heiltsuk have clans, but these are neither consistently exogamous nor matrilineal. The Oweekeno have the most fluid social organization, with inheritance going through either or both parents.

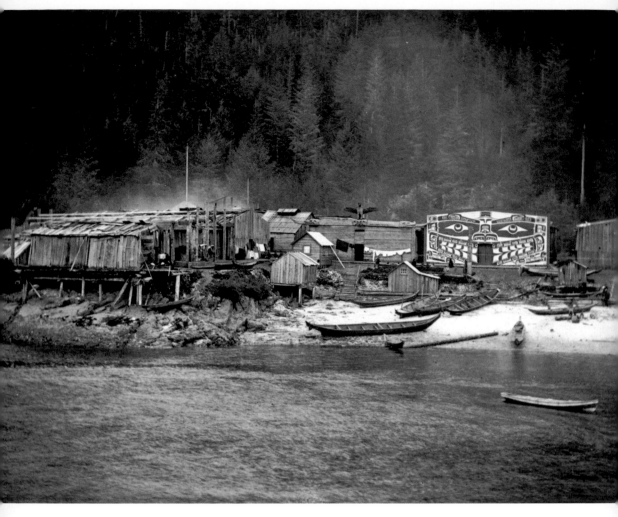

4.7 Kwakwaka'wakw. Facade of John Scow's Sea Monster house,
Gwa'yasdams (Gilford Island), ca. 1900.

*Royal British Columbia Museum, PN235. Photo: C. F. Newcombe.*

Kwakwaka'wakw painters were among the boldest and most expressive on the
coast. The artist who painted this facade used two-dimensional design elements
such as u-forms and ovoids, but did not unify the entire composition by using a
formline to connect its various components. The representation of a crest depicts
a huge face with a broad, smiling mouth. Anyone entering the structure would
appear to be "swallowed" up by the being, a symbolic act that would enhance
the prestige of the chief who appeared to be one with his family's legacy, but that
might have been somewhat difficult for rival chiefs to accept.

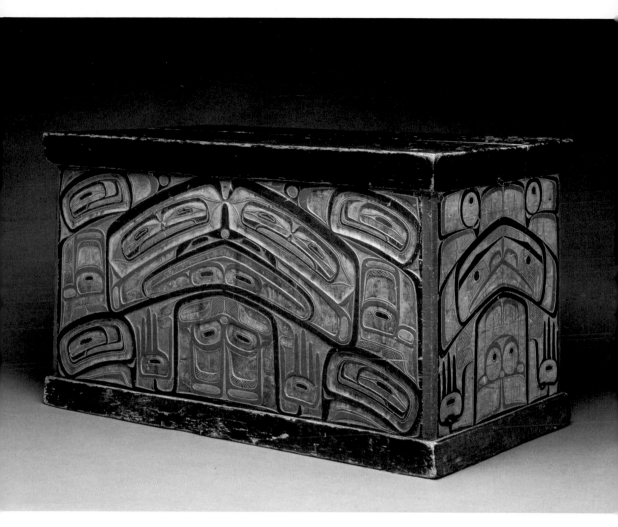

4.8   Heiltsuk. Box, probably made by Captain Carpenter, c. 1875.

*Yellow and red cedar, pigment. 21 x 36 x 20 in.*

Seattle Art Museum, Gift of John H. Hauberg and John and Grace Putnam, 86.278.

Photo: Paul Macapia.

With its delicate, thin formlines and use of intense blue pigment, this box typifies
the kind of work that originated around Waglisla (Bella Bella) and was traded
up and down the coast. The carver of this work was in most likelihood Captain
Carpenter, a well-known and distinguished artist. An elite member of the Blackfish
clan, Carpenter enjoyed the position of second-ranking chief of Waglisla, married
two women of high rank, and hosted several potlatches. Chests of this type held
clan treasures such as ceremonial regalia that were brought out only for major
ceremonies. The ends of 19th-century bentwood boxes were secured together with
pegs, rather than the earlier stitches.

The Heiltsuk developed impressive dancing societies. In 1834, a Hudson's Bay Company trader and physician, William Fraser Tolmie, visited a Heiltsuk village, where he had the memorable experience of attending a dramatic masquerade:

> A wall of painted boards reaching from the floor to the level of eaves extending from side to side and having a small door way in centre, formed a screen behind which the actors and artists prepared for the evening's entertainment.... In the outer apartment, a large fire had been kindled around which the savages were singing and dancing ... one [mask] resembled ... the Falco Leucocophalus [bald eagle] and beset with tail feathers of that bird radiating from its edge all around—it was called Tech te cheinny and seemed to be held in great reverence.... By pulling a string which the wearer can do with his mouth, two pieces of shining brass are made to pass from within over the eye, like the film of a bird's eye—a rude wooden horn was occasionally blown and was believed to be the voice of the Tech te cheinny.[1]

This is one of the earliest written descriptions of masks made with elements that move in order to more convincingly depict supernatural beings.

Summer and winter were distinctly different in terms of lifestyle and ceremonialism. Winter was the time for masquerades, and summer was the secular time for food acquisition. During the summer, families dispersed to temporary quarters near fishing streams or berrying grounds, where they conducted subsistence activities. In the fall, the various kin groups reunited in the permanent villages, and communal activities such as potlatches and dancing-society presentations began. Members of the societies inherited the privilege to perform certain masked dances, some of which became quite elaborate. Among the Heiltsuk there were two general types of dancing societies, the *Tseka* and the *Dluwulaxa*. These had complementary natures, with the *Tseka* having destructive and often violent elements, the *Dluwulaxa* performances being more restrained. In addition to the *Tseka* and *Dluwulaxa*, the Haisla and Heiltsuk also had the dog-eating society, in which the initiation ceremony involved eating a live

dog. The presentation of any of these privileges needed to be validated by distribution of wealth at a potlatch.

*Tseka* performances reenacted shamanic encounters with supernatural beings, but the dancers did not themselves interact with spirits as shamans did. The *Tseka* privilege is believed to have originated when an ancestor encountered a supernatural who granted him the rights to songs, dances, regalia, and masks; this is in keeping with the experiences of the guardian-spirit quester of the Salish. To be initiated into the society, a young person, most often a boy but sometimes a girl, acted as though the supernatural who had possessed the ancestor now possessed him. Some dramatic performances included the taming, through ritual, of the dancer, to eliminate from him the violence inspired by that supernatural. Although in earlier times active spirit possession may have been a central feature of these ceremonies, by the late nineteenth century, when anthropologists began studying the Northwest Coast groups, they had become theatrical events.

### THE HAMATSA

THE MOST PRESTIGIOUS dance of the Heiltsuk *Tseka* was the *hamatsa*, or cannibal dance. One version of the origin story of this privilege recounts the experiences of a group of hunters pursuing mountain goats. Despite their chief's warnings that they must avoid the house of Bakbakwalanuxsiwe, a great man-eating spirit who lives in the north, they went there anyway, and, at the invitation of a woman who offered to help them, entered the house. She advised them to dig a hole in the center of the house, fill it with hot stones, and sit in the corner. The monstrous Bakbakwalanuxsiwe, or Man-eater-at-the-north-end-of-the-world, entered, his body covered all over with mouths; then he ran around the room four times, crying "hap." Bird-attendants also danced around the fire. As Man-eater-at-the-north-end-of-the-world was dancing, he glanced upward rather than looking where he was going and, as a result, stepped into the pit of hot stones and died. The hunters learned the songs of the cannibal spirit from the woman and returned home with masks and other ritual regalia, which they displayed to their community. As a result of this encounter, their family obtained the privilege to perform the *hamatsa*.

Young men who had inherited the right to the *hamatsa* were initiated during elaborate ceremonials which concluded with the distribution of wealth, the acceptance of which on the part of the audience signified their validation of the family's right to display that privilege.

The first episode in the *hamatsa* initiation was the removal of the novice to the home of Man-eater-at-the-north-end-of-the-world, where he became possessed with cannibalistic cravings. In reality, the initiate was brought to a site outside the village to be educated in the history, songs, and dances of the *hamatsa*. When he returned to the village, he acted possessed by the desire for human flesh, and lunged at people, trying to bite them. Although attendants attempted to restrain him, sometimes he escaped their grip and actually appeared to sink his teeth into a member of the audience. (In actuality, the "victim" knew in advance that this would occur, and was later paid by the initiate's family.) In an action intended to pacify him, the initiate was presented with a corpse brought into the house upon which he dined. It is not clear whether human flesh was actually ingested during these ceremonies. In early times, that may have happened, but later, the "corpse" might have been a skinned bear (which looks strikingly like a human) with a highly naturalistic carving of a human head. Four masked dancers impersonated the birds, equally voracious for human flesh, who represented the avian attendants of Man-eater-at-the-north-end-of-the-world (fig. 4.9). By the conclusion of the performance, the initiate had calmed down and become reintegrated into the human group, a fitting end to an adventure into a unsafe place with dangerous beings that could, if allowed free rein, cause havoc to human society.

After the violence inherent in this and other *Tseka* performances, a different series of dances, which were performed in the late winter, contributed to the restoration of order and chiefly authority. Called *Dluwulaxa*, which translates as "Returned-from-heaven," these are based on the scenario of an ancestor being brought up to the heavens and then rejoining the human world. As with the *Tseka*, families inherited the rights to these dance privileges. A chief wishing to demonstrate a close association with their ancestors and spirits did so by performing dances during which he was said to be carried to heaven, or to be traveling around the world with a great supernatural. At the end of the performance, the

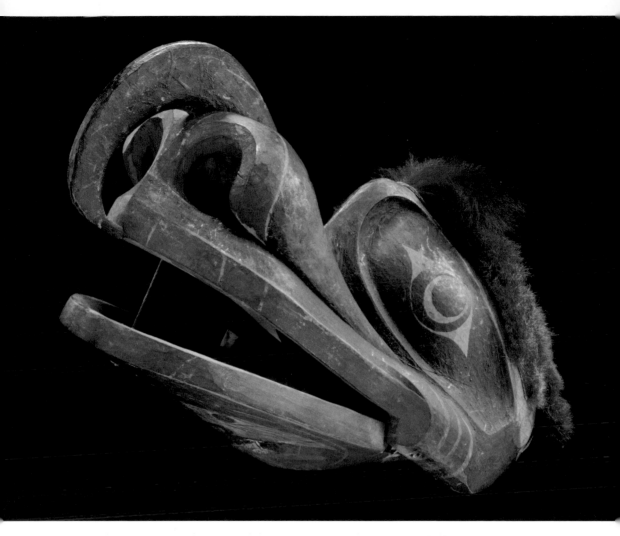

4.9 Heiltsuk. Cannibal bird mask, c. 1870.

*Wood, bear fur, cord, pigment. 28.25 x 22.75 x 54 in.*

American Museum of Natural History Library, 16/963.

The *hamatsa*, or cannibal dance, is one of the most dramatic and important Kwakwaka'wakw ceremonies. It did not, however, originate among that group but instead, among the Heiltsuk, from whom the Kwakwaka'wakw acquired the privilege. The Heiltsuk created a group of masks that represent the avian attendants of Bakbakwalanuxsiwe, the monstrous Man-eater-at-the-north-end of-the-world who is the center of the cannibal dance scenario. This powerful sculpture has a prominent curved appendage over the beak that could indicate this creature's great supernatural power. Its articulated beak can be snapped, creating not only a visual but also an aural experience for the observer.

dancer donned a northern-style headdress and shook a raven rattle such as those shown in figure 5.13.

## NUXALK

THE NUXALK (Bella Coola) speak a Salishan language and live in central British Columbia in the vicinity of the Bella Coola River, separated from the Pacific shoreline by Heiltsuk and Haisla lands. Nuxalk descent was traced through both maternal and paternal lines, and marriages could take place within or outside the descent group. Each family claimed an ancestor who had descended to earth, wearing a cloak of animal or bird skin, and bestowed names, prerogatives, food, tools, and ceremonial knowledge to the family. Some houses had false fronts that were taller than the actual building, and were painted with the animal form assumed by the family's ancestor when he came from the sky (fig. 4.10).

Unlike the other Northwest Coast groups, the Nuxalk conceptualized a relatively systematic cosmography inhabited by an array of supernatural beings. Their multilevel world consisted of the heavens, the earth—an island floating in the ocean—and the underworld. In heaven stood the House of Myths, in which lived the deities, including a supreme deity who, like Raven, had reconfigured the original universe into the form it has today. The supreme deity had also made four supernatural carpenters, whom he charged with creating the land, plants, animals, and humans. These four lived in an elevated room at the rear of the House and, in addition to successfully executing their assigned tasks, taught humans to carve, build houses, make canoes, paint, hunt, and fish. One of these carpenters was Yulatimot, "the one who finishes his work by rubbing once." Once humans were created, several were sent to Earth in animal form, carrying names and privileges and becoming the first ancestors of each extended family.

Of special importance to the Nuxalk was the sun, which three guardians accompanied on his daily walks across the sky. Humans prayed and made offerings to this deity. For hunting success, men tossed small bits of game meat into the fire. To cure a sick person, they burned parts of the patient's clothing. The sun appears on artworks such as masks, where it is depicted as a human face surrounded by a halo (see fig. 4.2).

4.10 Nuxalk village of Komkotes, 1873.

*British Columbia Archives, A-03980. Photo: Richard Maynard.*

Five houses in this photograph have painted facades in the Nuxalk style. In
the foreground is Israel Powell, the commissioner of Indian Affairs in British
Columbia, with members of his team. The commissioner and his group made
periodic "inspection" voyages to the villages, and often had their pictures taken
in poses such as this one. Usually a professional photographer accompanied the
commissioner's group on these tours in order to record their activities. Victoria
photographer Richard Maynard took this image using a glass-plate negative,
which still exists in the British Columbia Archives.

The mask can be attached to a mechanical device that causes it to appear near the roof on the back wall, then move from east to west across the house, and finally "set" by disappearing. When presented to the potlatch guests, this mask appeared to "rise and set" on four consecutive days.

Another deity, known as Lalaiail, initiated shamans and is depicted in masks as an otherworldly creature with an enormous projecting nose, a black face, and a ruff of bearskin. This individual wielded enormous power—when he jumped into a pond, its water boiled; he prompted women to menstruate and provoked nosebleeds in men; and he roused sexual desire in both humans and animals. The person wishing to become a shaman would seek out this being, who usually resided in the woods. When they met, the human fainted, then was revived, and received a song from the deity. Each subsequent year they met again, and the deity presented the shaman with new songs.

The Nuxalk credit the Heiltsuk for many of their ceremonies. Their two dancing societies, the *Sisaok* and the *Kusiut*, resemble the *Dluwulaxa* and *Tseka* of the Heiltsuk. The *Sisaok* was restricted in membership to certain elite families. Initiates spent two weeks to four months in seclusion, where they learned important information about their lineage and participated in the composition of two new songs based on their history. The actual initiation took place before an audience and included a display of masked figures depicting family crests. Then the initiate appeared, wearing a robe, neckrings made of shredded cedar bark, and a frontlet with a crown of sea-lion whiskers. When he danced to the rhythm of a raven rattle, swan's down contained within his crown floated down to the ground. Families had received the privileges to wear these masks and perform these dances in the mythic past, but at each presentation they needed to validate their appearance with a potlatch. Thus, the presentation of *Sisaok* masks was always accompanied by the distribution of a considerable amount of wealth, which reinforced the elite nature of the society.

From November to March the *Kusiut* society sponsored dramatic performances representing supernatural powers, similar to the Heiltsuk *Tseka* series. It was believed that in September, a supernatural canoe left the world of the Salmon people and paddled to the village. Other supernaturals joined in and performed *Kusiut* dances as they awaited the

society's leader, the supreme deity. An especially important being was the female spirit who guarded the deposits of power where *Kusiut* names were held. The human dancers who impersonated these beings devoted considerable time and energy to reinforcing the belief among non-initiates that these spirit beings were really present in the community. *Kusiut* initiates had their faces blackened, and wore rings of shredded cedar bark dyed red on their heads and around their necks, ankles, and wrists. They first visited the secret place where *Kusiut* names were stored, and traveled back to their village on a platform supported by two canoes, surrounded by already-initiated dancers. On the fourth day, an elaborate masquerade was presented. *Kusiut* masks appeared at one performance only, and then were usually burned, so somewhat less care was devoted to their refinement, finish, and details.

## KWAKWAKA'WAKW

THE KWAKWAKA'WAKW live on northeastern Vancouver Island and on the mainland in the region of Queen Charlotte Sound and Johnstone Strait. Kin groups called *numayms* shared crests and myths, and were organized into approximately thirty autonomous "tribes" with their own territory and towns. There were no specified marriage rules, and women and men both brought privileges into marriages. Potlatches were lavish affairs, often held to memorialize deceased ancestors or to celebrate marriages, an individual's assuming a chiefly name, or the erecting of houses and poles. The house facades of the elite depicted large, striking images of their crests (see fig. 4.7).

During the years of maritime fur trade, few vessels came to Kwakwaka'wakw territory, and whatever furs they sold went through Nuu-chah-nulth intermediaries. The Kwakwaka'wakw fared better during the years of land-based fur trade. Once the Spanish withdrew from Yuquot, the Kwakwaka'wakw found that they could organize their own trade at Newitty, a small island off Vancouver Island. In 1836, the Hudson's Bay Company launched the steamer *Beaver* for trading with northeast Vancouver Island communities, and this led to the virtual abandonment of Newitty as a trading center. Then coal was found in Beaver Harbour, and in 1849 the Hudson's Bay Company

established Fort Rupert at that site. Four closely related tribes, together named the Kwakiutl, had winter villages on islands north of Johnstone Strait, but also possessed the land on Vancouver Island bordering Queen Charlotte Strait—which includes Beaver Harbour. In 1849, all four tribes moved to Tsaxis, adjacent to Fort Rupert, to be in closer proximity to the Hudson's Bay Company. Fort Rupert became a major community which would assume great importance in the ethnographic and art history of the region.

Kwakwaka'wakw potlatches became more and more elaborate toward the end of the century, and involved the distribution of abundant food, pompous and sometimes aggressive oration, and lavish masquerades. Much art went into enhancing the status of the host chief at a potlatch. When guests were about to arrive, the host would sometimes position a carving near the entrance that celebrated his riches. Some of these carvings portrayed the wealth of the host family, represented in the form of a chief proudly holding his copper (fig. 4.11). Others, however, insulted the guests by portraying them as stupid, overwhelmed by the host's lavish spread, or simply insignificant. One such carving at first appears to be a father and child, but in reality is meant to depict the potlatch host holding a small being who represents all the other chiefs—greatly diminished in size and wearing a somewhat idiotic expression.

The production and distribution of food made up a significant component of the affair, and much energy went into carving bowls for its presentation; the bowl in figure 4.12 depicts a sea otter on its back, its open belly serving as a receptacle for food. Sometimes the symbolism of bowls supported the hierarchy, as when hosts brought guests food in immense vessels such as the one shown in figure 4.13. This elaborate vessel depicts the wild woman of the woods, a sometimes malevolent being who kidnaps babies but who also can impart great wealth. The hosts would fill the body cavity as well as all the additional bowls with food, bring the dish into the potlatch, and serve the highest-ranking guests from the bowl that forms her head; others would be served, in descending rank order, from her breasts, her navel, her knees, and her body cavity. Care was also paid to the act of serving the food, which was often done with finely carved ladles.

4.11 Kwakwaka'wakw. Potlatch figure, late 19th century. *Wood. 45 in.*

*Staatliche Museen zu Berlin - Preussischer Kulturbesitz Ethnologisches Museum, IVA 119.*

During potlatches, chiefs made every effort to convey their high position through all means possible. Masks and dances that represented inherited privileges, vast quantities of special feast food, and blankets piled to the rafters all expressed a host's elite status. Hosts also sometimes put carved figures at the doors of their houses or placed them at the side of a speaker. This strikingly naturalistic carving represents a chief embracing his family's most treasured possession, the copper that might be worth thousands of blankets, and wearing a cedar-bark headring. The dynamic and powerful figure crouches on bent knees, seemingly ready to spring forward. The diagonal slant of the copper contributes to the internal energy of this piece.

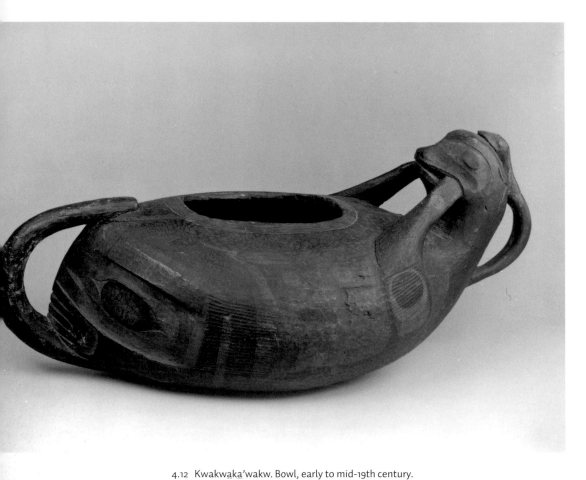

4.12   Kwakwaka'wakw. Bowl, early to mid-19th century.

*Wood, pigment. 28.75 x 12 in.*

*Staatliche Museen zu Berlin - Preussischer Kulturbesitz Ethnologisches Museum, IVA 1520.*

This comparatively minimalist bowl with carved striations represents
an early style of Kwakwaka'wakw sculpture (see fig. 4.1). It depicts a sea
otter swimming on its back in the position these sea mammals often
assume when eating. Women would bring these highly prestigious
"house bowls" into their marriages, thus augmenting the number of
treasures their husbands could present during potlatches. Such bowls also
held the rich and lavish food distributed to guests at those events.

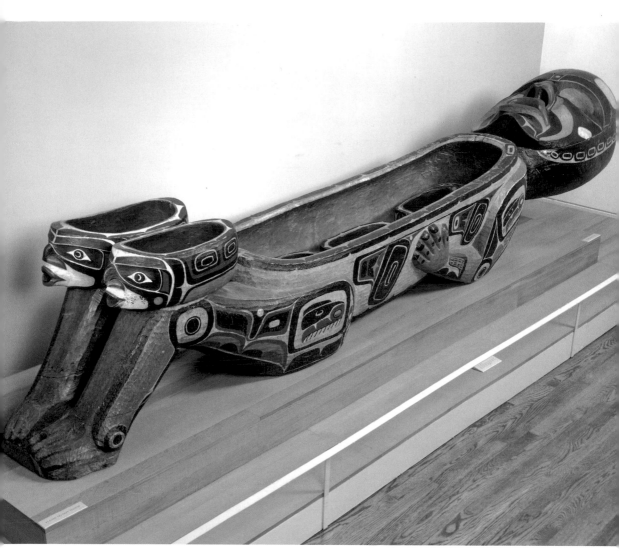

4.13 Kwakwa̱ka'wakw. Dzonokwa bowl, late 19th to early 20th century.
*Cedar, pigment. L. 14 ft., 2.5 in.*

© *Portland Art Museum, Oregon. Axel Rasmussen Collection, purchased with the Indian Collection*
*Subscription Fund, 48.3.523a, b.*

This enormous bowl was carved from a single cedar log, and represents the
Dzonokwa, a huge, hirsute woman with pendulous breasts and a beard who
kidnaps human children and throws them into a basket on her back. In addition to
being monstrous and dangerous, this powerful being can bring great wealth to the
individual with the inherited right to her beneficence. This vessel is a celebration
of containers for food, as the body itself is hollowed out. The carved face can be
removed, and food placed within the head. Smaller bowls sit on her knees and,
originally, on a rod placed across her chest. The containers placed on that rod
represented Dzonokwa's breasts.

ALTHOUGH the Kwakwaka'wakw were famous for their dancing societies, it appears that many of these dances and masquerades were actually invented by the Heiltsuk and Oweekeno, and the traditions then diffused to the south. But once the Kwakwaka'wakw obtained these privileges, they produced for them some of the most dramatic, dynamic masks and artworks on the coast. A masquerader impersonating a being that receives great power from mucus would pull seaweed or oysters out of his large nose and toss the slimy stuff into the crowd (fig. 4.14). Masqueraders representing bees would run around the house, biting guests with their stingers. Transformation masks could reveal two or even three entirely different beings. Long beaks of birds snapped. Tails on sea creatures rose and fell, side fins flapped, mouths opened wide and shut. An octopus's tentacles pulsated and its beaklike mouth opened and closed. Articulated puppets of ghost spirits seemed to rise out of the earth, fly around the house, and return underground.

These flamboyant and impressive creations appeared during two dancing society ceremonials: the *Tseka*, or shaman's series, which were ranked dances restricted to those with the inherited rights to do so; and the somewhat less prestigious but still notable *Tlasala.* During the winter season, the appearance of red cedar bark signified the *Tseka* time, when social hierarchies were disregarded and chiefly positions ignored, replaced instead by membership in various dancing societies. Dances and privileges to participate in specific masquerades were inherited along lines distinct from the secular ranking, and assumed positions in a different hierarchy imposed by supernaturals. However, in reality, the elite of the secular season inherited high-ranking dances, and those of lower rank had rights to less-significant dances, so the *Tseka* rankings reinforced the secular ones.

The Kwakwaka'wakw obtained from the Heiltsuk the highest-ranking *Tseka* privilege—the spectacular *hamatsa,* or cannibal dance. The scenario was much the same—a youth traveled to the realm of Bakbakwalanuxsiwe, became possessed by cannibalistic urges, returned to his community and tried to eat people, then was gradually tamed. Different families had the rights to present different aspects of the

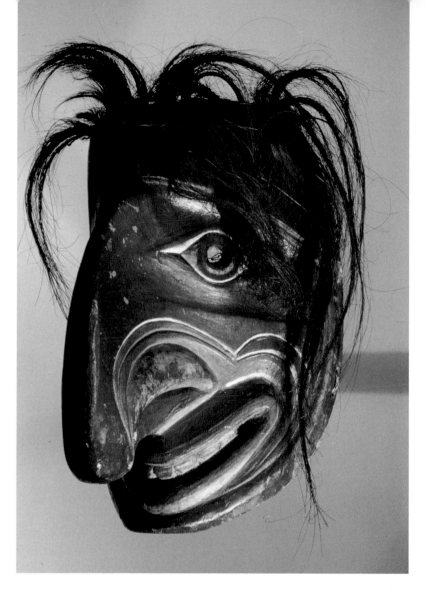

4.14  Kwakwaka'wakw. Noohlmahl mask, c. 1880.

*Wood, horsehair, pigment. 14.5 in.*

*Milwaukee Public Museum, 17332.*

Among the Kwakwaka'wakw, comedic masked dancers representing the
Noohlmahl perform a policing function to ensure that the ceremonies
are properly done. This being is a supernatural whose power resides in his
mucus, hence the exaggerated nose. During the potlatch, the Noohlmahl
masquerader sometimes amuses the audience by pulling slimy seaweed or
oysters from his nose and tossing them into the crowd. He is very sensitive
about his nose and can become irrational when anyone jokes about it. In
addition, he is also the enforcer of rules, such as the proper steps of dances
and uses of appropriate names, and can become quite violent at any indication
of violation of those rules. On this mask, the being's outlandishly large nose
is accentuated by two thin lines that curve around the mouth and over the
nose, ending at the nostril area, as if pointing to the source of mucus.

*hamatsa* ritual, and to sing songs associated with their privileges. The *hamatsa* song of one group, the Tlawitsis, went as follows:

> I went all around the world to find food.
> I went all around the world to find human flesh.
> I went all around the world to find human heads.
> I went all around the world to find corpses.

The Koskimo sang these words:

> You will be known all over the world;
> You will be known all over the world, as far as the edge of the world,
> you great one who safely returned from the spirits.
> You will be known all over the world;
> you will be known all over the world, as far as the edge of the world.
> You went to Bakbakwalanuxsiwe,
> and there you ate first dried human flesh.
> You were led to his cannibal pole in the place of honor of his house,
> and his house is our world.
> You were led to his cannibal pole,
> which is the Milky Way of our world.
> You were led to his cannibal pole at the right-hand side of his world.[2]

During the gradual "taming" of the wild, cannibalistic initiate toward the end of the *hamatsa* ritual, avian attendants of Bakbakwalanuxsiwe appeared, snapping their beaks and shouting "Hap! Hap!" the cannibal cry. One, the Crooked Beak of Heaven, had a broad bill and curving nose like that of the Heiltsuk example in figure 4.9, and another, Hokok, a long-beaked bird, was known to crack human skulls in order to eat their brains. The third was Raven (fig. 4.15), prone to pluck out eyes and eat them. At the end of the *hamatsa* ceremony, the finally subdued initiate danced in a quiet, elegant fashion, and wore a robe and headdress indicative of his reintegration into the social group.

Many Kwakwaka'wakw dancers engaged in dramatic performances, some with masks, some without. Transformation masks depicted two or three separate beings. A performer wearing the mask shown in figure 4.16

4.15   Kwakwaka'wakw. Raven mask, collected 1881.

*Wood, cedar bark, feathers, pigment. 47.25 in.*

Staatliche Museen zu Berlin - Preussischer Kulturbesitz Ethnologisches Museum, IVA 892.

When masks, such as this one, of the avian attendants of Bakbakwalanuxsiwe
were worn during the *hamatsa* ritual, dancers entered the house with graceful,
high steps following a strictly choreographed sequence. At the appropriate
time, the dancers sit on the floor, moving their masks from side to side,
then rise, snapping their beaks with strings and issuing forth the "hap,
hap" of the birds' voices as they continue their dance. The masks were
worn so that the bird's beaks projected upward. The small skulls that hang
from the bird's head allude to the human-eating Bakbakwalanuxsiwe.

would appear as a raptor with a large, sharply curved bill. Then, by pulling strings, the dancer would snap the bird face open to reveal a double-headed serpent with an anthropomorphic face in its center. The war dancer (fig. 4.17) did not need a mask to shock. He impersonated a great warrior who always wanted to go on war expeditions, but his community, desiring peace, tied him up. When he broke loose and killed some people, they pulled ropes through holes cut in his skin and hung him from the house beam. After he quieted down, the people took him down. The war dancer reenacted this bloody event by allowing skin on his back and legs to be cut, and a rope strung through. Wearing a belt that depicted the double-headed serpent, the dancer was strung up into the air; he would then cut his skin and fall to the ground.

Women had significant roles in Kwakwaka'wakw ceremonies. They performed numerous dances in which they wore robes decorated with buttons or beads and colorful aprons such as the one in figure 4.18, which depicts the wearer's privileges to represent eagle, bear, and *sisiutl*, a fabled being in the form of a double-headed serpent. Women also had their own *Tseka* privileges, one of the most striking of these being the *toogwid*. The person with this privilege demonstrated incredible supernatural powers by appearing to give birth to frogs or crabs, by raising decorated screens from the floor without touching them, or by miraculously coming to life after having been killed. To demonstrate this last power, the *toogwid* would command an assistant to decapitate her. When he did so, her head would roll to the floor and blood would gush from her neck. Later, she would be "miraculously" revived, with her head reconnected and no wounds visible. This was a carefully planned theatrical act: the woman entered the house and danced, and at the moment of "decapitation" her attendant, who all along had been concealing a wooden portrait head, dropped it onto the floor and covered her "corpse" with a blanket. For the blood, the dancer hid a seal bladder full of seal blood which was pierced when the head was "severed."

The *Tlasala* took place after the *Tseka*, and paralleled the *Dluwulaxa* of the Heiltsuk that had inspired this dance. An initiate emerged from behind a curtain wearing a blanket, apron, and frontlet headdress, and proceeded to dance. In response to merciless teasing from the other dancers, the initiate ran from the house, followed by his tormentors. They returned

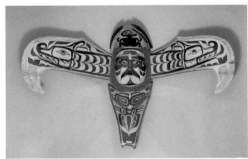

4.16  Kwakwaka'wakw. Transformation mask.

Red cedar with nails, leather, pigment, and metal.

17 x 29 x 12 in. closed, 17 x 29 x 71 in. open.

Brooklyn Museum, 08.491.8902.

The notion of one being turning into another at will is ancient; myths worldwide describe such metamorphoses. But rarely is the imagery of one being becoming another so concretely visualized as with the Kwakwaka'wakw transformation masks. This example presents the metamorphosis from bird to human form and back. When the mask is open, the central human face is flanked on either side by the fabulous double-headed serpent, *sisiutl*, which is a great privilege for a family to display. Other transformation masks show different animals and humans, or even one human transforming into another.

4.17  Kwakwaka'wakw. War dancer, 1904.

© Field Museum, CSA131594.

The warrior spirit was a powerful supernatural who gave magical powers to those with the inherited privilege of receiving them. One manifestation of this power was insensibility to pain, represented dramatically in the potlatch by a dancer having his skin pierced and then hanging, suspended, from his skin. The *sisiutl*, or double-headed serpent, is frequently depicted during performances associated with the warrior spirit. Charles Nowell, one of the last Kwakwaka'wakw war dancers to be hoisted into the air by ropes attached to his skin, posed for this photograph when at the Field Museum in Chicago. He carries a carving of the *sisiutl*. Nowell was in the Midwest as part of delegation to the St. Louis world's fair.

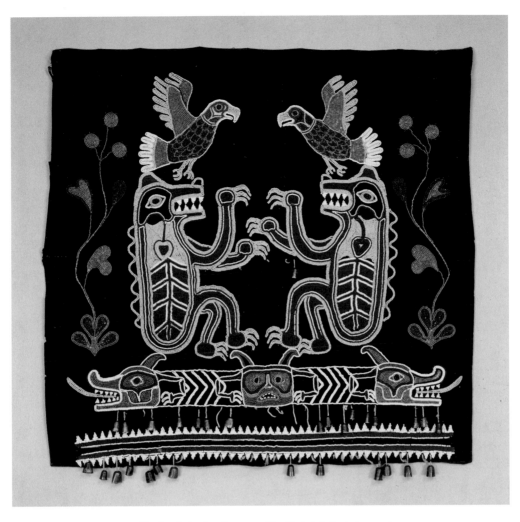

4.18  Kwakwaka'wakw. Apron. c. 1880. *Trade cloth, beads, brass. 29 in. sq.*
*Denver Art Museum Collection: Native Arts acquisition funds, 1969.406.*

During Kwakwaka'wakw potlatches, both men and women wore their finest
clothing, often decorated with images of their family crests. When the wearer
danced, the brass pieces jangled against each other, adding an aural dimension
to the presentation. In this example, the crests are depicted with colored beads.
For centuries, Native American women decorated many types of articles with
porcupine quills. Once they could obtain beads from Euroamerican traders,
however, many substituted comparatively easy beading for the more labor-
intensive quillwork. The use of beads spread east to west, and Northwest Coast
women borrowed the technique from the Athapaskans, who live on the east side
of the coastal range.

carrying only the novice's costume, indicating that he had been taken away by the supernatural from whom he would receive the *Tlasala* privilege. Another performer then returned wearing a mask of the initiate's crest being, sometimes in the form of a complex transformation mask. At the end, the hosts performed the "peace dance," in which they wore northern-style headdresses and robes.

Both these *Tlasala* and the *Tseka* performances were occasions for families to display their inherited privileges, and to initiate those who had inherited the privilege to participate in such events. Their hosts distributed piles of blankets, silver bracelets, and other items that constituted their wealth; by accepting those gifts, the guests who served as witnesses to these displays were acknowledging the hosts' claims and thus validating their rank. By the late nineteenth century, Kwakwaka'wakw potlatches had become exceptionally lavish, with blankets literally piled up to the rafters of houses, very convincing simulations of cannibalism, and at times actual destruction of property. This conspicuous consumption was a consequence of contact. Before contact, the Kwakwaka'wakw had a finite number of chiefly positions, all of which were held by individuals with inherited positions of high status. The early potlatches would have included some boasting and expressions of rivalry, but were apparently nothing compared to what they were to become. As the nineteenth century progressed, and epidemics took their toll, depleting an estimated precontact population of 18,000 to less than 2,000, some chiefly positions had no chiefs to fill them, because certain families had died out. The lines of descent had become muddled, or even broken, which opened up space for those not in the chiefly line to vie for a position. Simultaneously, some people of lesser rank were working for wages in canneries, fishing, and so on, and wanted to assume chiefly positions. These "nouveaux riches" sponsored lavish potlatches, to the apparent dismay of the old wealth. Potlatches hosted by these different groups developed into an intense rivalry that was expressed in the changing nature of these ceremonies.

## NUU-CHAH-NULTH AND MAKAH

THE NUU-CHAH-NULTH live on the west coast of Vancouver Island
south of the Brooks Peninsula. Their close relatives and the southern-
most Wakashan group, the Makah, reside in the northwest portion of the
Olympic Peninsula in Washington State. The Nuu-chah-nulth had been
well positioned for the maritime fur trade, but traded few terrestrial furs.
As a consequence, their international eminence disappeared early in the
nineteenth century, and they lost contact with most Euroamericans
until later.

Like the Kwakwaka'wakw, the Nuu-chah-nulth and Makah had flexible
marriage rules, and inheritance came from both parents. Potlatches were
hosted to celebrate assumptions of chiefly names, to validate a secret
society ritual in which performers imitated wolves, or, most importantly,
to celebrate a daughter's first menses. At the beginning of this puberty
ritual, the girl stood before her house flanked by masked dancers repre-
senting whales or thunderbirds, while four men poured water at her feet
four times. She then entered the house and remained behind a painted
screen for four days, fasting. Some of these screens (see fig. 4.5) represent
fine examples of the archaic painting style that may have been more wide-
spread among the southern Wakashan people before the diffusion of the
tighter formline style from the north. After the girl had remained behind
the screen for the prescribed four days, she received a new name, and her
family hosted its greatest possible potlatch.

### THE WOLF RITUAL

ANOTHER MAJOR OCCASION for a potlatch was the Wolf ritual, a Nuu-
chah-nulth and Makah version of the dancing societies found among
other Wakashan people. In the past, an ancestor had encountered
wolves who invited him into their abode and presented him with songs,
dances, and regalia. Afterward they returned him to the world of humans.
A wealthy chief would sponsor the multiple-day Wolf dance, which
reenacted this experience and initiated his son or young relative into the
society; sometimes groups of young people were initiated together at
these ceremonies. Dancers impersonating the wolves entered the village

and kidnapped the initiates, who remained isolated, learning the proper dances and songs. On the last day, the "wolves" appeared on the water in canoes with their captives, whom members of the community rescued. Like the *hamatsa*, these young people acted as though possessed, in this case by the wolf spirit. After ceremonies aimed at reintegrating them into society, the initiates presented the supernatural gifts bestowed upon them by the wolves—songs, dances, and regalia.

Different masks and headdresses were worn on different days of this event (see fig. 4.5), and rattles provided musical accompaniment (fig. 4.19). In some communities, a solid wood mask appeared on the second day, and its wearer performed the highly prestigious Whirling Wolf dance. An observer described how Chief Maquinna's son performed this dance in 1803, wearing a wolf headdress and "springing up into the air in a squat posture, and constantly turning around on his heels with great swiftness in a very narrow circle."[3] Among the Nuu-chah-nulth, on the fourth day of the Wolf ritual the Wild Man sometimes appeared. This destructive being with a very large, fierce-looking mask ran about smashing objects, scattering food around, destroying canoes, and extinguishing the fire; only when the men sang sacred songs did he leave the area willingly. This was also the day when the wolf spirits were exorcized from the initiates, who then were "tamed" and brought back to civilization. A great feast celebrated the conclusion of this part of the ritual. During the fifth day, announcements were made as to which masks people would wear at the dances, and everyone practiced their roles. That evening, and for the next two days, many people, including the initiates, danced wearing headdresses that represented beings inherited through their families, such as thunderbirds, wolves, and lightning serpents. The lightning serpent in certain areas always appeared next to a thunderbird mask.

### THE WHALER'S SHRINE

IN HISTORIC TIMES, the Nuu-chah-nulth and Makah were the only whalers on the Northwest Coast. They took the gray whale on its spring and fall migrations, and the humpback whale that lives in the region throughout the summer. Although whales served as a food resource,

4.19 Makah. Rattle. 19th century. *Wood, glass beads, pebbles, cord. 12.6 in.*
*Courtesy of the Burke Museum of Natural History and Culture, Catalog Number 4857.*

The Makah, like their close relatives the Nuu-chah-nulth, conduct multiday
ceremonies to initiate young people into the Wolf society. During that ceremony,
the initiates are removed from the village by supernatural wolves. For eight days
elders teach them important cultural traditions. In the dances performed during
this highly sacred ceremony, rattles such as this are shaken with a circular motion,
to accompany songs and dances as well as placate the spirits. This instrument's
simple globular shape and the bird head's geometric rendering suggest an archaic
carving style. The alert-looking bird is a grouse, possibly a ruffed grouse.

whaling functioned most importantly as indication of chiefly rank, for only chiefs were allowed to harpoon cetaceans. Whaling was a formidable endeavor in which teams of eight men in canoes up to thirty-six-feet long paddled out to find whales, which sometimes swam more than twenty miles offshore. After they killed their prey with eighteen-foot-long wooden harpoons tipped with mussel-shell and elk-antler heads, the team had to tow the huge animal back to shore.

Whaling implements and ceremonial objects associated with the hunt were unearthed in the prehistoric Makah whaling community of Ozette (see pp. 20–21). During the nineteenth century, a considerable amount of ceremonialism surrounded preparations for a whale hunt. As is so often the case in aboriginal hunting, the whale, if treated respectfully and with proper rituals, would willingly submit to its pursuer. Prior to a whale hunt, the chief and his wife would retreat to a secret spot where they scrubbed their bodies with fresh water and hemlock branches and cleansed themselves of the human smell that whales found offensive. Sometimes the ritualists would pray to the skulls of their successful whaling ancestors. Because the Nuu-chah-nulth envisioned an intimate relationship between the whale and the woman, when the chief went out to harpoon the whale, his wife had to lie completely still. If his wife did not move, the whale would also not move and would allow the chief's harpoon to make its mark. Once the successful hunter returned to the village, his wife greeted the whale with fresh water and welcoming prayers.

One of the most extraordinary artifacts ever found on the Northwest Coast is a large shrine used by Maquinna, his successors, and other great chiefs of Yuquot to ensure success in acquiring whales. This assemblage of eighty-eight anthropomorphic carvings, sixteen human skulls, and an open-air shed stood on a small island in a freshwater lake not far from the village of Yuquot. Human remains had a magical connection to whaling (although today the reason for their significance is unclear), hence the presence of skulls in the shrine. Because all available images of the shrine show human skeletal remains, I have chosen not to include an illustration of it in this book. However, photographs of the shrine can be found in various publications.[4]

There are several stories about the meaning and function of the shrine and its contents. One involves a thunderbird who taught a chief to ritually

bathe in preparation for a whale hunt, to make whaling implements, and to harpoon whales. After this "education," the chief swam to an island in a freshwater lake where the whalers' shrine is located. The chief addressed the wooden images, which he called "Doctors of Yaan," the good givers of the woods, asking them for power to "take the life of a whale when the time comes for me to go and get one." He then addressed the skulls of his great-grandfathers, who built the shrine, knowing that if he did not perform the rituals correctly, they would come to him in a dream and instruct him about the proper actions. He prayed to these skulls to help persuade the four Great Chiefs to give him strength to kill a whale. The chief then took the desiccated mummy of his father, tied its arms around his neck, placed a small wooden whale on his stomach and dove into the lake, imitating the movements of a diving whale. Afterward he did the same with his mother's mummy. At the end of all this ritual preparation, the chief was ready to assemble his paddlers and embark on a whaling expedition during which only he was permitted to harpoon the prey.

## NORTHWEST COAST CEREMONIAL HISTORY

A DEFINING CHARACTERISTIC of central Northwest Coast culture is the dancing society, which takes two general forms. The first, represented by the Heiltsuk and Kwakwaka'wakw *Tseka*, the Nuxalk *Kusiut*, and the Nuu-chah-nulth/Makah wolf ritual, often had elements of violence. In relatively recent times, the Tsimshian, presumably influenced by the people farther south, developed a dancing society called the Dog Eaters, who return from the supernatural world with an insatiable appetite for dogs, and need to be tamed and reintegrated into society. The other type of dancing society, such as the Heiltsuk *Dluwulaxa*, the Nuxalk *Sisaok*, and the Kwakwaka'wakw *Tlasala*, is more restrained and elegant and often concludes with performances of dancers wearing northern-style front-lets and shaking raven rattles. This distribution of conceptually similar ceremonials indicates that the various groups on the coast, despite the linguistic and cultural differences that make them distinct, interacted with each other considerably, borrowing and exchanging dances, masks, privileges, art styles, and ceremonial concepts. Sometimes this occurred peacefully, sometimes during warfare.

The first category of ceremonials is sometimes referred to as the "shaman's series," but the performers are not shamans, nor do they actually experience the altered state of consciousness that characterizes shamanism. Nevertheless, that term is suggestive. The most ancient type of spiritual experiences on the Northwest Coast presumably were shamanic rituals, in which supernaturals interacted with specialists, and guardian-spirit quests, in which access to such beings was open to all. Both of these occur among the Salish. It is thought that the dancing societies of the central region are based upon a shamanic initiatory scenario, in which an initiate leaves the world of humans, voyages to other levels of the universe, and encounters supernaturals who possess and provide him with great power. These become his spirit-helpers. Afterward, he returns to his community, having attained the ability to transform at will into one or another of his spirit-helpers.

Perhaps these societies began as a group of shamans actually traveling to the world of the supernatural as did, for example, the shamans participating in the Southern Coast Salish spirit canoe ceremony. Instead of an individual encounter with spirits and a lifetime of practicing the shamanic art by themselves, members of these societies all *reenacted* the same experiences with the same supernaturals. It could be that the members of these societies really did experience altered states of consciousness and thus interactions with supernaturals, but by the time anthropologists such as Boas described these events, they had become dramatic, staged performances. At some point, perhaps after contact, the shamanic group experience turned into a masquerade representing a shamanlike encounter with spirits, devoid of actual supernatural journeys or direct interactions with spirit beings. Elite families began to appropriate these previously genuinely spiritual experiences and turned them into performances that buttressed their social standings. This change from actual experience to dramatic reenactment may have paralleled the increased competitiveness of potlatches. Now, instead of individuals venturing into the other world in order to accomplish a task such as retrieving a lost soul, initiates inherited the right to perform according to a predetermined script. The outcome of this orchestrated presentation did not so much bring the supernatural world into the village as it enhanced the status of the family hosting the initiation.

# NINETEENTH-CENTURY
# NORTHERN COAST ART

THE NORTHERN REGION of the Northwest Coast is justly celebrated for
its two-dimensional art. Late precontact and early-contact artists crafted
works with broad, weighty formlines, which as the nineteenth century
progressed became thinner and more elegant. The Haida box in figure 5.1
represents an example of that nineteenth-century high style. Although
there was a system—indeed, an artistic canon—artists did not slavishly
follow strict stylistic and formal rules. Instead, some especially creative
individuals experimented with the formline style to produce innovative
artworks that still remained within the northern design system, some-
times creating works so distinctive that their hands can be identified.

Northern three-dimensional sculpture, with its refinement and
elegance, complements the virtuosity of two-dimensional design.
Tsimshian masks have a timeless serenity, with smooth transitions
between facial features and skin pulled tight over a fine bone structure,
often with a pyramidal shape to the cheek (fig. 5.2). Haida and Tlingit

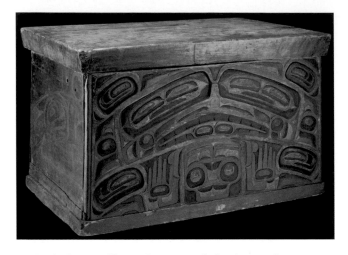

5.1  Haida. Bentwood box. 19th century. *Red cedar, pigment. 35 in.*

© *Canadian Museum of Civilization, VII-C-109. Photo: Richard Garner, S94-6802.*

Such boxes were containers for treasured heirlooms up and down the coast. Like the houses that "contained" the living members of a clan as well as its large-scale monumental house posts, boxes contained smaller items of great historical significance. The front of the box depicts a broad frontal face above two upright hands. It is not evident, however, what being this is meant to represent. Indeed, many bentwood boxes have ambiguous designs. It is possible that this was intentional, for boxes were sometimes traded to remote villages and could be interpreted to represent crests of whatever family ended up owning them.

masks are sometimes difficult to distinguish from one another, as they share a naturalism that sets them apart from the sculpture of other groups. However, some Tlingit faces have thick brows, eye sockets that end at the upper lip, and flat, broad lips (fig. 5.3). Some Haida masks (fig. 5.4) are so strikingly naturalistic that they may have been portraits of specific individuals.

### THE TLINGIT

THE NORTHERNMOST Northwest Coast group, the Tlingit, live on the Alaskan coast from Yakutat south to the British Columbia border. Individuals identify themselves not so much with all speakers of the Tlingit language, but instead with their regional groups, such as the

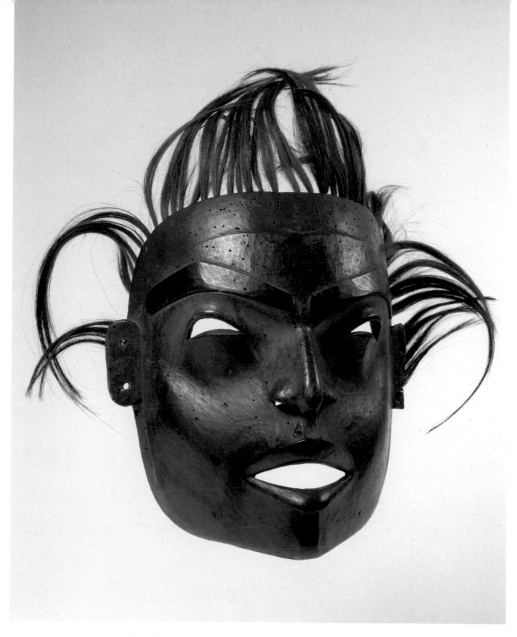

5.2 Tsimshian. Mask, 1800–1850. *Wood, human hair, pigment. 9 in.*

*Courtesy National Museum of the American Indian, Smithsonian Institution, 3/4678.*

*Photo: David Heald.*

This fine mask was acquired by George Heye, who gathered an immense collection of North and South American Native art, which he exhibited at the Museum of the American Indian, Heye Foundation. In 1989, the collection was transferred to the Smithsonian Institution, to be housed in the newly founded National Museum of the American Indian. This mask was probably used in dramas that represented a family's mythical past.

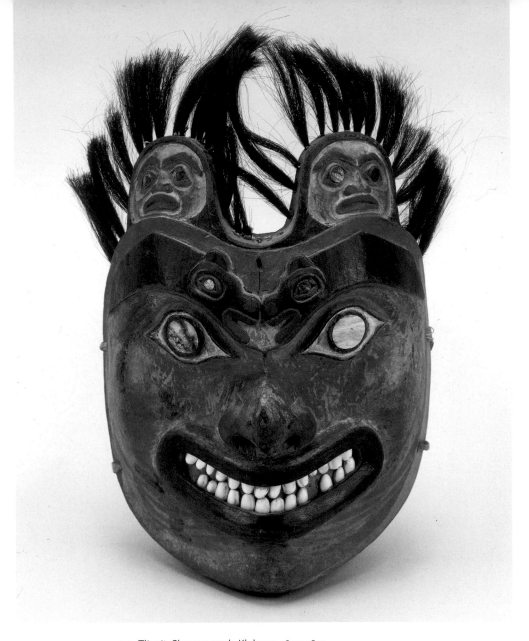

5.3  Tlingit. Shaman mask, Klukwan, 1800–1850.

*Wood, human hair, abalone, pigment, opercula. 7 x 11.5 in.*

Courtesy National Museum of the American Indian, Smithsonian Institution, 9/8030.

Photo: Bobby Hansson.

Most Tlingit shaman masks depict individual beings, but some, such as this one, include subsidiary figures as well. The collector of the piece, George Emmons (see p. 208), identified the main face as a bear and the confronting profiles that constitute its eyebrows as land otters, the shaman's most potent supernatural spirit helper. Land otters were believed to once have been humans who drowned and were taken to the land-otter village, where they slowly transformed into land otters themselves. They are capable of harming people, but can be controlled by a shaman who draws tremendous power from this were-animal. The faces in the ears could depict other shamanic helping spirits.

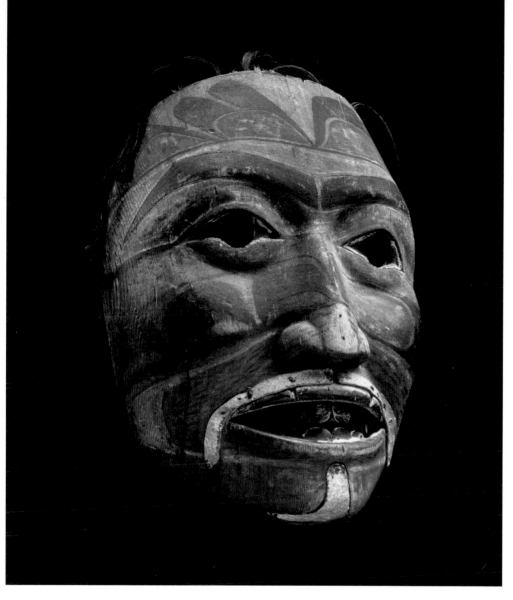

5.4  Haida. Portrait mask, c. 1840.

*Cedar, leather, copper, pigment, nails, human hair, sealskin. 10 x 7.5 x 4 in.*

*Seattle Art Museum, Gift of John H. Hauberg, 91.1.38. Photo: Paul Macapia.*

The Haida were masters of highly naturalistic carving. This example displays the artist's ability to render the human face with genuine understanding of bone structure, musculature, and skin. There is a striking contrast between such naturalism and the abstractions characteristic of the formline designs painted on the mask's surface. Those designs derive from the facial paintings that depicted crests and were applied during ceremonial occasions.

Tongass, Yakutat, and Sitka Tlingit. Until around the time of first contact, they inhabited all islands of what is now southeast Alaska, but were driven out of southern Prince of Wales, Dall, Long, and Sukkwan Islands by the Haida during their expansion in the late eighteenth and early nineteenth centuries. While the Haida were displacing the southernmost Tlingit from their traditional lands, the northern Tlingit were forcing the Eyak and Athapaskan from Dry and Yakutat bays.

In 1834, the Russians set up a post named Redoubt St. Dionysius at what is now Wrangell, near the Stikine River. In 1840, the Russians leased the post for ten years to the Hudson's Bay Company, which changed the post's name to Fort Stikine. But the company stayed there only until 1843, the year that their steamboat *Beaver* began traveling to various Native communities on the coast to purchase furs. Soon after the Russians had founded their trading fort, the powerful Stikine tribe, led by Chief Shakes, moved from their traditional village site to one in closer proximity to the source of wealth. Because Shakes controlled all access to the interior along the Stikine River, he functioned as a middleman in the lucrative land-based fur trade and thus became an even more powerful and wealthy "superchief."

Trade brought large quantities of Euroamerican goods, which the Tlingit rapidly incorporated into their culture. During the decades of their occupation, the Russians had maintained an uneasy truce with the Sitka Tlingit, and from 1804 to 1821 banned them from New Archangel. But starting in 1821, the governor—reinforced by warships, strengthened stockades, more cannons, and a strict dusk-to-dawn curfew within the post—allowed them to return for certain occasions. For holiday feasts, the Russians invited the Tlingit nobility, who sometimes arrived in traditional clothing, but at other times wore uniforms discarded by the Americans, British, and Russians. Although some romantics prefer to imagine Native people maintaining their ancient traditions intact, this was certainly not the case among the Tlingit, who by 1850 comfortably melded the old with the new. In addition to their appropriation of Euroamerican dress, they filled their houses with objects purchased from white traders. For example, in addition to an assortment of bentwood boxes, handmade skin garments, elegant cedar-bark and mountain-goat-wool textiles, and carved

house posts, a family would also own iron pots, Chinese containers, and stacks of trade blankets that now were measures of its wealth. Consumerism had become an element of culture in the region.

## Social Organization

Such cultural hybridization did not compromise the Tlingit social organization that had developed over the centuries prior to contact. A Tlingit individual's exact placement within society is determined by a rigidly structured social organization composed of two moieties or halves, the Ravens and the Wolves (who in some communities are referred to as the Eagles). One inherits one's mother's moiety (matrilineality) and must marry out of one's moiety (exogamy). Moiety affiliation is critical for marriage and other ceremonial functions, but an individual's identity is most closely attached to his or her extended family group, called the lineage. Each lineage, in turn, is composed of one or more house groups, the members of which claim a common origin. Although the moieties are considered equal opposites, hierarchies pervade the entirety of Tlingit social organization: individuals within the house, houses within the lineage, and lineages within the moieties are all ranked.

A fundamental social concept of the Tlingit is balance and respect between the two moieties. The two house chiefs of the highest-ranking lineage houses in each moiety have the greatest status within a village. Until quite recently, numerous reciprocal obligations connected these two halves—one married a member of the other moiety, opposites performed funerary functions, built houses, and attended potlatches. Ideally, those who carried out these obligations were of equal ranking within their respective moiety. The creation of an artwork illustrating a crest, the visual depiction of lineage history and status, was the responsibility of one's opposite; if that individual was unskilled as an artist, he hired the best artist available for the task. The commissioner repaid his moiety opposite for all these services, including creation of crest art, with gifts. The most formal of such ritual gift-giving was the funerary potlatch, during which a family paid its opposites for tending to the funeral of a high-ranking individual, rebuilding his house, and, in some communities, erecting a memorial totem pole.

Two groups of guests were invited to the Tlingit potlatch: the opposite moiety lineage which had done the work such as constructing a house, and another opposite moiety lineage from a more distant village. Dressed up in their best finery, the guests entered the house of the host and took carefully selected seating positions appropriate to their ranking. The regalia worn and carried in such ceremonial occasions were highly valued. Carved hats were especially esteemed, and during a potlatch a hat would be shown, its story told, and payment distributed to the opposite-moiety witnesses (fig. 5.5). For several days, the guests provided entertainment by dancing, singing, imitating animals, or performing amusing skits, some of which mocked foreigners such as the Athapaskan. The two groups of visitors played up rivalry and a competitive spirit, trying to catch each other's mistakes and at times hurling insults at each other. Then the hosts would become more involved in the event, presenting their nieces and nephews, displaying cherished heirlooms of clan regalia, making speeches about their lineage and its high position, and thanking their guests for contributing labor. Then the hosts distributed thousands of dollars worth of goods—often woolen trade blankets—not only to pay their guests for the actual work they did, but also, and perhaps even more importantly, to validate their claims of status. By accepting these payments, the guests acknowledged that their hosts were indeed as aristocratic as they claimed, their regalia estimable, their young nobles worthy inheritors of high positions.

### Crests—At.oow

The crest, which takes the form of images on artistic objects—such as the clan hats mentioned in the paragraph above—as well as the stories about those images, serves as one of the most important indications of Tlingit rank. Both image and story refer to interactions in mythic times when certain beings interacted with ancestors and sometimes provided their families with wealth and status. A concept essential to Tlingit culture and central to understanding the crest is *at.oow*. This translates as "something you own," and refers to things both material and immaterial. An object with *at.oow* maintains a strong link with the past, will exert a powerful presence in the future, and forms a connection between the living and the dead. An artwork depicting a crest is not automatically *at.oow*. Its owner

5.5   Tlingit, Sitka. Kiksadi frog hat, 19th century.

*Wood, copper, brass, ermine, spruce root, abalone, pigment. 12.75 in.*

University of Pennsylvania Museum, NA11740.

The conical crest hat made of basketry or wood was the most esteemed
headgear of the Tlingit; the value of this particular hat is indicated by the four
basketry rings. The rich copper brows and mouth, as well as the gleaming
abalone eyes, convey status and wealth. The crest story collected with this
hat describes a man who, when out walking, kicked a frog. The frogs took the
man's soul from his body to their house, where they tied it to a post. Then the
frog chief informed the man that he had insulted his kin. The man returned
and related this story to his clan, who then treated frogs with respect.

5.6  Tlingit, Klukwan. Exterior of Whale House, 1895.

*Alaska State Library, Winter & Pond Photograph Collection, PCA 87-9.*

This plain facade, unlike the more elaborate Kwakwaka'wakw and Tsimshian facades with their vivid paintings, gives no indication of the treasures within (see fig. 1.1). The upright planks represent an older style of architecture; later, milled boards were placed horizontally on the outsides of houses. This house was built in 1835 and torn down in 1899. See figure 1.7 for diagrams of the exterior and interior of this type of house.

must give the object a name and present it formally at a potlatch held in memory of a deceased relative. Only then, and after the owner has properly paid the witnesses, does the object become a treasured and valued embodiment of the lineage. Once an item achieves this status (which can increase with more presentations at subsequent potlatches), it must be cared for by a steward who ensures its proper treatment and determines appropriate times for its display.

At.oow can be both architectural and portable, such as the objects from the Whale House of the Ganaxtedi lineage of the Klukwan Tlingit. In the 1880s, the 565 residents of Klukwan lived in twenty-three houses lined up in a row facing the Chilkat River. The one Raven moiety lineage, the Ganaxtedi, had eight houses clustered together, flanked upstream by six Wolf Daklawedi houses, and downstream by six Wolf Kagwantan and three Wolf Dakistench houses. Although the Whale House exterior (fig. 5.6), with its gabled roof and vertical planks, had no decoration, its interior was lavish and ornate (see fig. 1.1). Its highest-ranking inhabitant, the house chief, had quarters separated from the communal space by a monumental screen painted by an early-nineteenth-century artist named Shkilahka. The image depicts Raven in the act of supplying humankind with water. According to legend, the petrel Ganook kept all the world's freshwater hoarded within his house. Raven entered Ganook's house and, by means of trickery, stole all his water. The screen depicts Raven with open wings, surrounded by small squatting anthropomorphic images that represent water dribbling from Raven's beak as he flew over the land, forming lakes and rivers.

Flanking this screen are two house posts carved around 1800 by a professional master artist who traveled to different communities to work on commission. This man, a Tlingit by the name of Kadyisdu.axch', created an array of exceptional works during the decades between about 1770 and 1810, including the posts in this Whale House. The post to the right of the screen also depicts Raven, this time in anthropomorphic form. He holds a bird in his mouth and an anthropomorphic jade adze between his knees, and stands on the head of a salmon. This post illustrates a story of how Raven captured the salmon, killed it with the jade adze, and then lied to various hungry birds to avoid sharing the fish with them; the bird in Raven's mouth symbolizes these lies. Although many Raven moiety

lineages can tell Raven stories, each family owns a distinctive, unique version; the Ganaxtedi's account of Raven providing fresh water to the world has distinctive elements that distinguish it from other accounts that to the uninitiated may seem similar. It is noteworthy that in the same house are two Raven stories that demonstrate the complex nature of this mythic bird: in one story he is a benefactor to humankind, in the other his character is selfish and unscrupulous.

Crest stories are also opportunities for lineages to tell their migration histories. To the left of the screen is a post that illustrates the story of a young Ganaxtedi girl who lived many years ago in Hoonah to the south. She discovered a small woodworm in the woods, took it home, and nursed it as if it were her own child, until it grew to the size of a human. The girl's parents, on learning of this, killed the "monster" and, with the rest of their lineage, moved north, ultimately settling in Klukwan. That girl appears on the post wearing a headdress composed of two wood-worms, fondling another large woodworm on her breast. At the base is a symbolic representation of the tree in which the woodworm lives; a crane represents its branches, and a frog below it, its roots.

### Women's Art

During nineteenth-century potlatches, high-ranking individuals often wore a greatly prized item of clothing, a Chilkat robe made from mountain-goat wool and shredded cedar bark (fig. 5.7). The Chilkat robe is not made in a textile-weaving technique using looms with both tops and bottoms, but instead is twined on a bottomless support with free-hanging warps.

The Tsimshian are said to have developed this textile during the nineteenth century. It is thought that as Northwest Coast artists were elaborating and refining their painting and sculpture traditions, skilled weavers began illustrating crest images, albeit in highly abstract ways. The Chilkat robe is probably the result of integrating the type of twining seen on raven's tail robes with the increasingly perfected formline style. Despite its Tsimshian origin, it is called a Chilkat robe because by the end of that century the women of the Chilkat region of the Tlingit maintained the tradition. The textile collected by Captain Cook from the Mowachaht in Yuquot (fig. 2.6), with its combination of abstract geometric designs

and tentative formline depictions of a face, suggests that this process had begun even before contact.

A figurative textile is a departure from the geometric and non-objective mode typical of women's work. In fact, the weaver did not actually design the image but instead copied the crest designs painted on a pattern board by a man (fig. 5.8). In a manner reminiscent of early-twentieth-century cubism, the Chilkat robe's three-part composition shows the subject being from several different perspectives: a central panel represents the crest animal's front, and two side panels its profile. The pattern board showed only the central panel and one side panel, but these robes are bilaterally symmetrical, so it is up to the weaver to create the other, mirror-image, side. Sometimes the design elements on these textiles are so stylized that identification of the specific crest being represented is difficult or even impossible. When the robe's wearer danced, its long fringes swayed rhythmically, adding to the overall effect.

Chilkat robes were meant to be hung flat as well as worn. When a chief died, his body, surrounded by *at.oow* that sometimes included his Chilkat robe, lay in state for four days. When a chief wore this robe, its central frontal face covered his back, the flanking panels his arms. The crest's front appeared on his back, and its sides merged with his own side. With a little imagination, it could appear that this representation of a lineage's history, wealth, and power was embracing the chief, who became one with the lineage's crest. It might even be that the man and robe became a new hybridized being that shared a body, with the man's face in front and his crest's at the back. When considered three-dimensionally in this fashion, the worn Chilkat robe resembles a bentwood box, a container that also illustrates its subject being, with two faces on four sides. A bentwood box's front depicts the subject *en face,* its sides show the same being in profile, and the back illustrates another face, perhaps a stylized representation of the being's rear. It could be that bentwood boxes inspired the transformation from raven's tail weaving to Chilkat robes.

## Shamanism

Shamans played an important societal role among most Northwest Coast groups, as they were responsible for curing the sick, controlling the weather, guaranteeing adequate fish runs, combating witches,

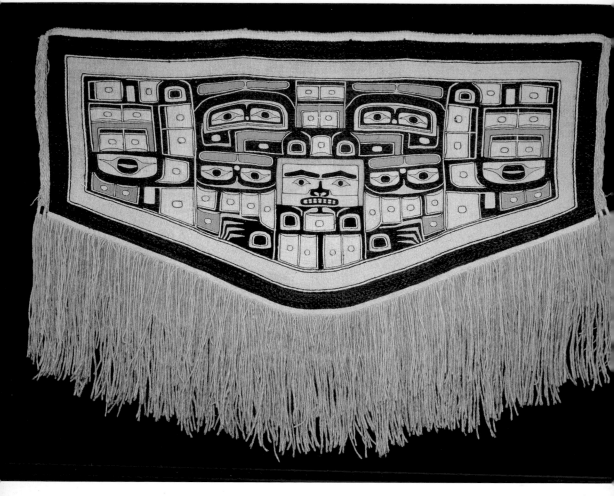

5.7  Chilkat. Robe, c. 1880.

*Mountain-goat wool, yellow cedar bark, natural dyes. 52 x 67 in.*

*Seattle Art Museum, Gift of John H. Hauberg, 83.229. Photo: Paul Macapia.*

Chilkat robes developed out of earlier types of textiles such as the raven's tail robe that used twining techniques to create geometric designs. In the early 19th century, Tsimshian weavers devised a method of twining and braiding to form circles, ovoids, and formlines, thus expanding beyond the angular imagery twining usually produced. As a result, women began working crest images into textiles. This weaving technique spread among the northern groups, but by the end of the 19th century, only the Chilkat were making the robes, hence their name.

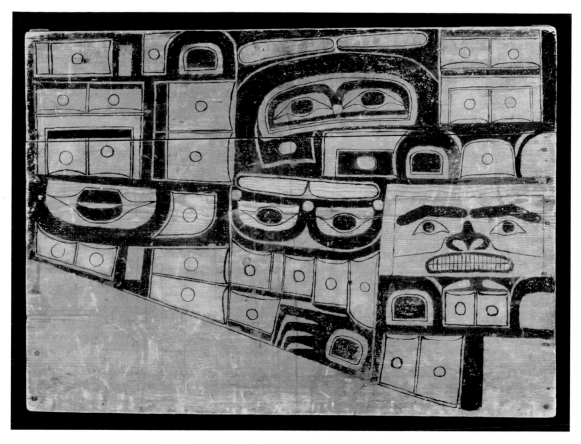

5.8 Chilkat. Pattern board, apparently for the robe shown in
figure 5.7, c. 1880. *Spruce, pigment. 21 x 37 in.*
*Seattle Art Museum, Gift of John H. Hauberg, 85.357. Photo: Paul Macapia.*

Men traditionally painted crest designs, and the Chilkat weaver translated into
textile the designs on the pattern boards that men painted. Such boards depicted
only the center and one side panel of the robe, for the other side was the mirror
image of this pattern. The image on the Chilkat robe depicts a crest image from
three perspectives. The central panel shows its front, the two side panels both of
its profiles. Some of these images are so highly abstract that only their owners can
verify their identity.

and providing assistance during battle. To perform these duties, they interacted on a personal level with supernaturals, both benevolent and malevolent. For most groups, the shaman was the sole individual capable of communicating directly and at will with spirits; only among the Salish did laypeople also enjoy such an intimate relationship with the other world.

The Tlingit had an especially elaborate form of shamanism, and the largest variety of shamanic artworks of any Northwest Coast group. At about the age of puberty, an individual was informed by spirits, sometimes through a serious illness, that they had selected him to be a shaman. He then went on an eight-day vision quest to an isolated place where he deprived himself of food and freshwater. Animals destined to become his helping spirits approached him, protruded their tongues (which contained their spirit power), and fell dead at his feet. The initiate excised these tongues and assembled them into a special charm. The ideal number of helping spirits was eight, the Tlingit number of completion. After this experience with the supernatural domain, the initiate returned to his community, where he either inherited his predecessor's regalia or had new regalia made. His wide array of spiritually powerful artwork would include charms, rattles, costumes, and masks that depicted the helping spirits he had encountered during his vision quest.

Healing the sick was the most frequent task for the Tlingit shaman, who received payment for these services. Once the price for a cure had been agreed upon, he brought his regalia into the patient's house, donned his special costume, began shaking his rattle or beating his drum, and started singing. This summoned his spirit helpers, who entered their artistic images, filling them with supernatural power. One important item of regalia was the shaman's carved ivory or bone charm, which the shaman might leave with his patient as a "prescription." These small objects often depict a variety of beings interacting with each other (fig. 5.9).

The most dramatic feature of a shamanic séance was masked dancing. The shaman owned an assortment of masks, ideally eight. He put on his first mask—often a representation of the land otter, and, after proper incantations, transformed into this creature, an immensely powerful being that was once a human who had drowned and become an animal.

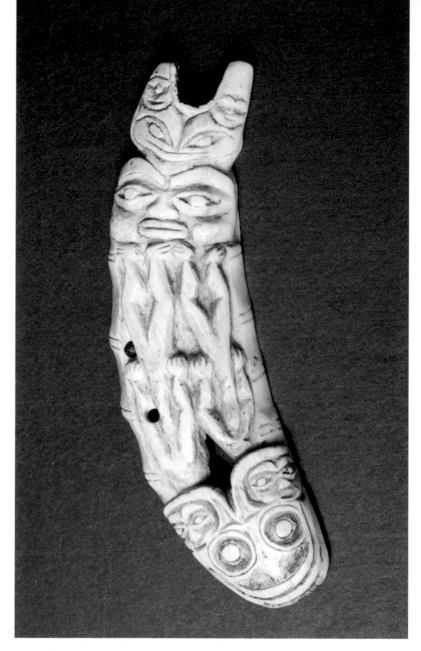

5.9   Tlingit. Shaman charm, c. 1820–50. *Whale tooth. L. 5 in.*

*Denver Art Museum Collection: Funds by exchange, 1953.570.*

Tlingit shamans often carried charms, wore them on necklaces, or attached them
to their clothing. Each charm is unique, and often includes subsidiary figures that
interact in some fashion with the main one. The variety of this type of shamanic
artworks suggests that their imagery depicts individual shamans' visions. This
finely carved charm was collected in 1867 or 1868 by Captain Edward Fast when he
was in Sitka as one of the very first military men stationed in Alaska, soon after its
purchase by the United States.

5.10   Tlingit. Oystercatcher rattle, c. 1780–1830.

*Wood, pigment, hide. L. 12.5 in.*

Peabody Museum, Harvard University, 69-30-10/1790

To call the spirits to his side, a shaman often shook instruments such as this carving of the oystercatcher bird. On its back sits a shaman with an animal-like face who ties up a long-haired witch from whose chest an animal—probably the witch's spirit-helper—emerges. Other beings, possibly land otters, surround the scene. It was believed that witches caused illness by performing spells over the victim's hair or nail clippings or articles of clothing. The only way to effect a cure was for the witch to confess and return the victim's materials. Shamans tortured witches into confessing by binding their hands behind their backs and pulling their hair, as the shaman on this rattle does.

Then the shaman took off the otter mask and donned others representing other mammals, birds, and sea creatures, especially the powerful octopus. Most masks depicted a single anthropomorphic or zoomorphic being, but some presented a variety of spirits, such as the one in figure 5.3, a bear spirit with small faces in its ears and eyebrows consisting of land otters in profile facing each other. In a shaman's cache of masks were also depictions of humans: dead people, young women, old women, old men, angry men, powerful warriors, peaceful men. Through the transformations he experienced when wearing his whole collection of masks, the shaman proved that he could travel with ease through the air, over land, and into the ocean, and that he could exert power over all aspects of life—human and animal, living and dead, old and young, male and female, aggressive and docile. During such rituals, the shaman often used percussive instruments such as drums and rattles (fig. 5.10).

In many ways the shaman seemed to exist in the realm beyond civilization—he looked different, with his long and unkempt hair, and his supernaturally potent regalia could be so harmful to laypeople that it remained outdoors and was brought into a house only during a séance. When a Tlingit shaman died, his body retained its supernatural potency and thus had to be removed from the village. Whereas laypeople were cremated, the Tlingit took a shaman's corpse to a remote area far from the village and placed it in an elevated grave structure. Around him was placed his regalia, which could be removed from this grave only by his successor. The differences between shaman and layperson made visible the shaman's unique ability not only to exist in the structured domain of the village with its social rules and hierarchies, but also to enter at will the supernatural world, which those human-made rules could not govern.

Some shamans' grave houses were exceptionally rich in artifacts. For example, one grave near Dry Bay held eight masks, two maskettes worn on the forehead, two twig bundles holding tongues found on vision quests, two headdress ornaments, four rattles, a cedar mat to sit upon, two cedar-bark neck rings, three necklaces, a spruce-root and ermine-skin amulet, a knife, two wooden arrow shafts, a neck ornament of branches and tongues, three wooden batons, two guardian figures, a comb, a wooden hand ornament, three charms, a bundle of beating sticks, a cedar-bark bag containing odds and ends, a basket for drinking salt water,

a portion of walrus tusk cut in preparation for being made into a charm, and two bone bracelets. In the 1880s visitors described an old decaying grave house outside Klukwan that held the supernaturally powerful remains of a deceased Chilkat shaman. Standing near the house were several old wooden carvings that served as grave guardians, responsible for protecting the shaman's remains and his regalia from evil forces.

Although not a shamanic object, the halibut hook often was decorated with shamanic images such as land otters, octopus, or bound witches. These hooks were used by fishermen to catch large halibut. Their quality varied considerably, suggesting that they were carved by their owners, some talented artists, others not. Halibut hooks were designed so that the image, meant to magically attract the bottom-dwelling fish, faced down when the hook was suspended in the water.

### THE TSIMSHIAN

THE TSIMSHIAN of northern British Columbia divide into four linguistic groups: the Nisga'a on the Nass River, the Gitksan on the upper Skeena River, the Coast Tsimshian on the lower Skeena and adjacent coast, and the Southern Tsimshian on coast and islands to the south of the Skeena. In precontact times the Tsimshian appear to have had a matrilineal moiety social structure similar to that of the Tlingit, but as a result of nineteenth-century community reconfigurations and movements a modified structure of four exogamous clans called phratries developed among some groups. Their highly complex system of crests includes hundreds of crests. As is the case with the Tlingit, each crest represents a being encountered in the past by an ancestor and inherited by the clan through matrilineal descent. The major crests, Orca, Raven, Eagle, Grizzly, Bear, Beaver, Frog, and Wolf, along with lesser crests, appear on portable and architectural art. In historic times the Tsimshian had four "classes": "real people" who outranked everyone else, "other people" with names of lesser rank, "unhealed people" without names in the potlatch system, and slaves. "Real people" had several responsibilities intimately associated with their position, including giving great feasts and distributing property, as well as hosting more spiritually oriented activities such as

dances dramatizing ancestral powers and displays of supernatural abilities.

Potlatches celebrated the completion of a house, investitures of new leaders, memorials for deceased chiefs, and pole raisings (fig. 5.11). The most important of these was the final mourning feast, during which a successor to a deceased chief assumed his new position. At great potlatches, treasured regalia were proudly displayed, with boxes, headdresses, garments, masks, and cedar-bark rings symbolizing a clan's history, power, and importance.

### Lax Kw'alaams (Fort Simpson)

In 1834, the Hudson's Bay Company founded Fort Simpson at the mouth of the Skeena River, at a site that had for years been a temporary eulachon-fishing camp called Lax Kw'alaams. As in other places, this trading fort became a magnet for Native people. Attracted to the fort's trading opportunities, nine groups of Tsimshian abandoned their winter villages on Metlakatla Pass and moved to Fort Simpson, which is now called Lax Kw'alaams. By the 1850s, this large permanent village had 140 houses and a population of approximately 2,300. In 1867, E. A. Porcher, commander of the British ship *Sparrowhawk,* visited Lax Kw'alaams, which he described as "the largest and best [village] I had as yet seen, the houses being better decorated and painted," with "doorways and pillars ... most elaborately carved with a great variety of the representations of animals ... of most artistic finish."[1]

The movement of several tribes into an amalgamated community such as Lax Kw'alaams created problems of social ranking. In their original communities, the relative status of individuals and families had been determined over the years, resulting in relatively stable hierarchies. However, in this new village no one knew for certain which chiefs outranked others. Because they were an essential means of working out these rankings, potlatches, which had previously been relatively low-key affairs, became intensely competitive and often outright hostile. As always, wealth formed the basis of hierarchy. At Lax Kw'alaams, certain families established monopolies over trade with interior people who trapped the furs, and as a result became fantastically wealthy. For

5.11  Gitksan. Gitanyow (Kitwancool) totem poles, 1910.

*University of Washington Libraries, Special Collections, NA3475. Photo: G. Emmons.*

Gitanyow was one of the most conservative Gitksan groups and had an impressive array of totem poles. Because the village pictured here was in the interior, the poles were lined up not on a beach by the sea, but instead along the Skeena River. Tsimshian poles tend to be relatively deeply carved (in comparison with those of the Haida, see figure 5.20), with the individual beings separate from one another, and no elements of one body interacting with those of another body situated above and below. Sometimes the Tsimshian added projections such as bird beaks that extended beyond the cylindrical form of the log.

example, the family whose leaders were each named Legiac controlled access to the Gitksan, whom they prevented from traveling downriver to barter their furs. The man bearing the Legiac name in the 1830s engaged in a traditional practice to establish trading alliances by giving his daughter in marriage to Dr. John Kennedy, a high-ranking Fort Simpson official. For centuries, families had married their daughters to prospective trading partners, and now Legiac was doing the same with new partners. The individuals were different, but the rules of the game were the same. According to Porcher, the tallest totem pole in Fort Simpson belonged to Legiac.

Because everyone approached the village by water, all could see the totem poles and painted house facades that lined up along the shore and vividly declared a family's eminent history and rank. Both types of monumental art became increasingly impressive as families vied with each other for supremacy. Totem poles, which had originated as statements of clan history, became ostentatious declarations of a family's importance, as did the painted house fronts that some communities held in even greater esteem than totem poles. The house front shown in figure 1.4 shows elements characteristic of Tsimshian house-facade decoration—small figures along the roof line, and a wealth of additional imagery within the main figure's eyes, mouth, wings, and ears. See also figure C (in introduction), a contemporary replica of another Lax Kw'alaams house facade.

### Spiritual Responsibilities of the "Real People"

"Real people" were ceremonial leaders, responsible for treating spirits and animals properly, ensuring stability during rituals, births, and deaths, and for initiating young people into ritual positions. When they assumed their roles as "real dancers," a term that connotes the extraordinary and phantasmal, chiefs wore carved frontlets and Chilkat robes and shook raven rattles; in this context, all of these items were signifiers of rank (fig. 5.12). The frontlet headdress, believed to have been invented around the Nass River, consists of a relief carving—often quite deep— of an anthropomorphic or zoomorphic face attached to an armature that fits on the head. Surrounding the face are sometimes rows of diminutive faces, a common

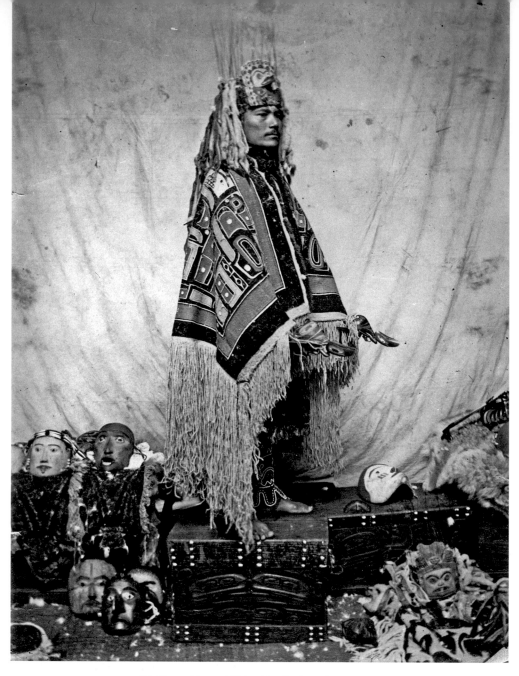

5.12 Chief James Skean of Gitlaxt'damiks, Nisga'a, c. 1903.

*Royal British Columbia Museum, PN4329. Photo: C. H. Orme.*

This chief poses on a box surrounded by his clan's ceremonial regalia and masks. He holds two raven rattles, as is conventional, upside down, so that the ravens would not fly away. His carved frontlet, which depicts his crest animal, is surmounted by a crown of sea-lion whiskers and has attached to it a train of ermine pelts. This type of headdress is said to have originated among the Nisga'a, from whom it spread north to the Tlingit and south to the Nuu-chah-nulth and Kwakwaka'wakw. The Chilkat robe that he wears presents his crest being's frontal face on his back, and its profiles over both his sides. Thus, the chief is wrapped in his crest—even merged into one with it.

feature of Tsimshian art. References to wealth include squares of abalone attached to the carving, sea-lion whiskers that project from the head-dress's top, and ermine pelts that cascade down the back.

The Tsimshian are said to have invented the raven rattle (fig. 5.13), which by the nineteenth century had a wide distribution and was used among the Haida, the Tlingit, and the Tsimshian, with versions appearing as far south as the Nuu-chah-nulth. Although its precise symbolism has been lost, according to one theory the bird represents Raven, who stole the sun from his grandfather. The elder had hidden the sun in a box, denying humans the warmth and light necessary for survival. Through clever deception, Raven convinced his grandfather to let him look inside the box, upon which he seized the sun in his beak and flew away. Images that appear on the bird's back vary, but often a human being reclines on its back, connected by tongue to another bird, probably the kingfisher, whose head feathers form the raven's tail feathers. This connection might represent the transference of spiritual power and knowledge to humans. Dancers hold the rattle face-side down when they perform, as shown in the illustration.

In their winter villages, chiefs and their attendants manifested important power with various items besides crests. This power was principally held and transmitted by specific beings with whom chiefs enjoyed special bonds called *naxnox*, which translates as "power beyond the human." At events that only *naxnox*-name holders could attend, performers wearing masks and costumes dramatized the stories of these beings. Some *naxnox* masks represented animals, celestial beings, human shortcomings (such as stupidity, pride, or arrogance), classes of people including foreigners, rival groups, elders, youths, males, and females. Sometimes these performances mocked individuals, as with one mask that represented a specific local white man—a minister known for his alcohol consumption. The performer wearing this mask appeared in a suit and carried a bible, and during the performance took a bottle from his pocket and proceeded to become fall-down drunk. A pair of nested masks made of stone (fig. 5.14) perhaps represent another of the *naxnox* abilities, which is to transform from blind to sighted. The outer mask has no eye holes, and thus represents blindness, while the inner one has openings that allow for sight.

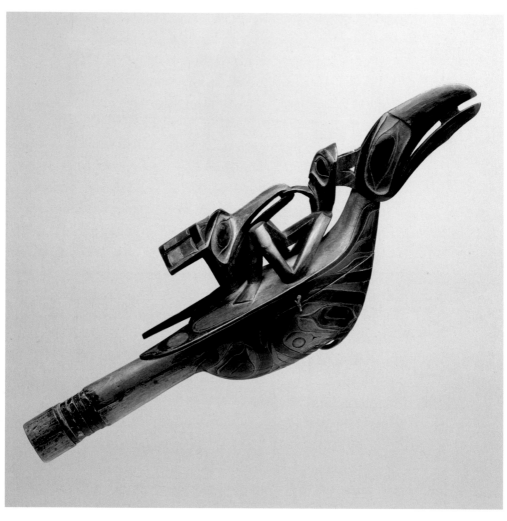

5.13  Coast Tsimshian. Raven rattle, c. 1840–60.

*Maple, leather, sinew, pigment. 4 x 4 x 13 in.*

*Thaw Collection, Fenimore Art Museum, Cooperstown, NY, T174.*

Museum collections abound with raven rattles made by groups from the
Kwakwaka'wakw to the Tlingit, but the distinctive form originated among
the northern Northwest Coast peoples, probably the Tsimshian. Numerous
interpretations have been made for the interconnecting figures on these
instruments, including a shamanic origin. For example, Tlingit shamans receive
spirit power from the tongues of their animal helpers, and this rattle could depict
spirit power transferring from one being to another through the tongue. Another
interpretation is that the rattle depicts Raven, who obtained the sun, moon, and
stars from the Raven-at-the-head-of-the-Nass, whose face with a beak curving
into his mouth appears on the Raven's breast. Intriguing as such readings may
be, there is no certain indication of the original meaning of the raven rattle.

5.14  Tsimshian. Stone masks, 19th century.

*Stone and pigment. 8.9 x 9.5 x 7 in.*

*Courtesy UBC Museum of Anthropology, Vancouver, Canada, VII-C-329, and Musée de l'homme.*

Until 1975, these two masks, located in different museums an ocean apart, had not been together since being collected; their actual connection was not entirely clear. But when they were brought to Victoria for the exhibit *Images Stone B.C.*, the exhibit's curator, Wilson Duff, was thrilled to discover that the two fit together snugly, indicating that they were meant to be used as a pair.

Anthropologist Franz Boas described Henry Tate's account of a particularly dramatic *naxnox* presentation, quoting directly some of the Tsimshian's words, which he felt were "not clear":

When Legel-gulagum lax-ha [Crack of Heaven] is called, the curtain is withdrawn, the song-leader begins the song, and the chief appears wearing the mask. He goes around the fire four times, and then stops at the same place where he came out. Suddenly the face of the mask parts, and each side of the face hangs down; only the middle part of the face remains in position. Then the face closes up again. This is repeated four times. The fourth time the mask opens, "it makes the large house crack. One side of the large house moves backward from the other. It goes with the half of the large fire, and the whole congregation is still sitting on both sides. The roof is asunder, and the large beams go backward. This is the great wonderful enchantment among these chiefs in the Tsimshian nation. It is not often shown, only in the house of the great chief Legeox (Ligeex)." When the mask closes the last time, the house comes together again slowly.[2]

Although one would assume this description to be purely fantastical, it may not be far from the truth, for sleight-of-hand tricks were often features of *naxnox* masquerades. Thus, a Tsimshian version of smoke and mirrors may have created the illusion that the house did indeed split apart during this performance, or special rigging caused it to move. Creators of such dramatic theatrical legerdemain, a group of song composers, carvers, and impresarios called *gitsontk* ("people secluded"), spent much of their time in secret designing these manifestations of special powers. The most gifted *gitsontk* became celebrated, and chiefs from other villages sought them out to create especially illusionistic presentations. Tsimshian chiefs were often significantly indebted to these men, who could, through elaborate mechanical devices, make an audience believe someone really did have extraordinary magical powers. If the devices failed, however, the *gitsontk* might be executed.

5.15 Button robe belonging to Chief Minisqu' of Gillaxt'damiks, Nisga'a.
*Wool, mother-of-pearl buttons.*

*With Permission of the Royal Ontario Museum © ROM, 929.21.54.*

Once women obtained trade buttons and woolen blankets, they started crafting
button robes that became very popular throughout the coast. They would cut
designs from colored wool and appliqué them onto wool of a contrasting color,
then use buttons to outline various elements of the images. Such robes became
colorful indicators of clan affiliation and history, and were worn at various
occasions. Today, button blankets appear at numerous Northwest Coast Native
events including potlatches, official events, and cultural celebrations.

## Textiles

Prior to contact, people had worn garments of woven cedar bark, some-
times in combination with mountain goat or dog wool, furs, and skins.
As was mentioned above (pp. 138–39), the Tsimshian were reputed to
have invented the Chilkat robe, which by the late nineteenth century was
being made almost exclusively by northern Tlingit women. Another type
of textile that became increasingly popular throughout the coast during
the nineteenth century was the button blanket, crafted from woolen trade
blankets, often blue, and decorated with felt appliqués and mother-
of-pearl buttons that depicted the wearer's crest. The button blanket
represents another example of how Northwest Coast Native people
creatively transformed materials obtained from trade into indigenous

expressions of social status and clan privileges. One such textile, owned by Chief Minisqu' (fig. 5.15), has red wool borders that frame the upper half of both sides and the area worn on the shoulders, except for directly behind the head. The central circle contains an anthropomorphic being with legs and one arm upraised, surrounded by six small squatting figures that are another version of the small faces that appear on the previously illustrated house facade and frontlet (see figs. 1.4 and 5.12). Buttons accent parts of all these beings as well as the circle itself.

### Shamans

Tsimshian shamanic practices resembled those of the Tlingit. Shamans, with exceptional powers to transform into animals, tended to come from lineages with histories of shamanism. As was the case with the Tlingit, a person did not typically decide to become a shaman, but instead received a calling from spirits who had selected him specifically. Shamans wore special costumes that signified their spiritual status; the Tsimshian shaman, for example, donned special robes and placed on his head a crown of grizzly-bear claws. After he entered a house to heal a sick person, the shaman first needed to accrue power by entering an altered state of consciousness, often by using percussive instruments that facilitated passage into a trance. Once in that state, the shaman both interacted with his helping spirits, who appeared on his ceremonial objects, and confronted malevolent beings. He sang songs to the accompaniment of rattles (fig. 5.16), manipulated carved puppets that represented his spirit helpers, and brandished supernaturally potent charms. One of these charms was called the "soul-catcher" (fig. 5.17). It could be that the shaman used this bone to suck out illness or to blow healing breath onto the patient. The bone and abalone shown here depicts on one side a two-headed creature and on the other a central anthropomorphic being flanked by animals in profile, perhaps bears or wolves.

## THE HAIDA

THE HAIDA LIVE in British Columbia on the Queen Charlotte Islands, which they call Haida Gwaii, and in Alaska on Dall, Sukkwan, and Long Islands, as well as on the southern portion of Prince of Wales Island. The

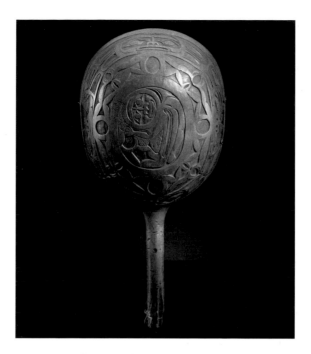

5.16  Nisga'a. Shaman rattle, Gitlaxt'damiks, c. 1830–50. *Wood. H. 12.25 in.*
© *Canadian Museum of Civilization, VII-C-215. Photo: Ross Taylor, S93-9015.*

Percussive instruments were commonly used during shamanic séances, as their
repeated rhythmic shakings were thought to attract the shaman's spirit helpers,
some of which are portrayed on this rattle. On one side, an anthropomorphic
being squats, arms raised, next to what appears to be a crescent moon. On the
other, an ovoid encloses a reclining being with upraised legs that appears to hold a
crescent moon with its feet. The being is surrounded by four broad-faced squatting
figures. The inclusion of small surrounding figures is a characteristic of some
Tsimshian art, such as the house front in figure 1.4. The image of the being within a
circle surrounded by small frontal figures is very similar to that on Chief Minisqu's
button robe (fig. 5.15).

Alaskan Haida, called the Kaigani group, migrated north from Haida Gwaii
in the late eighteenth and early nineteenth centuries. Like the Tlingit, the
matrilineal Haida are divided into two exogamous matrilineal moieties
called Ravens and Eagles, composed of twenty-two and twenty-three
lineages, respectively. Lineages trace their existence back to several super-
natural women of each moiety, and claim their origin in a mythic "story
town" on Haida Gwaii. The chief of the highest-ranking house of the
wealthiest lineage in each town becomes the "town master." Crest

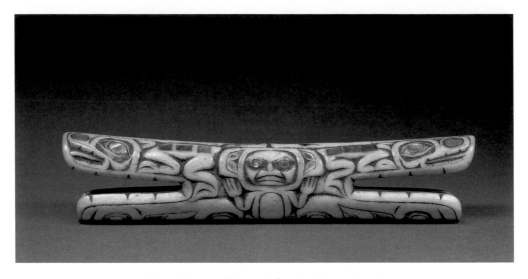

5.17  Gitksan. Gitanyow (Kitwancool) soul catcher, c. 1840–60.

*Bone, abalone. L. 8 in.*

*Courtesy National Museum of the American Indian, Smithsonian Institution, 9/7935.*

*Photo: Bobby Hansson.*

Shamans are often charged with the task of retrieving lost souls of sick people. The shaman who possessed this carving would have traveled into the world of supernaturals, located the soul, returned to the human world, and replaced the soul in its owner's body. He is said to use the soul catcher to "blow" the patient's soul back into his or her body. A shaman could also use the soul catcher to suck out intrusions that cause disease, or to blow away evil forces from a patient. This unusually elaborate soul catcher depicts crouching bears at either end, flanking a small anthropomorphic being with splayed legs and upward-bent arms. Its collector, George Emmons, noted that it belonged to the head of the Gitanyow Eagle clan, who in addition to being chief was also a shaman. These amulets were often worn around the shaman's neck.

figures are the most esteemed of all lineage property, and appear on a dizzying array of artworks, including hats, leggings, tattoos, and totem poles.

In the nineteenth century, the Haida's major ceremonial event was the potlatch that celebrated the erection of a plank house and its frontal pole; this validated the house's chief as a man of importance, and paid those who had worked on the house and pole. During potlatches, hosts served lavish meals of salmon, fish oil, and other elegant foods, which were eaten out of beautifully carved bowls with special spoons used

only at such occasions. The shape and imagery of these vessels—such as the one in figure 5.18, a bowl that integrates the forms of a canoe and a seal—made them visual expressions of wealth and abundance. The seal, its head pointing upward from a gracefully curving body, has nestled under its chin a squatting human figure, who looks almost as though he is wearing the seal as a headdress. Seals provided a pungent oil considered a precious commodity by the Haida and other Northwest Coast people. Canoes functioned as vehicles for transportation, but had symbolic significance as well; in this context the canoe shape suggested the abundance of a boat fully laden with food. This elegantly carved dish, filled with the seal oil into which food was dipped, not only functioned as a serving utensil, but also expressed the concepts of wealth that underlay the Haida hierarchy and were expressed at the potlatch.

A medium especially valued for making spoons and sometimes bowls was horn of the mountain sheep and of the mountain goat, which the Haida obtained from trading trips that brought it from the mainland. This material can be steamed, a process that renders the firm horn flexible and plastic, easily bent and shaped. Both mountain-sheep and mountain-goat horns were sometimes used for the highly valued spoons, although later in the nineteenth century cow horn was substituted (fig. 5.19). To make a spoon, the artist placed the steamed, pliant horn into a spoon-shaped mold and let it cool. He then took another horn and carved on it formline designs in relief. The two pieces were then riveted together end to end. Families kept their spoons, with handles depicting clan crests in a vertical form similar to that of totem poles, in special containers, and brought them out at the most important feasts.

Haida masquerades reenacted scenes from clan histories, depicted supernaturals, and represented ancestors. Some masks, such as the one in figure 5.4, are remarkable for their naturalism. In that example, the nostrils, nose, eye sockets, and cheeks are rendered with such precision that the mask could be the portrait of an eminent personage. The painting on its face probably represents the face-painting design owned by the dancer's clan. Although northern sculptures are sometimes difficult to distinguish from those of other regions, this kind of realism is found only on Haida masks.

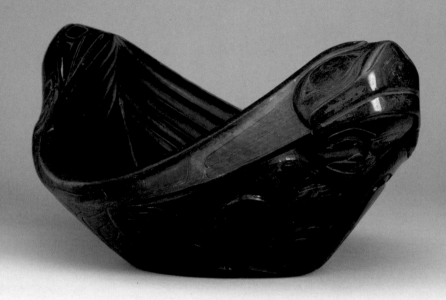

5.18   Haida. Bowl, c. 1820–50. *Alder. 7.25 x 15.5 x 10.5 in.*

Thaw Collection, Fenimore Art Museum, Cooperstown, NY, T179. Photo: John Bigelow Taylor, NYC.

The heavier formlines and smaller negative spaces suggest an early date for this
unusually large dish. Like many oil bowls, this example resembles a canoe with
its flaring sides and high ends. It also takes the form of a seal with upturned head
and tail flippers. Nestled underneath the seal's head is an anthropomorphic figure
that appears to be emerging from the body of the seal in what could be considered
an image of transformation. This dish was collected in Sitka, Alaska, around
1883—it might have come north to Tlingit territory as a gift from a clan leader.
During potlatches, hosts sometimes gave their guests lavish meals as well as the
containers in which they were served, such as this bowl.

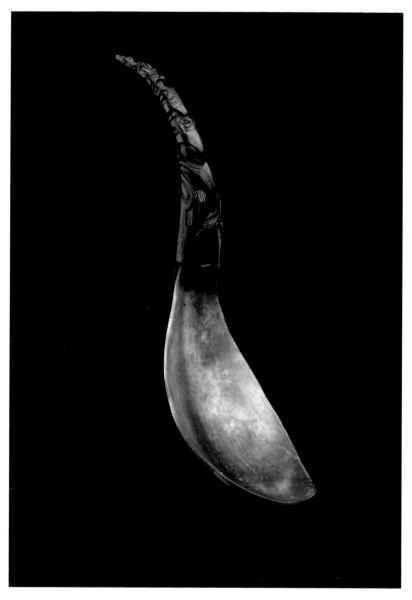

5.19  Haida. Spoon, c. 1860.

*Mountain-goat horn, copper, cow horn. 11.5 x 3 in.*

*Seattle Art Museum, Gift of John H. Hauberg, 91.1.40. Photo: Paul Macapia.*

The carved handles of spoons such as this have a structural resemblance to totem poles, with images, often intricately interconnected, stacked one atop the other. Such spoons were brought out during special feasts, and demonstrated to all the crest histories of the hosts. Many carved spoons are made entirely of dark mountain-goat horn, with the handle's shape assuming the graceful curve of that material; some, like this one, are made of two different types of horn. Originally the lighter portion was made from mountain-sheep horn. The bowl of this spoon, however, is made from cow horn that has been boiled and widened.

## Totem Poles

Totem poles, the most striking type of Haida art and one of the most frequently illustrated and commonly photographed types of Northwest Coast art, were rare until the nineteenth century. Only two stood in Dadens in the late eighteenth century, but by the first decades of the nineteenth century the numbers of poles in both Haida Gwaii and in the Kaigani-region Haida villages expanded rapidly. In 1817, Camille de Roquefeuil visited Massett and wrote:

> There is something picturesque in the whole appearance of this large village: it is particularly remarkable for the monstrous and colossal Figures which decorate the houses of the principal inhabitants, and the wide gaping mouths of which serve as a door.[3]

A decade later, poles had multiplied into small forests. For Jonathan Green, totem poles had transformed the Skidegate of 1829 from a group of primitive dwellings into a pleasant community:

> To me the prospect is almost enchanting, and, more than anything I had seen, reminded me of a civilized country. The houses, of which there are thirty or forty, appeared tolerably good; and before the door of many of them stood a large mast carved in the form of the human countenance, of the dog, wolf, etc., neatly painted.[4]

The increased wealth of chiefs and growing competitiveness between them probably stimulated the flourishing of totem poles. Chiefs with greater riches wanted more impressive visual expressions of their high positions, and they commissioned taller and more numerous poles. Artists using metal tools obtained in trade carved larger and more complex works of art, and commercial paints facilitated their decoration. The most elite houses often stood in the village center. Chief Wiah of Massett's immense house, said to have been constructed around 1840 or 1850, bore the descriptive name Monster House. A boardwalk led from the shoreline to the entrance of the sixty-foot-wide structure. Nine totem poles surrounded Wiah's house, the tallest rising to forty-five feet. All

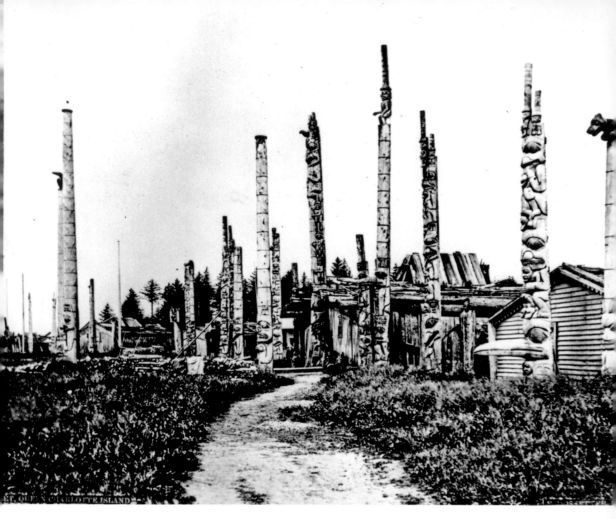

5.20  Massett. 1881.

*British Columbia Archives, B-03588. Photo: Edward Dossetter.*

The images on Haida poles are rendered in shallow relief that wraps around the
half-cylinder of the log. The individual figures often interact with those near
them. For example, the "watchman" figure on the second pole from the right
can be seen through the ear of the uppermost being. Components of that being
extend down between the ears of the next lower being. This photograph was
taken by Edward Dossetter, an American photographer who briefly maintained
an operation in Victoria. In 1881, Dossetter accompanied Indian Commissioner
Powell on the HMS *Rocket*. On that voyage, Dossetter was also commissioned to take
photographs for the American Museum of Natural History, of which this is one.

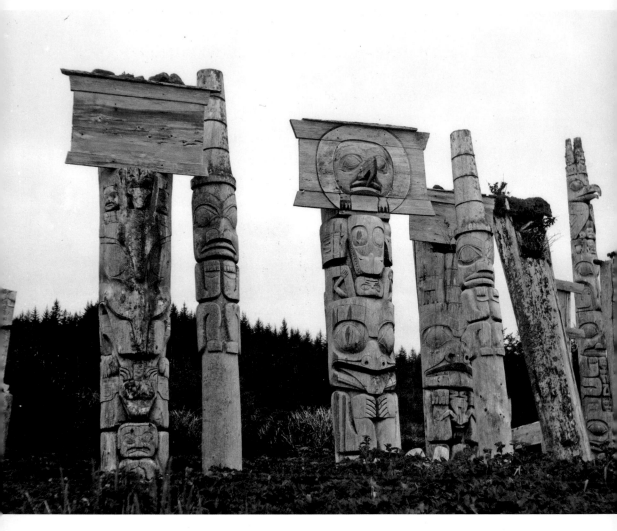

5.21  Haida. Mortuaries, SkungGwaii (Ninstints).

*Royal British Columbia Museum, E79.*

Totem poles served various functions—as house entrances, as memorials, and, as
is the case in these, as mortuaries. Remains of notable individuals were interred in
these poles. Like many villages, SkungGwaii, the southernmost Haida community,
was abandoned by the late 19th century. However, many of its poles remained
in place, as they were neither collected nor fully destroyed by the elements.
Even today one can see 19th-century totem poles there. Because of its historical
significance, SkungGwaii has been designated a UNESCO World Heritage Site.

houses had a central firepit on the floor and a smokehole in the roof, but the most opulent ones had several levels of excavation; the Monster House had an unusually deep lowest floor, which had been excavated by hundreds of workers.

The Haida constructed two types of buildings: House Type A, with seven roof beams, six of which project several feet past the front and rear facades; and House Type B, with four non-projecting beams (see fig. 1.7). These structures were inevitably associated with totem poles, which punctuated the sky—some stood attached to the house facades, some stood between the buildings and the shore. Faces and bodies of bears, ravens, killer whales, salmon, and humans populated these poles, their delicately carved images functioning as historical documents that heralded the history as well as the prestige of the families within the houses. The Haida produced three types of poles: the attached frontal pole, which stood adjacent to the house and had at its base a hole through which one entered and exited the building; the memorial pole, which was erected in honor of deceased notables; and the mortuary pole, which held the remains of the dead. When a nobleman died, his body, in full regalia and surrounded by his treasured crest items, was laid out at the house rear. As among the Tlingit, all work to prepare and inter the body was performed by moiety opposites, ideally of the father's clan. Remains of dead nobles were placed in mortuary posts, the most elaborate of which consist of a large box that can hold several bodies, raised above the ground on one or two poles (fig. 5.21).

The abundance of totem poles among the Haida impressed everyone who visited those remote islands. Many scholars believe that the Haida originated this impressive form of monumental carving, in most likelihood during late precontact times. After the Haida invented this type of crest monument, it spread from Haida Gwaii to the Kaigani region of Alaska and to Tsimshian territory. From there, poles spread north to the Tlingit and, in the later nineteenth century, south to the Wakashan groups (see pp. 176–78).

OF THE FEW early- to mid-nineteenth-century artists whose names we know, Haida Albert Edward Edenshaw (c. 1812–1894) is among the most important. Edenshaw claimed to be "the greatest chief of all the Haidas," and hosted a good number of potlatches to validate that claim. Various small and monumental artworks have been attributed to him, including a headdress frontlet depicting a dogfish (fig. 5.22) and several totem poles. He was the uncle and teacher of the best-known and most highly respected late-nineteenth-century artist, Haida Charles Edenshaw, who worked during a time of greater social upheaval (see pp. 196–97).

In addition to his high status among his own people, Albert Edward Edenshaw enjoyed a good reputation among non-Natives. He worked as a pilot for boats that sailed the sometimes treacherous waters around Haida Gwaii, traded with considerable skill, and was sometimes asked to protect traders and travelers from antagonistic Haida. William Henry Hills, a crew member of the *Virago*, had this to say about the thirty-five-year-old chief:

> He is decidedly an interesting character, and an example of what splendid abilities are only waiting culture among these Indians. He would make a Peter the Great, or Napoleon, with their opportunities. He has great good sense and judgment, very quick, and is subtle and cunning as the serpent.... He is ambitious and leaves no stone unturned to increase his power and property.... He talks very intelligible English; and is a very sharp hand at driving a bargain.... Wears his hair in European style, and whenever we saw him was always dressed neatly ... [in] a blue cloth traveling cap, white shirt, and black silk handkerchief, blue cloth monkey jacket, white waistcoat, blue cloth trousers and boots; and every article fitted as if made for him.[5]

But at least one episode suggests it had not been wise for the schooner *Susan Sturgis* to trust Edenshaw when it employed him in 1852. Apparently, when the ship was close to Massett, he told a local chief that the *Sturgis*

5.22 Albert Edward Edenshaw, Haida. Dogfish headdress.

*Wood, abalone, sea-lion whiskers, feathers, down, pigment, ermine. 7 x 6 in.*

Denver Art Museum Collection: Native Arts acquisition funds, 1948.315.

The dogfish, a small bottom-feeding shark, is a major Haida crest. In representations of dogfish, their high, domed foreheads contain repeated curves that represent gills. Frontlets were indications of rank, and were often worn with Chilkat robes, as shown in figure 5.12. The detailed stylistic analyses of Robin Wright have identified a good number of works that have no documentation as to their authorship. This carving, according to Wright, displays the characteristic eyes, ovoids, and formline designs that are Albert Edward Edenshaw's stylistic signatures.

was poorly protected and could be captured without much difficulty. The next day, twenty-five canoes with 150 Haida in battle dress approached the ship, which, because Edenshaw had given no warning, was unprepared to defend itself. The warriors boarded, robbed the passengers, took them hostage, and burned the ship. Edenshaw then argued that the passengers should not be killed, because the Hudson's Bay Company would pay a good ransom for them, which they did. Edenshaw's involvement in the attack was never actually proved, and many considered him a hero for saving the hostages' lives. It could be that Edenshaw used his share of the booty from the *Sturgis* episode to host great potlatches and display more art. Albert Edward Edenshaw, a great chief who maintained Haida traditions and created significant artworks, was also a man who cleverly adjusted to the intruders and turned their presence into opportunities for profit, wealth, and art-making.

Albert Edward Edenshaw was an example of how interactions between Native and non-Native people contributed to artistic flourishing. It is interesting to speculate on the effects of such interactions upon the development of the northern style in general. If there is one type of Northwest Coast art universally admired, and thought of by many to be the epitome of aesthetic achievement of the entire region, it is the creations of Haida, Tlingit, and Tsimshian masters. These display refinement, elegance, and exquisite craftsmanship that justify high praise. Archeological evidence and objects collected by the first Europeans to visit the area reveal their prehistoric roots. Nevertheless, such "classic" northern works, like the "classic" works of the central and Salish areas, did not occur in a historical or cultural vacuum but represented in part creative responses of the northerners to the foreigners with whom they traded. Wealth brought about by the initially maritime and then land-based fur trade, coupled with destabilized social hierarchies that resulted from amalgamated villages as well as from periodic population decimation, inspired the increased use of public art such as totem poles and painted house facades, and of lavish displays of crest images at potlatches.

The northern formline style became tighter, more controlled, and more precise during the initial decades of encounter. Perhaps because art could serve as a visual support and endorsement of the hierarchy, it endeavored to maintain its highly formalized rules of social engagement

in the light of changing ways of life. "Classic" northern Northwest Coast art, therefore, emerged in part not from the pristine world of "pure" and unacculturated Native people but rather from the creativity of those who rose to the challenges of their new situations.

# SETTLEMENT AND
# ITS CONSEQUENCES

THE PREVIOUS CHAPTERS have presented Northwest Coast art and
culture as it existed during a period of relatively little intrusion—but
significant influence—from settlers. From the time of first contact to
the mid-nineteenth century, many Native–Euroamerican interactions
on the Northwest Coast were mutually beneficial. The exception was, of
course, the precipitous population declines caused by infectious diseases.
Nevertheless, the tremendous influx of wealth enhanced the position of
certain families, encouraged ceremonialism, and nurtured art produc-
tion. Most Euroamericans had vested interests in maintaining good
relationships with Native people in order to ensure the continuation of
their sole objective: trade. This resulted in relatively respectful, equal, and
peaceful interactions between the inhabitants and their visitors. When
groups left traditional village sites for new ones, such as Fort Simpson and
Fort Rupert, they usually did so of their own volition, rather than being
forced to do so. This all began to change in the middle of the century.

BEFORE 1849, the Hudson's Bay Company's interest in British Columbia was purely economic. In that year, however, the British Crown granted the company a royal charter for the colony of Vancouver Island, and charged it with encouraging and promoting settlement. "Civilized" folk were to appropriate the land being wasted by the "lazy savages" and make it productive. James Douglas, chief factor of the company, was appointed governor of Vancouver Island in 1851. In 1858 the mainland was also chartered, as the colony of British Columbia, and Douglas became governor of both colonies. As a longtime resident of the region since the fur trade years, Douglas had greater understanding and sympathy for the First Nations than the colonists would prove to, although he remained a man of his time and supported British settlement of the region. To deal fairly (from his perspective) with residents of lands needed for settlement, Douglas negotiated fourteen treaties for parts of the Victoria region and for land around Fort Rupert and Nanaimo. In these treaties, most land became the property of whites "forever," leaving some village sites as reserves for Native use. Douglas's treaties were unique efforts, not replicated elsewhere in the province before Douglas left his post. Unlike the standard Canadian and United States policies that recognized aboriginal title and the consequent need to make treaties with First Nations for their land, the colonies of Vancouver Island and British Columbia decided that Native title to land simply did not exist. This, in their minds, made treaties unnecessary, something that would haunt the province in later years.

Settlers began arriving in ever larger numbers, to the chagrin of Native groups. In 1852 the Haida drove away the gold miners on Haida Gwaii, and in 1857 the Thompson River people did the same with miners in their interior homeland. But foreigners simply could not be held back, for by 1858 huge numbers of gold-seekers had arrived in British Columbia, bringing an end to the fur trade era and opening the era of settlement that would permanently shift the power balance and ultimately turn the First Nations of the region into minorities in their own land. In 1881, the Native population of British Columbia was approximately 26,000, and settlers numbered 24,000. Ten years later, Native population was slightly less than in the previous decade, but settlers had increased to 70,000. And by 1901,

British Columbia had a total population of 178,657, with just 24,000 First Nations people.

Almost from the start, the settlers showed neither respect for nor understanding of the Native population, and treated First Nations with a racism we find appalling today. Fort Victoria, which had been founded in 1843, became a major city whose Euro-Canadian residents objected to the presence of the local Salish, and feared the Haida, Tsimshian, and other northern people who canoed south annually to trade. As settlers grew in numbers, they began to clamor for more protection from or even expulsion of the "savages" from their communities. A letter to the *British Colonist* in 1859 shrilly asked, "How much longer are we to be inflicted with the intolerable nuisance of having hundreds of hideous, half-naked, drunken savages in our midst ... teeming ... reeling about and shouting?"[1] When the 1862 smallpox epidemic hit the slums of Victoria, officials evicted the residents and burned their houses. This forced diseased people, especially the Haida, to canoe back up north; as they paddled to their homes they also infected communities along their routes, and hundreds died. By that time, medical knowledge was such that officials could have known that this expulsion would lead to disaster, and the disease could have been properly contained within Victoria. But that was not the goal of the settlers.

After Douglas retired from his governorship, official opinion about the Native people of British Columbia began to buttress the racist attitudes of settlers. Joseph Trutch, as commissioner for land and public works from 1864 to 1871, was responsible for the lands of Native people, whom he described as "utter savages living along the coast, frequently committing murder amongst themselves, one tribe upon another, and on white people who go amongst them for the purpose of trade."[2] Trutch wanted to leave the Native people with as little land as possible, and worked toward that end. In 1865 the *British Colonist* published a letter arguing against any Native right to the land:

> Shall we allow a few vagrants to prevent forever industrious settlers from settling on the unoccupied lands?... Locate reservations for them on which to earn their own living, and if they trespass on white settlements punish them severely. A few lessons would soon

enable them to form a correct estimation of their own inferiority, and settle the Indian title too.[3]

British Columbia and Vancouver Island were united into a single colony in 1866, and joined the Confederation of Canada in 1871. Now responsibility for its Native people resided not in the province but in Ottawa. In 1872, the national government appointed Dr. Israel Powell, a Victoria physician who knew very little about the British Columbia First Nations, to be Superintendent of Indian Affairs. Powell learned relatively little about Native culture despite his years as superintendent, and did not advocate for their interests during his tenure. For example, he did not challenge commercial fishing and cannery operations when, in the 1870s and 1880s, they began appropriating aboriginal fishing territories, depriving residents of their traditional means of subsistence.

Perhaps the most contentious, and certainly the most long-lived, disputes between settlers and aboriginal inhabitants of British Columbia involved how much land would be allocated to Native families. Elsewhere in Canada, families on Native reserves each had 160 acres, or 1 square mile. Recognizing the interests of the settlers, Ottawa proposed that reserves in this new province be 80 acres per family. Resisting what they considered unjustified land-generosity, local British Columbian officials argued that 20 acres per family was adequate. This particular phase of land disputes would not be resolved until 1924.

During the last decades of the nineteenth century, both United States and Canadian official government policy toward aboriginal peoples was assimilation. The goals of assimilation, shared by missionaries, teachers, and government functionaries, were to destroy tribal organization, educate Native people in "civilized" ways, and in general transform Natives into whites. The Northwest Coast people posed special problems to the assimilationists, because these hierarchically organized people with a keen sense of property devoted considerable time and effort to accruing wealth not to save it, but rather to give it away. Officials and missionaries both firmly believed that what they judged to be senseless extravagances had to be eradicated before Northwest Coast Native groups could be "civilized." As a result, in 1884 the Canadian government banned the potlatch and related dances:

Every Indian or other person who engages in or assists in cele-
brating the Indian festival known as the "Potlatch" or the Indian
dance known as "Tamanowas" [shamanic or shaman-like perform-
ances] is guilty of a misdemeanor and shall be liable to imprison-
ment for a term of not more than six nor less than two months in
any gaol or other place of confinement; and any Indian or other
person who encourages, either directly or indirectly, an Indian or
Indians to get such a festival or dance, or to celebrate the same, or
who shall assist in the celebration of same is guilty of a like offense,
and shall be liable to the same punishment.[4]

In other words, in addition to taking the Natives' lands, reducing their
ability to maintain a subsistence economy, and endorsing racist attitudes,
the government criminalized ceremonies that were central to Native
identity and culture. Officials and missionaries who in the late nineteenth
century observed the ongoing potlatches saw haughty, self-aggrandizing
oratory on the part of the hosts, serious rivalries between hosts and
guests, and occasional destruction of property, and had no idea that these
highly competitive affairs had developed since contact from compara-
tively low-key affairs into elaborate events as a result of Native–white
interactions.

## THE AMENABLE HAIDA, THE "INCORRIGIBLE KWAKIUTL"

IN SOME CASES, legislation was not even necessary to put an end to
potlatching. This was the case among the Haida. This group had profited
immensely during the maritime fur trade years, as they had productive
harvests of sea otters. They had a dearth of terrestrial fur bearers that
could sustain a similar level of commerce, but they responded inventively
to the decline in trade by developing other ways to generate income.
Discovering the potential of potato cultivation, they began a healthy agri-
cultural business. From the immense cedar trees that grew in Haida Gwaii
they manufactured excellent seaworthy canoes, which they sold up and
down the coast. And, realizing the desire Euroamericans had for souve-
nirs, they initiated a lively and profitable trade in small-scale artworks
such as model totem poles (see pp. 193–97).

Always excellent traders, the Haida made regular trips to the Hudson's Bay trading center at Fort Simpson, where they exchanged goods with white traders there as well as with Tsimshian, Tlingit, and whatever other Northwest Coast groups were present. By 1860, these entrepreneurial island dwellers were regularly canoeing south to the city of Victoria for even better trading opportunities. The 1862 smallpox epidemic hit the Haida especially hard, ultimately leaving only 10 percent of their entire original population. Whole villages became ghost towns when almost every inhabitant died. The survivors moved to one of the two surviving communities, Massett and Skidegate, built houses, and erected their last mortuary and memorial columns. By the 1880s, the decimated Haida had assumed the "progressive" path—they welcomed missionaries and teachers, stopped potlatching, and almost entirely ceased production of traditional crest art. And they stopped carving totem poles.

By the late nineteenth century, authorities considered groups such as the Haida as models of assimilation. Totally different were the Kwakwaka'wakw, whom officials termed "incorrigible" because they persisted in giving away enormous quantities of goods and continued performing ceremonies such as the *hamatsa* dances. When Canadian authorities began to enforce the anti-potlatch law, the Kwakwaka'wakw designed various subterfuges to avoid it. Sometimes they would hold potlatches in remote villages in the middle of winter, when police had difficulty traveling about. Sometimes they would have potlatches around Christmas, insisting that they were merely giving away Christmas presents. And sometimes they would give immense sacks of flour or sugar, as well as boxes of biscuits, claiming that they were providing food for their hungry neighbors.

Because the Kwakwaka'wakw insisted on potlatching, they continued to need art. While some Northwest Coast groups abandoned most of their traditional works by the end of the nineteenth century, the Kwakwaka'wakw continued to make art that was, if anything, more lavish and baroque than mid-century pieces had been. They had erected relatively few totem poles during the nineteenth century. But in the first decade of the twentieth, poles began to proliferate, especially in Alert Bay (figs. 6.1, 6.2). Totem poles, which were meaningless without the potlatch

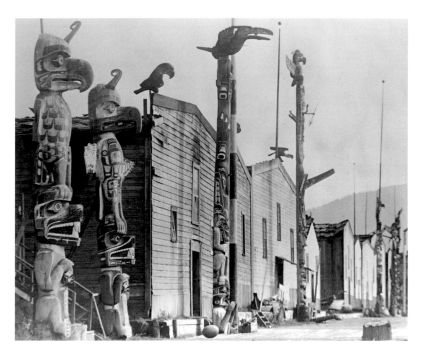

6.1  Kwakwaka'wakw village of Alert Bay, c. 1917.

© Canadian Museum of Civilization, 41968. Photo: Percy Algernon Taverner.

By 1917, Alert Bay was the most important Kwakwaka'wakw village, and it became a renowned center for art and (illegal) ceremonialism. The site of the present village on small Cormorant Island, not far from mainland Vancouver Island, was used for subsistence activities by the Nimpkish tribe. When a fish saltery was built there, Nimpkish from Vancouver Island moved to be closer to sources of income as well as provisions. Turn-of-the-century guidebooks praise Alert Bay as a major totem pole center, and many tourists stopped off there on their way to Alaska.

that validated their erection, signified an ostentatious disregard for the law and visually expressed Kwakwaka'wakw resistance to white authority.

## ALASKA

ALTHOUGH Russians did colonize and send missionaries to Alaska, at any one time there were probably no more than 500 Russians and 1,200 Creoles (of mixed Russian and Native descent) in the entire territory. In 1867, Russia sold Alaska to the United States for $7,200,000. On October 18

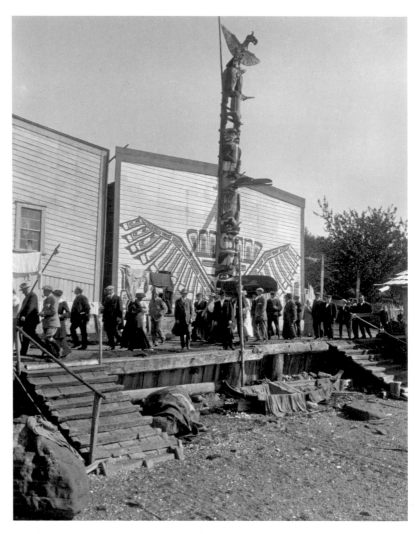

6.2   Kwakwa̱ka̱'wakw. Wakius house, Alert Bay, visited by tourists.

*University of Washington Libraries, Special Collections, NA2760.*

The projecting beak of the lowermost raven was made from the front of a dugout
canoe. It could open and shut (much like the *hamatsa* bird masks) and be used
as a house entrance. So intrigued by this architecture was Edward Curtis that he
replicated the facade and pole for his film *In the Land of the Head Hunters* (see
pp. 205–7). This pole was acquired by the Art, Historical and Scientific Association
of Vancouver, which in 1924 erected it along with several other poles in Stanley
Park. In 1987 it was transported to Hull, Quebec, to stand in the Grand Hall of the
new Canadian Museum of Civilization (see fig. C). The pole that stands today in
Stanley Park is a replica of the original.

of that year, the Russian flag at Sitka was lowered and the American one raised, immediately transforming the Tlingit, Kaigani Haida, and all other Native Alaskans into wards of the federal government, as was the United States' policy. According to the Treaty of Cession, "the uncivilized tribes will be subject to such laws and regulations as the United States may, from time to time, adopt in regard to the aboriginal tribes in that country."[5]

The Tlingit believed this sale to be illegitimate, arguing that because Native Alaskans, not Russians, were the rightful owners of the region, the United States should pay *them* the $7,200,000. Several councils of clan chiefs came together as a united front—for one of the first times in history—to present their objections to the sale. A U.S. Treasury Department special agent recorded in 1869 that this group formally protested this sale made without their consent, but took no action. Instead of showing respect, U.S. officials treated the southeast Alaskans with hostility.

The Russians had maintained an uneasy truce with the Tlingit for decades, having learned they could do little to wield control over this proud group. The United States inherited the supervision of the Tlingit, whom they considered ferocious, bullying, and smart. General Jefferson Davis, Military Commander for the District of Alaska, had orders to "exercise the most careful vigilance, as these Natives are known to be both warlike and treacherous."[6] As a result, the army and navy were quick to respond to real or perceived threats, taking harsh action against hostile villages. For example, in 1868, some residents of Kake killed two white men in retaliation for an earlier killing of a villager by the army. In response, the navy sailed to Kuiu Island and burned down virtually all the Tlingit houses. And in 1882, the navy destroyed the village of Angoon in retaliation for some of its residents having kidnapped a white person.

The military ruled Alaska between 1867 and 1884, with first the army and then the navy occupying the land. During this anarchic and chaotic period, little law and order prevailed either in the tiny white communities of Sitka and Wrangell or in the Native villages. Alaska's economy plummeted. Despite their initially low numbers, the intrusion of the Americans—or, more precisely, the military occupiers—into Native territory led to significant changes among the Tlingit. In contrast to the Russians, for whom it had been illegal to sell spirits to the Native people,

the Americans almost encouraged the use of alcohol, which became part of Tlingit culture as they learned how to construct stills and distill alcohol. Many clan houses had stills, and alcohol began to be as important as lavish food at potlatches, leading to the excesses and social devastation common among so many other alcohol-ravaged Native Americans and Native Canadians.

The situation worsened, as it had in British Columbia, with the discovery of gold in 1880. After Joe Juneau and Richard Harris found gold in Auk territory, thousands of people from the United States began pouring into the region, and the city of Juneau sprung up. With a burgeoning population, lawlessness increased, as did the mistreat-ment of Native residents. This appalled a committed and determined Presbyterian missionary, Sheldon Jackson, whose life's vocation was to improve the living conditions of Alaska Natives. Jackson had established a mission in Wrangell in 1877; shocked by the brutal chaos of the frontier and by the newcomers' viciousness toward the Native population, he petitioned Congress to establish some form of functioning civilian government.

In response, the United States Congress passed the 1884 Alaska Organic Act that applied the laws of Oregon State (the closest state at the time) to Alaska and established the positions of governor, district judge, attorney, four deputy marshals, and four U.S. commissioners. In contrast to the policy in the contiguous United States, where Natives lived in tribes on reservations, Alaska Natives were treated as individuals in this legislation. Only the Tsimshian community of Metlakatla in the southernmost area of the state was a reservation. The Organic Act declared that Native people possessed sites "where permanent villages existed or other areas which were actually and visually occupied and improved by individual Indians." Unfortunately, this left tracts of land open for exploitation, and deprived not only the southeast people, but all Alaska Natives ownership of many traditional hunting, fishing, and gathering territories. As with the British Columbia First Nations, land claims were contentious in Alaska, where they were not properly settled until the mid-twentieth century.

## Missionaries in Alaska

The majority of white settlers in Alaska felt utter disdain for the Native peoples whose lives they had so seriously disrupted. Although some Protestant and Catholic missionaries agreed with those settlers that Native people were inferior and barbaric, many had different attitudes, believing it possible to improve these unfortunates' souls and transform them into responsible, productive people differentiated from others only by the color of their skin. This, naturally, required total submission to Christianity and total rejection of traditional ways —something that education would accomplish. In both the United States and Canada, education usually meant education in English; students were prohibited from, and sometimes punished for, speaking their Native languages.

By 1882, the Presbyterian church had six schools operating in southeast Alaska, and succeeded in converting large numbers of Tlingit and Haida. However, some Tlingit found the Russian Orthodox church far more sympathetic to their clan traditions, and during the last decade of the nineteenth century, considerable numbers of more conservative people converted to that faith. Unlike the more austere practices of the Protestants, the elaborate and aesthetically rich Orthodox services attracted Native people used to rituals with regalia and complex ceremonials. Some ancient Tlingit beliefs actually became syncretized with Russian mortuary and memorial rituals, adding to this religion's attractiveness.

Some missionaries showed unusual understanding of Native culture. For example, Sheldon Jackson realized that a consequence of the education he so avidly promoted would be rapid change in the traditional ways of Native life. Unlike many other missionaries who wanted to eradicate all aspects of indigenous culture, Jackson thought it necessary to preserve, in a museum, artifacts that could educate the properly acculturated Indians about their past. He wrote in 1887 that he was forming a museum to "procure and have on hand for study of the students the best specimens of the old work of their Ancestors; otherwise, in a few years there would be nothing left to show the coming generation of Native people how their fathers lived."[7] His first collection, an array of Haida carvings in argillite, a type of shale, arrived in 1888 (fig. 6.3). In striking contrast to the museums in New York, Washington D.C., Chicago, and elsewhere to

the south that were at the time acquiring large amounts of Northwest Coast art, Jackson's museum presented work to a community with a large Tlingit population. Indeed, Jackson's was the only museum established at the time expressly for the preservation of Native materials *for the benefit and education of Native people.*

### John Brady

Jackson's conviction that education would improve the future of the Tlingit was shared by another man who was for a time a Presbyterian minister, John Brady. In 1881, Brady founded the Sitka Industrial Training School dedicated to "improving" the quality of life of Native people. One component of his agenda for bettering these people was for them to produce art for sale. John Brady had always been fascinated by Native art and wrote that "Nearly everything they use has some sort of carving on it—their halibut hooks, knife handles, spoons, pipes, baskets, dancing apparatus.... This talent could be cultivated and made a source of income to them."[8] Consequently, the Sitka School offered young men the opportunity to earn money from their heritage by promoting and marketing the creation and sale of model totem poles, which tourists enthusiastically purchased.

Brady, who served as Alaska's governor from 1897 to 1906, also shared Jackson's passion for saving the past. From 1901 to 1903, Brady, in keeping with his interest in preserving the culture of the (he hoped) assimilating Natives, approached several Tlingit and Kaigani Haida chiefs, asking them to donate their totem poles to a new totem-pole park he intended to set up in Sitka. He assured them that these treasures would be well cared for, protected, and treated with the great respect they deserved. The first such chief who agreed to donate his clan's treasures, Saanaheit of Kasaan, showed his understanding of the significance of his generous donation in his statement, "The conditions [for this donation] are that these are to be transported to the government park at Sitka and be erected and remain there as memorials to my people."[9] The totem poles, in effect, had evolved from memorials to individual deceased chiefs of specific clans into memorials for an entire group whose culture was expected, by both Natives and non-Natives, to disappear as religious conversions and English education took hold. After Saanaheit's donation, other chiefs in

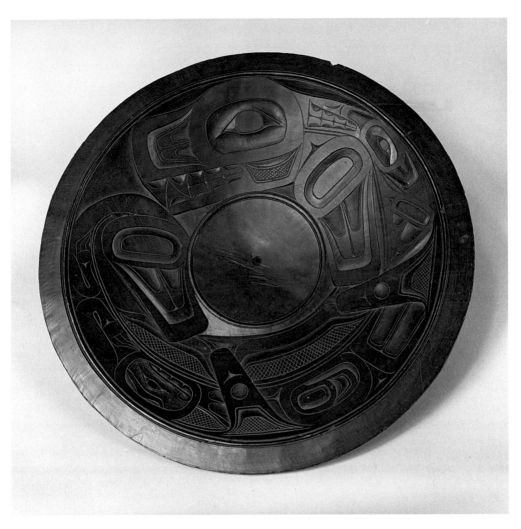

6.3   Haida. Platter, 1880s. *Argillite. 10.25 in.*

*Sheldon Jackson Museum, Sitka, I-B-23.*

Reverend Sheldon Jackson obtained this platter, along with a number of other argillite works, in 1887 from a store in Metlakatla run by a Protestant missionary there. Soon afterward, he donated it to his newly established Sheldon Jackson Museum in Sitka, Alaska. This kind of circular platter was a popular trade item among the Haida, who carved argillite for sale to visitors and collectors. It depicts a double-finned killer whale gracefully wrapped around the central circle. Its face appears at the top, one fin at three o'clock, the other at six o'clock, and at nine o'clock, the tail turned in under the whale's mouth.

Kaigani Haida and Tlingit villages joined in, and Brady acquired eighteen poles. The governor traveled to the villages on the U.S. government revenue cutter *Rush* to collect his treasures; figure 6.4 is a photograph, taken by one of the crew members on that ship, of an unidentified chief standing before the Wolf pole in 1903, shortly before it was removed. These treasures ended up traveling outside the state for a few years prior to their final installation in Sitka National Historical Park, for Brady decided to send them to the St. Louis world's fair as the centerpiece of the Alaska exhibition (see pp. 211–13).

Brady admired the past, but actively promoted a "civilized Indian" of the future. Like most whites, he disapproved of the potlatch, although it was never made illegal in Alaska. To encourage local rejection of the ceremony, Brady urged the Tlingit to celebrate "one last potlatch," at which their past would be acknowledged, but their future planned. This event occurred in Sitka over several weeks in late December 1904, and participants from many Tlingit villages came in their most colorful and striking regalia (fig. 6.5). The local newspaper, the *Daily Alaskan*, carried the story of the highly successful event:

> The Indians have had one or two prosperous seasons, and great quantities of money and merchandise are being given away. The program is one of alternating feasts and dancing. Every morning and afternoon there is a great feast … at the feasts the man or woman who can eat the most is regarded as the special hero of the occasion and he receives an extra allowance of the good things it is within the power of the hosts to bestow.[10]

The various religious orders of the town were horrified by what they considered outrageous excess, and feared that the traditionalists among the participants might convince younger Tlingit to continue the old ways. The "last potlatch" concluded with chiefs declaring that they had given up their customs and presenting Brady with the cherished Raven Hat worn by their ancestors when fighting the Russians, which he deposited in the Sheldon Jackson Museum. But like the Kwakwaka'wakw and some other Northwest Coast groups, some Tlingit paid only lip service to this pledge and did not cease potlatching.

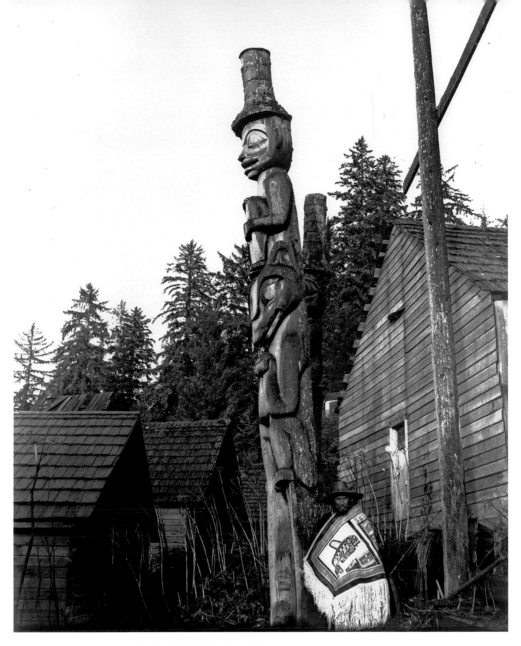

6.4 Howkan(?). Wolf pole and donor, 1903.

*Sitka National Historical Park, SITK 3825.*

In 1902 and 1904, Alaska Governor John Brady collected totem poles donated by southeast Alaskan chiefs to be placed in a park in Sitka. During the travels to retrieve them, several photographs were taken of the poles still in situ. This photograph shows the Wolf pole, probably (although not certainly) in Howkan, with a chief, presumably its owner, standing beside it. Before this and other poles were erected at the Sitka National Historical Park in 1906, they traveled to world's fairs in both St. Louis and Portland. Like so many other totem poles that stand outside in the damp Northwest Coast climate, the Wolf pole became so deteriorated that in 1981–82 Reggie Peterson carved a new version, which stands today in the park.

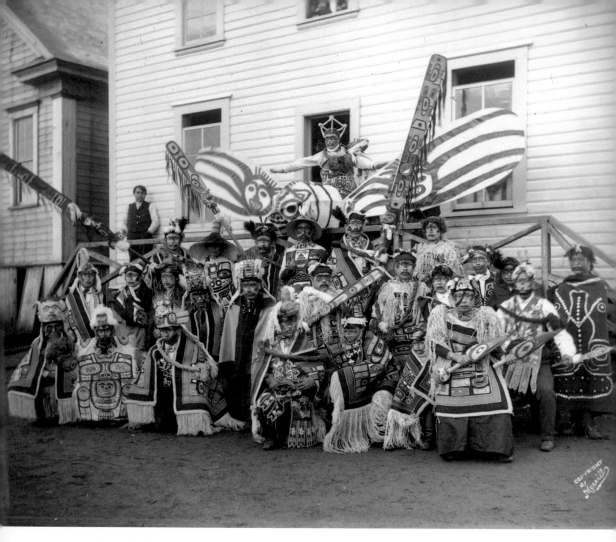

6.5   Angoon dancers from Teikweidi clan (Tlingit)
at "The Last Potlatch," Sitka, 1904.

*Alaska State Library, Elbridge W. Merrill Photograph, PCA 57-28.*

This group of dancers, some with face paintings, wear Chilkat robes, button
blankets, frontlets, conical hats with nobility rings, and other headdresses. The
long staffs, commonly called "song leader's staffs," are carried as clan designators
by each group's leader. During dance performances, the staff bearer shakes the
carving in rhythm to the drumbeat. Other dancers carry smaller staffs. The fourth
man from the left in the first row and the second man from the far right both hold
"octopus" bags, so named for the hanging tabs that carry floral beadwork designs.
Originally traded from the interior tribes, this type of regalia became part of many
noblemen's finery.

6.6 Haisla. Grave marker, Kitamaat, 1902–6.

*Royal British Columbia Museum, PN 11366. Photo: George Raley.*

This grave marker displays a hybrid of Native and non-Native concepts. The base gives the deceased's name and other information commonly found on tombstones. Above it, however, a crouching bear with small faces in its ears and hands demonstrates the endurance of crest imagery. The photographer of this image, George Raley, was the Methodist minister at Kitamaat, and, although anxious to convert the residences and educate them to white ways, he also actively promoted Native arts and craft activities as a means of economic self-sufficiency.

THE UNENDING INFLUX of settlers, missionaries, and government agents affected Northwest Coast art in a variety of ways. Certain groups drastically curtailed their art production, some devoted all their artistic energies to making art for tourists or museums, and others continued making art for internal uses, but with less concern for the classical canons. For example, the late-nineteenth-century Tlingit Thunderbird screen discussed in the introduction (see fig. B) lacks the smooth-flowing connections that result from application of a fine and precise formline network. Instead, individual elements placed on the surface have little association with one another, and appear as disjointed units rather than components of an organic whole. The workmanship lacks the precision and symmetry of earlier works, and presents a slipshod appearance. The "golden age" of Northwest Coast art had come to an end. But an end of an era of formally excellent art does not, in this case, signify the death of that art. True, the art was no longer as abundant or as fine as it had been, but artists continued to produce visual expressions of their heritage. There would always be some demand for art in certain communities, such as the Tlingit who commissioned the Thunderbird screen, and the Kwakwa̱ka'wakw who needed masks for their *Tseka* and *Tlasala* performances. Even those who fully converted to Christianity did not entirely abandon their crest system, as they depicted treasured clan images on their Christian gravestones (fig. 6.6). Despite external appearances, Native people had not been completely assimilated into the white world, and their traditional culture was by no means eradicated. Instead, under very difficult circumstances, Northwest Coast art managed to survive throughout the twentieth century.

## PUBLIC AWARENESS OF
## NORTHWEST COAST ART

AFTER THE INITIAL curiosity of the early travelers who, infused with the scientific spirit of the Enlightenment, acquired "artificial curiosities," until the 1880s, non-Native people paid relatively little attention to Northwest Coast art. Indeed, this region and its culture remained relatively unknown to the majority of Canadians and Americans until tourism, world's fairs, and museums provided opportunities for them to become familiar with a foreign yet impressive body of art. It is one of the great ironies of colonial history that once the Northwest Coast people had been subjected to governmental authority and converted to Christianity, thus turning into unthreatening minorities in their appropriated lands, their artistic culture became more valued. Indeed, so intriguing had Native culture become to outsiders that a group of Nuxalk dancers brought to Germany in 1886 proved to be an exceptionally popular attraction.

SHORTLY AFTER the completion in 1882 of the transcontinental railroad connecting the east and west coasts of the United States, passenger steamship service to Alaska on the Inside Passage began. Tourists could embark in San Francisco, Portland, Seattle, and Victoria and travel north. The naturalist John Muir wrote the following about the behavior of these 1890 travelers who stopped in Wrangell on their way to Glacier Bay:

> There was a grand rush on shore to buy curiosities and see totem poles. The shops were jammed and mobbed, high prices being paid for shabby stuff manufactured expressly for the tourist trade. Silver bracelets hammered out of dollars and half dollars by Indian smiths are the most popular articles, then baskets, yellow cedar toy canoes, paddles, etc.[1]

Even the extraordinary sights of Glacier Bay itself might be forgone for shopping:

> She arrived about 2:30 p.m. with two hundred and thirty tourists. What a show they made with their ribbons and Kodaks! All seemed happy and enthusiastic, although it was curious to see how promptly all of them ceased gazing [at the glacier] when the dinner-bell rang, and how many turned from the great thundering crystal world of ice to look curiously at the Indians that came alongside to sell trinkets.[2]

In Muir's time, as today, shopping for curios was a favorite pastime, for tourists wanted to return from this splendid land with some memento of their travels, usually in the form of a Native artwork.

The early tourists, fascinated by the totem poles they saw, ranked the poles among the "must-sees" on every tourist itinerary. For example, note the group of tourists exploring Alert Bay in figure 6.2. In addition, their desire for curios generated a demand for what has been disparagingly designated "tourist art." Certainly there exist many examples of tourist art on the Northwest Coast that are poorly made,

and doubtless Muir's descriptions of "shabby stuff" was accurate for some items created expressly for the tourist market. But many other pieces made for sale displayed craftsmanship as fine as in works used within Native communities.

Even today, another objection to such art is that because it was not used within the community, "tourist art" is inauthentic. This evaluation is based on the flawed concept that only unacculturated, pristine communities untouched by Euroamerican influences were authentic. In recent years, scholars have reassessed the nature of art made for outsiders, giving it the respect and credibility it fully deserves. It is axiomatic that any item made by a Native person is an authentic Native article, regardless of its intended destination, whether a potlatch or a mantlepiece in Philadelphia. The Native artist was fully aware that his creation was intended for outside consumption, and took advantage of the opportunity to share his culture with foreigners. Sometimes, in fact, tourist art was the *only* type approved of by teachers and missionaries, and thus the sole permissible expression of Native artistic culture.

The market for souvenirs stimulated the development of models and miniatures, which had doubtless been made in earlier times as children's toys. Especially popular were model totem poles (such as those made in Brady's school), thousands of which flooded the market. Dolls also found a willing market. Also valued by visitors were model canoes, which probably appealed especially to seamen who could admire these seaworthy vessels. Such models served not only as charming mementos of trips to this misty land, but also became valuable sources of ethnographic information. For example, no full-size "head canoe" described by the earliest travelers to the region exists in collections, but models such as the one shown in figure 2.8 document the early history of Northwest Coast water craft. Some artists included images of humans performing various activities, and sometimes artists even portrayed Euroamericans in their creations, such as the carving in figure 7.1, which depicts two sailors.

In addition to being works of art, desirable tourist purchases, and sources of ethnographic information, Northwest Coast souvenirs (and those of other regions as well) made significant contributions to the Native economy. By the late nineteenth century, Euroamericans and Canadians had so severely disrupted the traditional subsistence economy

7.1  Haida. Pair of sailors carved in argillite, c. 1845. *Argillite, ivory. 18.5 x 7.75 in.*

*Thaw Collection, Fenimore Art Museum, Cooperstown, NY, T187. Photo: John Bigelow Taylor, NYC.*

The residents of the Northwest Coast found the newcomers intriguing, and learned
quickly of their lust for souvenirs. The Haida, who in the 1820s first carved argillite
pipes for sailors who visited their land, began crafting figures of that material
in the 1830s. Their attention to detail of clothing, hairstyle, and facial features
suggests a fascination with these foreigners. After the 1862 smallpox epidemic,
however, artists stopped carving Euroamericans and devoted themselves entirely
to traditional Haida imagery.

that many Native people had to purchase food and other commodities from white-run stores. Because the market for tourist art coincided with the new need for cash, carved masks and woven baskets that had originally functioned within the community were sold alongside types of art made exclusively for the market, to provide much-needed income during a very difficult time.

## HAIDA SOUVENIR ART

THE PREVIOUS CHAPTER discussed how the Haida willingly accepted education and religious conversion, and abandoned making most crest art. But this does not mean they stopped making all art. The ever-entrepreneurial Haida, who realized that merchants with whom they traded enjoyed returning home with souvenirs of their voyages, began making works to sell to the foreigners even before tourism developed. The works these Haida masters produced for sale duplicated the quality of art used within the community, and thus constitute a major body of nineteenth-century northern art. For example, in the 1820s a Kaigani Haida artist carved a mask of a labret-wearing female that eventually made its way to Harvard's Peabody Museum of Archaeology and Ethnology. Although an inscription inside the mask reads "A correct likeness of Jenna Cass, a high chief woman of the Northwest Coast," research has revealed that this image does not represent a real person, but instead depicts a supernatural ancestress of the Eagle moiety, Djilaqons. The same artist made other, similar masks of women with labrets (fig. 7.2), as did other Haida carvers, responding presumably to a market that favored that particular image.

The most important type of Haida souvenir art was made from argillite, a black carbonaceous shale quarried on Haida Gwaii. The earliest pieces they made expressly for sale during the 1820s were pipes that depict an assortment of interconnected beings surrounding a central receptacle for tobacco. Some early examples could have been used for smoking, but most later pipes became functionless objects of art, thinner and, with pierced elements, more delicate. (The Haida themselves did not smoke tobacco in aboriginal times, but apparently chewed a tobacco-like

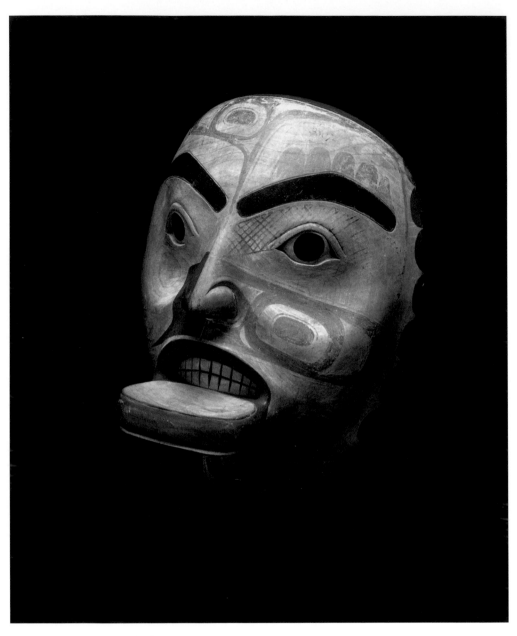

7.2 Kaigani Haida. Mask, c. 1820. *Wood, pigment. 9.8 x 7.5 x 4 in.*

*Photograph courtesy Peabody Essex Museum, E3483.*

This mask, probably made for sale, shows the large labret that non-Natives found simultaneously fascinating and disgusting. Complementing the smooth, elegant carving are asymmetric blue and red formline painting and cross hatching, which represent facial painting. Several masks exist by this carver, who appears to have lived in Kasaan. Several other similar masks by different hands suggest that a group of artists made these masks of labret-wearing women that became popular souvenirs.

7.3 Haida. Pipe in the shape of a ship, c. 1840. *Argillite. 13.4 x 4 in.*
Royal British Columbia Museum, 16155.

On this pipe, which represents a Euroamerican vessel, are carved leaves,
flowers, and berries, which are not found in traditional Haida imagery. It has
been suggested that these vegetal motifs allude to the tobacco plant, which,
according to Haida histories, was first brought to Haida Gwaii by Raven.

plant.) Images on these carvings included the beings familiar in the wood
carver's repertoire—birds, mammals, anthropomorphic figures. The
subject matter of Haida argillite carving changed around the 1830s, when,
responding perhaps to the demands of the marketplace, artists began
making portraits of ships and their captains. Carvers often created fanciful
depictions of stylized ships adorned sometimes with non–Northwest
Coast motifs of flowers, leaves, and berries, and variously populated by
men, women, and animals such as horses and dogs (fig. 7.3). The Haida
appeared to have enjoyed depicting these strangers to their lands, who in
turn appreciated such exotic images of themselves.

From 1840 to 1860, non-Haida subjects remained popular in Haida
art, but this changed after the great smallpox epidemic of 1862. After
that devastating event, demand for totem poles, houses, and ceremo-
nial regalia artworks declined. This was in part because fewer people
were alive to commission them, and in part because the missionaries
who converted the Haida insisted that they abandon their traditions.
Consequently, most surviving artists began concentrating almost
exclusively on carvings made for sale to outsiders, producing prodigious
amounts of argillite works—but almost exclusively with Haida images.
Platters, candlestick holders, bowls, boxes, and inkwells became fields
for exquisite formline designs. Ravens, eagles, and bears reappeared on

7.4   Charles Edenshaw, Haida. Argillite chest. *17.7 x 12 x 14.6 in.*

*Royal British Columbia Museum, 10622.*

Traditional Northwest Coast art is rarely narrative, because the stories associated with images are meant to be told, not visually represented. However, non-Natives favored works that told a story, and argillite carvers accommodated their wishes. Charles Edenshaw often depicted Raven tales, such as this one showing Raven transforming into human form as he stands on the clamshell from which humans emerge. He seems to be smiling, perhaps pleased at the appearance of these new creatures. The complexity of this carving, as well as its elegant combination of two- and three-dimensional components, might also be Edenshaw's response to the market, which would have appreciated the emerging faces on the sides, and the box feet made of little frogs.

these portable objects, but with a difference. The artists knew that white consumers liked stories, and thus sometimes incorporated into their creations narrative themes—and sometimes even emotions—that did not appear in more traditional artworks.

Argillite offered the Haida an acceptable means of maintaining their art traditions, and offered support for Haida masters, some of whose names we know: John Gwaytihl (c. 1820–1912), Simeon Stilthda (c. 1799–1889), and the most famous Haida carver of all during this period, Charles Edenshaw (1839–1920), the nephew of Albert Edward

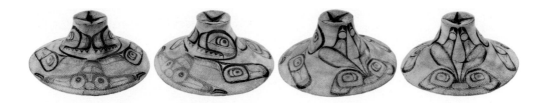

7.5   Isabelle and Charles Edenshaw, Haida. Hat, late 19th century.

*Spruce root, pigment. 7 x 17 in.*

*Courtesy UBC Museum of Anthropology, Vancouver, Canada, 4407. Photo: B. McLennan.*

This artist couple made basketry hats, as well as mats and baskets, for sale. Most of these were sold at Robert Cunningham's trading post at Port Essington. This series of shots shows how the painter used the conical surface of the hat to create the image of a killer whale. At the front, two profile whale heads face one another and together create a broad frontal face. Rotating the hat presents the profile image of a killer whale with an erect fin. Then, at the back, both profiles meet again to create the tail. This "splitting" of the animal on a two-dimensional surface to depict a three-dimensional being is a characteristic of some Northwest Coast graphic art. The painting on this hat is here rendered visible by the use of infrared photography.

Edenshaw. Among Charles Edenshaw's numerous argillite carvings is a complex box that depicts Raven and the first humans (fig. 7.4). According to the story, humans did not exist on the earth that Raven had organized, until he discovered a group of them in a clamshell on a beach at Rose Spit. In his interpretation of this event, Edenshaw made Raven into a hybrid being, his face containing both human and bird features, his feet a composite of toes and claws. He stands on the bivalve, looking at a row of diminutive human faces nestled within.

Edenshaw's wife, Isabelle Edenshaw (1846–1920), was also a Haida artist of note. Haida women were distinguished for the elegance and refinement of their woven and painted spruce-root hats which, like the Chilkat robe, were the product of collaboration between a man and a woman. Isabelle Edenshaw skillfully wove the hat shown in figure 7.5 using plain twining on the upper part and diamond-shaped twining on the lower portion. Gracefully inhabiting this field is a finely painted orca, which does not entirely cover the surface but rather is depicted with thin formlines through which the perfection of the basketry technique can be seen.

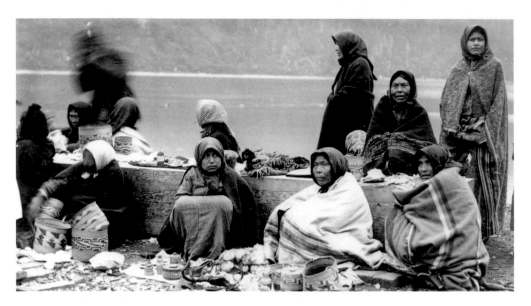

7.6   Tlingit women, probably Taku, selling baskets in the Juneau area, c. 1894.
*University of Washington Libraries, Special Collections, NA905. Photo: F. La Roche.*

This was a common scene encountered by tourists coming off steamers. A group
of women sit near the Juneau waterfront showing their creations to tourists, who
often returned home with such mementos of their trip north. The lively trade
during the turn-of-the-century "basket craze" provided much-needed income for
Native families. Notice the size range of the baskets—from diminutive to more
than a foot high. In addition to baskets, some women sell small glass bottles
covered with decorated twined weaving.

## BASKETS

AT THE TURN of the century, a "basket craze" spread through the United
States that supported a thriving industry for Native American women.
Victorian parlors often had a special table for small collectibles, including
the ever-popular Indian basket. Because they were finely crafted and
handmade from natural materials by Indians—that is, by people
considered less evolved, less "civilized," and more closely connected to
nature—Native American baskets held special appeal for people increas-
ingly pressured by industrialization and urbanization. Basket weavers
from the Southwest, California, Washington State, British Columbia, and
Alaska discovered an enthusiastic and seemingly limitless market for their
creations, and began producing enormous numbers of baskets. These

were sometimes sold in stores, and sometimes directly by the weavers themselves.

Basket selling thrived on tourism, for here were attractive, lightweight souvenirs that could easily be transported home. Throughout the coast, Native women waited by the steamer docks to sell their creations to willing consumers who streamed off and onto their vessels (fig. 7.6). Tlingit women in particular were renowned for their fine spruce-root baskets, some of which they used for subsistence activities such as berrying or storing food, others of which were made especially for visitors (fig. 7.7). The former tended to be thicker for sturdiness, and sometimes included geometric designs. Baskets made for tourists tended to be smaller, so as to fit nicely into a Victorian curio cabinet.

Several Salish and Wakashan groups farther south also became highly regarded by consumers for their basketry skill. The Twana made some of the most distinctive Salish baskets, using wefts of cattail and warps of cedar bark or beargrass. The example shown here (fig. 7.8) has a row of what might be wolves and little birds underneath a scalloped rim, and geometric anthropomorphs stand in vertical rows. Between those rows are geometric designs with doglike creatures.

The Nuu-chah-nulth and Makah also made baskets for trade. Especially important as trade items were lidded cedar-bark and grass baskets that often depicted whaling scenes. An unusual example of this type of Makah basket is the one shown in figure 7.9, which illustrates a whale being towed not by the conventional canoe, but instead by a motorized boat. And on the lid are four anchors, images that the artist appropriated from the non-Native nautical world. Most basket makers, like the artist who made this lidded basket, are anonymous, so the identification and celebration of a particular artist is unusual. However, there is one woman whose fine work has become renowned—Ellen Curley (birth and death dates unknown) not only produced exquisite baskets but also revived the practice of making the bulb-topped "Maquinna hats." The especially elaborate piece shown in figure 7.10 includes scenes of canoes with paddlers and of a harpooner pointing his weapon toward a whale, colorful bands at the brim and under the "onion" portion, geometric motifs, and an unusual tip made from ivory.

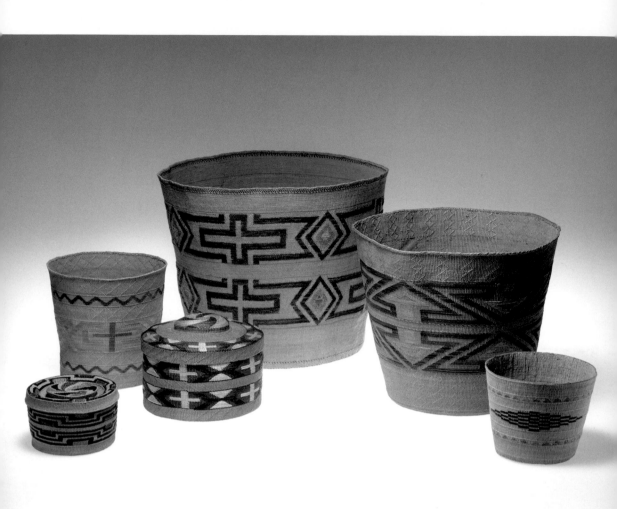

7.7 Tlingit. Baskets. *Spruce root, maidenhair fern, dyed grass. Largest: H. 9.5 in.*
*University of Alaska Museum of the North, (left to right) 840-60AB, 840-8, 67-98-101AB, 840-2,*
*840-44, 840-30. Photo: Barry McWayne.*

For centuries Tlingit women made spruce-root baskets for berry picking and food
storage. Market forces stimulated them to make smaller, more transportable items
with thinner split spruce roots and finer weaving that was especially attractive to
serious basket collectors. These became among the most desirable mementos for
tourists who visited southeast Alaska. Tlingit basket weavers created their designs
by using a technique called false embroidery, in which a strand of decorative
material is wrapped around the outside of the exposed weft. Unlike other modes
of decoration, designs made in this way cannot be seen on the inside of the basket.
The geometric designs each have the name of a natural element or animal, such
as Wave, seen on the body and lid edge of the leftmost basket; Mouth Track of the
Woodworm, on the top and bottom of the next basket to the right; and Goose
Track and Half the Head of a Salmonberry on the far-right piece.

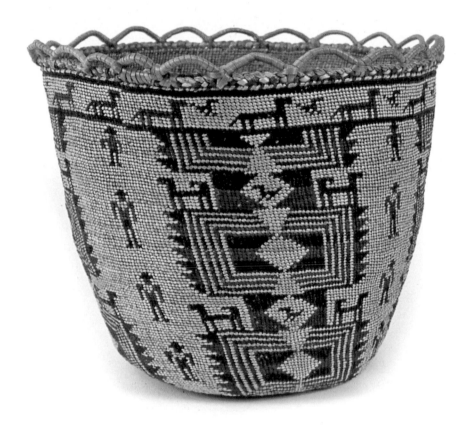

7.8　Salish. Twana basket, late 19th century.

*Cattail leaves, beargrass, cedar bark. 14.6 x 12 x 10.6 in.*

*Courtesy of the Burke Museum of Natural History and Culture, Catalog Number 1 507.*

Of the variety of basket types made historically by the Twana, this basket made of
soft twining and overlay decoration represents the favorite type for trade, which
became very popular among collectors. These commodified items are elaborations
of the simpler, more restrained Twana style of the early 19th century (see fig. 3.8).
Typical of these trade baskets is the line of animals just under the rim; in this
example the procession includes wolves with downturned tails and mergansers.
Dogs with up-curled tails, small mergansers, and men populate the body of
the basket. The rectangles within rectangles on the center seem to have some
affiliation with the squares within squares on the bottom of the Wasco-Wishram
bowl shown in figure 1.18, and could represent boxes or fishnets.

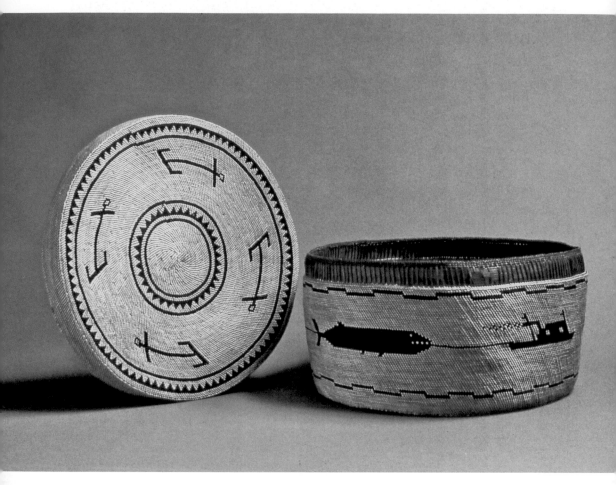

7.9  Makah. Basket, 20th century. *Cedar bark, grass. 14.5 x 7.5 in.*

*Courtesy of the Burke Museum of Natural History and Culture, Catalog Number 1-507.*

In Makah and Nuu-chah-nulth wrapped-twining technique, two weft strands are used, an uncolored one that passes the warp at the back forming a latticework, and a colored one that wraps around that inside weft as well as the warp. This technique produced small, delicate, very fine work such as this basket, and differed from the more traditional twining of earlier basketry. Wrapped twining was probably inspired by the market, as was the prevalence of the cylindrical shape with lid, called a trinket basket. During the 19th century, most Nuu-chah-nulth and Makah baskets were decorated with geometric images, but by the 20th century weavers began to make figurative designs. Many such trade baskets depict scenes of hunters in canoes pursuing whales; this example brings that concept up to date by illustrating a steamer pulling the whale, which in turn tows the hunters by means of a harpoon line. Four anchors encircle the lid. The unusually large size and perfection of technique distinguish this work as especially masterful.

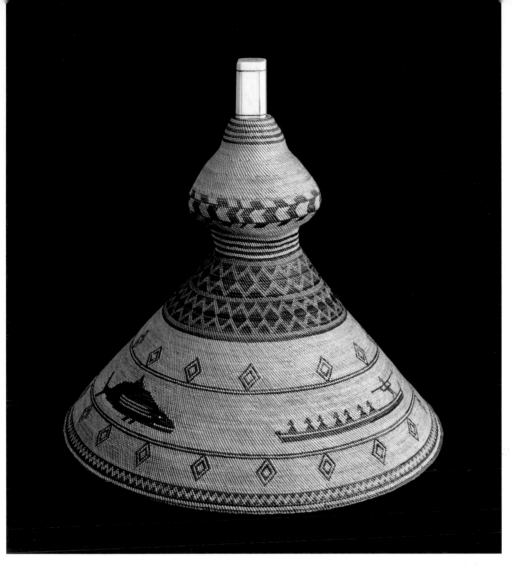

7.10 Ellen Curley, Nuu-chah-nulth. Maquinna hat, c. 1905.

*Grass, red cedar bark, ivory.*

© *Field Museum, A113772c.*

Little other than her name is known about this excellent weaver from the
village of Opitsaht. She was brought to the St. Louis world's fair in 1904, where
she demonstrated her skill at basketmaking. The museum collector Charles F.
Newcombe, who arranged for Curley to visit the fair, probably commissioned the
piece shown here. Curley was asked to weave a whaler's hat (see fig. 2.5), and she
produced this elaborate version with geometric designs that include some bright
colors. The original Maquinna hats were made with overlay twining, but Curley
employed the wrapped twining used for trade baskets (see fig. 7.9).

PHOTOGRAPHS OF villages and objects in situ, such as the curving line of houses and totem poles in Skidegate (see fig. 1.2) and regalia worn at the Sitka potlatch (see fig. 6.5), greatly enhance one's understanding of Northwest Coast art. These images were taken for a variety of reasons that include anthropological records, documentation of colonial lands, and commercial profit. Professionals conducting research in the region often took photographs. George Mercer Dawson visited Haida Gwaii in 1878 on a Geological Survey expedition mainly to identify potential mineral resources, and took the 1878 image of Skidegate. Soon after British Columbia became a province, government agents, accompanied by professional photographers, began conducting "inspection tours" of villages. Israel Wood Powell, Indian commissioner and local history buff, tried to retrace the routes of late-eighteenth- and early-nineteenth-century explorers when he traveled to coastal villages in the 1870s and 1880s. Powell especially liked having his photograph taken in villages, such as when he visited the Nuxalk town of Komkotes (see fig. 4.10).

In 1893, a team of two professional photographers, Lloyd Winter and Percy Pond, opened up a studio in Juneau and began producing images of Tlingit and Haida villages, house exteriors and interiors, potlatches, and groups of Native people and individuals, sometimes in traditional garb, sometimes in store-bought clothing. These constitute one of the finest arrays of southeast Alaska Native images, a couple of which appear in this book (figs. 1.1 and 5.6). Winter and Pond sold their photographs both to tourists at their store and to books and magazines through a national agency. At this time there was a significant market for photographs of Native Americans, and Winter and Pond's high-quality photographs, taken using glass-plate negatives, became commercially successful. They also transformed some of their images, such as that of the Whale House interior, into postcards which, like the baskets described above, became exceedingly popular collector's items during what could be called a "postcard craze" between 1895 and 1915. During that era, thousands of postcards depicting totem poles brought Northwest Coast art into the homes of people who had never visited Alaska or British Columbia.

Another photographer of distinction is Edward Curtis, known for his images of Native Americans taken as documents of the "vanishing Americans." On the Northwest Coast, Curtis took pictures of Native people and also filmed among the Kwakwaka'wakw one of the earliest full-length silent movies, *In the Land of the Head-Hunters*. This boy-gets-girl–boy-loses-girl–boy-gets-girl-again story was filmed largely on a set created by Kwakwaka'wakw artists on an island near Fort Rupert. In keeping with Curtis's insistence that his subjects present themselves as they existed prior to influence of Euroamericans, the actors wore shredded-cedar-bark garments that had been out of style for decades, and paddled large decorated canoes popular during previous generations. In addition to serving as actors, the villagers made costumes, carved masks, canoes, house posts, and totem poles, and painted elaborate facades to ensure the verisimilitude of this production. In doing so, they made good money and are said to have had a good time. The Kwakwaka'wakw found the project important for themselves, for the entire production allowed them to experience, if only temporarily and on film, their ancestors' way of life.

This film has provided some of the most unforgettable images of Kwakwaka'wakw ceremonial life. The scene with canoes approaching land, carrying three masked dancers—Wasp, Thunderbird, and Bear—dramatically waving their arms and swaying their bodies, has captured the imagination of many (fig. 7.11). Another distinctive image shows a large group of masked dancers who appear when a curtain is suddenly dropped. Even the village—which in reality consisted only of a row of false fronts—is impressive. A tall frontal pole, similar to one from Alert Bay, has at its bottom a raven with projecting beak; normally closed, the beak opened when people entered the house. Within the roofless house, which consisted of just sides and a rear wall, stood two large house posts by artist Charlie James, depicting a bear surmounted by a spread-winged thunderbird. Because Curtis used the same set for different houses, he needed to alter the look of their interiors; he did this by removing the wings of these house posts, which then represented crests of other families. These posts ultimately made their way to Stanley Park in Vancouver, where they stood for almost three quarters of a century until they so

7.11  Dance of the Grizzly Bear, Thunderbird, and Wasp. Still frame from
      Edward Curtis's film *In the Land of the Head-Hunters*, 1914.
      *Courtesy of the Burke Museum of Natural History and Culture, Plate #35. Photo: Edmund Schwinke.*

In 1914, photographer Edward Curtis worked with the Kwakwaka'wakw to film
a feature-length love story he hoped would be a commercial success. It was,
unfortunately, not. However, the film, restored under the name *In the Land of the
War Canoes*, provides remarkable scenes of hunting, feasting, and dancing. This
unforgettable image shows masked dancers on their way to a wedding. Bear,
Thunderbird, and Wasp perform on the groom's family's canoes as they approach
the bride's village.

deteriorated that they were removed, to be replaced by a copy carved by
contemporary carver Tony Hunt.

Edward Curtis did not make the kind of money from this film that he
had hoped. After an unsuccessful opening, *In the Land of the Head-Hunters*
disappeared from the world of cinema and was soon forgotten. In the
late 1940s, a damaged copy of this film was given to the Field Museum
in Chicago by a collector of old movies. In the 1960s, George Quimby,
director of the Burke Museum at the University of Washington in Seattle,

collaborated with fellow curator, artist, and Northwest Coast Native art scholar Bill Holm, to restore this valuable cinematographic document. Holm brought the film to the Kwakwa̱ka'wakw in Fort Rupert, some of whom were descendants of the actors. In a contemporary version of Curtis's involvement of Fort Rupert residents to create the film, Holm worked with the contemporary Kwakwa̱ka'wakw to make a soundtrack of the speeches and songs. The film was rereleased in 1967 under a new name, *In the Land of the War Canoes,* and is now recognized as a classic of its genre.

## MUSEUMS

AS COLONIALISM around the globe irrevocably changed the lives of aboriginal peoples, the discipline of anthropology developed in order to record and understand those cultures. While tourists were seeking out small items with which to return home, museum collectors combed the Northwest Coast for artifacts that would make interesting exhibits thousands of miles away. Much of the professional collecting, which occurred between 1880 and 1920, was inspired by a certainty that all these cultures were rapidly disappearing, and that their remnants had to be salvaged for science. Because it was believed that Euroamerican influence "tainted" the authenticity of Native culture, collectors were urged to acquire the oldest, least acculturated items and forgo anything that seemed to include non-Native materials. (But in fact, as the preceding chapters have demonstrated, the influence of Euroamericans on Northwest Coast art from first contact on had been considerable.) In addition to such purely scientific motivation, museums also competed with each other to acquire the largest and finest array of Native material.

In 1897, anthropologist Franz Boas initiated the Jesup North Pacific Expedition, named after the then-president of the American Museum of Natural History, Morris K. Jesup, which sent anthropologists and archeologists to British Columbia and eastern Siberia to collect objects, record myths, and describe cultures. Between 1897 and 1901, thousands of artifacts from and pages of information on these cultures entered the museum's collections. The result was an outstanding collection of

Northwest Coast material (particularly from the Kwakwaka'wakw) at the American Museum of Natural History, along with major ethnographic publications. And thanks to Boas's explicit instructions to collectors to "get the stories" associated with artifacts, the documentation on Jesup North Pacific objects is especially rich. Several items illustrated in this book (figs. 1.6, 4.2, 4.9) were collected during this expedition.

Museums searching for ethnographic collections sometimes benefited from the changing values of Native people themselves. Of all Tlingit cultural practices, shamanism was the one that most disturbed white officials and missionaries. Shamans were accused of witchcraft and imprisoned, and missionaries urged their congregations to reject their "dark magic." By the twentieth century, shamanism seems to have disappeared not only among the Tlingit, but throughout virtually all of the Northwest Coast. Although the Tlingit converted to Christianity during the last decades of the nineteenth century and turned away from their reliance on shamans, they remained wary of their powers. Fortuitously, Lt. George Thorton Emmons of the United States Navy, a man fascinated by Native life, was stationed in southeast Alaska during the 1880s. He became good friends with various Tlingit, who told him of the locations of remote shaman's graves. These contained the regalia as well as the bones of the deceased, and it is possible that even these converted Tlingit feared the power emanating from these objects and appreciated their removal. As a result, Emmons collected from these burials hundreds of shamanic objects, which he sold to museums including the American Museum of Natural History, the Field Museum of Natural History in Chicago, and the Burke Museum in Seattle. The presence of large numbers of shamanic artworks in museums across the United States could be in part due to the recently converted Tlingit's avoidance of such potent items.

Museum collecting presented certain moral issues that remain problematic to this day. In their rush to obtain the most and the best from the Northwest Coast, collectors sometimes crossed ethical lines. Even Boas himself removed human remains from cemeteries in order to conduct osteological research. Louis Shotridge, a Tlingit nobleman employed by the University of Pennsylvania's University Museum from 1912 to 1932, often pressured members of his community to sell their priceless clan

treasures, knowing full well how this would deprive families of their most cherished possessions. In addition to purchasing such *at.oow*, Shotridge even tried, unsuccessfully, to steal the Klukwan Whale House artworks, after the clan refused to sell them.

Another interesting case was that of George Hunt, who collected large amounts of material during the Jesup North Pacific Expedition for the American Museum of Natural History. Hunt, the son of a Hudson's Bay Company official and a noble Tlingit woman, was raised in Fort Rupert and served as a consultant on the Kwakwaka'wakw for Edward Curtis and for Franz Boas. After the conclusion of the Jesup Expedition, Hunt continued to collect Northwest Coast material for the American Museum of Natural History. In 1903, he heard stories of an unusual and important shrine used for whaling magic, located in Yuquot on the west coast of Vancouver Island (the site discussed above in the section on the Nuu-chah-nulth, pp. 122–25). He traveled there, and asked the chief to let him see the shrine that stood on an island in a lake not far from the village. The response was that only people with great spirit power like shamans could see it, inspiring Hunt to claim that he was a shaman. The chief then ordered Hunt to cure a sick person who, luckily, recovered, and Hunt was allowed to see the shrine.

The next year, Hunt returned to Yuquot and offered the chief $500 for the carvings, human remains, and structure of the shrine. Before the transaction was finalized, another chief approached Hunt, insisting that *he* owned the shrine. After considerable negotiation, an agreement was reached that each chief would receive $250. But they also insisted that Hunt take it all in absolute secrecy, to keep the community unaware of the shrine's removal. This underhandedness has led to the accusation by some contemporary individuals, both Native and non-Native, that Hunt actually stole the shrine, although no irrefutable evidence of this exists. The shrine and its contents were packed up and shipped to New York City, but Boas resigned from the American Museum of Natural History at about the time it arrived, and it has remained in storage until this time.

SOME NORTHWEST COAST COLLECTIONS were first presented to the public not at museums but at international expositions. World's fairs had originated in Europe as public spectacles glorifying the benefits of colonialism. London's 1851 Great International Exposition celebrated the transformation of raw goods from the colonies into economic prosperity for Britain. Ethnographic and archeological objects joined the natural products of the colonies in the 1867 Paris Exposition. In 1889, at that year's Paris Exposition, colonized people themselves became exhibits, when 182 Africans and Asians wearing their aboriginal garments lived in "traditional" houses organized into "native villages" and performed authentic, if staged, ceremonies. The underlying message of these and other world's fairs was that the undeveloped natural resources and backward inhabitants of colonies were ready for European control. Fairgoers could experience for themselves the commodities of the colonies—first raw materials, then artifacts, and, finally, people themselves—all waiting to be exploited by the superior civilization.

Fairs in the United States also celebrated development and featured the superiority of whites over all other races. Despite Boas's efforts to refute social Darwinism by highlighting the effects of historical events on relationships among racial groups, the prevailing ideology at the turn of the century was that dark-skinned races stood on the lowest rungs of the evolutionary ladder, whereas light-skinned people held the highest positions, because, they had evolved much farther. This twisted form of evolutionism ideologically endorsed American nationalism and "scientifically" legitimated imperialism and segregation. At some fairs, the anthropologists from institutions such as Harvard and the Smithsonian who organized ethnographic displays bestowed academic respectability upon presentations of "primitives" as lowly and whites as superior. As a result, the Native exhibits reinforced white Americans' conventional perception of Native peoples as inferior aliens.

Fairs became the principal locations for exhibits of Native artworks. The first such display occurred in 1876, when Smithsonian Institution decided to exhibit Native American material at the Philadelphia Centennial Exposition. Among the various collectors sent to the field to

acquire objects for this display was James Swan, who lived in north-western Washington State and had longtime relationships with many Native groups. He was assigned to travel north and collect Native materials for the coming world's fair. In addition to acquiring a wide range of smaller artifacts, Swan purchased several totem poles, an art form that up until this point most Americans had never actually seen. After the fair, the National Museum of Natural History in Washington, D.C., added these materials to its collections (see figs. 1.4 and 4.3).

In 1893, Chicago hosted the World's Columbian Exposition, which celebrated the four-hundredth anniversary of Columbus's landing in the New World. The theme of this fair was "Progress," by which was meant white progress. Like the Philadelphia fair earlier, this one, too, had ethnographic displays, managed by Frederic Ward Putnam, director of Harvard's Peabody Museum of American Archaeology and Ethnology. Putnam put Franz Boas in charge of the Northwest Coast exhibit. Boas in turn assigned several residents of the region, including George Hunt, the task of collecting pieces. The result was an exhibit including several totem poles and two entire houses, one Haida, the other Kwakwaka'wakw, that had been disassembled at their villages of origin and rebuilt on the fairground. The houses and the sweep of totem poles in the Northwest Coast section of the fair (fig. 7.12) offered visitors a sense of the variety of British Columbia coastal styles. Hunt also convinced a group of Kwakwaka'wakw to stay at the fair during its duration, as a living cultural exhibit. They also performed some impressive dances, including the *hamatsa*—which created quite a stir in Chicago. The newly founded Field Museum of Natural History made the Columbian Exposition objects the core of its Northwest Coast collections.

Another fair with a strong Northwest Coast presence took place during 1904 in St. Louis, in celebration of the centennial of the Louisiana Purchase. In addition to Kwakwaka'wakw and Nuu-chah-nulth "living exhibits," an impressive array of Alaskan totem poles stood before the Alaska building, thanks to the efforts of that state's governor at the time, John Brady. These were the poles that, as described in the previous chapter, Brady had negotiated with southeast Alaskan chiefs to donate to a park in Sitka. The governor was anxious to dispel the commonly held belief that Alaska was a frozen, barren wasteland, so

7.12 Chicago World's Columbian Exposition, Northwest Coast Indian outdoor exhibition, 1893.

*Haida house at left, Kwakwaka'wakw house in center.*

American Museum of Natural History Library, 322897.

World's fairs sometimes included "living displays" of Native people from various parts of the world. In 1893, a group of Kwakwaka'wakw traveled south and east to live for the duration of the Chicago world's fair in the large house in the center of this photograph. That entire structure was transported from Vancouver Island and erected on the fairgrounds. At the left in the photograph is a smaller Haida house. In addition to the houses, several totem poles were brought to Chicago for the fair. The person who acquired and assembled this display of houses and totem poles was Franz Boas's colleague and collaborator, George Hunt, who stands before the second pole from the right. The items later became part of the collection of the Field Museum of Natural History.

as to attract new (white) settlers to the region. He believed that totem poles had a special appeal, so decided to send the donated poles all the way to St. Louis for the fair. Brady hoped that people, attracted to the monumental carvings, would then enter the Alaska building and see its exhibits—which would, he hoped, encourage them to move north. The next year another exposition was held in Portland, Oregon, where the same poles were erected outside that fair's Alaska Building. After the close of the Portland exposition in 1905, Brady's totem pole collection returned to Sitka, where it found a permanent home at what would become the Sitka National Historical Park. Set along a path through the thickly forested woods, the poles became a major tourist attraction in this community that had once been the capital of Russian America. Over the years these monuments deteriorated, were restored, and were ultimately replaced by newer versions.

## COMMISSIONING ART

SOMETIMES the owner of a desirable object refused to sell it to a collector. If the collector really wanted the item, he could commission an artist to make a replica. In 1881, the Berlin Ethnographic Museum sent Johan Adrien Jacobsen to the Northwest Coast to collect. In the Heiltsuk community of Waglisla (Bella Bella), an elegantly carved and painted chief's seat caught Jacobsen's eye. He could not persuade its owner to relinquish possession of the masterpiece, so he commissioned Captain Carpenter (1841–1931), a high-ranking and well-respected artist and presumably the creator of the box shown in figure 4.8, to create a replica of the seat (fig. 7.13). This chief's seat includes a boldly carved three-dimensional masklike face, a painted bird's body on the chair's back, and elegant formline images on the arms and seats.

Ethnographers sometimes commissioned models of larger items such as totem poles and houses. One especially striking example of this was exhibited at the Chicago Columbian Exposition of 1893: a small-scale rendering of the entire village of Skidegate as it was thought to have looked in 1864. James Deans, a Hudson's Bay Company employee from Victoria, commissioned several Haida to create this model specifically for the fair. Following proper protocol, and acknowledging the Haida

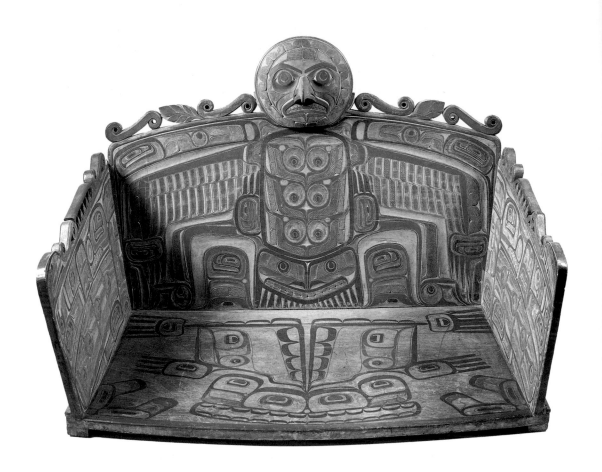

7.13 Replica of a chief's settee from Waglisla (Bella Bella),
Captain Carpenter, Heiltsuk. Commissioned 1881 by J. A. Jacobsen.
*Yellow cedar, red cedar, pigment.*
*Staatliche Museen zu Berlin - Preussischer Kulturbesitz Ethnologisches Museum, IVA 2475/76/77.*

Furniture like this was reserved for the highest-ranking individuals, who sat on them near the fire. Johan Adrien Jacobsen, a collector for the Berlin Ethnographic Museum, saw a settee in the village of Waglisla (Bella Bella) that he desired, but could not purchase it. So he commissioned one from a local artist who has been identified as Captain Carpenter, a member of the Blackfish clan, who was born in the Heiltsuk village of 'Qvuqvai in 1841, but then moved to Waglisla to be nearer the Hudson's Bay trading post. He was a high-ranking chief who twice married aristocratic women and hosted several significant potlatches throughout his life.

concept of ownership of crests, Deans asked the individual Skidegate families to make copies of their own houses and totem poles. The entire assemblage of twenty-five houses, six mortuary posts, two burial houses, and ten memorial poles was set on a fifty-foot-wide platform with a background screen painted with hills and trees, and was exhibited in the fair's anthropology building.

During the Jesup North Pacific Expedition, Franz Boas sent John Swanton, a young recent Ph.D. from Harvard, to Haida Gwaii, where he stayed from 1900 to 1901, collecting ethnographic information. When Swanton visited Massett, he met Charles Edenshaw. Earlier, Boas, who considered Edenshaw the best living Haida artist, had taken advantage of his extensive knowledge. When they met in 1897, Edenshaw explained facial paintings, interpreted designs on artworks, illustrated Haida images, and narrated myths for Boas. Swanton also found Edenshaw's knowledge of great value, and commissioned him to make some model totem poles, model canoes, and a house model. Around the same time, the British Museum commissioned Edenshaw's contemporary, John Gwaytihl, to create a house model that featured a replica of a pole in the museum's collection (fig. 7.14). Thus Edenshaw, Gwaytihl, and other Northwest Coast artists could profit from both the tourist market and anthropological commissions. In this way many of their traditions were maintained, despite the assurance of "experts" that Northwest Coast culture was disappearing.

## NORTHWEST COAST ART IN MUSEUMS

During the decades when more and more non-Natives settled on the Northwest Coast, huge quantities of objects were removed from their original villages. Acquisition of ethnographic objects had begun well before the nineteenth century, for the earliest travelers such as Captain Cook and Malaspina collected "curiosities" from the lands they explored, bringing valuable early Northwest Coast works into European museums. But the numbers of new accessions accelerated enormously between 1880 and 1920. With the exception of objects in the Sheldon Jackson Museum in Sitka and a handful of other small institutions, very few pieces discussed in this book can be seen today north of Vancouver,

7.14   John Gwaytihl. Haida house model, 1898.

*Wood and pigment. 19.8 x 15 x 34.7 in.*

© *The Trustees of the British Museum, 10-20.1/150.*

The carver of this model, John Gwaytihl of Massett, made masks, model houses, canoes, and totem poles of wood. He did not work in argillite, a material many other artists of his generation used extensively. The original of this model, Bear House, stood in Kayang, a village near Massett. The proportions of the pole to the house itself are inaccurate, but serve to bring attention to the central totem pole, which also functions as the house entrance.

B.C., near their places of origin. Instead, thousands upon thousands of them reside in the exhibits or storage areas of places such as the American Museum of Natural History in New York City, the Smithsonian's National Museum of Natural History, Chicago's Field Museum, the Burke Museum on the University of Washington campus in Seattle, and the Museum of Anthropology at the University of British Columbia. Others are in European institutions such as the British Museum and the Vienna Ethnographic Museum.

The most prized object for museums was the totem pole. In 1901 Charles Newcombe, collecting for the Field Museum of Natural History,

7.15  The Northwest Coast hall of the American Museum of
Natural History, c. 1902.

*American Museum of Natural History Library, 12633.*

This was the conventional manner of exhibiting anthropological as well as natural
history material at the turn of the 20th century. Cases filled with specimens,
and some with artifacts positioned on top, offered the intrepid visitor hours
of education. Franz Boas, curator of ethnography at the American Museum of
Natural History from 1895 to 1905, designed the hall so that the casual visitor could
learn about the region from introductory cases that presented information on
Northwest Coast people and culture. For the more serious student, materials on
the individual tribes, from the Coast Salish to the Tlingit, filled row after row of
cases. In this photograph, one of the museum's great treasures, a sixty-three-foot
canoe collected in 1881, hangs from the ceiling.

set a standard price for these monuments: $1.00 per foot for house posts,
$1.50 per foot for grave posts. Eight years later, Harlan Smith traveled to
British Columbia to acquire poles for the American Museum of Natural
History. In a letter to museum authorities, Smith described how "poles
are now practically wiped off the Earth in many localities where they were
numerous twelve years ago when I had the buying fever."[3] Even in 1897,
relatively few totem poles still stood in Skidegate, which twenty years

before had boasted a spectacular array of these monuments. By the 1920s, few Northwest Coast artworks of any kind remained in their originating communities, for many had left for points south and east.

Throughout the period of contact and settlement, roles and perceptions of the carvings, paintings, weavings, and baskets of the Northwest Coast people underwent several major shifts. In the earliest times they were central to the fabric of groups from the Salish to the Tlingit, reinforcing social order and facilitating connection to the supernatural. After the initial interest of Euroamericans in other cultures, fostered by the Enlightenment and manifested by eighteenth-century collections of "artificial curiosities," reaction to Native art was changed by white settlers' racist and disdainful attitudes—whatever the heathens made was yet another indication of their fundamental barbarism. But soon the Native residents became unthreatening minorities and attitudes shifted slightly. Scientific collecting during the late nineteenth and early twentieth centuries was based on the notion that these people were rapidly disappearing. Tourists found them quaint, and happily purchased souvenirs from them. Most items acquired during this period were placed into natural history museums rather than art museums (fig. 7.15). This was not surprising, given that the anthropologists who studied Native societies worked at natural history museums and approached Native-made objects from scientific rather than artistic perspectives. But the residence in natural history museums of the materials discussed in this book signifies more than their collectors' scientific perspectives, for this went to the core of attitudes toward race. At the turn of the century, many non-Natives believed that only "high" cultures created art, whereas "primitive" people made artifacts that, even if decorated, existed in a completely different— and lesser—realm. In keeping with the prevalent belief that Native people were in some way inferior to civilized whites, it was believed reasonable to exhibit their artistic creations alongside rocks, stuffed animals, and dinosaurs. Only in the twentieth century would these creations enter the rarified world of art.

# PERSISTENCE OF ARTISTIC TRADITIONS, 1900 TO 1960

BY 1920, the vast majority of Northwest Coast people lived in single-family dwellings. They were actively discouraged from speaking their languages; in the boarding schools that so many young people were forced to attend, children were punished for speaking any language other than English. Artists received far fewer commissions. Despite all this, Native art did not die. While not as abundant or as fine as it had been in the nineteenth century, some sort of art continued to be created by men and women from nearly every group. Enforcement of the anti-potlatch law resulted in diminished ceremonialism, although potlatching, with its concomitant art, never fully ceased among the Tlingit, Kwakwaka'wakw, Nuu-chah-nulth, and Gitksan. Even among the Haida, often described as a people who had completely lost their extraordinary artistic tradition, argillite carvers still created model totem poles and other souvenirs for sale. Some, such as Henry Young (1872–1950), crafted works of respectable quality (fig. 8.1).

8.1  Henry Young (Haida) working on argillite, 1938.

*Royal British Columbia Museum, PN 5187.*

Photographs such as this provide clear evidence that Haida artistic production
did not end when Charles Edenshaw died. Although less numerous than in the
19th century, early-20th-century argillite carvers such as Henry Young of Skidegate
maintained the traditions of Haida art by creating art for a non-Native market.
The works by these devoted artists are not, as some have charged, indications of a
"dead" visual heritage, but instead are an important link between the past and the
future of Haida art.

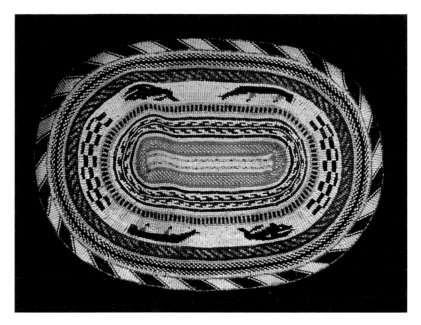

8.2  Nuu-chah-nulth. Rug made of rags and yarn, c. 1940.

*Royal British Columbia Museum, 11993.*

Although this piece was crafted from nontraditional materials and in the
nontraditional oval shape of a rug, its geometric designs clearly derive from
the basketry designs that women on the Northwest Coast have been creating for
hundreds of years—in this case, the ubiquitous Nuu-chah-nulth image of whalers
and whales. Like the argillite carvings, rugs such as these were made for sale.

In some places along the coast, women maintained their traditions in
basketry and textiles. For example, Tlingit Jennie Thlunaut (1892–1986)
continued crafting the time-consuming Chilkat robes. Among the Nuu-
chah-nulth, women continued weaving, sometimes making ingenious
use of non-traditional materials. For example, figure 8.2 shows a rug
crafted from torn-up rags purchased from second-hand stores and woven,
along with yarn, into fine geometric designs and images of hunters in
canoes pursuing whales. Throughout the region, button blankets main-
tained the tradition of wearable crest art.

Ceremonialism did not disappear either. Because most Native people
of the region had been converted to Christianity, missionaries and
government officials thought their efforts to eradicate Native ceremoni-
alism had been successful. In some places they may have been, but that

was by no means universal. For example, some Salish individuals still held puberty ceremonies, conferred names on younger people, and memorialized the deceased with gift-giving and feasting. And despite the vigorous opposition of missionaries, government officials, and Native converts, some quietly maintained the practice of traditional spirit dancing, within private residences or in the large and now-abandoned plank houses. During the winter, ceremonies were held during which guardian spirits entered participants, who performed their unique songs and dances to the accompaniment of percussive instruments, sometimes wearing special regalia such as tunics decorated with secret spirit-prescribed images. These garments often contained small wooden paddle-shaped carvings that rattled during the dance, creating an aural as well as visual experience. The dancers also wore knee-length trousers, leggings, and conical hats of wool and feathers or human hair.

## HISTORY OF THE FIRST HALF OF THE TWENTIETH CENTURY

CONSIDERING THE EFFECTS that Euroamerican settlers had on the Northwest Coast, Native artistic culture demonstrated impressive resilience. With few exceptions, the growing white population of British Columbia, intent on developing its natural resources and farming its lands, felt little sympathy for the rights of Native peoples. Before the 1870s, few of the new residents of British Columbia had cared much about land under Native control. But with increased settlement, concerns arose that Native claims to the land might prevent its development. To prevent this, Native land allotments needed regularization, and, ideally, reduction. In 1916, a commission charged with studying the needs of B.C. Native people produced a report known as the McKenna-McBride Agreement, ratified in 1924 by both the dominion and provincial governments. Although the government and most settlers judged this a fair and reasonable settlement of the thorny land rights issue, for many coastal Native people the McKenna-McBride Agreement was anything but just. Not only did the agreement leave them with what they considered an inadequate allocation of land, but British Columbia Native people also argued that

since they had never signed treaties, they had never given up title to their lands. In 1926, the federal government appointed a special joint committee of the Senate and House of Commons which, after several months investigating these claims, ruled that the Indians had no claim on British Columbia lands, and that was that.

Inequities plagued Alaska's Native people just as much as their British Columbia brethren. In 1912, a group of twelve Tlingit and one Tsimshian from Metlakatla founded the oldest Native organization in the United States, the Alaska Native Brotherhood (ANB), dedicated to promoting Indian rights and ensuring citizenship for Alaska Native people. Thanks to their efforts, in 1915 the Alaska territorial legislature passed a law allowing Native people U.S. citizenship and the concurrent right to vote—as long as they disavowed their tribal affiliation, acted "civilized," passed an examination, demonstrated that they had the endorsement of five whites, and received approval from the district judge. Cases existed in which individuals satisfied the first four criteria, but failed to receive the judge's approval. As a result, few Native people became citizens.

The situation came to a head in 1922, when Chief Shakes of Wrangell and his niece, Tillie Paul Tamaree, were arrested—for voting. William Paul, the first Native Alaskan lawyer, defended his great-uncle Shakes and his own mother, winning their acquittal. As a result, Alaskan Native people received the right to vote two years before the passage of the 1924 Indian Citizenship Act, which provided other Native Americans with that same right. The Tlingit, an increasingly formidable political force in the state, worked through the ANB and the Alaska Native Sisterhood (ANS), founded in 1923, to promote Native subsistence rights, fight the segregation that prevented them from entering public places reserved for whites, and integrate the schools. Alaska Natives finally achieved these goals with the passage of the Anti-Discrimination Bill of 1945, years before racial segregation was made illegal in the rest of the United States.

A major issue in Alaska, as in British Columbia, was land rights. In the 1950s the ANB sued the United States, contending that twenty million acres of land in the Tongass National Forest and Glacier Bay National Monument (later Glacier Bay National Park) had been illegally appropriated from the Tlingit and Haida. Resolution of this difficult issue would

have to wait until the late 1960s, when the discovery of vast oil reserves in the Arctic forced the government to settle the Native land claims for the entire state (see pp. 250–51).

(see pp. 250–51)

### RESISTANCE: THE KWAKWA̲KA'WAKW AND THE NUU-CHAH-NULTH

DESPITE the Canadian government's ban on potlatching, the "incorrigible" Kwakwa̲ka'wakw insisted on continuing the practice, to the chagrin of officials. In 1921 a Nimpkish chief, Dan Cranmer, hosted an exceptionally lavish potlatch during which he gave away thousands of dollars worth of goods, including sewing machines, wooden chests, and gasoline-powered boats. An informant told the local Indian agent, William Halliday, about this event. Halliday then arrested many of the participants and offered them a choice: either relinquish all the regalia that they displayed at potlatches, or go to jail. Although some chose prison, a good many gave up their masks, costumes, and other indications of rank; these became known as the "Potlatch Collection" (fig. 8.3). These items made their way into museums in Ottawa, Toronto, and New York City, where they took their places next to the totem poles and other items that had been more legitimately purchased. (Most would eventually return to their communities; see pp. 285–87.)

see pp. 285–87.

After this, Kwakwa̲ka'wakw ceremonialism went further underground, but was by no means eliminated. In 1927, an illegal potlatch that took place in Kingcome was commemorated by a pictograph thirty feet long and six feet high that illustrated coppers, a boat, and cows that had been butchered, cooked, and distributed at the feast (fig. 8.4). The Kwakwa̲ka'wakw also managed to maintain a high standard of artistry. Indeed, the masks, poles, and other carvings they made during the first half of the twentieth century resonate with an energy and vitality that one could interpret as an expression of Kwakwa̲ka'wakw pride in their heritage and as resistance to what they judged unacceptable restrictions to their cultural expressions. Several artists of considerable abilities are still celebrated today: Charlie James (1870–1938), Willie Seaweed (1873–1967), Arthur Shaughnessy (1880–1946), and Mungo Martin (1881–1962). Although all carved model totem poles for the commercial market, they

8.3 Confiscated Kwakwaka'wakw potlatch regalia in
Anglican church hall, Alert Bay, 1922.

*Royal British Columbia Museum, PN 12189. Photo: Rev. V. Lord.*

The Indian agent who arrested the potlatchers and confiscated their regalia,
William Halliday, had the items displayed in the parish hall, where they were
inventoried by a teacher. Although the collection, now considered governmental
property, was going to be sent to Ottawa, Halliday sold thirty-five of the finest
pieces to George Heye, the collector who amassed the wealth of art currently at
the National Museum of the American Indian in Washington, D.C. Many of the
confiscated articles have since been repatriated to the Kwakwaka'wakw.

8.4  Kwakwawa'wakw pictograph in Kingcome Inlet
       that records a 1927 potlatch.
       *Photo: Aldona Jonaitis.*

Even though potlatches had been declared illegal, the Kwakwaka'wakw continued
to host these ceremonies that were so central to their identity. Sometimes they
commemorated particularly elaborate affairs with works such as this pictograph,
which depicts the gifts distributed at a 1927 potlatch. The pictograph is an example
of the hybridization that occurred during the 20th century, with traditional
symbols, such as the greatly valued copper, positioned next to the appropriated
symbols of wealth in the form of cows purchased from white settlers. The
pictograph was painted by Mollie Wilson.

also carved house posts and totem poles and made regalia for officially illegal ceremonies.

Charlie James, son of a non-Native father and a Kwakwaka'wakw mother, was a prolific carver who made full-size and model totem poles, food bowls, and masks. One of his most popular types of totem pole (which remains popular today) was a two-figure version featuring an anthropomorphic being at the bottom and a thunderbird with outstretched wings at the top. Charlie James's wife, Sara Nina, had several children from a previous marriage, one of whom would become another great Kwakwaka'wakw artist, Mungo Martin. Martin learned art from his stepfather. After James died in 1938, Martin took over whatever carving commissions came along, but still needed to fish in order to make a living for himself and his family. Despite the anti-potlatch law, Martin actively participated in and made art for some of the potlatches that took place. As will be pointed out later (pp. 241–42), during his later years, Martin was brought to museums in both Vancouver and Victoria to restore older poles and carve new ones, demonstrating his carving talents to a fascinated audience.

Willie Seaweed, an artist trained in traditional Kwakwaka'wakw style and admired for his vivid and refined painting applied to well-carved and highly sculptural surfaces, began creating increasingly baroque masks in the 1920s. The shiny commercial enamel paint with which he replaced the subtle natural pigments of early works produced especially reflective surfaces that glistened in the firelight (fig. 8.5). With an array of intense and shiny colors—red, yellow, blue, green, orange, deep black, and pure white—some of them new to the art form, Seaweed created masks even more dynamic and flamboyant than nineteenth-century prototypes—a notable achievement considering how extraordinary earlier Kwakwaka'wakw masks were.

James, Martin, and Seaweed also made model totem poles for the non-Native market, continuing the tradition of quality tourist art established in the previous century. Ellen Neel (1917–1966), granddaughter of Charlie James and niece of Mungo Martin, ran a totem pole carving business in Vancouver, B.C. She had learned to carve in her home of Alert Bay, then moved to Vancouver with her family and started Totem Art Studios, where she and her children made small and full-size totem poles. In 1950, she

8.5  Willie Seaweed, Kwakwaka'wakw. Crooked Beak of Heaven mask, c. 1940.

*Wood, pigment, cedar bark, feathers. L. 38 in.*

*Collection of Bill Holm. Photo: Bill Holm.*

Willie Seaweed's Crooked Beak of Heaven masks take the dynamism characteristic of late-nineteenth-century Kwakwaka'wakw masks over the top, with flourishes and flamboyance. Willie Seaweed is considered by some to be the most original artist of his period, having created a unique style of both painting and sculpture that influenced successive generations of Kwakwaka'wakw artists. A meticulous artist who devoted considerable attention to details, Seaweed used compasses to create perfect circles that have become his signature. In the eyes of this being, he used a compass for each interior circle, moving the compass point toward the being's nose to create series of nonconcentric rings.

was commissioned by a group of Vancouver citizens to make a model pole that could be used as the emblem for the region's nickname in the tourist industry, "totemland." Intrigued by the possibilities of this commission, Neel created a unique two-foot pole (fig. 8.6). A thunderbird sits atop an egg-shaped globe prominently depicting western British Columbia and Vancouver Island, and a human figure kneels underneath. Neel explained the Totemland pole as a narrative of the thunderbird giving British Columbia to the first man. Maps were not part of the artistic vocabulary of Northwest Coast artists, but in this pole Neel successfully integrated symbols and sculptural forms from her own heritage with a distinctly Euroamerican geographical representation. It is worth noting that Neel carved the globe with her hometown of Alert Bay in the middle, subtly communicating the centrality of her people within the province.

The Nuu-chah-nulth also managed to maintain many of their traditions. Instead of painting images on wooden screens as before, they began depicting images on cloth curtains, which, in addition to being easier to store and move, could be hidden from the Indian agents who knew how significant they were to ceremonialism. The images on the cloth screen in figure 8.7 are those also seen in the earlier wooden screen, but thanks to the artist's successful combination of northern formline style and older Nuu-chah-nulth tradition, the illustrated beings are depicted in a more unified manner that shows a long whale with upturned head and two wolves within its body, surmounted by a thunderbird that extends its unusually long wings and is in turn crowned by two lightning serpents that neatly fit in the triangular spaces above its head.

Despite the government's efforts, Nuu-chah-nulth masks were not all discarded, as figure 8.8 reveals. This photograph shows a float at the 1929 Dominion Day parade in Port Alberni with a truckload of men and women wearing a variety of masks and headdresses that conveyed to all their unique cultural heritage, which the law had not succeeded in eradicating. Their pride was also expressed in the sign carried by Chief Dan Watts, at the farthest right. Its words, "We are the Real Native Sons," responded to a float of non-Native people entitled "Native Sons of Canada." That same year, Captain Jack of Yuquot donated a pole to the Canadian governor general, the representative of the British king, upon his visit to that

8.6  Ellen Neel, Kwakwa̱ka'wakw. *Totemland Pole,* 1950.

*Wood, pigment. H. 24 in.*

Collection of Phil Nuytten.

Ellen Neel is one of the few women who carved full-size totem poles; even today, more men than women make these monuments. She also created numerous model poles, which sold well in Vancouver and elsewhere. This model pole was commissioned by Vancouver's Totemland society in order to promote tourism to British Columbia. It became so popular that Neel made several versions of it. It was also replicated in various commercial forms, including a china dish set.

8.7   Nuu-chah-nulth. Dididaht curtain, 1880–95. *Cotton, paint. 81 x 247 in.*
*The Menil Collection, Houston, 71-44 DJ.*

The imagery on this cloth curtain also appears on the earlier Nuu-chah-
nulth painted screen (see fig. 4.6), although here the design is tighter and
its elements fill the surface more completely. Along the bottom is a large
whale with two wolves inside its body and a small creature emerging from its
mouth. At the top are two lightning serpents, and in the middle a thunderbird
spreads it very long wings from end to end of the curtain. Adding to the
dynamism of this piece are the dramatic diagonals of the wings, and the
energetic treatment of the wolves' tails and the whale's mouth. The artist has
played with colors and form to subtly accentuate the painting's asymmetry,
as, for example, in the differing body sizes of the serpents and undulating
tails. The colors of the designs painted within the serpents also varies.

8.8   Nuu-chah-nulth. Dominion Day parade in Port Alberni, 1929.

*Royal British Columbia Museum, PN 11167.*

On the back of this truck, individuals display their own family prerogatives: from left to right, a bird headdress worn by James Rush, a transformation mask on Rochester Peter, and wolf headdresses on Porter Ned, Mrs. Seymour Callick, and Mrs. Doctor Ned. The other people wearing wolf headdresses are unidentified. At the back is Mrs. James Rush and Chief Dan Watts. Although it was prohibited by law to present these during potlatches, they were seen as acceptable in the context of a Canadian holiday celebration.

community. At the celebration surrounding the presentation, dancers in headdresses performed, then food and gifts were distributed, in what was by any account a potlatch.

### FREDERICK ALEXIE

THE WORKS DISCUSSED thus far adhere to the general principles of Northwest Coast Native style, even if, in the north, they abandoned the strict canon. During the period under discussion here, several artists diverged from these traditions and created what can be characterized as hybridized works. Frederick Alexie (1854–c. 1944), the son of a Tsimshian woman and an Iroquois man brought west by the Hudson's Bay Company, lived in Lax Kw'alaams. Raised in his mother's clan, as would have been appropriate, Alexie became a carver and crafted regalia for *naxnox* demonstrations. In addition to art for use in his community, Alexie produced pieces for non-Native commissions. One of his best-known three-dimensional works is a baptistry made for a church in Lax Kw'alaams. Alexie also ventured into the world of European-style painting.

Alexie painted images of his community as it existed between 1850 and 1870, such as the one reproduced in figure 8.9, of a pole raising held at Lax Kw'alaams decades earlier. Alexie's paintings have sometimes been classified as "Indian primitive," because their naive, apparently self-taught style presents an immediacy and sincerity that complements their value as ethnohistorical documents. It would appear that Alexie was attempting to educate a largely non-Native audience about his culture by using a visual vocabulary they could understand. So, instead of creating isolated, uncontextualized items of regalia that outsiders may have found obscure, Alexie painted narrative works that included Native personages and portrayed dynamic moments that few non-Natives would have experienced.

8.9 Frederick Alexie, Tsimshian. *Pole raising at Port Simpson*, c. 1900.

*Oil on canvas. 13.4 x 22 in.*

*Collection of Louise Hager.*

Frederick Alexie was raised in Lax Kw'alaams and was trained as a carver. He taught himself to paint, and used the medium to portray scenes from his childhood, such as this one of a nobleman presiding over a totem-pole raising. This painting, done decades after the event being recorded, depicts the dynamism of a pole raising, with men straining to pull the lines up, others pushing the pole with long stakes. At the top of the stairs of the house stands the chief, preceded by two individuals carrying coppers. The white dots flowing out of his headdress represent eagle down. A line of men to the right of the stairs carry piles of blankets to be distributed during the succeeding potlatch.

BOTH the Canadian and United States governments recognized the value of totem poles as tourist attractions, and supported projects for their restoration. Public appreciation grew for the remaining totem poles that, often decayed and deteriorating, still stood in situ. Instead of allowing these monuments to be taken away and erected in distant museums, people initiated efforts to preserve, restore, and when necessary, copy the originals, now viewed as treasures. One example of this involves the Gitksan poles along the Skeena River. Between 1926 and 1930, the Canadian government collaborated with the Canadian National Railway to restore thirty Tsimshian poles along the railroad's Skeena River route. A "totem pole preservation committee" consisting of Duncan Campbell Scott of the Department of Indian Affairs, J. B. Harkins of the Parks Department, and Edward Sapir and Marius Barbeau of the B.C. Provincial Museum, had been convened to oversee the restoration of poles in order to "encourage tourist travel" to this splendid region. Negotiations were conducted with chiefs for their cooperation, and poles were taken down and restored, then re-erected close to the train tracks so that passengers could easily see them. Although during the first few years the restorations were carried out relatively successfully, by 1927 antagonism toward the project began to develop. Some Tsimshian were particularly incensed that the government that just a few years earlier had strongly discouraged the carving of totem poles now spent money on their preservation. By 1931, the project had lost its momentum, but it represented the beginning of non-Native–sponsored totem pole projects that remain popular to this day.

The anti-potlatch law in British Columbia remained in effect until the 1950s. In contrast, official attitudes in the United States toward Native people changed during the Franklin Roosevelt administration. In keeping with the more liberal social programs begun during the Great Depression, the United States government reversed its policy of assimilation and promoted religious and social tolerance. In 1934, Congress passed the Wheeler-Howard Indian Rights Bill, often referred to as the "Indian New Deal." This legislation included support for more Native self-government;

gradual closure of Native-only boarding schools; acknowledgment of the contributions of the indigenous people of the United States; affirmation of religious freedom; and promotion of Native arts and crafts.

An "Indian New Deal" restoration program propelled Alaskan totem poles into the public eye. The Indian Civilian Conservation Corps (Indian CCC), founded in 1933, provided work for increasingly impoverished and disadvantaged Natives. In Alaska, the first projects under this program, such as housing for teachers and nurses in Hoonah, worked to improve social conditions. In 1938, the Indian CCC, under the supervision of the U.S. Forest Service, began a highly visible and well-publicized Alaskan project that became one of Indian Arts and Crafts Board's success stories: restoring totem poles, which were promoted as significant expressions of American artistic heritage. At the beginning of the century, Governor Brady had requested the donations of Haida and Tlingit poles for the Sitka Park (see pp. 182–85), but other poles remained in southeast Alaska village sites, most of them steadily decaying in the rainy climate.

By the 1930s, most Tlingit and Alaskan Haida had moved from their original villages to locations closer to white populations. Their poles remained standing in now-empty villages. Here was an opportunity to transfer poles from abandoned towns to more populated communities, and, after they had been properly restored or replicated, erected in parks. As Brady had done several decades earlier, Forest Service personnel sought permission from Native leaders to salvage their poles. Recognizing the centrality of clan ownership in Tlingit and Haida culture, the officials assured Native communities that they remained in control of the ultimate fate of clan treasures. Each restoration team had a senior carver in charge of the work; one of the most distinguished artists who functioned in this capacity was Kaigani Haida John Wallace (1880–1950), himself the son of a carver. Because communities did not want their poles to be taken too far, the restored poles ultimately stood relatively close to their original villages: poles from Kasaan went to New Kasaan; those from Klinkwan, Sukkwan, and Howkan went to Hydaburg; ones from Tuxekan went to Klawock; and poles from Tongass, Cape Fox, Cat Island, and Pennock Island went to Saxman and Totem Bight, both in Ketchikan. In addition to copying extant poles, carvers also made some entirely new ones. The Indian CCC ultimately employed about 250 Native people, who restored,

8.10 Restoration of totem poles, Saxman, Alaska, 1939.

*USDA Forest Service, 384899. Photo: C. M. Archbold.*

During the Depression, the United States initiated many public works programs, including projects for Native Americans. In addition to being hired to build trails and various buildings, teams of Tlingit and Haida men were hired by the Indian Civilian Conservation Corps to restore or recarve poles that had been salvaged from deserted villages. Groups of younger carvers who had never made any kind of traditional art worked under the guidance of an elder who was knowledgeable in traditional techniques. The resulting poles, or modern replicas of them, stand today in various places in southeast Alaska, including Saxman Totem Park and Totem Bight Park in Ketchikan, at Chief Shakes's house in Wrangell, and at the National Historical Park in Sitka.

copied, and created anew more than one hundred poles (fig. 8.10). The greatest number of these are in Ketchikan, the first stop on the ferry from Washington State.

This project had an impact upon the attitudes some young men had about their culture. Like other Native Alaskans of the time, the Tlingit and Haida had lived all their lives subject to discrimination, segregation, and disdain for their traditions and, as a result they knew little about the art of their ancestors. However, if the United States government saw great value in the old carvings, so could they. As older men trained them in the art of woodworking, young men learned to value their heritage. A new respect for and pride in their cultural traditions developed among some of the young men who participated in this project.

## NORTHWEST COAST ART AS ART

DESPITE the discrimination and cultural repression imposed upon Northwest Coast people as settlers move in, by the third decade of the twentieth century increasing numbers of non-Native people had begun to admire the aesthetic qualities of Northwest Coast art, which in turn inspired some art-oriented exhibitions. Although most permanent collections of Northwest Coast pieces remained in natural history museums, some art institutions presented special exhibits of Northwest Coast material. In both cases to be discussed here, a central motivation for presenting Native art was nationalistic—both Canada and the United States were struggling to form their national identities in distinction from Europe. The art of indigenous people represented an indisputably North American tradition.

In 1927, the Canadian Diamond Jubilee year, the ambitious and historic exhibition titled *Canadian West Coast Art: Native and Modern* was installed at the National Gallery of Canada, in part to acknowledge the importance of aboriginal art in forming the nation's identity. The curators hung contemporary Canadian non-Native art next to Native pieces, which included several Frederick Alexie paintings. In the exhibition catalogue, anthropologist Marius Barbeau wrote, "A commendable feature of this aboriginal art for us is that it is truly Canadian in its inspiration. It has sprung up wholly from the soil and the sea within our national boundaries."[1]

Northwest Coast art began taking a new meaning projected onto it by non-Native Canadians, and now symbolized the nation that had deprived the First Nations of their land as well as their ceremonies. This irony was certainly not recognized as such by those who, at that time, truly believed themselves to be simply honoring these wonderful artistic creations.

In the United States, too, Native American art, including that of the Northwest Coast, was becoming more widely appreciated. Its recognition during the 1930s was part of a larger national effort by the Roosevelt administration to reverse governmental policies and allow Native Americans more cultural freedom. John Collier, the commissioner of Indian affairs, who believed strongly that Native art sales could provide good income and thus promote economic self-sufficiency for the mostly impoverished tribes, persuaded Congress to establish the Indian Arts and Crafts Board (IACB) to encourage, support, and market Native art. Under General Manager René D'Harnoncourt, who later became the director of the Museum of Modern Art in New York City, the IACB also fostered the belief that exposing the public to the recognizable excellence of Native American art could contravene the prevailing racism so deeply entrenched into the white American consciousness.

As was the case in Canada, the value of Native art became tied to issues of national identity. D'Harnoncourt believed that indigenous art could be instrumental in distinguishing a uniquely *American* culture, distinct from that of Europe. Thus, Native American art went beyond the culture of its creators, as it could serve a broader national purpose: "I personally believe that the Indian artist has enough to contribute to American civilization to make it worth while to spend a great deal of time and effort to give him every chance for a free development of his potentialities. I sincerely believe that Indian art ... may become a powerful fresh factor in American art."[2]

In 1939, D'Harnoncourt partnered with Frederic Douglas, curator of Indian Art at the Denver Art Museum, to assemble an outstanding array of Native American art at the San Francisco Golden Gate Exposition. Among the Northwest Coast pieces on display at that exhibition were the Nuu-chah-nulth screens (fig. 4.5) and the Tsimshian mask (fig. 5.2) reproduced earlier in this book. Two years later, many of the same works were presented at the Museum of Modern Art in New York City in an

exhibition, *Indian Art of the United States*, that filled the entire modernist building. This was the first time this material art had ever been exhibited *as art* in so prestigious an American museum, and it received highly laudatory reviews in prestigious art journals such as *Art Bulletin* and *Art News*. Several writers singled out as especially noteworthy the art from coastal British Columbia and southeastern Alaska, such as the pole that Haida artist John Wallace had carved in San Francisco during the 1939 fair and which stood on New York's 53rd Street outside the museum entrance for the duration of the exhibit. Inside, other objects were displayed in the Northwest Coast room, designed to evoke the interior of a large communal house, with a central firepit and dim illumination.

In the early twentieth century, African art needed Picasso to admire and appropriate it before European connoisseurs would classify it as "fine art" as opposed to "artifact." In a similar vein, Northwest Coast art (as well as other Native American traditions) achieved higher status in the Euroamerican art world after being "discovered" by the surrealists, some of whom perceived a special otherworldliness in Northwest Coast art. Without much solid grounding in the actual cultural meaning of these carvings and paintings, the surrealists interpreted them as the workings of the unconscious mind, an artistic goal for which they themselves strived. Max Ernst, for example, became fascinated with the psychological possibilities of totemism, and integrated images reminiscent of totem poles into his paintings and sculptures. Demonstrating an intellectual debt to the works of Sigmund Freud on this subject, Ernst titled a 1941 painting of female and bird forms placed before objects similar to totem poles *Totem and Taboo*, after Freud's publication of the same name.

The early abstract expressionists who gravitated toward the surrealists also found Northwest Coast art fascinating; for example, as was noted in the Introduction, Barnett Newman praised Northwest Coast two-dimensional art in the catalogue to his 1946 exhibition, *Northwest Coast Indian Painting*. In addition to promoting its aesthetic qualities, Newman also used this art to validate the kind of work he and his colleagues produced: "there is answer in these works to all those who assume that modern abstract art is the esoteric exercise of a snobbish elite, for among these simple peoples, abstract art was the normal, well-understood,

dominant tradition."[3] With these words, Newman honored Northwest
Coast art by attributing to it qualities that non-Native Western artists were
only recently inventing.

## MUSEUM SALVAGE AND RESTORATION PROJECTS

AFTER WORLD WAR II, two major British Columbia museums, the
Royal British Columbia Museum in Victoria (originally called the British
Columbia Provincial Museum) and the Museum of Anthropology on the
University of British Columbia campus in Vancouver, initiated salvage
and restoration projects that have become models of cultural preserva-
tion. In 1949, the University of British Columbia (UBC) purchased several
Kwakwaka'wakw poles, house posts, and an eleven-piece house frame
which they planned to erect outdoors on the campus. These needed
to be restored and repainted, so the Museum of Anthropology (MOA)
contacted Ellen Neel, who had a business in Stanley Park carving full-size
and model poles. Neel did not enjoy restoration, and after one season,
recommended her uncle Mungo Martin. From 1949 to 1951, Martin was in
residence at MOA, restoring his own Raven-of-the-Sea pole from Alert Bay
and carving two new poles with his family's crests. In 1951, the museum
erected Martin's poles, the internal frame of an old-style house, and three
other poles at a three-acre site on the UBC campus that had been set aside
as the location for a totem park.

In 1940, the Royal British Columbia Museum had erected its totem-
pole collection in what was christened Thunderbird Park, and constructed
two Northwest Coast–style houses, the larger of which blended Coast
Salish, Kwakwaka'wakw, and Haida elements, the smaller an amalgama-
tion of Kwakwaka'wakw and Nuu-chah-nulth components. In the early
1950s, it became clear both that several of the poles needed restoration or
even duplication, and that the hybridized buildings needed to be replaced
with a more authentic structure. At the urging of curator Wilson Duff,
the Victoria museum decided to hire Mungo Martin, who had done such
splendid work at the Museum of Anthropology in Vancouver.

Martin settled into Victoria with his wife, Abayah, and became a major
tourist attraction for visitors, who could watch him carve and ask him

questions. Martin needed help to do all the restoration and replication work, and brought his son David to Victoria to serve as his assistant until David died in a fishing accident in 1959. Martin also worked with his adopted daughter's husband, Henry Hunt (1923–85; George Hunt's grandson), and Hunt's son Tony Hunt (b. 1942). Bill Reid (1920–1998), a man of Haida ancestry who was to become one of the most highly regarded northern Northwest Coast artists, also worked alongside Martin in 1957, on Reid's first pole, a monument that now stands at the United States/Canada border in Blaine, Washington. Over the ten years Martin was chief carver at the Victoria museum, his team replicated twelve old poles—three Kwakwaka'wakw, three Tsimshian, two Nuxalk, and four Haida. During his tenure, Martin also carved two original Kwakwaka'wakw poles.

In 1953, Martin built a Kwakwaka'wakw-style house which he named *Wawaditla*, which translates as "He orders them to come inside," an expression of tremendous authority and power (fig. 8.11). It featured a vividly painted facade and interior house posts. Outside stood a totem pole. To validate this building, its imagery, and the exterior pole, Martin hosted a splendid three-day potlatch, December 14–16, 1953. Two years before, the potlatch prohibition had been eliminated from the Indian Act, and Martin's opening ceremony for this house represented the first legal potlatch since 1884. On the first day only Native people and a small number of special non-Native friends attended the ceremonies. The next day, December 15, invited non-Native guests were treated to an incredible presentation of dances and performances with masks owned by Martin's family. In the past, anthropologists such as Boas had attended potlatches and produced scientific accounts of the ceremonies; now, in something of a reversal, Martin, who understood the value of anthropological documentation, himself invited anthropologists to record the event. There were speeches, food (at a restaurant nearby), and distributions of gifts and money. On the third day, another event was produced for the public. These were fitting celebrations of a tradition that, despite all the accounts to the contrary, had never disappeared.

Anthropologist Wilson Duff worked first for the British Columbia Provincial Museum in Victoria, and later at the University of British Columbia in Vancouver. Throughout his career, he demonstrated consid-

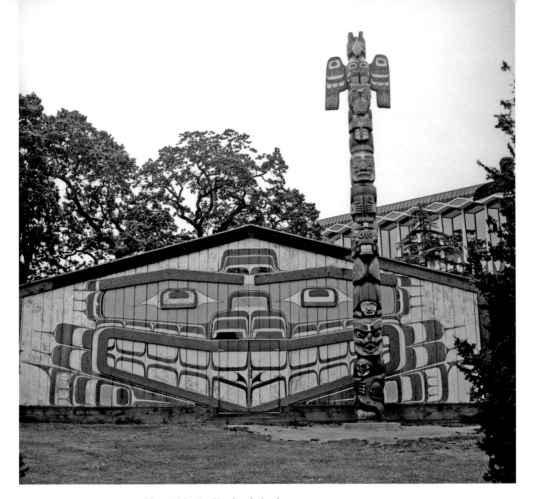

8.11 Mungo Martin, Kwakwaka'wakw.

*Wawaditla* house, Thunderbird Park, 1953.

*Royal British Columbia Museum, PN13195-10.*

The British Columbia Provincial Museum (now the Royal British Columbia Museum) hired Mungo Martin to replicate totem poles. They also had him build a big house, which he called *Wawaditla*, which translates as "He orders them to come inside." This means the chief is so powerful that he can command anyone to come into his house and serve him. The painting on the facade is Martin's version of a crest image owned by his ancestor who lived in Fort Rupert. The pole that stands before it, in contrast, does not depict Martin's own privileges but instead the crests of four Kwakwaka'wakw tribes. The events that celebrated the opening of Martin's house constituted the first public potlatch held since the decriminalization of the potlatch.

erable sensitivity to the protocols of Native communities as well as to the immense importance of crest images to families. One of his major goals was to retrieve totem poles from their original sites in order to preserve and protect them within museums. By midcentury, most Haida poles still in situ were almost one hundred years old, and rapidly deteriorating. In 1955, Duff met with Haida chiefs and received their permission to organize an expedition to Tanu and Skedans to retrieve poles. Two years later, he returned to Haida Gwaii and salvaged poles from the southernmost Haida site, SkungGwaii (Ninstints; see fig. 5.21).

Duff had less immediate success with the Gitksan, whose poles he admired enormously. These people, who had managed to put a stop to the 1927–31 Skeena River totem pole restoration project, were like the Kwakwaka'wakw and Nuu-chah-nulth in that they, too, resisted the potlatch ban by continuing to erect totem poles which were always accompanied by potlatches. In 1936, a Skeena River flood had destroyed or damaged numerous Gitksan poles; over the next decade, villages along the river repaired those that could be salvaged and carved new versions of those that were lost. In 1945, in the village of Gitsegukla, five totem poles were raised, accompanied by two weeks of feasts and power demonstrations. These Gitksan totem poles embodied all the social significance of their precursors, but lacked the elegantly refined carvings of nineteenth-century northern-style art. The artists paid less attention to three-dimensional carving, and more to the application of vivid paint and, indeed, utilized colors rather than carving to represent the beings that populate the pole.

Although the quality of these fairly shallow and unmodulated carvings could be judged inferior to earlier Gitksan works, they represent significant statements about the standing and privileges of their owners. The events that took place during the two-week period when these poles were raised represented significant continuities of earlier traditions. After they were erected, feasting and gift-giving validated the poles and their owners. Prior to raising one of the poles, a family put on an impressive demonstration of power that began when a warrior attempted to disrupt the proceedings. In response to attempts by attendants to restrain him, he hurled an axe at a man, who fell down, bleeding profusely. Many

attendees thought this had been a real murder, for the victim appeared quite dead, and the axe had to be removed from his bloody head. Then the chiefs were called upon to restore his life by means of their special powers. Each chief approached the body, singing songs and performing dances meant to raise him from the dead, but to no avail. Finally a last chief began to sing, and the blankets covering the victim began to move. After increasingly energetic singing, he sat up and, very weakly, arose and walked away.

In 1952, Duff visited the Skeena River villages and became troubled by the ongoing deterioration of the poles, a condition he knew could only get worse. As he had done with the Haida, Duff asked the Gitanyow (Kitwancool) chiefs for permission to remove the poles (see fig. 5.11). Unlike the Haida, these chiefs resisted Duff's efforts, unwilling to relinquish their treasures, regardless of their level of deterioration. To this highly conservative group still unhappy about their land claims, poles embodied their history, their land, their way of life. Ever persistent, Duff came to an agreement—he could remove the Gitanyow poles, as long as replicas were made and erected in the village. But even more importantly, the Museum would publish a book, *Histories and Territories of the Kitwancool* (1959), which presented their claims to their land. This would be most useful to the group as they pursued their land claims. Today, the replicated poles still stand in Gitanyow, the originals are in Victoria, and *Histories and Territories of the Kitwancool* remains in print.

These Canadian projects inspired a similar one in Alaska, where by the 1960s some monuments still remained in abandoned villages. These had endured the southeast Alaska climate for a long time, and, as might be expected, were decayed. The Alaska State Museum in Juneau, aware of the important strides both the British Columbia Provincial Museum and the University of British Columbia Museum of Anthropology had made in restoring poles, initiated its own salvage project to protect these treasures. In 1966, the Alaska State Museum conducted a survey of poles in Tlingit and Haida villages. The following year, with support of the Alaska Native Brotherhood (ANB) and the Alaska State Council on the Arts, these poles were retrieved from old villages and placed in the collection of the Totem Heritage Center in Ketchikan. Throughout this project, the

managers regularly consulted the ANB and the Alaska Native Sisterhood to ensure that the museum was acting according to the wishes of the people whose culture they were preserving.

## THE NON-DEATH OF NORTHWEST COAST ART

THE PERIOD BETWEEN around 1900 and 1960 was a time of resistance to official authority and cultural persistence on the part of Native people, and also a time of growing appreciation for Native art on the part of non-Natives. According to some versions of art history, Northwest Coast art "died" with the death of Charles Edenshaw, and only began to flourish again after 1960, during the so-called "Northwest Coast renaissance" that will be discussed in the following chapter. The reality was different, however. Kwakwaka'wakw defied the potlatch law and nurtured several outstanding artists. Totem-pole raisings and related ceremonies took place without repercussions among the Gitksan and Nuu-chah-nulth. The Haida, Tlingit, Nuu-chah-nulth, Kwakwaka'wakw, Salish, and other groups continued to produce art for sale to outsiders, who by purchasing items such as baskets and model totem poles, encouraged the maintenance of artistic traditions. The vitality of artistic culture during the years between 1920 and 1960 depends upon one's perspective; if art equals adherence to canon and concern for refinement and quality, only in some places did material that qualifies as "art" appear. However, carvers continued to create, and communities continued to use art, even if under highly modified circumstances. And all creations, canonical or not, were expressions of Native identity. Just because an artwork is not finely made does not mean that its tradition is "dead." Northwest Coast art production was neither as active nor as widespread as it had been, nor as it would become, but it persisted under the most trying of conditions.

During this period, activities sponsored by museums and government agencies intended to preserve Native artworks not only provided work for carvers, but, by encouraging artists to create traditional works and by placing considerable value on their works, contravened some of the racism still prevalent. Northwest Coast Native people, while remaining subject to appalling conditions and treatment, were slowly becoming more respected for the quality of their art. By the 1960s, that

respect had grown to great admiration, and artists confidently began to create new artworks of quality and quantity not seen for decades.

The major exhibits held earlier in the century in preeminent Canadian and U.S. institutions, *Canadian West Coast Art: Native and Modern* and *Indian Art of the United States*, with their presentation of Native artworks as signifiers of these nations' unique artistic identities, gave Northwest Coast art, at least temporarily, an aesthetic respectability within the world of Western art. Praise from non-Native artists such as the surrealists enhanced this newfound status. These validations of Northwest Coast artistry began to open the eyes of the public to the aesthetic, rather than strictly ethnographic, possibilities of these creations. Unfortunately, attitudes toward artworks by people of color do not always change as quickly as one might hope, and it would be some time before the public would fully embrace as an unquestioned principle the concept that Northwest Coast works qualified as true "art." Because it has no place in the Western art-historical sequence of styles that includes periods such as medieval, renaissance, impressionist, and abstract expressionist, most aboriginal art has had an uncertain relationship with art museums. Despite the praises Northwest Coast art received from artists and museumgoers alike, and despite its appearance in temporary exhibits at fashionable galleries and art museums, permanent displays of it were still, for the most part, at natural history museums. One rare exception was the Denver Art Museum, which founded an Indian Art department in 1925 and exhibited Native American art as part of its collections. By the end of the twentieth century, however, many art museums would be proudly displaying Northwest Coast art in permanent exhibits, for by that time Native American art had finally assumed a position equal to the art of any culture, Western or not.

# IDENTITY AND SOVEREIGNTY, 1960s TO TODAY

BEFORE THE 1960S, Northwest Coast artists had continued carving
and painting, but in relative silence and with little public appreciation.
However, as the spirit of liberation and social equality pervaded the
United States and Canada, more and more non-Natives recognized the
value of contemporary Northwest Coast art. The market exploded, and
large numbers of Native artists flourished. Their new works embodied
messages that would never have even been conceptualized until the
late nineteenth century, and, during the early decades of the twentieth
century, would rarely have been openly expressed. The artists were saying,
on behalf of their communities, "We exist, we have survived, we are now
a force to be reckoned with." Unlike their ancestors, contemporary artists
represent a minority in their own land, and have an historic conscious-
ness of the settlers' mistreatment of and discrimination against Native
people. They draw on the traditions of their predecessors yet are fully
aware of living in an immensely different world. Some artists are content

to present simply their Native identity and heritage, while others make statements, sometimes quite strong, on issues of land claims, discrimination, ecology, and sovereignty, thus challenging the dominant culture and expressing resistance against those who so long oppressed them. This is very much in keeping with the times, and represents a monumental shift in relationships between Natives and non-Natives.

During the 1960s, activists vociferously campaigned for greater social justice and against all forms of oppression. In addition to African American, Latino, and women's rights, the rights of Native Americans became a national and international issue. Centuries of mistreatment, discrimination, broken treaties, and land appropriation began to be discussed openly, and citizens of both the United States and Canada became sensitized to the history of colonialism. The American Indian Movement (AIM), founded in 1968, sometimes used force, under the battle cry "Indian Power," to achieve its goals of equality for Native Americans. Over the next several decades, Native Americans and Canadian First Nations became increasingly empowered, promoting both self-determination and cultural pride. One consequence of this large-scale shift in public attitudes toward Native people was a tremendous upsurge in interest in art, and dramatic increases in its production.

Meanwhile, land claims remained contentious in both the United States and Canada. For years, Alaskan Natives had experienced great difficulties with the federal government regarding land rights, as ownership of almost all of the territory of Alaska was uncertain. In 1959, when Alaska finally became a state, discussion continued on the question of land claims, for although the statehood act recognized Native rights to some Alaska land, specific territories were not designated as Native. These problems remained unsettled until 1971, when somewhat ironically, an event quite unrelated to Native issues ultimately solved this problem: the discovery of oil in the North Slope. In the Prudhoe Bay area of the Arctic Ocean was an oil field of approximately ten billion barrels—by far the largest in the United States. The problem of getting that oil to market could be solved by building a pipeline from Prudhoe Bay to the ice-free port of Valdez on the Gulf of Alaska. But Native groups claimed parts of the land through which the pipeline would go, and litigation over these land claims could prevent the flow of oil. If that happened, the United

States would be denied its oil and Alaska would suffer economically. So, in 1971, President Nixon signed into law the Alaska Native Claims Settlement Act (ANCSA), which gave Natives title to forty-four million acres—10 percent of the land—and $962.5 million in compensation for other lands taken over by the government. Regional and village corporations were formed to administer the land and invest the funds. Under ANCSA, the Tlingit (along with the smaller number of Haida who lived in southeastern Alaska) formed the Sealaska Regional Corporation, which received title to 200,000 acres of land. Ten smaller village corporations that organized outside the Sealaska corporation acquired surface rights to 23,000 more acres. By and large, Alaska land claims had been settled by the 1970s.

Not so in Canada, where—despite the 1951 elimination of the anti-potlatch section of the Indian Act—the laws of the 1867 British North America Act and the remaining laws of the 1876 Indian Act still denied First Nations their sovereignty and defined them as wards of the state. In keeping with national and international aboriginal rights movements, British Columbia Natives along with other Canadian First Nations struggled to win back their independence as autonomous units with self-determined political, social, and economic affairs. This was slow in coming, as only in 1982 did First Nations appear as a category of citizens in the Canadian constitution. Article 35 explicitly states, "The existing aboriginal and treaty rights of the aboriginal peoples of Canada are hereby recognized and confirmed…. In this Act, 'aboriginal peoples of Canada' include the Indian, Inuit and Metis peoples of Canada."

Because most B.C. Natives never signed treaties with the federal or provincial governments for their land, land rights and control of resources remain contentious. Recognizing the need to address these issues in order to come to some mutually acceptable agreements, in 1991 a task force on land claims consisting of representatives of the federal and provincial governments and First Nations representatives was established. This group recommended the establishment of the British Columbia Treaty Commission (BCTC), which began operation in 1993 and soon received statements of intent to negotiate from numerous British Columbia Native groups. The Nisga'a, who had commenced negotiations before this time, reached an agreement in 1998 that settled well over a century of land claims. Other treaty negotiations are ongoing.

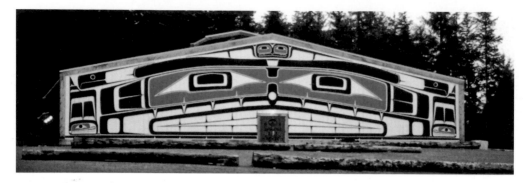

9.1 Sea Monster house facade painted by Doug Cranmer
(Kwakwaka'wakw) and others, Alert Bay, 1999.

*Courtesy UBC Museum of Anthropology, Vancouver, Canada. Photo: Bill McLennan.*

A community bighouse was originally built on this site with funds from the British Columbia Centennial in 1965. Although at the time it was promoted as a place to carve and sell Native art, it soon became the location for very active potlatch activity. The house was enlarged, and then, after it burned down, was totally rebuilt. Doug Cranmer, son of Dan Cranmer, at whose potlatch participants were arrested (see p. 224), was trained with Mungo Martin and later joined Haida artist Bill Reid to create Haida-style poles and houses (see fig. 9.4). The broad, dramatic face on the 81-foot-wide facade is a descendent of 19th-century Kwakwaka'wakw painting (see fig. 4.7) and mid-20th-century works such as Mungo Martin's (see fig. 8.11).

The array of Northwest Coast art made after the 1960s is impressive and varied. In addition to works that adhere relatively closely to historic prototypes, some artists have chosen nontraditional paths and use elements from Northwest Coast art to create innovative artistic statements. Native people themselves use new artworks in ceremonies that are either continuations of unbroken traditions such as Kwakwaka'wakw potlatching, or new forms such as the Rainbow Creek Dancers, a group that performs original songs and dances created by their founder and leader, Haida Robert Davidson (b. 1946). Some communities, such as Alert Bay, Fort Rupert, and Gilford Island, built structures for the many Kwakwaka'wakw potlatches that take place each year (figs. 9.1, 9.2). In other towns, feasting, dancing, and gift distribution occur in the community hall. Today a healthy internal market for robes, masks, musical instruments, and a wealth of other types of regalia for contemporary ceremonialism keeps artists working. The non-Native market is also

9.2  Potlatch given by Chief Peter Knox, Alert Bay, 1996.

*Photo: Vickie Jensen.*

Masks and other regalia used at potlatches become part of vivid
settings in which other participants clad in colorful button robes often
sing and dance. Most of the artworks presented in this book were
not meant to be seen in a pristine museum-like setting but rather in
a dynamic, energized, and complicated context such as this.

9.3   Richard Hunt, Kwakwa̱ka'wakw. Sculpin mask. *Wood, pigment. 60.7 in.*

Royal British Columbia Museum 16612.

Masks such as this one are still actively used in potlatches, but are also prized
collector's items. This particular piece was made for the *Legacy* exhibit at the Royal
British Columbia Museum (see p. 284). The artist was inspired by another, older
mask in the RBCM collection, which was used during the *Tlasala* ceremony. Parts
of this mask—the dorsal spines, pectoral fins, jaw, and tail—can be manipulated
through strings by the dancer.

strong, with the same type of work that would be used in a community ceremony often appearing on the walls of art galleries (fig. 9.3).

## THE RETURN OF THE CANON

DURING THE FIRST HALF of the twentieth century, most if not all northern artists abandoned the canons of nineteenth-century art, presumably having lost the knowledge of their ancestors' elegant form-line style. In the 1960s, two men, one Native, one non-Native, analyzed artworks from the nineteenth-century "golden age" and reconstructed the distinctive two-dimensional systems of past masters, opening up the way for a great resurgence of Northwest Coast creative activity. Through careful study of objects in museums and in-depth analysis of the elements of design and how they fit together, Bill Reid and Bill Holm led the way for the return to the nineteenth-century canon and the creation of contemporary artworks of considerable aesthetic merit.

Bill Reid, a talented jeweler who had grown up far from his mother's Haida community, had little connection to Native traditions until midlife. After studying Northwest Coast artworks in museums, and becoming familiar with techniques used in their production, Reid himself began crafting "new" Haida artworks of considerable aesthetic merit. Reid began working in monumental mode when in 1957 he assisted Mungo Martin in Victoria in carving a totem pole. In 1958, UBC's Museum of Anthropology hired Reid, along with Kwakwa̱ka'wakw master Doug Cranmer (b. 1927), to replicate some of its Haida poles and build some Haida-style structures. By 1962, the two Haida houses and array of poles that stood on the university campus became a highlight of any trip to Vancouver (fig. 9.4).

Non-Native artist and scholar Bill Holm similarly spent long hours in museums, studying nineteenth-century northern works and analyzing the complex component elements of two-dimensional design. As he states, "My motivation for this was to learn to *make* things that looked right. Each thing I make adds to my understanding."[1] The result of Holm's meticulous work was *Northwest Coast Indian Art: An Analysis of Form* (1965), which remains to this day the most insightful stylistic study of northern art. This book identifies the essential elements of northern two-dimensional art and

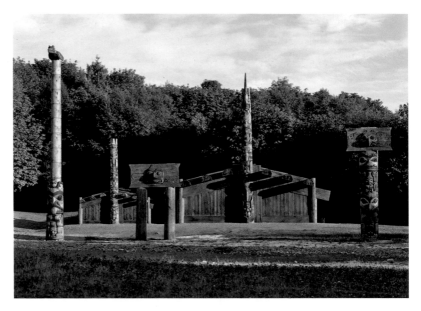

9.4  Bill Reid and Doug Cranmer. Haida village replica, 1959–62.

*Museum of Anthropology, University of British Columbia.*

*Courtesy UBC Museum of Anthropology, Vancouver, Canada. Photo: Bill McLennan.*

The Museum of Anthropology at the University of British Columbia and the
Royal British Columbia Museum in Victoria were pioneers in supporting Native
artists to make new and replica totem poles. Even though Bill Reid had not had
much experience in large-scale carving, the Museum of Anthropology hired him
along with Kwakwaka'wakw artist Doug Cranmer to create a portion of a Haida
village. It includes two houses with frontal poles, two memorial poles, and two
mortuaries. When the frontal pole of the larger house became deteriorated, it was
removed and placed inside the museum. The story of the carving, its raising, and
the celebration of its replacement can be both seen and read on the Museum of
Anthropology's web site.

the principles that govern their arrangement and interconnections. In it,
Holm defines the elegant, calligraphic formline, designating two versions
as primary and secondary. He also names and deciphers other, smaller
elements—ovoids, u-forms, split u-forms, and tapered eyelids—and
analyzes how all the diverse elements work together to create a unique
and immediately recognizable style.

Historians often give Holm and Reid credit for initiating what is
commonly called the "Northwest Coast renaissance," during which

northern artists turned away from the poorly executed works of their twentieth-century predecessors and drew inspiration from nineteenth-century masterpieces. Others should be recognized as well. Wilson Duff, curator at the Royal British Columbia Museum and professor at the University of British Columbia, although neither an artist like Reid, nor author of an influential book like Holm, promoted tradition and canon through his work with museums and Native artists. And, more recently, Peter Macnair, retired curator of the Royal British Columbia Museum, played a significant role in maintaining standards of Northwest Coast art by encouraging excellence among artists working today. Two other scholars who were trained in Northwest Coast art styles have also made major contributions to knowledge of the form. Steve Brown has refined and advanced Holm's original analysis, and Robin Wright has identified numerous artist's hands.

Over the last fifty years, the number of Northwest Coast artists has grown exponentially, responding to an ever-expanding and enthusiastic market. To satisfy the desire of buyers for relatively inexpensive Northwest Coast two-dimensional works, artists in the 1960s began working in serigraphy, a printmaking medium to which two-dimensional Northwest Coast images lent themselves nicely. Groundwork had been done in the 1950s when Kwakwaka'wakw artist Ellen Neel silkscreened formline designs on silk scarves, which consumers enthusiastically purchased. Then, in the early 1960s, Kwakwaka'wakw Henry Speck (1909–71) produced unlimited-edition prints of mythological beings, followed by other artists including Tony Hunt (b. 1942), Robert Davidson (b. 1946), and Art Thompson (1948–2003). By 1980, approximately 100 artists had published more than 900 different images (fig. 9.5).

Galleries in Seattle, Vancouver, Victoria, and elsewhere began selling large numbers of prints, as well as other types of contemporary two- and three-dimensional Northwest Coast works. Several Native entrepreneurs opened up galleries as well. Between 1969 and 1990, Tony Hunt, his brother Richard (b. 1951), and their non-Native friend John Livingstone owned and operated the Arts of the Raven gallery in Victoria, which sold Northwest Coast prints and carvings and also trained the next generation of Kwakwaka'wakw carvers, including Tony's second cousin, Calvin Hunt

9.5  Art Thompson, Nuu-chah-nulth. *Pook-Ubs*, 1980. *Serigraph print. 18 x 24 in.*
*Courtesy of the Burke Museum of Natural History and Culture, Catalog Number 1998-90/960,*
*Art Thompson Print.*

In Nuu-chah-nulth winter dances, Pook-Ubs, the spirit of a drowned whale hunter,
appears in the form of a dancer with white-painted body and a white mask with
deep wrinkles. Here Thompson has translated this being into two dimensions in
a print with the kind of asymmetry and open spaces seen in older Nuu-chah-nulth
paintings. Although most Native serigraph prints are made for the art market,
some are created specifically for potlatches and distributed to the guests.

(b. 1956). The latter in turn became another Kwakwa̱ka'wakw entrepreneur when in 1982 he began operating a shop and training studio called The Copper Maker in Fort Rupert.

In the past, an individual who wished to become an artist was apprenticed to a master artist. Today some individuals still train in this traditional fashion, watching and assisting an established artist; Tony Hunt learned his craft from his father and Mungo Martin in this way. Others attend mainstream art schools and receive M.F.A. degrees, learning Native artistic traditions along the way. Eric Robertson, for example, earned an M.F.A. from Concordia University in 1992. Beginning in the 1970s, the Kitanmax School at 'Ksan in northern British Columbia provided formal training in northern-style art. When it opened, the school brought to the Gitksan region instructors including Kwakwa̱ka'wakw Doug Cranmer and non-Natives Bill Holm and Duane Pasco. The first student trained at 'Ksan was Walter Harris (b. 1931) who, in addition to creating works for sale and for use within his community, raised the first contemporary totem pole in Kispiox in 1971.

## MAINTAINING ARTISTIC TRADITIONS FROM SOUTH TO NORTH

TODAY, virtually every Northwest Coast nation can boast of artists working in traditional styles of both men's and women's art. In the second half of the nineteenth century, mission schools encouraged the Cowichan to forgo their weaving traditions (which to some missionaries represented connections with their heathen past) and begin to knit wool. By the twentieth century, Cowichan knitting had become and remains a significant source of income. Becoming interested in their heritage, Stó:lō Mary Peters and Adeleine Lorenzetto began studying traditional Salish weaving techniques and, in the 1960s, began making textiles like those of their ancestors. The knowledge of traditional weaving soon passed to women in Musqueam, and more recently to the Lummi of Washington State.

Salish weaving embodies far more than a traditional practice now revived; it is for many the essence of Salish identity. At Musqueam, Debra and Robyn Sparrow continue the weaving traditions of their ancestors

(fig. 9.6). Debra Sparrow articulately expresses her connection to those who came before: "We hear time and time again that if you don't know who you are, or you don't know where you come from, then you're nobody. You're nobody if you don't have a history, if you can't relate to it, talk about it, or communicate it. So, the weaving is our gift back to us, and to our community. It's amazing to be involved in the time that we are, to be bringing back the values and a sense of success, through our own creative process."[2]

Wakashan women's art remains strong, as is evident in the large number of colorful and well-crafted button blankets that grace dancers at potlatches and public presentations. Basketmaking continues too, especially among the Nuu-chah-nulth. Jessie Webster (b. 1909), for example, began weaving baskets when she was seven, learning from her mother and other talented women in the village of Ahousat. Well known for her fine cylindrical baskets with lids, Webster also occasionally diverged from the constraints of traditional form and wove more contemporary items such as rectangular shopping baskets, replete with such traditional images as whalers, whales, and thunderbirds with outstretched wings.

The Kwakwaka'wakw clung tenaciously to their cultural and artistic traditions, and are justly proud of their unbroken line of great carvers during the twentieth century. Between the 1920s and 1960s, Willie Seaweed and Mungo Martin—as well as many other carvers—quietly produced masks and regalia for community use. The Royal British Columbia Museum's Thunderbird Park carving program, which began when Wilson Duff hired Mungo Martin in 1952, became an important training ground for a number of young Kwakwaka'wakw artists. When Martin died in 1962, Henry Hunt became the chief carver, and brought on board as his assistant his son Tony Hunt, who, in addition to numerous other works, in 1970 carved the memorial pole for Mungo Martin that stands in the Alert Bay cemetery. At the Museum of Anthropology, Martin's student Doug Cranmer worked with Bill Reid on the Haida houses and poles. Tony Hunt's brother Richard Hunt, cousin Calvin Hunt, and son Tony Hunt Jr. also became well-known artists.

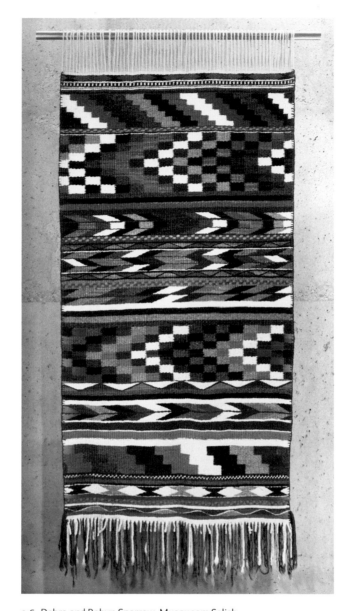

9.6  Debra and Robyn Sparrow, Musqueam Salish.

*Ten robe, 1997. Wool, pigment.*

Courtesy UBC Museum of Anthropology, Vancouver, Canada. Photo: Bill McLennan.

When a group of Musqueam women decided to start learning to weave, they found
that many of their tribal sisters were not familiar with the old style of weaving.
They studied old textiles in museums, learned several stitches, read books,
and successfully revived a tradition. In addition to weaving exquisite textiles,
Musqueam women also market woolen blankets with Salish imagery. In 1997 the
UBC Museum of Anthropology commissioned sisters Debra and Robyn Sparrow to
weave this vivid robe, which was installed in the museum in 1999.

Once the northern style canon was reestablished, art began to flourish among the Tlingit, Haida, and Tsimshian. Bill Reid's work at the Museum of Anthropology with Doug Cranmer on the Haida houses and poles was just the beginning of Reid's brilliant career, which included large-scale installations at the Vancouver International Airport, the Vancouver Zoo, and the Canadian Embassy in Washington, D.C., totem poles, including the first erected in Skidegate in decades, full-size canoes, argillite sculptures, masks, and jewelry. His *The Raven and the First Men*, a signature piece at the Museum of Anthropology, was inspired by an argillite work by Charles Edenshaw depicting the same theme (see fig. 7.4). In 1970, Reid carved a small version of the story, but showing Raven as a bird. Walter Koerner, patron of the Museum of Anthropology, commissioned Reid to carve a large-scale version of his interpretation, which would have a place of honor in the museum's new building designed by Arthur Erickson. Reid completed this ambitious work by supervising a team of younger artists that included James Hart (b. 1952) and Reg Davidson (b. 1954). The end result presents a bird with open wings standing on a clamshell being pushed open by diminutive naked human beings. In addition to such monumental works, Reid used his training in metalworking to translate northern-style forms into gold and silver miniatures and jewelry.

In 1966, Robert Davidson, Charles Edenshaw's great-great grandson, met and became apprenticed to Bill Reid. Davidson has also produced a prodigious amount of strikingly original art solidly based in Haida traditions. In 1969, when he was twenty-three years old, Davidson, with the assistance of his brother Reg, carved the first pole to be raised on Haida Gwaii in ninety years (fig. 9.8). Since that time, he has created superbly crafted totem poles that stand on both private and public lands, silver and gold jewelry, bronze castings, and masks both to be sold and to be used by Haida dancers. His innovation is especially evident in two-dimensional work such as his silkscreens. Although often he uses the formline style to represent beings, sometimes he uses elements of design as abstract images. In addition to his two- and three-dimensional artworks, Davidson is a writer of poems and songs, and leader of the highly regarded Rainbow Creek Dancers.

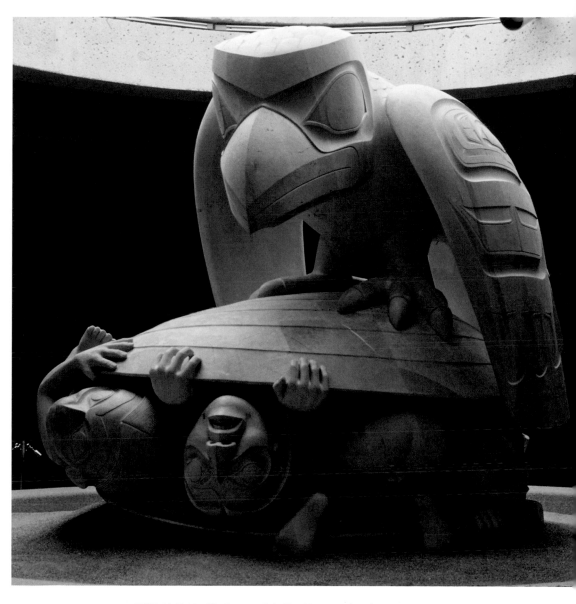

9.7 Bill Reid, Haida. *The Raven and the First Men*, completed 1983.
*Yellow cedar. 74 x 75.6 in.*

Courtesy UBC Museum of Anthropology, Vancouver, Canada, Nb1.481. Photo: Bill McLennan.

Bill Reid was first trained as a jeweler, and excelled in creating diminutive gold
sculptures. He also made full-size totem poles, such as those in figure 9.4. This
original and greatly admired monumental sculpture draws its inspiration from
Charles Edenshaw in presenting a traditional narrative. The piece was carved from
a block of laminated cedar and, unlike most totem poles, must be seen as a truly
three-dimensional creation. As one walks around it, each small man struggling
to emerge from the shell shows its own unique personality and response to
this extraordinary experience, while the wings and tail of the raven spread out
dynamically and gracefully.

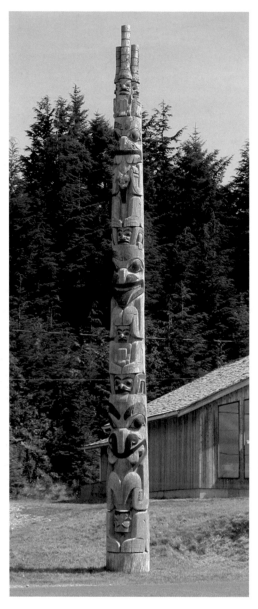

9.8  Robert and Reg Davidson, Haida. Pole at Old Massett, 1969.

*Cedar, pigment.*

*Photo: Aldona Jonaitis.*

Robert Davidson, who apprenticed with Bill Reid, is a master of all types of
contemporary art from jewelry and original formline images to large-scale
sculptures. Relatively early in his career, Davidson carved for his community of
Massett the first totem pole raised on Haida Gwaii since the late 19th century.
As such, it is the monument that signaled the tremendous flourishing of totem
poles installed in communities on Haida Gwaii. Since this time, Davidson
has carved many other poles in Canada and around the world. In addition, he
has mentored many young artists, and advised on numerous art projects.

Throughout the twentieth century the Tlingit maintained their cultural traditions, including the importance of lineage and clan. Despite the lack of adherence to the northern canon during that period, new art continued to be made, and a considerable amount of treasured regalia remained within the families. The most senior and respected living Tlingit artist, Nathan Jackson (b. 1939), who worked with Bill Holm and studied museum collections, has produced large numbers of small and monumental artworks, and trained numerous apprentices. Jackson's totem poles stand in many locations throughout Alaska, as well as in the mainland United States and other countries.

Women's art is also well represented in the northern region. Massett Haida Selina Peratrovich (1889–1984) grew up in Howkan, Alaska, and learned basketmaking by observing her mother-in-law, Elizabeth Adams (fig. 9.9). She then became an influential teacher, who helped develop an entire generation of basket weavers such as Isabel Rorick (b. 1958). Rorick also had other women to emulate and from whom to learn. Her mother, Primrose Adams, her grandmother Florence Davidson (Robert Davidson's grandmother as well), and her great-grandmother Isabelle Edenshaw all maintained the tradition of root weaving, as did her her aunt Dolores Churchill of Ketchikan.

By the early decades of the twentieth century, fewer and fewer women had taken on the challenge of the time-consuming and complex Chilkat robe, and no one had crafted a raven's tail robe for almost one hundred years. The last Tlingit woman who learned to make Chilkat robes by having been apprenticed to an experienced weaver was Jennie Thlunaut (1891–1986), a woman who produced dozens of fine robes and tunics. She attracted a number of apprentices, such as Clarissa Hudson (b. 1956), who today, along with numerous other women, continue the Chilkat tradition, creating masterful artworks. Non-Native Cheryl Samuel contributed to this endeavor by analyzing Chilkat robes in museums and publishing *The Chilkat Dancing Blanket* (1982), which offers detailed descriptions of the technique used by nineteenth-century textile artists. Samuel also investigated in detail the few remaining raven's tail weavings, then wrote a book on this more ancient technique, *The Raven's Tail* (1987). Soon an active group began creating these geometric textiles.

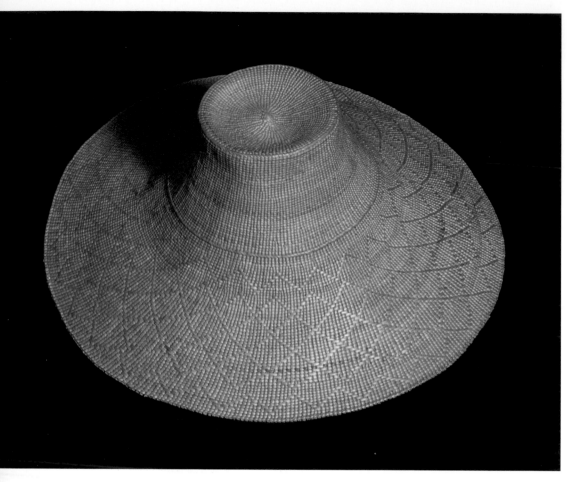

9.9 Selina Peratrovich, Haida. Hat, 1970. *Spruce root. 16 in.*

*Alaska State Museum, Juneau, II-B1680.*

Selina Peratrovich was one of the maintainers of the spruce-root basketry
traditions, and educated a number of contemporary basket weavers. It is time-
consuming to acquire spruce roots during the correct season and then craft
a fine work like this. Nevertheless, basket makers and weavers describe the
great pleasure they derive from the process of obtaining and manipulating raw
materials, and transforming them into works that can be used in ceremonies
or sold as art. Hats such as this one can be painted with crest designs or left plain.
The monochromatic treatment of this hat accentuates the delicate subtlety of
its twining.

An artist who has created a number of raven's tail robes is weaver and basket maker Teri Rofkar (b. 1956). Rofkar's raven's tail robes often look traditional, but include elements that demonstrate innovation and creativity. An example is a robe named *Ice Walker,* shown in figure 9.10. The textile was commissioned by Grace Schaibel, who is devoted to polar bears and goes north every summer to see them in the Arctic. In addition to the usual sea-otter fur lining the top of the robe, Rofkar used polar-bear fur. Rofkar also used colors specific to her subject, such as the cream and yellow threads that imitate the colors of polar bears, which are not truly white. The dark blue horizontal lines, called Polar Bear Tracks by Rofkar, are not tracks as seen from above, but instead, represent the trail of the bear as it walks through wet snow. The blue color at the bottom of the tracks represents the icy blue water that fills the depressions left in the snow by a walking polar bear.

A stimulus for the creation of new southeast Alaska Native art is the Sealaska Heritage Institute's festival named Celebration that was started in 1982 and takes place in Juneau, Alaska, every two years. Specifically *not* a potlatch, this three-day event provides a setting for many dance performances, a juried art show, and art sales. It is an increasingly popular event—at the 2004 Celebration, 48 dance groups performed with 1,700 participants. Much attention is paid to well-made regalia, and people from very young to very old appear in exquisite button blankets, Chilkat robes, and basketry hats. Dancers make use of masks, drums, and rattles. A major feature of the event is the grand parade that is held on the morning of the first day with dancers in full regalia marching from the Alaska Native Brotherhood building to the Centennial Hall, in which performances take place (fig. 9.11).

## IDENTITY AND POLITICS

SOME CONTEMPORARY Northwest Coast artists include political messages in their art. Nuu-chah-nulth artists Joe David (b. 1946), Ron Hamilton (b. 1948), and Tim Paul (b. 1950), each a master at translating his artistic heritage into contemporary works, sometimes use their art to express messages critical of the dominant society. One major issue for B.C. First Nations is the environment, for the streams, lakes, and ocean waters

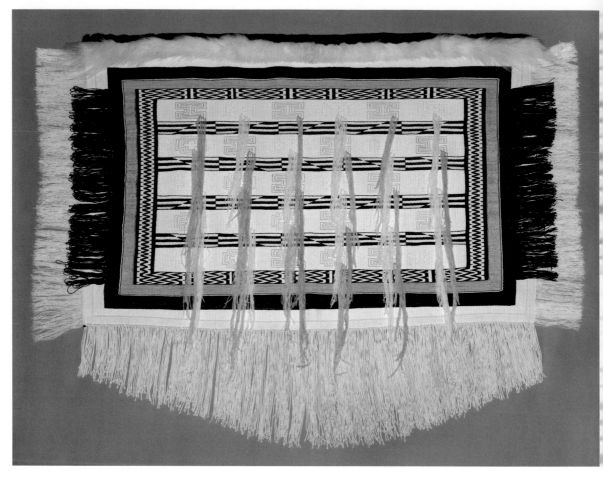

9.10  Teri Rofkar, Tlingit. *Ice Walker* robe, 2005.

*Wool, polar-bear fur, sea-otter fur, pigment.*

*University of Alaska Museum of the North. Photo: Barry McWayne.*

Teri Rofkar is one of several contemporary textile artists expert in the once-lost art
of the raven's tail weaving. Like many other contemporary Northwest Coast artists,
Rofkar infuses her creations with personal meaning, often making strikingly
original creations based on traditional forms. This raven's tail robe was inspired by
polar bears, in honor of the favorite animal of Grace Schaibel, who commissioned
the textile. Rofkar uses nontraditional colors that allude to polar bears—the
cream and tan of their fur, the various blue shades of sea ice. In addition to the
traditional sea-otter fur, this robe is lined with polar-bear fur.

9.11  Dan Brown, Teikweidi Tlingit, at Celebration 2004, Juneau, Alaska.
*Courtesy of Sealaska Heritage Institute. Photo: Joe Leahy.*

At Celebration, a biannual event sponsored by the Sealaska Regional Corporation, Native people gather in full regalia to express pride in their traditions and participate in dance and song performances. On the opening day, dancers from Alaska and British Columbia march in a gala procession that signifies the great strength of Native culture in the region. Participants wear button robes, Chilkat robes, headdresses, and masks, and carry musical instruments and staffs. During Celebration 2004, Dan Brown wore a carved headdress, a Chilkat tunic, and bore a tattoo on his arm that depicts his crest, the bear.

that so many still depend upon for their livelihood have been depleted by rapacious fishing and logging. Tim Paul has made large-scale carvings that address environmental topics, such as salmon habitat destruction. On one pole, stenciled salmon appear in addition to images of the moon, Killer Whale, and Eagle of the Deep. As Paul explains, "The silhouettes are negative images of salmon. They are confused—having no parent stream to return to. They do not address *your* question, 'What's happening to the migratory salmon?' They pose *mine*, 'Where are the parent streams?'"[3]

    In 1984, Joe David carved a twenty-one-foot welcome figure of Haa-hoo-ilth-quin, Cedar Man, which was erected before the B.C. Parliament building in Victoria as part of a large demonstration of Native peoples

and environmentalists protesting logging of Meares Island by commercial enterprises. The carving is now in the collection of the Museum of Anthropology at the University of British Columbia (fig. 9.12). For David, this statue was not a statement about Meares Island alone, but a plea for preserving all the natural resources of the Nuu-chah-nulth people. David describes his sense of the responsibility to community that accompanies the role of Native artist: "If I had to say what was my contribution as an artist, I'd want to say that I understood my heritage, and I understood my position—that I took responsibility for my tribe, for my people, and for our heritage. I want to be remembered as trying to make a reasonable contribution."[4]

Expressions of sovereignty can be subtle yet forceful. In the International Arrivals area at the Vancouver Airport are several carvings by Musqueam Susan Point (b. 1952). When she was learning to make art, Point was able to obtain training only in the northern style, and had to teach herself Salish art by studying objects in museums. Now she is a recognized master of her artistic tradition, making prints based upon traditional Salish images, and Salish-style works in a variety of media, including wood, metal, and glass. At the top of the escalator that arriving international passengers ride into the arrivals building hangs her sixteen-foot-diameter spindle whorl of red cedar (1994) suspended over a waterfall that symbolizes Salish rivers (fig. 9.13). At the base of that escalator stand two welcome figures (1996), the male and female ancestors of the Musqueam. These monumental works are replete with expressions of identity and sovereignty. Two large, flying eagles within the spindle whorl envelop in their wings images of the Coast Salish people. Within those human figures there are salmon. Point's images convey several ideas to new visitors to the province. Ever gracious, the Musqueam welcome them to their ancestral land. The eagle, a motif found in earlier Salish art, straddles the ancient and the modern by alluding to natural and man-made flight. The salmon and water symbolize not only the traditional economic basis of the Salish, but also the contemporary struggles for fishing rights. The very position of these images as the first monumental carvings that greet newcomers communicates clearly and vividly that they have arrived on *Musqueam* land. Point has taken the motifs of her ancestors and created

9.12 Joe David, Nuu-chah-nulth. Nuu-chah-nulth welcome figure, 1984.
*Wood. L. 21 in.*

*Courtesy UBC Museum of Anthropology, Vancouver, Canada. Photo: Aldona Jonaitis.*

In 1984, Nuu-chah-nulth artist Joe David was asked to help in a protest against logging on Meares Island in Clayoquot Sound. In response, he carved this large cedar figure, which was presented publicly during the protest outside the B.C. Parliament building in Victoria. At that time, the figure's hands were down at its side, a gesture signifying that the loggers were not welcome in this land. For David, this statue was not a statement about Meares Island alone, but a plea for preserving all the natural resources of the Nuu-chah-nulth people. Today it stands in the more friendly atmosphere of the Museum of Anthropology at the University of British Columbia, and its hands have been repositioned to extend in a welcoming gesture.

9.13  Susan Point, Musqueam. *Flight*, 1994.

*Cedar. D. 16 ft.*

*Vancouver International Airport. Courtesy UBC Museum of Anthropology, Vancouver, Canada.*

Susan Point is one of the most versatile contemporary Northwest Coast artists, making prints, carvings, glasswork, and bronzes. She also works in different scales, from small, delicate glass pieces to monuments such as this. The Vancouver International Airport's arrivals building displays a number of artworks by contemporary British Columbia First Nations artists, including this large carving by Point, based on a spindle whorl, which greets visitors to Canada as they descend via a bank of escalators into the international arrivals area. Its imagery communicates greetings to newcomers as well as expressing sovereignty over the land the airport occupies.

a work that not only stands as an exceptional work of art, but makes a strongly political statement in support of Musqueam land claims.

## INNOVATIONS—VARIATIONS ON THEMES

ALTHOUGH MANY of the artists described above have responded creatively to the traditions they have inherited, their work tends to adhere to nineteenth-century style and falls into well-established categories such as masks, textiles, and totem poles. In contrast are other contemporary artists who base their works on Northwest Coast concepts but depart considerably from tradition, often creating original expressions of identity, community, and connection to the land. Tlingit teacher, artist, poet, and writer James Schoppert (1948–92) abandoned explicit cultural references and instead investigated the formal possibilities of the formline by manipulating its patterns to produce increasingly abstract images. Schoppert insisted that the term "traditional" is an arbitrary selection of a single developmental stage in an ongoing and vital pattern of creativity, and he intentionally developed the formline into new directions, trying to answer the question, "What would Alaska Native art have become if allowed to progress uninterrupted?"[5] In a number of carved wood panels, Schoppert breaks up formline elements, rearranging them on the surface and taking advantage of the power of the forms, their potential not only as complete images, but as dynamic visuals in their own right. *Blueberries* (fig. 9.14) seems to be a rearranged puzzle, nine squares each containing parts of ovoids and u-forms. The result is not a crest image of an identifiable being, but an abstract composition that stands alone as an artwork yet quotes the artist's heritage. Schoppert insisted that his pieces were laden with meaning: the broken-up pieces signify the destruction of the culture during colonization; their organization into a cohesive whole unified by color declares how successfully that culture has persisted despite generations of discrimination, mistreatment, and disease.

Women's art offers some intriguing possibilities for creativity. Kaigani Haida Dorothy Grant (b. 1956) has brought the button blanket up to date with her haute-couture fashions using appliquéd images of Northwest Coast beings. Like the Chilkat weavers, Grant at first translated into textile art the formline designs of a male artist, Robert Davidson, but

9.14 James Schoppert, Tlingit. *Blueberries*, 1986. *Poplar, paint. 72 in. sq.*
*Anchorage Museum of History and Art.*

James Schoppert believed strongly that Native artists needed to be grounded in tradition, but he also consciously sought to make innovative art. He felt that some contemporary Northwest Coast art was stagnant, with artists only learning the old conventions, and wanted to encourage new artistic creations that, like this relief painting, took the past and threw it into the future. The nine-part panel contains squares with segments of formline designs, arranged without apparent heed to traditional northern design principles. However, careful study of this work reveals that most of the panels contain a visual link to one or more neighbor panels, thus lending a kind of unity to the composition. For example, in the square at the lower-right corner, a line extends from the square above into the formline that surrounds the ovoid on the right. And a formline that extends off to the left from that ovoid continues into the next square on the left.

later started making her own designs, occasionally departing from the appliqué technique used on button blankets and silkscreening images onto fabrics. In 1994, she contributed to a presentation of Vancouver designers celebrating the Commonwealth games in that city. "Raven Takes the World," a wedding dress of white deerskin screened with one of Grant's designs, was the much-celebrated grand-finale piece (fig. 9.15). Haida purchase many of her creations, but Grant's wearable art also finds an appreciative market among non-Natives. Like her Haida ancestors who carved argillite, Grant conveys strong cultural beliefs and images to outsiders through the medium of a purchasable commodity.

Several artists, including Susan Point, have experimented with entirely new media, such as glass. Preston Singletary (b. 1963) draws from his Tlingit heritage and applies classic formline designs onto his glass sculptures, some of which assume the forms of traditional types of art such as conical painted hats (fig. 9.16).

Marianne Nicholson (b. 1969), Kwakwaka'wakw, uses art to speculate upon her place within the world and her small, isolated community, Kingcome. In 1998, Nicholson embarked upon a strikingly ambitious project—painting a copper upon a 120-foot sheer cliff that plunges into Kingcome Inlet, near the pictograph of the 1927 potlatch (fig. 9.17; see also fig. 8.4). In keeping with proper protocol, the artist asked for and received permission from the community to do this, and then worked on a platform suspended from the cliff's top, applying red oxide paint through the canvas stencil that guided her. Today, anyone traveling by boat to Kingcome passes by this forty-foot image of a copper that, with an image of Wolf with a treasure box, presents the history of the community. Nicholson's painting quotes the small coppers on the earlier pictographs that refer to the status of chiefs who, defying the ban, potlatched in Kingcome in the 1920s. Nicholson's copper acknowledges the painful history of her people, but also looks to the future, as more and more land claims are settled. This enormous representation of an image imbued with such cultural meaning makes a clear statement: this land is ours.

Contemporary artists, like their traditionalist siblings, address issues of identity and politics. They ask how to maintain, embrace, express being a Native in the contemporary world. Land ownership is an issue on which Native and non-Native perspectives collide, and thus location constitutes

9.15  Dorothy Grant, Haida. "Raven Takes the World" wedding dress, 1994.
*White deerskin, pigment, mother-of-pearl, glass. L. 49 in.*
*Private collection.*

Dorothy Grant produces wearable art that draws from the traditions of northern two-dimensional formline painting and button blankets. The silkscreened image on the bodice of this dress depicts Raven as the transformer holding the circular Earth in his human hands as well as his beak. Raven is represented with two confronting profiles that create a frontal, downward-pointing head, with feathers on either side. To go with the dress, Grant commissioned the Salish-inspired headdress by Marianne Jones, which is made from dentalium shells, beads, and mother-of-pearl.

9.16   Preston Singletary, Tlingit. *Glass Hat*, 2004.

*Sandblasted blown glass. D. 15 in.*

Courtesy Preston Singletary Studio.

Preston Singletary, a glass artist who has done work at the Pilchuck
glass school, has been instrumental in fostering the use of this medium
among Native artists. Glass, he believes, is a way to bring Native art
into the twenty-first century. This glass hat, for example, transforms a
traditional type of headgear into a contemporary artistic expression. The
sculpture can be positioned two ways: with one side up it looks like a hat;
turned over, it is like a vase. In the latter position, as in this photograph,
illumination from above creates a formline pattern on the pedestal.

9.17   Marianne Nicholson, Kwakwaka'wakw. Pictograph of a copper on
       a cliff near Kingcome, 1998. *H. 40 ft.*
       *Courtesy of the artist.*

Marianne Nicholson works in a variety of media, including painting, photography,
and installation art. This monumental pictograph is on a sheer cliff near her
mother's community of Kingcome, and refers to another close-by pictograph
painted earlier in the century (see fig. 8.4). For the images depicted on this
monumental copper, Nicholson turned to an origin story narrated by two
distinguished and knowledgeable maintainers of tradition, James King and Ernie
Willie. Two wolves, who transform into humans, are instructed to take a journey
and end up, respectively, in Wakeman and Kingcome inlets. They build houses,
make canoes, and receive supernatural treasures. This is the origin of Kingcome
Village, known as Gwayi.

a major source of identity formation. Some investigate through art the uncertain position of the Native person in the contemporary world, whereas others express anger at those who settled in their territory and sought to destroy their culture. Eric Robertson (b. 1959), Euro-Canadian/ Gitksan, creates installations that address the relationships between the two groups from which he descends. He embraces the culture, the craftsmanship, and the aesthetics of his Native artistic ancestry while drawing on concepts and images from the majority culture to create uniquely personal expressions. The piece shown in figure 9.18, entitled *Bearings and Demeanours*, is a complex assemblage of three copper conical hats with status rings suggesting family prerogatives, arranged above two rectangles and a square from which emerges just the beak of Raven, holding the sun. Below is a table upon which land measurements are written. Robertson uses this installation to contrast the two perceptions of the land: for the non-Native, it is to be exploited; for the Native, the land, arranged by Raven into the source of life and owned by extended families, embodies the past, present, and future.

Tlingit-Nisga'a Larry McNeil (b. 1955) uses photography and collage to investigate his Native heritage as it intersected with colonizers and settlers. In addition to mounting gallery and museum shows of his work, McNeil has created Web-based exhibitions that allow access from anywhere. Much of his work includes antagonistic jabs toward the American settlers (being Nisga'a as well, McNeil also sometimes denounces the Canadians); at other times, he uses wry humor to criticize. His Web-based exhibits consist of series of related images, captions, and sometimes accompanying text. The photomontages themselves incorporate original photographs, historical photographs such as those by Winter and Pond, two-dimensional images, and texts; for the Web surfer, he illustrates the complete photograph as well as details of its elements. For example, the *Killerwhale House, Keet Hit* series (2002) investigates his ancestors, largely through photographic images, in exploration of his identity. The ongoing *Raven Art* series examines his relationships and interactions with Native and dominant cultures. In addition to McNeil's presence on the Internet (www.larrymcneil.com), one of his images has been made into a billboard (fig. 9.19).

9.18  Eric Robertson, Gitksan and Euro-Canadian.

*Bearings and Demeanours*, 1990.

*Copper, brass, mixed media. 96 x 96 x 48 in.*

Indian Art Center, Department of Indian and Northern Affairs Canada.

Robertson defines himself as a person from two worlds, Native and non-Native. In his early artistic career, Robertson was influenced by Native artists engaged in reconstructing their traditions. For several years he made "traditional" art, but ultimately found that it could not express his complete identity. So he began creating more personal expressions of the Native–non-Native experience, using elements from both worlds. He investigates the contradictions of colonialism and the differing concepts of the natural environment in installations such as this visualization of how Native and non-Native people understand and use the land.

9.19 Larry McNeil, Tlingit-Nisga'a. *Raven billboard*, 2004.
*Courtesy of the artist.*

This is a monumental enlargement of a collage from Larry McNeil's *Raven Art* series that appeared on Highway 40 in Albuquerque. *Raven Art* is an ongoing project that can be accessed on the Internet (www.larrymcneil.com), and investigates the artist's relationship to his Native heritage and mainstream culture. The numerous images in the series consist of juxtapositions of items from both worlds as well as often humorous text. For example, this billboard combines a raven on a Kwakwaka'wakw house front, a 20th-century automobile, a photograph of a raven wearing glasses, and drawings of a human skeleton and a bird skeleton posed to look remarkably similar. In addition to generating scientific-looking formulae "on the rules of cultural diffusion," McNeil's words that "the creator made humans in raven's image" join the Judeo-Christian biblical idea of creation with the Tlingit idea that Raven organized the world. The man in the Cadillac is a representation of Billy Graham.

Formally trained in art school and well versed in Native and non-Native art history is Cowichan-Okanagan Lawrence Paul Yuxwelupton (b. 1957), who uses artworks to criticize colonialism, racism, and ecological mismanagement. Yuxwelupton employs his fine painterly skill along with classic Northwest Coast imagery to create surrealistic depictions of energized, anthropmorphized landscapes populated by fantastical beings; the images comment—often harshly—on changes that First Nations have endured. The words Yuxwelupton uses when explaining his work express his frustration and anger:

I cannot celebrate or feel any allegiance to the Canadian flag
when such racist legislation as the Indian Act remains in force:
the system native people are governed under is the despotism of
white self-interest. Because of this, a lot of my pieces are historical.
You cannot hide the real history or even the censorship of native
history, a colonial syndrome. You can hide Department of Indian
Affairs documents from the time of federation, but you cannot
hide my paintings. They are there for all people to see.… My work
is very different from traditional art work. How do you paint a land
claim?… Painting is a form of political activism, a way to exercise
my inherent right, my right to authority, my freedom.[6]

One expression of his political activism is a deep concern for the way colo-
nialism has laid waste the land. *Hole in the Sky* (fig. 9.20) presents a Native
individual with a white person standing on his shoulders trying to fill in
the ozone hole. The earth, personified by a blue-colored being, stands
weeping, surrounded by land laid bare by rapacious timber harvesters. "I
don't have any rights in this country, so I paint the ozone as a problem."[7]

### MUSEUMS AND NATIVE PEOPLE TODAY

WITH FEW EXCEPTIONS, Native art has historically been exhibited in
permanent installations not in art museums, but rather in natural
history or ethnographic institutions such as the American Museum of
Natural History, the Field Museum of Natural History, and the Royal
British Columbia Museum. The aesthetically oriented presentations at
the National Gallery of Canada in 1927 and the Museum of Modern Art in
1941 opened the eyes of some, but did not permanently alter the general
perception of Native art. Northwest Coast art (and other regional styles)
had to wait until the mid-1960s to finally achieve a secure place as one of
the great world art traditions.

Three historic art exhibits devoted entirely to Northwest Coast art,
two during the 1960s and one in 1971, contributed significantly to this
enhanced position. In 1964, the Art Institute of Chicago, a museum with
outstanding collections of European and non-Native American art, hosted
*Yakutat South: Indian Art of the Northwest Coast*. Art historian Allen Wardwell,

9.20 Lawrence Paul Yuxwelupton, Cowichan Salish/Okanagan.

*Hole in the Sky*, 1989.

*Private collection.*

In both the United States and Canada today, more Native people live outside
reservations and reserves than on them, and they experience considerable
difficulties living in urban areas. Lawerence Paul Yuxwelupton identifies with the
more than 40,000 Native people who live in the greater Vancouver area, many of
them plagued by poverty and alcoholism. Yuxwelupton is well versed in formline
style as well as surrealism. Like James Schoppert, he has gone well beyond the
constraints of traditional art by transforming the elements of a visual system into
a vehicle for bitter critique of contemporary Native life. Yuxwelupton's surrealistic
landscapes peopled with strange beings suffering from the degradation of the
world by the dominant culture can be jarring to those unused to seeing Northwest
Coast style used for social criticism.

a man with an exceptional eye for quality, curated this exhibit, which brought together many of the finest pieces from museums in the United States, Canada, and Europe. In keeping with the paradigm that Northwest Coast culture had died, Wardwell describes in his catalogue introduction the deterioration that followed white settlement, and asserts that "because the culture of the Northwest Coast is such a recent fatality, we are fortunate in having many ephemeral objects left to us which provide a good ethnography."[8] He was not yet appreciative of the exciting events taking place on the coast.

For his exhibit, Wardwell chose only historic—mainly nineteenth-century—Northwest Coast artworks, neglecting contemporary art. Only three years after *Yakutat South*, in 1967, contemporary art received the recognition it deserved at the Vancouver Art Gallery's *Arts of the Raven: Masterworks of the Northwest Coast Indian*, organized by Doris Shadbolt, assisted by Wilson Duff, Bill Holm, and Bill Reid. Alongside masterpieces of historic Northwest Coast art, including a room dedicated to the art of Charles Edenshaw, appeared more recent works by Kwakwaka'wakw artists Doug Cranmer, Henry Hunt, and Tony Hunt; Haida artists Bill Reid and Robert Davidson; non–Northwest Coast Native artist Lelooska Smith; and non-Native Bill Holm. The curators wanted to convey two messages— one being that Northwest Coast art belongs in the category of "fine art," as opposed to being anthropological artifacts, the other being that contemporary art can have quality equivalent to older pieces.

The number of contemporary works in *Arts of the Raven* was quite small, compared with the several hundred historical pieces. In 1971, another major exhibit focused entirely on new works after Peter Macnair, curator of ethnology at the Royal British Columbia Museum, commissioned eighty-eight objects from various living artists on the British Columbia coast. Entitled *The Legacy*, this exhibition brought to the public's attention the wealth of creativity that was flourishing at the time, and challenged the notion that Northwest Coast art had died. The show traveled to various venues in Canada, and in 1980 an expanded version including some older art opened in Scotland at the Edinburgh Festival, giving Europeans the opportunity to discover what was happening in British Columbia arts. The catalogue included short biographies of the artists, presenting them to the public as individuals rather than as tribes.[9]

Such changing attitudes are reflected in the several significant art museums (in addition to the Denver Art Museum) that present Native American art as being on a par with that of Europe and white America. The Minneapolis Institute of Arts has a large gallery devoted to Native art, including that of the Northwest Coast. The Fenimore Art Museum in Cooperstown, New York, has an exceptional exhibit of Native art collected by Eugene Thaw and donated to the museum; a good number of the works reproduced in this book are from its Northwest Coast collection. Also well represented on these pages are pieces from the Seattle Art Museum, which devotes an entire gallery to Northwest Coast art. There appears to be little argument anymore on the part of major art museums against the aesthetic value of this splendid artistic tradition.

## Repatriation

As was described in Chapter 6, immense amounts of Native art were removed from the Northwest Coast in the past, especially between 1880 and 1920. Today the people of the coast, like aboriginal groups around the world, are working to repatriate many of these cultural treasures currently housed in museums. The only legitimate repatriation, museums had long argued, was of artifacts that a community could prove had been stolen. This idea was challenged by a tenacious group of Kwakwa̱ka'wakw. For years, Kwakwa̱ka'wakw families had willingly sold their carvings and regalia to collectors, comfortable in the knowledge that they sold only the object, not the privilege to present it. Another one could easily be made. But the objects confiscated by William Halliday after the 1921 Cranmer potlatch (described in Chapter 8) were a different story. Shortly after potlatching was decriminalized in 1951, several Kwakwa̱ka'wakw, including Gloria Cranmer Webster, Dan Cranmer's daughter, began to press for the return of this regalia, which they insisted had been acquired under duress. They argued that offering families the option of relinquishing their coppers and masks or going to jail qualified as coercion, not free choice. In the 1970s they finally succeeded in convincing the National Museum of Man, now the Canadian Museum of Civilization, to return the Potlatch Collection items under the condition they be placed in museums. The result was the construction of the Kwagiulth Museum and Cultural Centre (founded 1979) and the U'mista Cultural Centre (founded

9.21  U'mista Cultural Centre exhibition, Alert Bay, 2003.

*U'mista Cultural Society, Alert Bay, British Columbia, Canada. Photo: Aaron Glass.*

Soon after the potlatch was decriminalized by the Canadian government, several Kwakwaka'wakw began to petition for the return of the regalia confiscated after the arrest of participants in Dan Cranmer's 1921 potlatch (see figure 8.3). After considerable negotiations, the Canadian Museum of Civilization, which held a large part of this collection, repatriated it to two newly built Native museums, the Kwagiulth Museum in Cape Mudge and the U'mista Cultural Centre in Alert Bay. Although U'mista exhibits the potlatch collection, a world-renowned and extremely moving display that attracts visitors from Canada, the United States, Europe and other countries, it primarily serves as a place where the people of Alert Bay can learn more about their heritage.

1980). Since then, the Royal Ontario Museum and the National Museum of the American Indian in Washington, D.C., have returned to British Columbia the regalia in their possessions from the Halliday confiscation.

The Kwagiulth and U'mista installations are as different from each other as they are from the typical museum displays that present Northwest Coast material either anthropologically, with attention paid to meaning and function, or art historically, with uncontextualized presentations of aesthetic creations. To the Kwakwaka'wakw themselves, the masks, robes, coppers, and other items are neither artworks nor anthropological artifacts—they are history and life. To clearly demonstrate

the importance of artworks as indicators of family identity, status, and history, the Kwagiulth Museum assembled together in cases the different objects that were owned by separate families. In the U'mista Cultural Centre, the display area looks like the interior of a big house, with artifacts arranged on benches along its walls according to when they appear during the potlatch (fig. 9.21). Coppers are displayed at the beginning of the ceremony, so they are the first objects on exhibit, followed by *Tseka* and then *Tlasala* regalia. Because the exhibit is intended for the community, whose members know the meanings of all these objects, no labels explain their imagery and uses. Instead, quotes from the potlatch trial and other historical events surrounding the confiscation offer poignant indications of what the Kwakwaka'wakw experienced during those difficult times.

The Kwakwaka'wakw worked long and hard to convince the National Museum of Man to relinquish the Potlatch Collection, arguing that even though Halliday did offer money for the objects, they were not sold freely. In the 1980s, many other Native peoples in the United States and Canada began to argue that museums held collections that, although not actually stolen, had been acquired in inappropriate or unethical ways. For example, sometimes missionaries pressured their converts to relinquish the regalia of their "heathen" past. Sometimes collectors purchased items from individuals who did not have the inherited right to sell them—which in the Native view constituted theft. And sometimes anthropologists and archeologists, under the justification of scientific investigation, excavated graves and removed all their contents, human remains and artifacts.

In the United States, increasingly empowered Native people, angry about what they perceived as pillaging of their communities and cemeteries, and demanding the return of their heritage, persuaded Congress in 1990 to pass the Native American Grave Protection and Repatriation Act. NAGPRA identifies several categories of artifacts as repatriatable within the law: human remains, funerary objects, objects of cultural patrimony, and sacred objects. The first two categories are clear—anything buried in a Native grave must be returned if requested. Objects of cultural patrimony are items that should not have been sold by an individual, as they are communally rather than individually owned. Sacred objects are those items necessary for the practice of an ongoing, living religion. Examples of repatriatable objects would include Tlingit shamanic carvings removed

from shamans' graves by George Emmons in the 1880s (which qualify as grave goods), Tlingit clan hats (which are objects of cultural patrimony), and Salish spirit figures (which belong to an ongoing religious tradition). The law does not specify that the returned items must be placed in a museum or other type of secure structure; that decision lies with the tribe requesting the repatriation. Although numerous British Columbian works reside in American museums, this law offers no opportunities for their repatriation, as it applies only to groups in the United States.

At around the same time NAGPRA was being formulated, Canadian museums and First Nations conducted a national dialogue inspired by the controversy set off by *The Spirit Sings,* an exhibit that opened in Calgary to coincide with the 1988 Winter Olympics there. A local First Nations group, the Lubicon Cree, had land claims to which they wanted to bring attention. In order to generate support, the Cree urged museums that had been asked to loan objects to boycott the exhibition. Although the land claims had nothing to do with museums, the boycott raised public consciousness of the Lubicon Cree's petition, and also revealed the troubled relationships between museums and First Nations. Built-up frustrations of Native communities were released in anger over what they considered the high-handed manner with which museums had for decades treated their cultures. Objects removed from communities had become inaccessible to those who created them. Moreover, white "experts" rather than the Native people themselves were interpreting their cultures, often presenting them as long gone.

To address these complaints, the government established the Canadian National Task Force on First Peoples and Museums, consisting of members proposed by the Assembly of First Nations and the Canadian Museums Association. After extensive deliberation, the group produced a report titled *Turning the Page: Forging New Partnerships Between Museums and First People* (1992) that encouraged museums to work more closely with Native people in every possible way. Recommendations included providing Native people access to collections, including Native perspectives in interpretations of objects, and encouraging the repatriation of those objects that should be not in museums but rather in their originating communities.

The Nisga'a final 1999 agreement with the provincial and national governments regarding land claims (see p. 251) included a section on

repatriation. Both the Royal British Columbia Museum and the Canadian Museum of Civilization were to repatriate parts of their Nisga'a collections. According to the agreement, one hundred artifacts of "spiritual and religious significance" at the Canadian Museum of Civilization would be returned within five years to the Nisga'a; this time frame gave the Nisga'a the opportunity to build proper storage and exhibit space. The agreement also provided for the continuing interactions between the museum and the Nation for loans and replication of totem poles that cannot be repatriated. The inclusion of repatriation in a lengthy and long-negotiated document shows how closely interwoven are cultural artifacts, contemporary politics, sovereignty, and land claims.

Some repatriations became opportunities for major celebrations of cultural pride. In 1899, the millionaire Edward H. Harriman had funded and participated in an ambitious expedition to the Northwest Coast and the Bering Sea. Harriman brought along artists, photographers, naturalists, and other scientists to study the lands they visited. On their return south, the Harriman Expedition stopped at Cape Fox village in southeastern Alaska. Seeing no residents, they decided that it was abandoned, and cut down a group of totem poles, which they sent to various museums. In fact, the residents had moved to another village site, but had not relinquished their claims on either the land or these poles. One hundred years later, the Cape Fox Village Corporation sent letters to those institutions requesting the return of the poles. The Smithsonian Institution, the Field Museum, the Peabody Museum at Harvard University, the Johnson Museum at Cornell University, and the Burke Museum at the University of Washington responded that they were willing to repatriate four poles and five large architectural fragments as the return of stolen items. That return coincided with a 2001 centennial reenactment of the Harriman Expedition during which Smith College chartered a ship and hired naturalists, artists, and photographers to accompany a shipload of passengers who retraced Harriman's voyage up the Inside Passage into the Bering Sea. Representatives of the five museums went to Ketchikan, some having traveled with the ship north from Seattle, and on July 23 were greeted by sixty Tlingit and Haida. The museum representatives then officially transferred ownership of the poles to the Cape Fox Corporation, among whose shareholders are most of the descendants of the village

from which the poles were taken. A great welcoming ceremony at the Ketchikan civic center allowed the community to see these treasures that had been removed so long ago. The poles will eventually be erected in a new community hall in Saxman.

It is recognized by all involved that partnerships and collaborations are the foundations of positive interactions between Natives and non-Natives in the contemporary world. For the Cape Fox people, the totem-pole repatriation has profound significance to their community, for whom the return of these poles "to the Saanya Kwaan clan members and the historical legacy surrounding it has brought full circle the events of 100 years ago and established a sense of healing for the clan and native community."[10] That healing includes reciprocity, and the Cape Fox Corporation offered to donate a cedar tree to each museum. The Peabody Museum took this opportunity to hire Nathan Jackson to carve a replacement pole (fig. 9.22), which was validated in November 2001 by potlatch-like dancing and oration by Jackson and others.

### Collaborations

Museums in both the United States and Canada eventually started listening to the Native argument that non-Native "experts" had decided for too long how to present their traditions, and that *their* voices should be heard in museum exhibitions. So, in the 1980s, museums began to relinquish some of their previously unchallenged authority and to collaborate with aboriginal people on representations of their cultures. The Royal British Columbia Museum in Victoria and the University of British Columbia Museum of Anthropology, which had begun working with Native communities even earlier, were leaders in these efforts, and served as models for other institutions.

The nature of these collaborations varies considerably, but in each one the voices of Native people are clearly heard. In 1989, the Burke Museum at the University of Washington developed *A Time of Gathering*, an exhibition on Washington State Native art. Curator Robin Wright assembled a nine-member Native advisory board, and worked with Roberta Haines of the Wenatchee Tribe as co-curator and Duwamish Cecile Maxwell as protocol officer. Ten years later, the Royal British Columbia Museum installed *HuupuKanum Tupaat Out of the Mist: Treasures of the Nuu-chah-nulth Chiefs,* in which

9.22  Nathan Jackson, Tlingit. Totem pole, 2001.

*Peabody Museum, Harvard University, 2001-26-1.*

In 2001, the totem poles that had been stolen from Cape Fox village by members of the Harriman Expedition more than a century before were repatriated with great celebration in Ketchikan, Alaska. The Peabody Museum at Harvard University commissioned Tlingit master artist Nathan Jackson to carve a replacement of their Harriman pole, which evokes the Teikweidi story of Kats and the bear mother. The original is a fairly simple column that has at its top a raven with spread wings and underneath it a hole from which peers a bear face; paw prints lead up from the floor to the bear's hole. Jackson chose not to copy the original, but created a more complicated visual interpretation of the story of the woman who married the bear, with the various participants in the story placed one atop the other.

every chief and every village determined the selection of objects and their interpretation. The Seattle Art Museum's permanent Northwest Coast installation was displayed and interpreted by Steve Brown, curator of Northwest Coast Art, along with a Native advisory team, several of whom wrote essays for the 1995 catalogue.[11]

Sometimes these collaborations can have unexpected results. The American Museum of Natural History, which has one of the largest collections of Northwest Coast art in the world, formed a partnership with the U'mista Cultural Centre and the Kwakwaka'wakw community to produce a large traveling exhibit that opened in 1991. *Chiefly Feasts: The Enduring Kwakiutl Potlatch* presented many items removed from British Columbia by Franz Boas and George Hunt at the turn of the century. Gloria Cranmer Webster, great-granddaughter of George Hunt and daughter of Dan Cranmer, served as co-curator with Aldona Jonaitis. The two of them, along with Peter Macnair, worked with a team of elders, each representing one of the communities from which the artworks originally came. While at the Natural History Museum in New York City, one chief discovered an array of masks from his community that represented a *Tseka* privilege that he still owned. Proudly, he stood up and orated in Kwakwala for a significant length of time, reestablishing his family's ownership of these old masks.

Perhaps the most ambitious collaborative project between museums and Northwest Coast First Nations was the Grand Hall of the Canadian Museum of Civilization (CMC). An impressive array of nineteenth-century totem poles stands before a row of six house replicas, each modeled upon a historical building known through photographs. Instead of having their own staff build and paint these structures, the museum invited teams of artists from each of the represented cultures to do so. Groups of Salish, Nuu-chah-nulth, Kwakwaka'wakw, Nuxalk, Haida, and Tsimshian worked in several locations in British Columbia to craft the components of these structures, which were then transported to Hull, and assembled by team members in the museum's Grand Hall. Instead of experiencing the sense of cultural loss inspired by earlier museum displays of lifeless items under glass, or incensed by inappropriate, insensitive, or insulting interpretations, these Native teams became part of a process that enhanced the public's understanding of their culture.

The Tsimshian house screen shown in fig. C in the introduction has an interesting biography that includes the use of new technology in interpreting Northwest Coast art. In 1980, Bill McLennan of the University of British Columbia Museum of Anthropology (MOA) began the long-term Image Recovery Project, which used infrared photography to penetrate the layers of oil and dirt that cover so many old Northwest Coast objects. Original paintings that had not been evident emerged through the photographic images, providing new documentation on the history of two-dimensional art. In the MOA collection are the surviving painted boards from a Lax Kw'alaams house front made in the mid-nineteenth century, their designs barely visible. Infrared photography revealed imagery that depicts a frontal bear mother flanked by two cubs. Above the large central bear is a female figure thought to represent the animal's human spirit.

Despite the images made available through technology, several boards, with their paintings, were missing. Lyle Wilson (Haisla, b. 1955), Glenn Wood (Gitksan), Terry Starr (Tsimshian, b. 1951), Harry Martin (Nisga'a), and Chester Williams (Gitksan) used their knowledge of two-dimensional design and imagery to extrapolate the missing images, then made a full-size drawing of the reconstructed painting. They transferred the drawing to cedar planks, painted the design, and placed the screen, more than 15 feet high and 36 feet long, on the facade of the Tsimshian house in the Grand Hall of the CMC. As a result, the museum exhibits a replica of what was once one of the largest structures in Lax Kw'alaams.

No matter how much authority museums relinquish to Native consultants during a collaborative process, however, the exhibits are still located within white-run institutions. The only way Native groups can have complete autonomy in the presentation of their cultures is to have their own museums. This is especially evident in the U'mista Cultural Centre in Alert Bay and the Kwagiulth Museum in Cape Mudge, whose establishment to house the repatriated Kwakwaka'wakw potlatch regalia was discussed earlier in this chapter.

Other museums that have been built in Native communities include the 'Ksan Indian Museum and Cultural Centre in Hazelton, B.C. (founded 1958), and the Makah Cultural and Research Center in Neah Bay (founded 1979) and the Suquamish Museum in Squamish (founded 1983), both in Washington State. An especially ambitious project is the Qay'llnagaay (Sea

Lion) Heritage Centre in Skidegate. In the nineteenth century, Skidegate and Massett were flourishing communities with impressive numbers of totem poles, but by the first decades of the twentieth century the poles were all gone. In 1998, the Skidegate band, in collaboration with provincial and federal agencies, embarked on a venture to create this cultural center, which includes the Haida Gwaii Museum, the Bill Reid Arts Centre (a training facility), a hotel, and a restaurant. Each of these structures is built on the model of a Haida longhouse facing the water. Erected before the buildings is a row of totem poles representing each of the Haida villages.

THE PROCESS of Northwest Coast art scholarship has changed considerably since I first started working on Tlingit art in the 1970s. This is especially true for the selection of images for this book. Tribes now have a say in what should or should not be shown publicly. As a result, I have had to eliminate various images that in the past I would have included without a thought. The description of the Salish spirit canoe (p. 70), for example, is not illustrated, out of respect for the wishes of the present-day inheritors of that tradition. Several important archeological pieces are not included, because we did not get tribal permission to reproduce them. Some magnificent items are not here either, as they are currently under consideration for repatriation. In some other cases, I greatly appreciate having received permission from the appropriate individuals to publish pieces such as the Tlingit shaman's mask shown in figure 5.3.

Although I regret some of these omissions, I am in full sympathy with those Native people who insist on having control over their cultural heritage. Indeed, this is the logical extension of their efforts to obtain a voice in representations of Native culture, and the absence of certain images tells an important part of the ongoing history of Northwest Coast art.

As I have shown in this chapter, some artists express their heritage by referring to traditions in innovative or unusual ways. One artist who does this is Quinault–Isleta Pueblo Marvin Oliver (b. 1946), who uses the form of spirit-canoe boards to create glass sculptures that are not replicas of the originals but are instead new creations that express personal

9.23 Marvin Oliver, Quinault–Isleta Pueblo. *Transporter*, 2005.
*Blown, fused, and cast glass, steel. 49 x 14 x 5 in.*
Museum of Arts and Design. Photo: Jeff Sturges.

Marvin Oliver works in a variety of media including wood, metal, and glass. Here he translates the shape of the Salish spirit-canoe board into a contemporary statement on the meeting of Native and non-Native worlds. Images in the board itself include ravens, a spirit face, and geometric designs in the Salish style. The clear-glass lower section contains a photographic image of the Salish spirit-canoe ceremony. All these images communicate the different means by which one can be transported from one place to another. Oliver views his art as a personal journey in which he invites viewers to participate.

beliefs (fig. 9.23). According to Oliver, these boards take him on his own journey, much as the original pieces took shamans to the other world. He welcomes others along on this venture into the unknown, one that takes him artistically and emotionally into the world of the future. In the piece shown here, Oliver transforms an object that the contemporary Salish believe should remain secret and unseen into a new, personal artwork that he, as its creator, welcomes others to see and experience. This is one of many paths Northwest Coast artists of the future might take.

At the end of the nineteenth century it was thought that Northwest Coast culture was "vanishing," and needed to be preserved in museum collections and by means of ethnographic texts that described precontact cultures. At the beginning of the twentieth century it was thought that Native people who had not died of disease would become assimilated into the dominant society. In the middle of the twentieth century it was thought that the formline style of the north had been lost forever, and that Chilkat weaving, Salish weaving, and basketmaking were also lost skills. None of these has come to pass. Northwest Coast culture remains alive, Northwest Coast Native people maintain a strong sense of identity, and Northwest Coast art continues to be produced in larger and larger amounts. The transformation of a sacred object into a personal artistic expression in Marvin Oliver's glass sculptures is just one example of the ongoing vitality of this great artistic tradition and of the strength and endurance of a proud and vibrant people.

### Introduction

1. Charles Pierre Claret de Fleurieu, *A voyage round the world, performed during the years 1790, 1791, 1792, by Étienne Marchand preceded by a historical introduction and illustrated by charts, etc*, translated from the French by C. P. C. de Fleurieu (London: Longman, 1801).

2. Barnett Newman, *Northwest Coast Indian Painting* (New York: Betty Parsons Gallery, 1946), n.p.

### 1. Creating a Great Art Tradition

1. Franz Boas, "The Shuswap." *Sixth Report on the Northwestern Tribes of Canada*, 1890 (British Association for the Advancement of Science), 90.

2. Quoted in Frederica de Laguna, *Under Mount St. Elias* (Washington, DC: Smithsonian Institution, 1972), 123, 433.

### 2. Art at the Time of Contact

1. John Frazier Henry, *Early Maritime Artists on the Pacific Northwest Coast, 1741–1841* (Seattle: University of Washington Press, 1984), 75.

2. James Cook and James King, *A Voyage to the Pacific Ocean, Undertaken … in His Majesty's Ships the Resolution and Discovery; in the Years 1776, 1777, 1778, 1779, 1780* (London: G. Nicol and T. Cadell, 1784), 306, 326.

### 3. Nineteenth-Century Southern Coast Art

1. Quoted in Robin Wright, *A Time of Gathering* (Seattle: University of Washington Press, 1991), 104.

2. Quoted in Morag Maclachlan, ed., *The Fort Langley Journals, 1827–30* (Vancouver: UBC Press, 1998), 75.

### 4. Nineteenth-Century Central Region Art

1. William Fraser Tolmie, *Physician and Fur Trader: The Journals of William Fraser Tolmie* (Vancouver, BC: Mitchell Press, 1963), 294–97.

2. Franz Boas, "The Social Organization and the Secret Societies of the Kwakiutl Indians," in *Report for the U.S. National Museum for 1895* (1897), 459.

3. John Jewitt, *The Adventures and Sufferings of John R. Jewitt, Captive among the Nootka* (Toronto: McClelland and Stewart, 1974), 38.

4. See, e.g., Wayne Suttles, ed., *Handbook of North American Indians Vol. 7: Northwest Coast* (Washington, DC: Smithsonian Institution Press, 1990), and Aldona Jonaitis, *The Yuquot Whalers' Shrine* (Vancouver and Seattle: Douglas & McIntyre and University of Washington Press, 1999).

### 5. Nineteenth-Century Northern Coast Art

1. E.A. Porcher, *A Tour of Duty in the Pacific Northwest* (Fairbanks: University of Alaska Press, 2000), 53, 97–98.

2. Franz Boas, "Tsimshian Mythology: Based on Texts Recorded by Henry W. Tate," *31st Annual Report of the Bureau of American Ethnology for the Years 1909–1910* (1916), 556.

3. Camille de Roquefeuil, *Voyage around the world, 1816–1819, and Trading for Sea Otter Fur on the Northwest Coast of America* (Fairfield, WA: Ye Galleon Press, 1981), 107.

4. Quoted in Robin Wright, *Northern Haida Master Carvers* (Vancouver and Seattle: Douglas & McIntyre and University of Washington Press, 2003), 98.

5. Ibid., 161–62.

### 6. Settlement and Its Consequences

1. Quoted in Robin Fisher, *Contact and Conflict: Indian-European Relations in British Columbia, 1774–1890* (Vancouver: University of British Columbia Press, 1977), 114.

2. Quoted in ibid., 161.

3. Quoted in ibid., 166.

4. Canada, "An Act Further to Amend 'The Indian Act, 1880,' " *Statutes of Canada*, 47 Vict. C. 27, 1884.

5. Quoted in Ted Hinckley, *The Canoe Rocks: Alaska's Tlingit and the Euramerican Frontier, 1800–1912* (Lanham, MD: University Press of America, 1996), 88.

6. Quoted ibid., 69.

7. Quoted in Bette Hulbert, *Faces Voices & Dreams* (Sitka: Sheldon Jackson Museum, 1987), xi.

8. Quoted in Hinckley, *Canoe Rocks*, 152.

9. Quoted in Andrew Patrick, *The Most Striking of Objects: The Totem Poles of Sitka National Historical Park* (Anchorage, AK: U.S. Department of the Interior, n.d.), 60.

10. Quoted in Hinckley, *Canoe Rocks*, 337–38.

### 7. Public Awareness of Northwest Coast Art

1. John Muir, *Travels in Alaska* (Boston: Houghton Mifflin, 1979), 293.

2. Ibid.

3. Quoted in Aldona Jonaitis, *From the Land of the Totem Poles: The Northwest Coast Indian Art Collection at the American Museum of Natural History* (Vancouver and New York and Seattle: Douglas & McIntyre and University of Washington Press, 1988), 226.

### 8. Persistence of Artistic Traditions, 1900 to 1960

1. Quoted in Diana Nemiroff, "Modernism, Nationalism and Beyond," in *Land, Spirit, Power: First Nations at the National Gallery of Canada* (Ottawa: National Gallery of Canada, 1992), 23.

2. Quoted in Jack Rushing, "Marketing the Affinity of the Primitive and the Modern: René d'Harnoncourt and the 'Indian Art of the United States,'" in Janet Berlo, ed., *The Early Years of Native American Art History* (Seattle: University of Washington Press, 1992), 199.

3. Barnett Newman, *Northwest Coast Indian Painting* (New York: Betty Parsons Gallery, 1946), n.p.

### 9. Identity and Sovereignty, 1960s to Today

1. Personal communication (letter to author), 2003.

2. http://collections.ic.gc.ca/musqueam/debra_sparrow.html.

3. Quoted in Peter Macnair, "Tim Paul: The Homeward Journey," in Alan Hoover, ed., *Nuu-chah-nulth Voices, Histories, Objects and Journeys* (Victoria: Royal British Columbia Museum, 2002), 372.

4. Karen Duffek, "*Tla-kish-wga-to-ah*, Stands with his Chiefs: From an Interview with Joe David," in Hoover, *Nuu-chah-nulth Voices*, 361.

5. Steven Brown, "Of Eyes and Teeth and Sacred Clouds: James Schoppert— Releasing the Individual," in David Nichols, ed., *Instrument of Change: James Schoppert Retrospective* (Anchorage: Anchorage Museum of History and Art, 1997), 21.

6. Quoted in Diana Nemiroff et al., *Land, Spirit, Power: First Nations at the National Gallery of Art* (Ottawa: National Gallery of Canada, 1992), 222–23.

7. Ibid., 226.

8. Allen Wardwell, *Yakutat South: Indian Art of the Northwest Coast* (Chicago: The Institute, 1964), 15.

9. Peter Macnair, Alan Hoover, and Kevin Neary, *The Legacy: Continuing Traditions in Northwest Coast Indian Art* (Victoria: Royal British Columbia Museum, 1980).

10. Cape Fox Corporation Web site, www.capefoxcorp.com/repatriation.html.

11. Steven Brown, ed. *The Spirit Within: Northwest Coast Native Art from the John H. Hauberg Collection* (New York and Seattle: Rizzoli and Seattle Art Museum, 1995).

# BIBLIOGRAPHIC ESSAY

THE MOST COMPREHENSIVE PUBLICATION on past and present Northwest Coast cultures is Wayne Suttles, ed., *Handbook of North American Indians Vol. 7: The Northwest Coast*. (Washington, DC: Smithsonian Institution Press, 1990), which covers the region from Yakutat Sound to northern California and includes a section on art. It features detailed essays by experts on each Northwest Coast group and discussions of the archeology of the different regions, as well as sections on the history of research and of contact. Of special interest to the reader of this book is Bill Holm's essay, "Art." An earlier, but still useful, overview of the coast is Philip Drucker, *Indians of the Northwest Coast* (Garden City, NY: Natural History Press, 1963).

Interactions between Native people and Euroamericans significantly influenced the history of Northwest Coast art. For historical studies of Canadian Northwest Coast First Nations, see Wilson Duff, *The Indian History of British Columbia, Vol. 1, The Impact of the White Man, Anthropology in British Columbia* memoir 5 (1964); Robin Fisher, *Contact and Conflict: Indian-European Relations in British Columbia, 1774–1890*, 2nd ed. (Vancouver: University of British Columbia Press, 1992); and Cole Harris, *Making Native Space* (Vancouver: University of British Columbia Press, 2002). Douglas Cole and Ira Chaiken, in *An Iron Hand Upon the People: The Law Against the Potlatch on the Northwest Coast* (Vancouver: University of British Columbia Press, 1990) offer the most thorough history of that law. For a study of contact in Alaska, see Ted Hinckley, *The Canoe Rocks: Alaska's Tlingit and the Euramerican Frontier, 1800–1912* (Lanham, MD: University Press of America, 1996). A valuable study of the epidemic history of the region can be found in Robert Boyd's *The Coming of the Spirit of Pestilence: Introduced Infectious Diseases and Population Decline Among Northwest Coast Indians, 1774–1874* (Vancouver and Seattle: UBC Press and University of Washington Press, 1999). The history of the collecting of Northwest Coast art is exhaustively covered in Douglas Cole, *Captured Heritage: The Scramble for Northwest Coast Artifacts* (Seattle: University of Washington Press, 1985).

The most important and influential book on formline style is Bill Holm's *Northwest Coast Indian Art: An Analysis of Form* (Vancouver and Seattle: Douglas & McIntyre and University of Washington Press, 1965), which established the terminology for this style and analyzed its organization. Prior to that, Franz Boas's *Primitive Art* (New York: Dover Publications, 1955, first published 1927) made an effort to understand the style as well as identify the various animals that appear in the art. Aldona Jonaitis's *A Wealth of Thought: Franz Boas on Native American Art History* (Vancouver and Seattle: Douglas & McIntyre and University of Washington Press, 1995), reprints and analyzes Boas's essays that form the basis for *Primitive Art*. Some books that provide simplified information on formline and imagery are Cheryl Shearar, *Understanding Northwest Coast Art: A Guide to Crests, Beings and Symbols* (Vancouver and Seattle: Douglas & McIntyre and University of Washington Press, 2003) and Hilary Stewart, *Looking at Indian Art of the Northwest Coast* (Vancouver and Seattle: Douglas & McIntyre and University of Washington Press, 2003). An enjoyable conversation between two masters, Bill Holm and Bill Reid, critiquing a body of art, is the subject of *Form and Freedom: A Dialogue on Northwest Coast Indian Art* (Houston: Institute for the Arts, Rice University, 1975).

Several efforts have been made to reconstruct the history of Northwest Coast style. A recent publication that shows how infrared photography is used to decipher old and faded images, which artist Lyle Wilson then reconstructs, is Bill McLennan and Karen Duffek's *The Transforming Image: Painted Arts of the Northwest Coast First Nations* (Vancouver: University of British Columbia Press, 2000). The most thorough presentation available of Northwest Coast art history is the exhibition catalogue, by Steven Brown, of *Native Visions: Evolution in Northwest Coast Art from the Eighteenth Through the Twentieth Century* (Vancouver and Seattle: Douglas & McIntyre and University of Washington Press, 1998).

There have been published over the years a variety of catalogues of exhibitions that have presented Northwest Coast art. The art in permanent collections of various museums is discussed in *Art in the Life of the Northwest Coast Indians*, by Erna Gunter (Portland, OR: Portland Art Museum, 1966); *Spirit and Ancestor: A Century of Northwest Coast Indian Art at the Burke Museum*, by Bill Holm (Seattle: University of Washington Press, 1987); and *Objects of Bright Pride: Northwest Coast Indian Art from the American Museum of Natural History*, by Allen Wardwell (New York: Center for Inter-American Relations, 1978). Two books on museums that hold significant Northwest Coast collections among their Native American materials are *Native American Art: The Collections of the Ethnological Museum Berlin*, by Peter Bolz and Hans-Ulrich Sanner (Vancouver and Seattle: Douglas & McIntyre and University of Washington Press, 1999), and *Art of the North American Indian: The Thaw Collection*, edited

by Gilbert T. Vincent, Sherry Brydon, and Ralph T. Coe (Cooperstown and Seattle: New York State Historical Association and University of Washington Press, 2000). In the Thaw Collection volume, Steve Brown wrote the section on Northwest Coast art. Several catalogues of museum collections include essays by various authors. In *Faces, Voices, and Dreams: A Celebration of the Centennial of the Sheldon Jackson Museum*, edited by Peter Corey (Sitka, AK: Sheldon Jackson Museum, 1987), Steve Brown writes on a specific early nineteenth-century Tlingit artist, Bill Holm on the head canoe, and Robin Wright on Haida argillite. *The Spirit Within: Northwest Coast Native Art from The John H. Hauberg Collection*, edited by Steven Brown (New York and Seattle: Rizzoli and Seattle Art Museum, 1995), contains essays on Tlingit culture by Nora Marks Dauenhauer, on Northwest Coast style by Steve Brown, on contemporary Kwakwaka'wakw potlatches by Gloria Cranmer Webster, on Haida traditions by Robert Davidson, and on Haida argillite by Robin Wright. Books that present information not only on museum collections but also on how they were obtained include *Raven's Journey*, by Susan Kaplan and Kristin Barsness (Philadelphia: University of Pennsylvania Museum Publications, 1986); *From the Land of the Totem Poles: The Northwest Coast Indian Art Collection at the American Museum of Natural History*, by Aldona Jonaitis (Vancouver, New York and Seattle: Douglas & McIntyre and The Museum and University of Washington Press, 1988); and *Objects of Myth and Memory: American Indian Art at the Brooklyn Museum*, by Diana Fane, Ira Jacknis, and Lisa Breen (Brooklyn and Seattle: Brooklyn Museum and University of Washington Press, 1991).

Catalogues of special exhibitions that present art from a variety of Northwest Coast nations include William Sturtevant's *Boxes and Bowls: Decorated Containers by Nineteenth Century Haida, Tlingit, Bella Bella and Tsimshian Indian Artists* (Washington, DC: Smithsonian Institution Press, 1974), and Allen Wardwell's *Yakutat South: Indian Art of the Northwest Coast* (Chicago: The Institute, 1964). Although *Indian Art of the United States*, by Frederic Douglas and René d'Harnoncourt (New York: Museum of Modern Art, 1941) does not deal exclusively with the Northwest Coast, the volume illustrates numerous Northwest Coast objects shown in that historic exhibition. Likewise, the Tlingit are included in *The Far North: 2000 Years of American Eskimo and Indian Art*, edited by Henry Collins et al. (Washington, DC: National Gallery of Art, 1973), as well as *Crossroads of Continents: Cultures of Siberia and Alaska*, edited by William Fitzhugh and Aron Crowell (Washington, DC: Smithsonian Institution Press, 1988). Catalogues of important exhibitions that featured contemporary Native art include Wilson Duff, Bill Holm, and Bill Reid's *Arts of the Raven* (Vancouver: University of British Columbia Press, 1967); Peter Macnair, Alan Hoover, and Kevin Neary's *The Legacy: Continuing Traditions in Northwest Coast Indian Art* (Vancouver and Victoria: Douglas & McIntyre and British Columbia Provincial Museum, 1980);

Ralph T. Coe's *Lost and Found Traditions: Native American Art 1965–1985* (New York: American Federation of the Arts, 1986); Wolfgang Haberland's *Donnervogel und Raubwal: Indianische Kunst der Nordwestküste Nordamerikas* (Hamburg: Hamburg Museum of Ethnology, 1979); and Peter Macnair, Robert Joseph, and Bruce Grenville's *Down from the Shimmering Sky: Masks of the Northwest Coast* (Vancouver and Seattle: Douglas & McIntyre and University of Washington Press, 1998). *Robes of Power: Totem Poles on Cloth* by Doreen Jensen and Polly Sargent (Vancouver: University of British Columbia Press, 1986) illustrates large numbers of button blankets and includes statements by the artists. *Box of Daylight: Northwest Coast Indian Art*, ed. Bill Holm (Seattle: University of Washington Press, 1983), contains several useful essays, including one on Tlingit basketry by Peter Corey, one on Haisla masks by Alan Sawyer, and another on Haida argillite by Robin Wright.

The totem pole has been the subject of several publications. The most extensive by far is Marius Barbeau's *Totem Poles* (Ottawa: National Museums of Canada, 1950), which unfortunately contains some errors of scholarship. Barbeau also wrote *Totem Poles of the Gitksan, Upper Skeena River* (Ottawa: National Museums of Canada, 1929), which focuses on the abundant poles of that single region. Marjorie Halpin's *Totem Poles: An Illustrated Guide* (Vancouver: University of British Columbia Press, 1981) is a good overview of the subject, with examples from the Museum of Anthropology at the University of British Columbia. Hilary Stewart provides another overview in *Looking at Totem Poles* (Vancouver and Seattle: Douglas & McIntyre and University of Washington Press, 1993). Edward Malin, in *Totem Poles of the Pacific Northwest Coast* (Portland, OR: Timber Press, 1986), provides extensive historical photographs and suggests the possible diffusion paths of various totem-pole types. Edward Keithahn's *Monuments in Cedar* (Seattle: Superior Publishing, 1963) is another popularly oriented overview of poles. Vicki Jensen, in *Where the People Gather: Carving a Totem Pole* (Vancouver and Seattle: Douglas & McIntyre and University of Washington Press, 1992), presents a photographic record of the carving of a pole by Norman Tait. Jensen also produced a useful handbook for the Vancouver visitor, *The Totem Poles of Stanley Park* (Vancouver: Westcoast Words, 2004). Several books have been written on southeast Alaska poles, including an account of their appearance at the St. Louis fair by Victoria Wyatt, "A Unique Attraction: The Alaskan Totem Poles at the St. Louis Exposition of 1904," *Alaska Journal* 16 (1986); Andrew Patrick's *The Most Striking of Objects: The Totem Poles of Sitka National Historical Park* (Anchorage, AK: U.S. Department of the Interior, 2002), an extensively researched cultural biography of these poles; and Linn Forrest and Viola Garfield's book on myths associated with the WPA Ketchikan poles in *The Wolf and the Raven: Totem Poles of Southeast Alaska* (Seattle: University of

Washington Press, 1948). *Totem Poles: Myth and Monument* by Aldona Jonaitis and Aaron Glass (forthcoming) is a cultural biography of the pole from prehistoric times to the present.

Several collections of essays on Northwest Coast art are noteworthy, and address both historic and contemporary art. Donald Abbott, ed., *The World Is as Sharp as a Knife: An Anthology in Honour of Wilson Duff* (Victoria: Royal British Columbia Museum, 1981), includes scholarly essays on various aspects of Northwest Coast art and culture as well as personal remembrances of and analyses of the work by this important Northwest Coast anthropologist. Of special interest are the article by Wilson Duff and George MacDonald about the meaning of the art, Bill Holm's piece on identifying the hand of Charles Edenshaw, and the chapter on Tsimshian masking by Marjorie Halpin. The theoretically sophisticated book by Judith Ostrowitz titled *Privileging the Past: Historicism in the Art of the Northwest Coast* (Seattle: University of Washington Press, 1999) uses several case studies to investigate the use of copies in Northwest Coast art. *Bird of Paradox: The Unpublished Writings of Wilson Duff,* edited by E. N. Anderson (Blaine, WA: Hancock House, 1996), makes available imaginative theoretical essays by an always-interesting anthropologist.

Hilary Stewart has produced three useful books that focus on materials and technology: *Artifacts of the Northwest Coast Indians* (Toronto: General Publishing, 1973), *Indian Fishing: Early Methods on the Northwest Coast* (Vancouver and Seattle: Douglas & McIntyre and University of Washington Press, 1977), and *Cedar: Tree of Life to the Northwest Coast Indians* (Vancouver and Seattle: Douglas & McIntyre and University of Washington Press, 1984).

## EARLY DEVELOPMENT OF NORTHWEST COAST ART

SEVERAL PUBLICATIONS address the archeology of the Northwest Coast and include information on archeological art. *Peoples of the Northwest Coast: Their Archaeology and Prehistory,* by Kenneth Ames and Herbert Maschner (London: Thames and Hudson, 1999), presents an accessible overview of the region, addressing various archeological questions including the development of art. *The Prehistory of the Northwest Coast,* by R. G. Matson and Gary Coupland (San Diego: Academic Press, 1995), offers a more scientific approach to the topic. *Indian Art Traditions of the Northwest Coast,* edited by Roy Carlson (Burnaby, BC: Archaeology Press, Simon Fraser University, 1982), contains essays on various aspects of archeology and art history, including the editor's discussion of artistic change and continuity in Northwest Coast Art, and chapters by Charles Borden on prehistoric lower Fraser art, George MacDonald on prehistoric northern material, Richard Daugherty and Janet Friedman on Ozette, Bill Holm on form, and Wilson Duff on meaning.

In *Images, Stone, B.C.: Thirty Centuries of Northwest Coast Indian Sculpture* (Toronto: Oxford University Press, 1975), Wilson Duff presents a unique and controversial sexual perspective on the art.

The history of early contact is the subject of a variety of publications. Erna Gunther's *Indian Life on the Northwest Coast of North America: As Seen by the Early Explorers and Fur Traders during the Last Decades of the Eighteenth Century* (Chicago: University of Chicago Press, 1972) is based upon the journals of late-eighteenth-century travelers, and constitutes a general ethnography of the region. Other books, several of them exhibition catalogues, illustrate good numbers of pieces from early Northwest Coast collections: Bill Holm and Thomas Vaughan (*Soft Gold: The Fur Trade and Cultural Exchange on the Northwest Coast of America* (Portland, OR: Oregon Historical Society, 1982); J.C.H. King, *Artificial Curiosities from the Northwest Coast of America: Native American Artefacts in the British Museum Collected on the Third Voyage of Captain James Cook and Acquired Through Sir Joseph Banks* (London: British Museum Publications, 1981); Mary Malloy, *Souvenirs of the Fur Trade: Northwest Coast Indian Art and Artifacts Collected by American Mariners 1788–1844* (Cambridge, MA: Peabody Museum of Archaeology and Ethnology, Harvard University, 2000); Pavilion of Spain, World Exposition, *To the Totem Shore: The Spanish Presence on the Northwest Coast* (Madrid: Ediciones el Viso, 1986); and Wallace Olson, *Through Spanish Eyes: Spanish Voyages to Alaska, 1774–1792* (Auke Bay, AK: Heritage Research, 2002). *Spirits of the Water: Native Art Collected on Expeditions to Alaska and British Columbia, 1774–1910*, edited by Steve Brown (Vancouver and Seattle: Douglas & McIntyre and University of Washington Press, 2000), includes some art collected during the eighteenth-century voyages.

Drawings and paintings by Euroamerican artists offer the kinds of contextual information later provided by photographs. John F. Henry's *Early Maritime Artists of the Pacific Northwest Coast, 1741–1841* (Seattle: University of Washington Press, 1984) illustrates many of works created by explorers in the early nineteenth century. Paintings from a single expedition undertaken between 1865 and 1868 are published in E. A. Porcher, *A Tour of Duty in the Pacific Northwest* (Fairbanks: University of Alaska Press, 2000). James Swan, the Smithsonian Institution's chief agent in the Northwest Coast, made drawings and watercolors of people, villages, and artworks during the second half of the nineteenth century which are published in *James Swan, Cha-Tic of the Northwest Coast*, by George Miles (New Haven, CT: Beinecke Rare Book and Manuscript Library, Yale University, 2003). *Paul Kane's Great Nor-West*, by Diane Eaton and Sheila Urbanek (Vancouver: University of British Columbia Press, 1995), reproduces some of the artist's paintings from the Coast Salish and lower Columbia regions. An earlier publication on that same artist is *Paul Kane's*

*Frontier*, edited by Russell Harper (Austin: published for the Amon Carter Museum by the University of Texas Press, 1971).

WAYNE SUTTLES, *Coast Salish Essays* (Seattle: University of Washington Press, 1987), offers a highly useful investigation of various aspects of Salish ethnography, including a seminal study of why Coast Salish art is not as abundant, refined, or complex as that of more northerly groups. Jay Miller's *Shamanic Odyssey: The Lushootseed Salish Journey to the Land of the Dead* (Menlo Park, CA: Ballena, 1988) is a more recent study of the spirit-canoe ceremony analyzed earlier by Thomas Waterman in "The Paraphernalia of the Duwamish 'Spirit Canoe' Ceremony," *Museum of the American Indian, Heye Foundation, Indian Notes* 7 (1930). *Songhees Pictorial: A History of the Songhees People as Seen by Outsiders, 1790–1912*, by Grant Kiddie (Victoria: Royal British Columbia Museum, 2003), presents early drawings as well as photographs of one Salish group.

Despite its general-sounding title, the earliest study of Salish art per se is Paul Wingert's *American Indian Sculpture: A Study of the Northwest Coast* (New York: J. J. Agustin, 1949), a detailed stylistic analysis of Salish sculpture. For a thorough presentation of Washington State Salish art, see Robin Wright's *A Time of Gathering: Native American Heritage in Washington State* (Seattle: University of Washington Press, 1991). Michael Kew, *Sculpture and Engraving of the Central Coast Salish Indians* (Vancouver: University of British Columbia Museum of Anthropology, Museum Note no. 9, 1980), is a small but useful catalogue of art from the central Coast Salish. Paula Gustafson, *Salish Weaving* (Seattle: University of Washington Press, 1980), describes both historical weaving and its contemporary revival. An account of recent weaving among one group is *Hands of Our Ancestors: The Revival of Salish Weaving at Musqueam*, by Elizabeth Johnson and Kathryn Bernick (Vancouver: University of British Columbia Museum of Anthropology, Museum Note no. 16, 1986). For the basketry of other Northwest Coast groups as well as the Salish, see Andrea Laforet, "Regional and Personal Style in Northwest Coast Basketry," in Frank Porter, ed., *The Art of Native American Basketry: A Living Legacy* (New York: Greenwood, 1990), and Dawn Glinsmann, "Baskets of the Plateau, Northwest Coast, Subarctic and Arctic," in Jill Chancey, ed., *By Native Hands* (Laurel, MS: Lauren Rogers Museum of Art, 2005). Norman Feder offers a deeper look into Central Coast Salish two-dimensional design in "Incised Relief Carving of the Halkomelem and Straits Salish," *American Indian Art* 8 (1983). A much-needed survey of Chinook art is included in Bill Mercer's *People of the River: Native Arts of the Oregon Territory* (Portland, OR, and Seattle: Portland Art Museum and University of Washington Press, 2005).

THE MOST EXTENSIVELY STUDIED Northwest Coast group is the Kwakw̱aka'wakw, starting with Franz Boas. His "The Social Organization and the Secret Societies of the Kwakiutl Indians," in *Report for the U.S. National Museum for 1895* (1897) contains detailed information on ceremony and art. Audrey Hawthorn's *Kwakiutl Art* (Vancouver: University of British Columbia Press, 1967) illustrates the collection at the UBC Museum of Anthropology, and Marion Mochon's *Masks of the Northwest Coast* (Milwaukee, WI: Milwaukee Public Museum, 1966) illustrates the primarily Kwakw̱aka'wakw material of that institution. *Chiefly Feasts: The Enduring Kwakiutl Potlatch*, edited by Aldona Jonaitis (Seattle: University of Washington Press, 1991), is the catalogue of the exhibit by that name, and contains essays on various aspects of the Kwakw̱aka'wakw potlatch by the volume editor, Wayne Suttles, Douglas Cole, Ira Jacknis, Gloria Cranmer Webster, and Judith Ostrowitz. Ira Jacknis's *The Storage Box of Tradition: Kwakiutl Art, Anthropologists, and Museums, 1881–1981* (Washington, DC: Smithsonian Institution Press, 2002) is an extensively researched history that straddles the nineteenth and twentieth centuries. *Wisdom of the Elders*, by Ruth Kirk (Vancouver: Douglas & McIntyre, 1986), focuses on three central groups: the Kwakw̱aka'wakw, the Nuxalk, and the Nuu-chah-nulth.

Studies of the northern Wakashan include Martha Black's *Bella Bella: A Season of Heiltsuk Art* (Vancouver and Toronto: Douglas & McIntyre and Royal Ontario Museum, 1997), which analyzes the collection of one individual, Richard Whitfield Large, and Michael Harkin's *The Heiltsuks: Dialogues of Culture and History on the Northwest Coast* (Lincoln: University of Nebraska Press, 1997), an insightful study of culture change.

The Nuu-chah-nulth have been the subject of several ethnographies, including Philip Drucker's "The Northern and Central Nootkan Tribes," *Bureau of American Ethnology, Bulletin 144* (1951), and Eugene Arima's *The Westcoast (Nootka) People* (Victoria: Royal British Columbia Museum, 1983). Specific aspects of Nuu-chah-nulth culture are addressed by Alice Ernst in *The Wolf Ritual of the Northwest Coast* (Eugene: University of Oregon Press, 1952), and by Aldona Jonaitis in *The Yuquot Whalers' Shrine* (Seattle: University of Washington Press, 1999). The historic exhibition *Out of the Mist: Treasures of the Nuu-chah-nulth Chiefs* at the Royal British Columbia Museum resulted in two books: the exhibition catalogue edited by Martha Black (Victoria: Royal British Columbia Museum, 1999), and a collection of essays edited by Alan Hoover and titled *Nuu-chah-nulth Voices, Histories, Objects and Journeys* (Victoria: Royal British Columbia Museum, 2000). Hoover's book contains analytical articles on a range of topics including basketry by Andrea Laforet, the history of Yuquot by Yvonne Marshall, art style by Steve Brown, canoes by Eugene Arima, archeological mate-

rial by Alan McMillan, the whalers' shrine by Aldona Jonaitis, and artist Tim Paul by Peter Macnair. The books also includes "conversations" with contemporary artists Art Thompson, Joe David, and Ron Hamilton.

The preeminent ethnography of the Nuxalk is Thomas McIllwraith's *The Bella Coola Indians* (Toronto: University of Toronto Press, 1948). In the Jesup North Pacific Expedition series is Boas's 1898 "The Mythology of the Bella Coola Indians" in *Publications of the Jesup North Pacific Expedition*, vol. 2 (New York: American Museum of Natural History), which includes illustrations of numerous Nuxalk masks. A more focused investigation can be found in *Bella Coola Ceremony and Art*, by Margaret Stott (Ottawa: National Museum of Man Mercury Series, Canadian Ethnology Service Paper No. 21, 1975). A more theoretical treatment is available in Jennifer Kramer's *Switchbacks: Art, Ownership, and Nuxalk National Identity* (Vancouver: UBC Press, 2006).

## NORTHERN GROUPS

THE TLINGIT have been extensively studied, thanks to the abundant information gathered by George Emmons. Much of his ethnographic data are published by Frederica deLaguna in *The Tlingit Indians* (New York and Seattle: American Museum of Natural History and University of Washington Press, 1991). John Swanton's "Social Conditions, Beliefs and Linguistic Relationships of the Tlingit Indians" in *Report of the Bureau of American Ethnology for 1904–5* (1908) contains useful ethnographic information as well. DeLaguna also produced a three-volume monograph on one particular Tlingit group, *Under Mount St. Elias: The History and Culture of the Yakutat Tlingit* (Washington, DC: Smithsonian Institution Press, 1972). Three books on Tlingit oratory by Nora Marks Dauenhauer and Richard Dauenhauer provide excellent information on numerous aspects of art: *Haa Skua: Our Ancestors* (Seattle: University of Washington Press, 1987), *Haa Tuwunaagu Yis: For Our Healing Spirit* (Seattle: University of Washington Press, 1990), and *Haa Kusteeyi: Our Culture: Tlingit Life Stories* (Seattle: University of Washington Press, 1994). A particularly useful publication, *Celebration 2000*, eds. Susie Fair and Rosita Worl (Juneau, AK: Sealaska Heritage Foundation, 2000), contains historical and contemporary information including an article on Tlingit art by Steve Brown. Aldona Jonaitis, *Art of the Northern Tlingit* (Seattle: University of Washington Press, 1986), is a structuralist interpretation of nineteenth-century Tlingit art. Allen Wardwell's *Tangible Visions: Northwest Coast Indian Shamanism and Its Art* (New York: Monacelli Press with the Corvus Press, 1996) includes illustrations of shamanic objects from the whole coast, but mostly concentrates on those of the Tlingit. "From Taquan to Klukwan: Tracing the Works of an Early Tlingit Master Artist," an essay by Steve Brown in *Faces, Voices and Dreams*, ed. Peter Corey (1987, see above), offers valuable information on the style

of an especially skilled artist from the early nineteenth century. See also Brown's essay "A Tale of Two Carvers: The Rain Wall Screen of the Whale House, Klukwan, Alaska," in *American Indian Art Magazine* vol. 30, no. 4 (2005), 48–59. Victoria Wyatt presents photographs, mainly of the Tlingit, by noted photographic team Lloyd Winter and Percy Pond in *Images from the Inside Passage: An Alaskan Portrait by Winter and Pond* (Seattle: University of Washington Press, 1989).

George T. Emmons wrote two early studies of women's art, *The Basketry of the Tlingit* and *The Chilkat Blanket* (1903 and 1907, respectively). Both were reprinted in 1993 by the Friends of the Sheldon Jackson Museum, Sitka. The Chilkat robe study contains an extensive section by Franz Boas, and his contribution was reprinted also by Jonaitis in *A Wealth of Thought* (1995, see above). In 1954, Frances Paul published *Spruce Root Basketry of the Tlingit* (Lawrence, KS: Department of the Interior, Bureau of Indian Affairs, 1954), another detailed work on technique and ornament; the Sheldon Jackson Museum reprinted this in 1991. More recent studies of Tlingit weaving include Cheryl Samuel's *The Chilkat Dancing Blanket* (Seattle: Pacific Search Press, 1982) and *The Raven's Tail* (Vancouver: University of British Columbia Press, 1987). Bill Holm's "A Wooling Mantle Neatly Wrought: The Early Historic Record of Northwest Coast Pattern-Twined Textiles," *American Indian Art* 7(4) (1982) presents a history of textile development on the coast. Sharon Busby, in *Spruce Root Basketry of the Haida and Tlingit* (Seattle: Marquand Books, distrib. University of Washington Press, 2003), offers a lavishly illustrated publication on nineteenth- and twentieth-century northern basket traditions. *The Art of Native American Basketry: A Living Legacy*, ed. Frank Porter (New York: Greenwood, 1990), includes "Tlingit Basketry, 1750–1950," by Ronald Weber.

An extensive study of Tsimshian myths and comparisons among Northwest Coast myths is offered by Franz Boas in "Tsimshian Mythology: Based on Texts Recorded by Henry W. Tate," in *31st Annual Report of the Bureau of American Ethnology for the Years 1909–1910* (1916). *The Tsimshian: Their Arts and Music*, by Viola Garfield and Paul Wingert (New York: American Ethnology Society, 1951), is a concise overview of that topic. Wilson Duff's *Histories, Territories and Laws of the Kitwancool* (Victoria: Royal British Columbia Museum, 1959) was a result of Duff's negotiations with the Kitwancool to salvage some of their poles. Two collections of essays, *The Tsimshian and Their Neighbors*, ed. Jay Miller and Carol Eastman (Seattle: University of Washington Press, 1984), and *The Tsimshian: Image of the Past, Views for the Present*, ed. Margaret Seguin (Vancouver: University of British Columbia Press, 1984), include several pieces on art-related topics: in the former, George MacDonald on house-front painting, and in the latter, Andrea Laforet on basketry and Marjorie

Halpin on masking. *Tsimshian Culture: A Light Through the Ages*, by Jay Miller (Lincoln: University of Nebraska Press, 1997), is a symbolic analysis that deals, among other topics, with the crests, *naxnox*, and shamans of the Southern Tsimshian. *Potlatch at Gitsegukla: William Beynon's 1945 Field Notebooks*, eds. Margaret Anderson and Marjorie Halpin (Vancouver: University of British Columbia Press, 2000), describes in great detail several poles raised in a Gitskan community in the mid-twentieth century. Richard Daley, expert witness for an historic land-claims case, presents extensive ethnographic information that supported the Gitskan, and also includes material on totem poles and crests in *Our Box Was Full: An Ethnography for the Delgamuukw Plaintiffs* (Vancouver: University of British Columbia Press, 2005).

Haida culture and art have been studied by scholars since John Swanton published *Contributions to the Ethnology of the Haida* (Leiden: E. J. Brill, 1905). George MacDonald, *Haida Monumental Art: Villages of the Queen Charlotte Islands* (Vancouver: University of British Columbia Press, 1983), contains numerous nineteenth-century photographs of villages and village plans. Robin Wright's *Northern Haida Master Carvers* (Vancouver and Seattle: Douglas & McIntyre and University of Washington Press, 2003) is an exhaustive study of the northern Haida tradition, and includes detailed analyses of individual carvers such as Albert Edward Edenshaw and Charles Edenshaw. For more on the identification of artists' hands, see Bill Holm, "Will the Real Charles Edenshaw Please Stand Up?" in Donald Abbott, ed., *The World Is as Sharp as a Knife* (1981, see above). Margaret Blackman, in *Windows on the Past: The Photographic Ethnohistory of the Northern and Kaigani Haida* (National Museum of Man, Mercury Series, Canadian Ethnology Service Paper No. 74, 1981), uses turn-of-the-century photographs to reconstruct Haida culture of that time. Blackman also investigates how Haida have adjusted artistically to the transformation of their culture in "Totems to Tombstones: Culture Change as Viewed Through the Haida Mortuary Complex," *Ethnology* 12 (1973).

Argillite has been the subject of various publications, including a most useful book by Peter Macnair and Alan Hoover, *The Magic Leaves: A History of Haida Argillite Carving* (Victoria: British Columbia Provincial Museum, 1984). Marius Barbeau wrote several monographs for the National Museum of Canada Bulletin, *Haida Myths Illustrated in Argillite Carvings* (no. 139, 1953) and *Haida Carvers in Argillite* (no. 152, 1957), which are well illustrated but have contested attributions. A creative but not universally accepted interpretation of changes in argillite style is offered by Carol Sheehan in *Pipes That Won't Smoke, Coal That Won't Burn: Haida Sculpture in Argillite* (Calgary, AB: Glenbow Museum, 1981). An especially interesting topic is discussed by Robin Wright in "The Depiction of Women in Nineteenth Century Haida Argillite Carving," *American Indian Art Magazine* 11(4) (1985).

THE PRINCIPAL PUBLICATION on Native art from the first half of the twentieth century is Ronald Hawker's *Tales of Ghosts: First Nations Art in British Columbia, 1922–61* (Vancouver: University of British Columbia Press, 2003), a thorough discussion of a usually-overlooked body of art. *In the Shadow of the Sun: Perspectives on Contemporary Native Art*, ed. Canadian Museum of Civilization (Hull, QC: Canadian Museum of Civilization, 1993), features an essay on art from 1880 to 1959 by Peter Macnair, and one on art from 1960 to the present by Karen Duffek. A noteworthy essay on the persistence of traditions is by Margaret Blackman, "Creativity in Acculturation: Art, Architecture and Ceremony from the Northwest Coast," *Ethnohistory* 23(4) (1976). Kwakwaka'wakw twentieth-century artists are well represented in the literature, including Bill Holm's *Smokey-Top: The Art and Times of Willie Seaweed* (Seattle: University of Washington Press, 1983), and Phil Nuytten's *The Totem-Carvers: Charlie James, Ellen Neel and Mungo Martin* (Vancouver: University of British Columbia Press, 1982). A fascinating study of early-twentieth-century Kwakwaka'wakw pictographs and a contemporary version by Marianne Nicholson is found in *Two Wolves at the Dawn of Time: Kingcome Inlet Pictographs, 1893–1998* (Vancouver: New Star Books, 2001). The work at a Native-run art school is the focus of *'Ksan: Breath of Our Grandfathers* (Ottawa: National Museums of Canada, 1972).

Publications about single artists began proliferating as individual artists became well known. Bill Reid has been the subject of several books: Karen Duffek's *Bill Reid: Beyond the Essential Form* (Vancouver: University of British Columbia Press, 1986); Doris Shadbolt's *Bill Reid* (Vancouver and Seattle: Douglas & McIntyre and University of Washington Press, 1986); and Robert Bringhurst and Ulli Steltzer's *The Black Canoe: Bill Reid and the Spirit of Haida Gwaii* (Vancouver and Seattle: Douglas & McIntyre and University of Washington Press, 1991). *Bill Reid and Beyond: Expanding on Modern Native Art*, edited by Karen Duffek and Charlotte Townsend-Gault (Vancouver and Seattle: Douglas & McIntyre and University of Washington Press, 2003), not only discusses Reid himself but also addresses the idea of the "Northwest Coast renaissance" from different perspectives, in essays by Karen Duffek, Alan Hoover, Aldona Jonaitis, Aaron Glass, and Charlotte Townsend-Gault. Especially noteworthy contributions to this book are those by First Nations artists and scholars Diane Brown, Marcia Crosby, Doug Cranmer, Ron Hamilton, and Marianne Nicholson. A far more critical look at Reid is offered by Maria Tippett in *Bill Reid: The Making of an Indian* (Toronto: Random House, 2003). There are also several volumes about Robert Davidson: Ian Thom, ed., *Robert Davidson: Eagle of the Dawn* (Seattle: University of Washington Press, 1993), which contains an essay on Haida art history by Aldona Jonaitis and a piece about Davidson by a Haida,

Marianne Jones; Robert Davidson and Ulli Steltzer, *Eagle Transforming: The Art of Robert Davidson* (Vancouver and Seattle: Douglas & McIntyre and University of Washington Press, 1994), a book noteworthy for its text written by the artist himself; and *Robert Davidson: The Abstract Edge* (Vancouver: University of British Columbia Museum of Anthropology, 2004). Other books on individual artists include *Instrument of Change: James Schoppert Retrospective*, ed. David Nichols (Anchorage: Anchorage Museum of History and Art, 1997), and *Susan Point: Coast Salish Artist*, ed. Gary Wyatt (Vancouver and Seattle: Douglas & McIntyre and University of Washington Press, 2000). Joe David, Lawrence Paul, and Susan Point are featured in *Indianische Künstler der Westküste Kanadas / Native Artists from the Northwest Coast,* by Peter Gerber and Vanina Katz-Lahaigue (Zurich: Ethnological Museum of the University of Zurich, 1989), the bilingual catalogue of a Swiss exhibition. *Lyle Wilson: When Worlds Collide,* by Karen Duffek (Vancouver: University of British Columbia Museum of Anthropology, 1989), investigates the art of this contemporary Haisla artist. Charlotte Townsend-Gault, Scott Watson, and the artist himself discuss the surrealistic art of Lawrence Paul in *Lawrence Paul Yuxweluptun: Born to Live and Die on Your Colonialist Reservations* (Vancouver: University of British Columbia Museum of Anthropology, 1995). Contemporary printmaking is the topic of *Northwest Coast Indian Graphics: An Introduction to Silk Screen Prints,* by Edwin S. Hall, Margaret Blackman, and Vincent Richard (Seattle: University of Washington Press, 1981).

Bill Holm and George I. Quimby trace the history of the creation of Curtis's film in *Edward S. Curtis in the Land of the War Canoes: A Pioneer Cinematographer in the Pacific Northwest* (Seattle: University of Washington Press, 1980). Kwakwaka'wakw photographer David Neel has produced two books of photographs, *Our Chiefs and Elders* (Seattle: University of Washington Press, 1992) and *The Great Canoes: Reviving a Northwest Coast Tradition* (Seattle: University of Washington Press, 1995).

For literature on repatriation, see *Turning the Page: Forging New Partnerships Between Museums and First People* by the Task Force on Museums and First People (Ottawa: Canadian Museums Association and Assembly of First Nations, 1992) and *Bringing Our Ancestors Home: The Repatriation of Nisga'a Artifacts* by the Nisga'a Tribal Council (1998). See also *Repatriation Reader: Who Owns American Indian Remains?* ed. Devon A. Mihesuah (Lincoln: University of Nebraska Press, 2000).

Hudson, Clarissa, 265

Hudson's Bay Company, 54–55, 107–8, 147

human figure motif: Cowichan, 282, **283**; exploration era, 44, **45**; Haida, **33,** 197, **263**; Kwakwaka'wakw, 90, **91,** 108, **109,** 229, **230**; Makah, **202**; Marpole, 17, **18**; Nuu-chah-nulth, 221; Quinault, **12,** 61, **66,** 67; Salish, 67, **68,** 83, **85**; Songhees, **78**; Tlingit, **49,** 139, **140**; as tourist art, 191; Tsimshian, 149, **150,** 156, **157, 158**; Wasco-Wishram, 61, **62–65**. *See also* masks

Hunt, Calvin, 257, 259

Hunt, George, 209, 211, **212**

Hunt, Henry, 242, 260, 284

Hunt, Richard, **254,** 257

Hunt, Tony, 242, 257, 259, 260, 284

Hunt, Tony, Jr., 260

*HuupuKanum Pupaat Out of the Mist* (exhibit), 290

*Ice Walker* (Rofkar), 267

Image Recovery Project, 293

imbrication, Salish basketry, **25,** 67

*Indian Art of the United States* (exhibit), 240

Indian Arts and Crafts Board, 236, 239

Indian Civilian Conservation Corps, 236–38

*In the Land of the Head-Hunters* (Curtis), 205–7

Iswa, Harold, **20**

Jack, Captain, 229

Jackson, Nathan, 265, 290, **291**

Jackson, Sheldon, 180, 181, 183

Jacobsen, Johan Adrien, 213

James, Charlie, 205, 224, 227

James, Sara Nina, 227

Jesup North Pacific Expedition, 207–8, 209, 215

Johnson Museum, 289–90

Jonaitis, Aldona (as co-curator), 292

Jones, Marianne, **276**

Kaigani Haida. *See* Haida *entries*

Kane, Paul, **59, 72, 79, 80**

Kennedy, John, 149

Kitanmax School, 259

Klallam houses/house posts, **72**. *See also* Salish art

knitting, Cowichan, 259

Koerner, Walter, 262

Komkotes village, **105**

'Ksan Indian Museum and Cultural Centre, 293

*Kusiut* dancing society, Nuxalk, 106–7

Kwagiulth Museum, 285–87

Kwakwaka'wakw art: bowls, 108, **110–11**; clothing, 116, **119**; coppers, 108, **109,** 275, **278**; human figures, 108, **109**; modern carving generally, 260; printmaking, 257; totem poles, 176–77, **178,** 224, 227, 229, **230,** 242, 260

Kwakwaka'wakw art, houses/house posts: construction style, 10; as crest displays, 97, **98,** 107; in Curtis film, 205–6; museum collaborations, 242, **243**; old-style carving, 90, **91**; Sea Monster motifs, 97, **98, 252**; world's fairs exhibits, **212**

Kwakwaka'wakw art, masks: Bakwas representation, **11**; in Curtis film, 205, **206**; dancing societies, 112–16, **117**; painting style, **11,** 90; during potlatch ban period, 224, **225,** 227, **228**; twentieth-century, **253–54**

Kwakwaka'wakw art, painting: Bakwas mask, **11,** 90; houses, 97, **98,** 242, **243, 252**; pictographs, 224, **226, 275, 278**; twentieth-century masks, 227, **228**

Kwakwaka'wakw people: Euroamerican conflicts, 176–77, 224; exploration era, 52, 53; film production, 205–7; gallery operations, 257; as language group, 7, 89; original lifestyle, 107–8, 112, 114, 120; repatriation conflicts, 285–86; world's fairs, 211, **212**

labrets, 27, 193, **194**

ladles. *See* spoons

Lalaiail, 106

land disputes, Native-Euroamerican, 172–75, 179–80, 222–24, 245, 250–51, 288

Lax Kw'alaams (Fort Simpson), 147

*The Legacy* (exhibit), 284

Legiac lineage, 149

Lightning Serpent motif, Nuu-chah-nulth, 95, **96,** 97, **231**

Livingstone, John, 257

looms and weaving tools, 83, **84–85,** 270, **272**

Lorenzetto, Adeleine, 259

Lummi art. *See* Salish art

MacDonald, George, xix

Macnair, Peter, 257, 284

Makah art: basketry, 199, **202**; box, 20–21, 29; headdresses, 122; rattle, 122, **123**; whaling shrine, 124–25

Makah Cultural and Research Centre, 293

Makah people, 89, 121–22, 124–25

Maquinna, Chief, **40, 43,** 53–54

Maquinna hats, 41, **43,** 44, 199

Marchand, Étienne, xiv

market-oriented art. *See* public-oriented art; twentieth-century art

Marpole art, 16–17

Martin, David, 242

Martin, Harry, **xix,** 293

Martin, Mungo, 224, 227, 241–42, **243,** 255, 260

masks: Haida, 127–28, **131,** 159, 193, **194**; Heiltsuk, 100, **103**; Nuu-chah-nulth, **42,** 90, **93,** 122, 229, **232**; Nuxalk, 90, **92,** 95, 104, 106–7; Salish, 73, 75–76, 86; Tlingit, 127–28, **130,** 142, 145; Tsimshian, 127, **129,** 151, **153,** 154

masks, Kwakwaka'wakw: Bakwas representation, **11**; in Curtis film, 205, **206**; dancing societies, 112–16, **117**; painting style, **11,** 90; during potlatch ban period, 224, **225,** 227, **228**; repatriation of, 292; twentieth-century, **253–54**

Mason, Oliver, 61, 67

Massett village, 162, **163,** 176

Maxwell, Cecile, 290

Maynard, Richard, 105